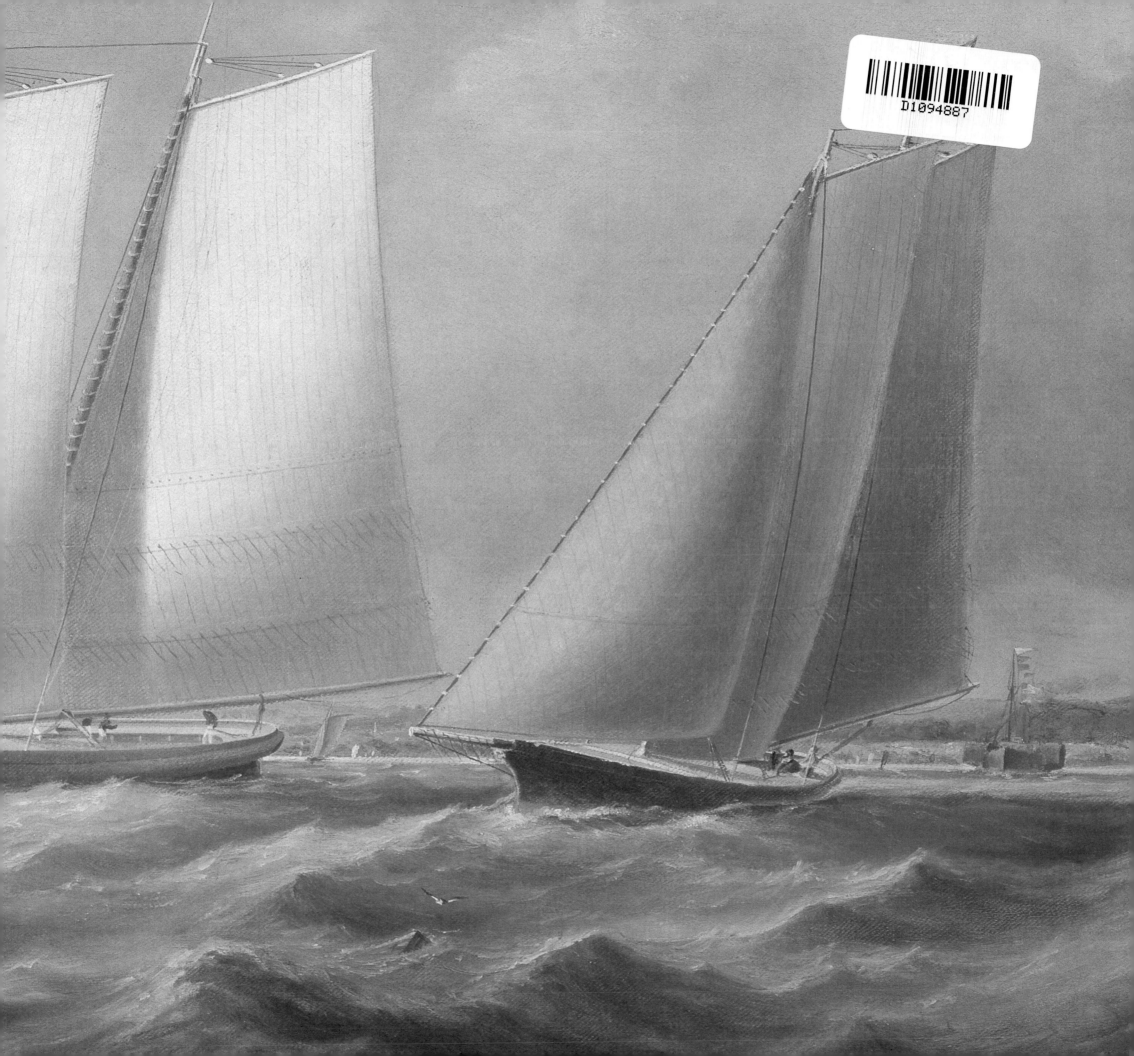

A YACHTSMAN'S EYE

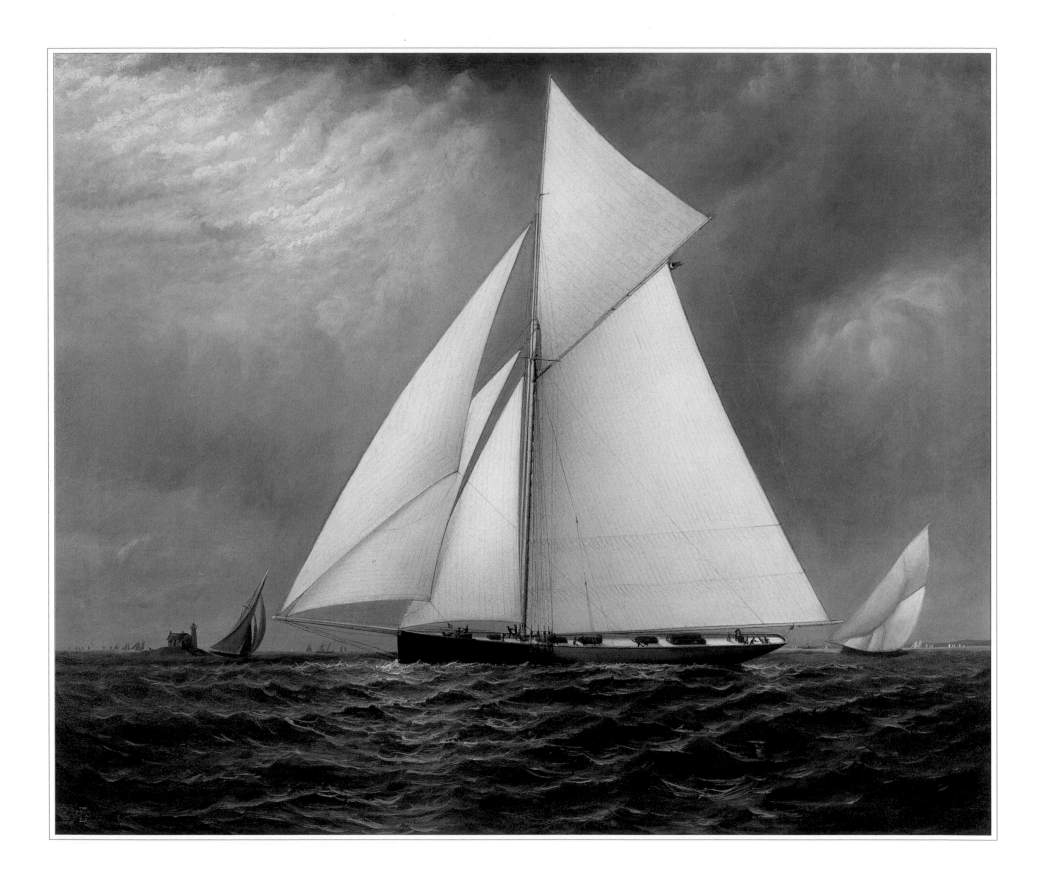

A Yachtsman's Eye

The Glen S. Foster Collection of Marine Paintings

Edited and Produced by

Alan Granby, Ph.D.

with Text and Captions by

Ben Simons

and Others

Independence Seaport Museum
Philadelphia, Pennsylvania

in association with

W. W. Norton & Company
New York

W. W. Norton
500 Fifth Avenue
New York, NY 10010
800–223–2584 • www.wwnorton.com

INDEPENDENCE SEAPORT MUSEUM
211 South Columbus Boulevard
Philadelphia, PA 19106
215-925-5439 • www.phillyseaport.org

First printing: December 2004
Four thousand five hundred copies of this book were produced.
Seventy-five copies are slipcased and numbered as a special edition signed by the principal author,
and twenty copies are hand-bound with leather, slipcased, and signed by the principal author.

Cataloging-in-Publication Data
Granby, Alan.
 A yachtsman's eye : the Glen S. Foster collection of marine paintings / Alan Granby,
Ben Simons.
 p. cm.
 Includes bibliographical references and index.
 ISBN 0-393-06063-2
 1. Marine painting, American. 2. Marine painting, British. 3. Yachts in art. 4. Foster, Glen S.,
d. 1999—Art collections. I. Simons, Ben (Ben T.) II. Title.
 ND1372.G73 2004
 758'.2'0941074—dc22

Painting of the crossed burgees (Royal Yacht Squadron, Glen S. Foster, and New York Yacht
Club) by Jan Adkins.

Frontispiece
The Seawanhaka Corinthian Yacht Club Cutter Bedouin *off Execution Rocks Lighthouse* by Elisha Taylor Baker.

Jacket Illustrations
FRONT: Puritan *Leading* Genesta, *1885* by James E. Buttersworth.
BACK: *Schooner with a View of Boston* by Robert Salmon.

Endpaper Illustrations
FRONT: *Yacht* America *from Three Views* by Fitz Hugh Lane.
BACK: *Greenock Harbour, 1820* by Robert Salmon.

Jacket and text designed on Crummett Mountain by Edith Allard, Somerville, Maine.
Layout by Nina DeGraff, Basil Hill Graphics, Somerville, Maine.
Copyediting by Jane Crosen, Crackerjack Editorial Services, Penobscot, Maine.
Production managed by Tilbury House, Publishers, Gardiner, Maine.
Printing and binding by Sung In Printing, South Korea.

TO THE MEMORY OF
GLEN FOSTER,
An inspiration to all
who appreciate a winning combination
of wind and water and canvas.

AND TO JANICE,
Thanks to her encouragement,
organization, and persistence,
I was able to take this book from
an idea to a reality.

ACKNOWLEDGMENTS

In addition to the contributors, we would like to thank the following people for their invaluable assistance in preparing this book:
Genevieve G. Alexanderson, John Steven Dews, Robert Erskine, Daniel Finamore, Brandon Brame Fortune, Colin Foster, Michael Frankel, Fritz Gold, Richard Grassby, Janice Granby, Robert B. McKay, John Mecray, Townsend Morey, Bill Roman, Ron Rosenberg, John Rousmaniere, Lindsay Shuckart, Deborah J. Warner, William Watson.

We would also like to express our thanks to Bonhams, Phillips de Pury & Luxembourg, and Jones-Sands Publishing.

This book has been made possible by generous donations from:
Genevieve G. Alexanderson
W. Graham Arader
Richard N. Bohan
Charles C. Butt
John Carter
Stephen S. and Mary Beth Daniel
Colin Foster
Janice and Alan Granby
Halsey C. Herreshoff
Edward W. Kane and Martha J. Wallace
Richard Kelton, The Kelton Foundation
George Lewis, S & Co., Inc.
Peter McCausland, The McCausland Foundation
George H. McEvoy, The Mildred H. McEvoy Foundation
Donald C. McGraw, The Donald C. McGraw Foundation
John and Marjorie McGraw
Brian O'Neill, The O'Neill Group
The Opatrny Family Foundation
Sumner B. Tilton, Jr., The Bradley C. Higgins Foundation

CONTRIBUTORS

Harry H. Anderson, Jr.

John Carter, president and CEO of the Independence Seaport Museum,
Philadelphia, Pennsylvania

A. S. Davidson, president of the Liverpool Nautical Research Society, honorary
consultant at the Maritime Museum, Liverpool, and former dean of Postgraduate
Medical Studies at the University of Liverpool

Karl Gabosh

Alan Granby, Hyland Granby Antiques

Llewellyn Howland III, Howland and Company

Betty Krulik

Richard C. Kugler, director emeritus of the New Bedford Whaling Museum

Alistair Laird, Bonhams

Erik A. R. Ronnberg, Jr.

Ben Simons, assistant curator of the Nantucket Historical Association

CONTENTS

FOREWORD
RECOLLECTING A CONNOISSEUR

GLEN FOSTER first appeared in my life over twenty-five years ago when I was curator of maritime history at the Peabody Museum of Salem (now the Peabody Essex Museum). He stopped by, as did many marine painting aficionados, to see works by his favorite artists as well as to do some research on various painters. I remember him well, a bit rotund and balding, usually in a finely tailored pinstriped suit and a tie with some sailing motif or club orientation. He had the unkempt air of a professor, and while his speech often came in halting staccato, he immediately clamped his eyes on whatever happened to be the best painting I had in my office for that particular visit. I remember one early visit when I had a J. S. Sargent of Commodore Sears on his schooner in full regalia, just to the left of my desk, a wonderful portrait of a canny and interesting competitive yachtsman from the north shore of Massachusetts; during the whole meeting Glen was speaking to me but addressing the commodore to my left.

He was particularly interested in J. E. Buttersworth and told me on one of his earlier visits that he had "collected a few." He also delved into our extensive files on Robert Salmon and Fitz Hugh Lane, taking copious notes and asking numerous questions. Eventually he was allowed access to the famous storage rooms where over ninety percent of the collection was stored—due to lack of space in the galleries of an institution founded in 1799 that actively collected for centuries. We corresponded periodically over the years on artists and new bits of research we each had unearthed. While he often told me about the art he had acquired, he never sent photographs of the pieces like many collectors often did, seeking praise for astuteness or an opinion of the subject and how it was handled. He knew and trusted his eye and didn't need anyone to assure him of his collecting sensibilities.

As time passed I went on to other positions and he collected more quality marine art, continually "upgrading" his collection and "culling" out lesser pieces as he developed a precise eye and saw his fortunes improve in his business situation. I was invited down to New York to see his collection more than once, but sorry to say, I always seemed to have too much on my plate on trips to the City and too little time, so it was not until 1989 that I finally paid a visit to his small walk-up apartment on the east side.

The apartment was only two rooms but with high ceilings—and how Glen needed the expanse of wall those ceilings provided, for stacked frame to frame was one of the best collections of marine art I had seen in a long time. The lighting was

poor, the hanging somewhat careless; but no matter, here was a treasure of immense proportions. As he had said many times, he did enjoy James Buttersworth, because Buttersworth was the predominant artist in yachting scene after yachting scene. While his favorites were granted wall space, other paintings crowded the floor and were everywhere, including the bathroom.

I can clearly remember three large Buttersworth paintings on the west wall of the apartment that were actually hung at a good viewing level. Equal in size, the three are in this book, and Glen had hung them perfectly so that their skies pyramided up from the left painting to a crescendo of cloud, light, and atmosphere in the middle painting and tapered off to a few clouds in the right painting. We often spoke of Buttersworth as a "big sky" painter who used his skies to convey depth as well as atmospheric conditions that affected the vessels within the painting almost always correctly.

Glen was a true connoisseur and not someone who purchased what the market was highlighting. In his profession he was a "market maker" and this professional aspect carried over marvelously into his collecting. The majority of the pieces that he collected for reasonable prices have reached stratospheric levels in recent years, but he was buying quality, had a knowledgeable eye, and knew his artists as well as what he liked. He was a stickler for that elusive term "quality" which is so well-used by connoisseurs as opposed to those who depend on others to tell them what their taste should be in a particular collecting area.

So often I have encountered "collectors" who either buy what some advisor tells them to or what the latest market fascination happens to be—not so with Glen. While Buttersworth, for instance, was recognizable and collected, the artist had not reached the level of, say, Salmon or Lane, when Glen collected the majority of his pieces. He drew inspiration from Rudolph J. Schaefer, whose carefully researched book on Buttersworth (*J. E. Buttersworth: 19th-Century Marine Painter*, Mystic Seaport, 1975) had appeared shortly after Glen began to collect in earnest.

Glen appreciated fine art as well as history, and these sensibilities coalesced with his love of sailing into a fine and practiced eye for the best in marine art. He knew firsthand what water looked like from a yachtsman's standpoint and what a sky could foretell for someone on the water. As he looked at and for marine art, he let this knowledge guide his carefully attuned instincts; combined with his financial acuity, he was an unbeatable collector who knew when to hold and when to fold.

Competition was a hallmark of Glen's time on the water, and as seen from the brief biography following, Glen pursued racing with an eye on the cup and a firm hand on the tiller. He carried this energy into other endeavors, and collecting fine art was an area that received his full competitive spirit. Like all serious collectors he

loved the chase, while as a connoisseur he was careful about both his research and the provenance of the works he set in his sights. He had wide-ranging contacts to keep abreast of the market and alert him to new pieces that would surface. Many times I called him when I found a particular painting or artifact that was not within my institution's purview or interest, but often I found that he already knew about the piece and could give me a rundown on its condition and previous owners.

We often talked about various pieces in his collection when we got together, which I am sad to say grew less and less as we both took on increasingly busy schedules. Whenever we would see one another at auctions or the New York Yacht Club, in committee meetings or on social occasions, it was always a time to catch up and invariably hear about a new treasure Glen had unearthed. His enthusiasm was boundless for racing and collecting, both of which he pursued to extremes.

Glen was as challenging on the auction floor as he was in a Six-Meter boat, and he was always, always looking for the edge, the slot, the advantage, and, of course, the win. While I never had the opportunity to observe Glen in action on the racecourse, I would bet that if I were speaking to his crew about my observations of Glen on the floor of an auction that held a "prize" among its items up for bid, they would immediately recognize their old crewmate and friend from my description of his manner, tact, and facial expressions. His collection grew along with his notoriety at the sales, and he eventually tapped Alan Granby, marine art dealer and confidant, to "do his bidding" and assist in further extensions to the collection.

As Glen's fortunes changed, he decided with his wife Kay that it was time to allow the collection some "breathing room" and the proper gallery space to show it at its best. Those of us who knew him well joked that the magnificent apartment he bought was chosen simply because it offered the best venue to display the large and uncompromisingly excellent collection that had been a good part of his life's work. Interestingly, the apartment looked out over the East River and was not too far from the original landing and docks for the New York Yacht Club when its yachts and commuters were a part of waterfront New York. While the apartment was wonderfully decorated, it almost seemed as though the space was built purely for the paintings that were hung with care and to their advantage for viewing. Finally the great Buttersworths had the space and lighting to really have an impact, and I heard more than one curator or collector gasp when they entered the main living room of the apartment.

Those of us who were fortunate enough to have Glen as a part of our lives came away much better for the experience. He helped me improve my eye for fine art immensely over the years and in the early period of our friendship was a great help

in gaining a "leg up" on the auction floor. His steady and unflagging interest in "clubmanship" and his assistance to the committees he sat on at the New York Yacht Club showed by example his deep and abiding interest in the preservation and the passing on of tradition and values. Often if an important painting needed conservation at the club or a frame wasn't of the proper period or quality, Glen would use his own funds to see that the job was done correctly and by the right hand. He was a gentleman and a true connoisseur. We hope that by publishing this book on the majority of his extensive collection, others might gain from his wisdom and competitive spirit as they study or assemble their own collections.

John Carter
Philadelphia

INTRODUCTION

FOR THE FIFTEEN YEARS prior to Glen Foster's death in 1999, I had a close relationship with him based upon our common interest in marine art. For many years I had been watching the marketplace and had seen great American marine and yachting paintings purchased but had no idea where the paintings were ultimately going. Finally I met Glen and was invited to his apartment, and when I scanned the walls—the paintings were all there, all the great paintings going back years.

With this initial encounter, our relationship grew. We would speak several times a week at length regarding marine art that was coming on the market. We discussed paintings being offered for sale both in the United States and Europe and analyzed which paintings would be appropriate for Glen's collection. Glen was extremely resourceful and he developed positive, friendly relationships with painting dealers and the art specialists at various auction galleries. Glen worked with many great dealers closely, but in the final years, he decided that I should represent him at auctions and consult on his purchases. Often during this time, Glen would be off yachting in the far corners of the globe for periods of six to eight weeks at a time, but he always wished to be kept abreast so as not to miss an opportunity to buy a great painting for his ever-growing collection.

In 1990 Glen sponsored me for membership in the New York Yacht Club—a club Glen loved, enjoyed, and enthusiastically supported. It was a great privilege for me to be sponsored by such a well-respected yachtsman and even further to receive Glen's encouragement in 1991 when I was asked to join the club's Fine Arts Committee, of which he was a member. Glen's involvement with the Fine Arts Committee was very meaningful as well as most fitting. I would watch Glen's excitement as issues were presented by the committee chairman, Bob MacKay. Glen was interested in all issues relating to the club's collection, including conservation, framing, placement, and acquisitions. After Glen's death, Bob MacKay was pleased to announce to the Fine Arts Committee that the large and important A. Cary Smith painting of the America's Cup defender *Columbia* was to have a plaque placed on its frame honoring Glen Foster. Glen would have been thrilled.

Glen was on familiar terms with museum curators and was frequently visited by groups of curators with whom he shared his collection, which for years had the reputation of being the finest private collection of marine paintings anywhere. Glen was often asked to lend his paintings to various museums for exhibitions, which he graciously agreed to do. Whenever possible, each painting that has appeared in an exhibition has been identified in this book. (Note that some exhibitions in which paintings appeared took place prior to Glen's ownership.)

Glen's paintings were like children to him, and he spared no expense in their conservation and framing. He worked closely with Ken Needleman and Peter Fedora of Fedora Fine Art in conservation. Glen considered framing to be an extremely important element in the overall presentation of a piece and believed strongly in using frames of the period with original surfaces. He consulted with Eli Wilner in selecting frames for many of his pieces.

Glen did not consider himself a marine painting collector, but a collector of fine art with an emphasis on marine subjects. The common ship portrait had no place in his collection. If a painting was great and had a few condition issues, he would put the problems aside and purchase it—regarding it as a major work of art. Glen took issue with collectors who purchased with the black light and demanded perfection. By doing so, he felt, they missed the opportunity to buy many great paintings. If the existing condition of the picture retained the essential message and original intent of the artist, with damages that did not compromise the integrity of the image, it was in his view an acceptable purchase.

Glen also did not consider the existence of signatures to be critical. He was perfectly happy to purchase an unsigned painting, because he claimed that the canvas was the signature. He argued that if you couldn't tell the identity of the artist or the quality of the painting by simply looking at the work, the signature would not help you. Ultimately, he felt, he was not a collector of signatures, but a collector of fine art.

Having been a world renowned yachtsman, Glen was sensitive to the elements involved in yachting such as hull design, sail trimming, etc. Glen's yachting experience no doubt "sensitized" him to the aesthetics and details of maritime art. Glen also enjoyed a broad scope of marine art beyond his collection and began expanding his knowledge to include the works of the Dutch masters; he likewise followed the works of the leading contemporary artists. If Glen had had more time and space, he might have begun to pursue the marine art works of the seventeenth- and eighteenth-century Dutch masters. He talked about going in that direction. In the end, the combined effects of his yachting knowledge and his scholarship relating to marine art enhanced his ability as a collector.

Glen was an old-world gentleman and had a manner in which he treated everyone around him with great respect. He was a warm, caring, friendly, sincere being, which made him very likable and beloved by his friends and colleagues in both the yachting and art communities. With his energy, resourcefulness, and considerable talents, Glen drew both his friends and the art community to gather at his tiny apartment covered from floor to ceiling with wonderful marine paintings. Yes, the

paintings were stashed in the bathroom, in closets, and around the bed. Glen proudly and eagerly invited newcomers to marine art and marine aficionados alike to join him for a viewing. Eventually, he felt obliged to strive for a perfect home for his collection and bought and renovated a splendid apartment overlooking the East River. He and his wife Kay were determined that the works be displayed in a proper setting so that he and all those who were interested could enjoy and appreciate this outstanding art collection. They painstakingly and passionately hung and placed each painting and artifact.

Glen became a mentor to me, and I count myself fortunate to have had such a great friend and advisor. Glen's perceptive comments, wise counsel, encouragement, and his infectious enthusiasm provided me with both a direction and a conviction to pursue the study of marine art. Glen generously shared his time and his ideas with anyone seeking his opinion. For example, he worked closely with the South Street Seaport Museum in the development of the James E. Buttersworth Exhibition in 1994. Glen's knowledge and level of taste was an asset to any individual or institution requesting his input. Spending time with Glen was like having a private tutor, and for that I am grateful.

With few exceptions, this book represents Glen's painting collection. In addition to the paintings, he had a small but outstanding collection of marine artifacts which were not in the scope of this book to discuss. But the objects were of the same quality and level as the paintings. Realizing that the collection was going to be dispersed, it became apparent that an effort should be made to preserve it in a book so that the collection could continue to be shared with anyone with interest. This book has been a team effort combining talent, scholarship, enthusiasm, and devotion to Glen Foster, the man, and the remarkable collection he assembled.

Alan Granby

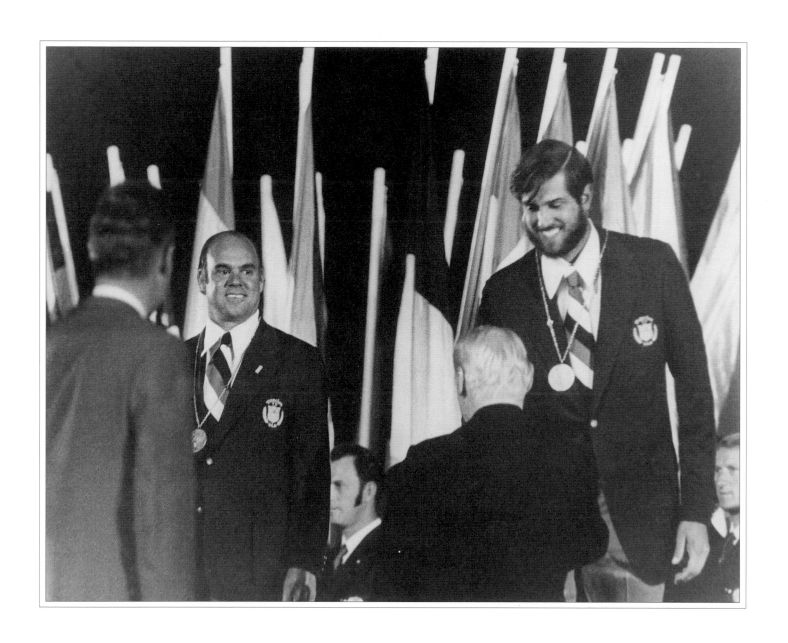

GLEN S. FOSTER:
Portrait of a Sailor and a Collector

GLEN S. FOSTER pursued the sport of sailing from his earliest summers in Edgartown, Massachusetts, to the weeks before his death from cancer in 1999. At various stages of his amateur career, he ranked among the best sailors in the world. He captured a bronze medal in the Tempest class in the 1972 Olympic Games in Kiel, Germany, and went on to win trophies in ten world championships, including one for a victory in the 5.5-Meter class in the last year of his life. He devoted the energy of a lifetime to his passion for sailing, as he did with all of the things he loved.

As a young man, Glen inherited from his father, Vernon Foster, an enduring love of marine art. Vernon was a war hero who served in both WWI and WWII and was one of the small group of early aviators called the "Army Fliers." He started on the floor of the New York Stock Exchange in 1918 and later founded the specialist firm of Foster & Co. When Glen was still quite young, his father gave him two Thomas Buttersworth (1768–1842) paintings entitled *English Ships in Harbor* and *HMS* Britannia *Beating Down the Channel Past the Eddystone Lighthouse*. The gift inspired a lifelong interest that would ultimately lead to his unparalleled collection.

Glen sailed competitively from the age of six. According to childhood friend Townsend Morey, a fellow Edgartown competitor and later commodore of the Brown University Yacht Club, Glen always had prints of ships and racing vessels in his rooms. He began sailing a 13-foot Beach Boat, moved on to an Edgartown 15, and then a Vineyard Sound Interclub. Morey relates that Glen sailed so intensely that at times it seemed he "sailed too much." He thrived under the tutelage of such yachtsmen as C. Sherman Hoyt and Eric Olsen and soon competed for the Sears Cup in the National Junior Championships. Morey claims that "It was the competitive spirit of Edgartown racing that made Glen the sailor he was."

After attending Phillips Andover, Glen entered Brown University in 1948. He competed successfully on the intercollegiate level, capturing the Sherman Hoyt Trophy and skippering the sailing team to victory in the McMillan Cup, held at the U.S. Naval Academy. Glen went on to graduate work at Columbia University, but soon joined the armed forces and served in the navy during the Korean War. When he was urged by Townsend Morey and others to form a crew for the 1952 Olympic trials in the Dragon class, Glen received special assignment by the navy to do so. He enlisted Dick Hovey and Edgartowner Tig Woodland as crewmates; his first effort to join the U.S. Olympic Yachting Team resulted in a second-place near miss.

Glen Foster (second from left) and his crew, Peter Dean, after they were awarded bronze medals for their third-place finish in the Tempest Class at the 1972 Olympics in Kiel, Germany.

After his navy service, Glen began a career on the New York Stock Exchange as a specialist on the floor for his father's firm, Foster & Co. But he also soon became involved in building up the competitive level of American sailing in international and Olympic classes. His enthusiasm and support helped bring the first fleet of Finns to America in the late 1950s for the United States International Sailing Association, a foundation for the development of U.S. dinghy sailors. He founded the USA Finn Association in 1959, serving as its first president. Throughout the early 1960s he was considered dean of the Finn class. Fellow Finn sailor Andy Kostanecki recalls, "He had the greatest intuitive touch on the helm I ever saw."

In 1956 Glen was joined by fellow crew members Don Matthews and Townsend Morey for another round of Olympic trials, this time in the 5.5-Meter class. According to close friend Harry Anderson, it was during those trials, held at Marion, Massachusetts, that Glen acquired the moniker "Battler." Peter Barrett, who won the Finn class 1960 Olympic Trials without owning a Finn, remembers how Glen insisted that Barrett borrow his Finn to practice before the games. Barrett describes a later scene at the 1964 Olympic Trials held at the Alamitos Bay Yacht Club in Long Beach, California:

> I started on starboard and when I looked over my shoulder to be sure I could tack, there was Glen, 20 feet behind me and to windward, teeth flashing in the sun as he grinned at me. It was blowing about fifteen, and hiking toughness equaled boat speed—conditions I liked. I tried to blow off this older guy and get onto port tack with the rest of the fleet—and I couldn't gain a foot. If I tried to work up, Glen threatened to drive over me. If I tried for speed, hiking 'til I thought I'd die, Glen matched me, wave for wave, sporting his huge grin. I don't remember how we finished. But Glen proved he was every bit as tough as the guy who had won the last Trials.

Glen approached collecting works of art with the same devotion and determination that he gave to sailing, and was a perfectionist in both areas. Robert B. MacKay, chairman of the New York Yacht Club Fine Arts Committee, recalls, "Glen had a terrific eye. He set out to assemble a wonderful collection and knew exactly what he was after. He brought to it not only a great deal of understanding of the painterly qualities of the artists, but an expert sense of boats, sail changes, wave motion, displacement of hulls—these things were inherent in him from sailing."

In the postwar era of the 1940s and 1950s, yachtsmen, collectors, and academics were rediscovering the works of American and British marine artists which had been neglected for nearly a century. Beginning in the 1960s, John Wilmerding and

other scholars published influential works that brought renewed attention to artists such as Robert Salmon (1775–after 1845), Fitz Hugh Lane (1804–1865), and William Bradford (1823–1892). During that period, Glen developed his own interest in paintings by those underappreciated marine artists. While his collection gradually expanded to include exceptional works by Salmon, Bradford, Lane, and others, he showed an early interest in large canvases by James E. Buttersworth (1817–1894). MacKay notes that he was among the first collectors to focus seriously on Buttersworth.

When Glen approached a work of marine art, he did not simply observe it as an imaginative connoisseur, but as someone who had an intimate familiarity with the scenes depicted. MacKay relates an incident in which Glen and a group of friends were gathered in the bar of the New York Yacht Club before the Edouardo de Martino (1838–1912) painting now hanging there: Columbia *and* Shamrock 1st *off Sandy Hook, Oct. 1899.* De Martino was known for his expertise in depicting water at a time when photography posed a threat to traditional painting. Glen delivered a wonderful appreciation of the painting based upon the fact that he had sailed in those same waters and could legitimate the artist's rendering. On another occasion, Glen was advising a prospective purchaser of a painting entitled *Schooner* America *Circling Round the Isle of Wight.* He described in great depth features of the landscape, such as the Pier at Ryde and other landmarks near Cowes, details that only an experienced sailor in those waters could recount.

In 1962 Glen married his first wife Valerie in the town of Marion, on Buzzards Bay, Massachusetts, where the bride had a summer home. Toward the end of the decade, their two children, Colin and Genevieve (Gigi), were born.

On the sailing front, Glen fell just short in the early 1960s in his pursuit of the "Holy Grail" of small boat international competition, the Prince of Wales Trophy conducted in English waters, in which he raced the International 14. He succeeded, however, in winning the Princess Elizabeth Cup in 1965 against such stalwart dinghy sailors as Stuart Morris, Shorty Trimingham, and Stewart Walker. Walker eventually became the first North American to wrest the POW Trophy from the British.

Based on his experience in the Finn and International 14, Glen challenged for the Olympic Medal in the Tempest class in the 1972 games held in Kiel, Germany. He and crewmate Peter Dean were the strong favorites for the class, having just captured the 1971 World Championship. In a surprise series that the Russian team won, Glen and Dean secured the bronze medal. No small feat for an amateur sailor with a full-time career in the financial world, it was also a victory for American sailing. Glen's greatest strength as a sailor lay in his nearly unmatched excellence in boat

speed and his deep knowledge of sails and sail shape. Though he was not trained in aerodynamics, he consulted throughout his career with sail designers about improvements to sail shape and trim.

Glen proved a remarkably versatile sailor, competing at various times in his adult career in the Finn, International 14, Dragon, 5.5 Meter, Six-Meter, Soling, and Twelve-Meter classes. He served as president of the Six-Meter class for two years. In addition to around-the-buoys racing, he had extensive experience on offshore yachts such as the Ziegler family's renowned schooner *Bounding Home* and sloop *Spookie*, Jim Farrell's *Impala*, and Bill Moore's *Argyll*. He sailed constantly in the summers and on vacation, frequently traveling to races as far afield as Sweden; Norway; the south coast of England; Cannes; Genoa; Portofino; and Hobart, Tasmania. Everywhere he sailed he gathered friends through his enthusiasm, encouragement, and love of competition and people.

As he continued to add to his art collection in the early 1980s, Glen purchased two canvases by Nicholas Pocock (1740–1821): *French and English Vessels in Battle* and *Achilles and Two Vessels after Battle*. He also began expanding his collection to include works by Salmon, Lane, Serres, Fowles, and others. With the help of experts and dealers, he devoted the same energy to his pursuit of the best in marine art that he had expended on his sailing. Sam Davidson, who consulted with Glen particularly on works by Salmon, remembers, "Glen would ask questions about paintings which only a yachtsman would. He noticed details such as the depiction of a tiller, or the beautiful rope-work. It's very different if you look at a painting with that kind of sailing experience. You start putting yourself aboard the vessel. That's what bit him."

Glen often attended an auction in which only a single piece of marine art appeared on the block. He sought splendid examples of each of the artists in which he took an interest, and took great pains to display them well. Daniel Finamore, Russell W. Knight curator of marine art and history at the Peabody Essex Museum in Salem, Massachusetts, writes:

> Glen was not interested in pictures by casual coastal artists, those who painted a seascape one day and a meadow the next. The sea requires a faithfulness and practice on the part of the artist to achieve the level of credibility that Glen sought. All of the artists he collected were specialists in their craft, and Glen's eye brought him to the best of their work.

Glen was divorced from Valerie and for many years rented a one-bedroom walk-up apartment in New York City on East 49th Street, down the street from Smith and Wollensky's Steakhouse. He had an old cast-iron bathtub, very few furnishings,

and according to fellow collector Fritz Gold, the rooms were "wallpapered from floor to ceiling with breathtaking marine paintings and prints." In 1993 he moved into a residence at One Beekman Place on the East River. He and his new wife Kay arranged and lighted his collection so that it became a museum-quality display of works by masters of American and British maritime painting. A group of extremely rare Fred Cozzens (1846–1928) original watercolors, for example, hung in the entrance hall. Finamore recollects, "A visit to the home of Glen Foster was like a day at sea. He gave vivid descriptions of the vessels portrayed and recounted events as if he'd been there on race day. But I'm sure that, even when taking such delight in his unparalleled collection, he would rather have been out sailing."

Glen continued to compete throughout the 1980s and '90s, racing in many international competitions. Sam Davidson stresses this aspect of Glen's sailing: "He was an international yachtsman through and through. I recall when in the early 1990s he competed in the Duke of Edinburgh's Cup on the Solent in the Dragon class against forty-five participants. He was the only foreign competitor, and he won the race." Glen crewed on the *Gretel* under Gordon Ingate of Sydney, Australia, first in 1986 and then in the Twelve-Meter Worlds in 1987.

In the 1990s he retired from the firm of Foster & Co. and had even more time to devote enthusiastically to sailing. Glen reached the peak of his performance as the decade progressed, and began to win every event that he entered in the 5.5-Meter class. He captured the Swiss National Championship in 1994, the French National Championship in 1997, the European Championships in 1997, and the World Championships in 1997. Ron Rosenberg, his crewmate in many of these victories, describes a memorable contest: "In 1998, after winning the Dragon Class Open Dutch National Championship, he competed in the Pro-Am Match Race Championship at the Bitter End Yacht Club in the British Virgin Islands against ten of the top skippers from around the world. These included names like Ed Baird, Peter Holmberg, Mark Reynolds, Peter Isler, Ed Mayers, Russell Coutts, and Ken Reed. To everyone's amazement, this retired amateur sailor led the entire fleet home with a win in the fleet race and then went on to take second place overall among the best skippers in the world. At the end of the decade, Glen was just hitting his stride."

He captured the Scandinavian Gold Cup in 1996, 1998, and once more in 1999 in the 5.5-Meter *My Shout*, when, despite being debilitated from a year-long battle with cancer, he overcame intense pain and stress to join fellow crew members Ron Rosenberg and Bill Bennett to win the cup just weeks before he succumbed to his illness. Rosenberg recalls: "Glen was such an inspiration during the race. Although he was very quiet because of his illness, he mustered an incredible amount of energy

to handle the mainsail, and he remained mentally sharp and extremely focused. One thing I will always remember is seeing him with his hand in the air, feeling the wind."

In numerous roles from crew to tactician to sail trimmer on Twelve-Meters, when they were the America's Cup class, and later in the current America's Cup class, Glen influenced the future direction of the America's Cup. His support came not only on the water but as an advisor and backer of syndicates for the Cup. He played a leading role in the New York Yacht Club's Young America Challenge for the 2000 Match. Glen was among the first to advocate that the club be a Challenger.

Glen contributed to the life of the New York Yacht Club in many other ways throughout his membership. His expertise and enthusiasm aided its sailing programs, the selection of boats for team racing, and the club's efforts in international team racing. He was undoubtedly one of its most peripatetic and highly respected ambassadors in the sailing fraternity. In addition, his involvement with the Fine Arts Committee helped to ensure the preservation and restoration of the club's holdings. He willingly lent his accumulated expertise in the field for the benefit of the club's outstanding collection of marine art.

Glen was also was an active member of the Seawanhaka Corinthian Yacht Club in Oyster Bay, New York. He represented that club in several British-American Cups; in the Seawanhaka International Challenge Cup for Small Yachts in 1987; in periodic Six-Meter class racing at Oyster Bay; in the Dragon class off Cowes on the Solent in 1989; and in the Dragon class off Hobart, Tasmania, in 1993. He was also a member of the Royal Yacht Squadron and the Imperial Poona Yacht Club and served on the board of the Herreshoff Museum–America's Cup Hall of Fame in Bristol, Rhode Island.

Glen lives on in American sailing history in the memories of his colleagues, friends, and competitors. He remains an icon for college sailors through the Foster Trophy—the National Intercollegiate Single-handed Championship Trophy that is named in his honor and displayed in the Robert Crown Center at the U.S. Naval Academy. In addition to his lifetime of victories and trophies, he left behind him a spirit of determined competitiveness in sailing that is a rare and valuable legacy. One sailor who knew him said, "He inspired great confidence in whatever boat and with whatever team he sailed."

The same focus, energy, and passion that Glen devoted to his career as a sailor carried over into his pursuit of paintings. In his lifetime he assembled one of the finest private collections of marine art. The Foster Collection, Daniel Finamore comments, is "based on a true understanding of the sea in all its moods." It is a natural expression of Glen's experience of a lifetime on the water. Until now, only a few privileged collectors and connoisseurs have experienced the collection in its entirety. This book presents this unique collection of marine art to the larger public for the first time.

AMERICAN YACHTING ART

THE AMERICAN YACHTING PAINTINGS in the Glen S. Foster Collection present a spectacular history of early American yachting beginning in 1851 with the competition at Cowes, England, for the Royal Yacht Squadron's Hundred Pounds Cup, which Americans came to call the Hundred Guinea Cup, and which eventually became known as the America's Cup. Foster carefully assembled some of the best depictions of early America's Cup races and classic yachting scenes by marine artist James E. Buttersworth and lithographers Currier & Ives, forming a pictorial panorama of the glorious early days of American yachting. The Foster Collection also features a rare group of watercolors and prints by Frederic Schiller Cozzens showing major cup races and yachts under sail in American waters. Finally, the collection includes a drawing by contemporary yachting artist John Mecray depicting the J-class sloop *Enterprise*.

JAMES E. BUTTERSWORTH
AND THE AMERICA'S CUP

BRITISH MARINE ARTIST James E. Buttersworth (1817–1894) was a self-taught painter, and the son of British naval artist Thomas Buttersworth (1768–1842).[1] Born on the Isle of Wight, the backdrop of so many illustrious yachting races, James learned the spirit of the sea from the scenes of his youth. His father was a successful maritime artist, exhibiting paintings of famous naval battles and vessels at the Royal Academy and the British Institute. James would study and refine his father's style, and discover fresh material for marine painting in his new home across the Atlantic.

James Buttersworth moved to America around 1845, arriving in the New York City area and settling in West Hoboken, New Jersey, by 1850. He soon made the acquaintance of lithographer Nathaniel Currier, at No. 152 Nassau Street, and they entered into a partnership that would last several decades. In the early 1850s, he exhibited and sold paintings at the American Art Union in New York City. He established a studio in Brooklyn, then a flourishing artists' colony, near fellow artist and Currier associate Charles Parsons. Buttersworth eventually returned to West Hoboken where he would work and live until his death in 1894.

Among the first paintings from Buttersworth's American period is *The Sloop* Maria *Racing the Schooner Yacht* America, *May 1851* (Plate I.1) depicting the test race held in New York Harbor in 1851 between Robert Stevens's sloop *Maria* and John Cox Stevens's schooner *America* prior to the latter's sailing to England at the time of the International Exhibition in London. *America* was an innovative schooner designed by George Steers along the lines of the Sandy Hook pilot boat *Mary Taylor*. (The captain of *Mary Taylor*, Richard Brown, would be at the helm of *America* during her historic Cup victory.)[2] *America* was 95 feet long with two masts raked sharply aft, a long 17-foot bowsprit, 23 feet on the beam, and a draft of 11 feet.

The centerboard sloop *Maria*, designed by Robert Stevens, was similar in size to *America* at 110 feet, but was "a fragile racing machine that existed solely for competing in protected waters."[3] *Maria* had an enormous 7,890 square feet of sail (2,500 more than *America*), and required a crew of fifty-five men (five alone at the tiller) to handle. She won the test race handily but was never designed for the crossing, so *America* traveled on to Cowes as intended and captured the Royal Yacht Squadron's One Hundred Guinea Cup in her historic victory. In 1852 one of the earliest Nathaniel Currier prints based on a Buttersworth painting appeared (Plate I.2), showing the same scene as Plate I.1, but with *America* turned fully about, correcting the

improbable direction mistakenly shown by the artist in the original (for the other Currier & Ives prints in the collection, see below). This would become one of the most popular prints of its day. The collection also includes an unusual painting by Fitz Hugh Lane, *Yacht* America *from Three Views* (III.14), showing the famous yacht in three different positions (see "American Marine Art" chapter).

The Foster Collection contains a painting of *America* in her challenge for the One Hundred Guinea Cup by the American artist William Bradford (1823–1892). Bradford's *Schooner Yacht* America *Winning the Cup at Cowes, 1851* (Plate I.3) is based on a lithograph by well-known English lithographer T. G. Dutton of the same scene as Plate I.2 with the stake boat removed in the foreground. Bradford's painting (long thought to be by Fitz Hugh Lane) is similar to Lane's painting of *America* in the collection of the Peabody Essex Museum, also based on the Dutton lithograph. The canvas is possibly the earliest surviving example of Bradford's efforts in oil painting. Though it represents an early effort in a new medium, with "clouds moving against the wind direction," the painting still exhibits considerable charm in its presentation of light on the sails and the disposition of the vessel.[4]

Another painting of the schooner yacht *America* by James E. Buttersworth, *Untitled View of Match Race between Schooner Yachts* America *and* Alarm, *Cowes, August 5, 1860* (Plate I.4), presents what Llewellyn Howland III has identified as the famous second meeting of *America* and the cutter *Alarm* nearly a decade after their first encounter for the One Hundred Guinea Cup on August 22, 1851 (this painting was long thought to show *America* in the original race—see painting caption). Joseph Weld's crack English cutter *Alarm* formed part of the formidable fleet that met *America* in the 1851 contest, and was among the favorites to win. In the 1860 match captured by Buttersworth, *America* experienced difficulty with its sails and fell well behind *Alarm*, which went on to finish the course 37 minutes 5 seconds ahead. Mr. Weld and his captain, John Nicholls, were able to hand the famous schooner a decisive defeat in "a triumph they have long deserved."[5]

In the first defense of the America's Cup in 1870, the top three finishers, including the winner *Magic*, were centerboard boats, while the challenger presented a keelboat, *Cambria*. At the time, the English considered centerboarders to be mere "skimming dishes," and challenger James Ashbury objected vigorously to their use by the Americans. Centerboarders could maneuver in the difficult conditions of New York Harbor—shifting currents, unpredictable sandbars, and heavy commercial traffic—and gave an advantage to the defenders. In challenging again in 1871, Ashbury demanded that the course run beyond Sandy Hook, outside the waters of the

harbor. He also argued that one challenger should meet only one defender. The result was a compromise match, a best-of-seven series, with alternating inside and outside courses, and four defenders, any one of which could be chosen to defend on a given day: centerboarders *Columbia* and *Palmer* and keelboats *Dauntless* and *Sappho*.

Magic won in 1870, while in 1871 *Columbia* and *Sappho* (the only two of the potential defenders selected) combined for a 4–1 victory over Ashbury's challenger *Livonia*. In two similar paintings, Buttersworth captured the defenders *Magic* and *Dauntless* in the 1870 America's Cup Race and *Columbia* and *Dauntless* in a dramatic battle in a lesser-known regatta in 1875. The first canvas, entitled *Schooner Yacht* Magic *Passing Sandy Hook Lightship, America's Cup, 1870* (Plate I.5), shows *Magic* having rounded Sandy Hook Lightship, with the reduced profile of *Dauntless* seen to the left of the lightship just beginning her rounding (but see painting caption for complications in the identifcation of the race). Three trailing vessels are shown in pursuit on the horizon to the right. Buttersworth gives the water and sky a dark treatment and experiments with stylized reflections of sails on the water in the foreground.

A larger version of a similar scene, entitled Columbia *Leading* Dauntless *Rounding Sandy Hook Lightship in the Hurricane Cup Race* (Plate I.6), illustrates the artist's ability to vary his technique and composition. The painting is an excellent example of what Rudolph Schaefer calls the "narrative" style of Buttersworth, in which "a relationship is established with other vessels. Always there is movement or conflict—a story."[6] Here the action is tight, and *Columbia* seems dramatically near to Sandy Hook Lightship and the trailing *Dauntless*. The lightship is positioned parallel to the pursuing boat, and *Dauntless* is seen shifting sails preparing to round. With a soft blue sky, delicate light-green waves, and a highly engaging placement of vessels, Buttersworth achieved a brilliant specimen of his signature style—the drama of sail and weather in a closely focused setting.

In 1881 the New York Yacht Club agreed for the first time to produce only one vessel to defend the Cup. Trials were held on October 13, 19, and 20 to select a defender to race against Canadian challenger Alexander Cuthbert's 70-foot sloop *Atalanta*. The first two trials took place along the club course, and the third was held 16 miles to leeward and return off Sandy Hook. In Mischief *and* Gracie, *America's Cup Trial Race, 1881* (Plate I.7), Buttersworth captures the action of the two rivals *Mischief* and *Gracie* rounding the mark, but leaves out the third trial racer, the centerboard sloop *Pocahontas*. Built by the club's syndicate as an insurance measure, *Pocahontas* proved slow and experienced rigging failure during the trials. *Mischief* beat *Gracie* in the third trial by 14 seconds on corrected time, and proceeded to defend America's Cup, defeating *Atalanta* handily by an average of 33 minutes. In *The Yacht*

Race (Plate I.8), Buttersworth presents the scene of a New York Yacht Club regatta in which a keel cutter, possibly *Mischief*, is shown leading, while an unidentified schooner is rounding the mark, and two sloops are seen fetching the mark.

The Royal Yacht Squadron first challenged for the Cup in 1885, when Sir Richard Sutton's narrow cutter *Genesta* raced against the centerboard sloop *Puritan*, the first of three victorious vessels designed by Edward Burgess. Before the race, the challenger *Genesta*, on starboard tack, was crossed by the defender, *Puritan*, on port tack, and lost her bowsprit. As a boat on starboard has right of way over a boat on port, the race committee ruled that *Puritan* had forfeited the race. Sir Richard refused to accept "a walk-over" and went on to see his *Genesta* lose the subsequent races 2–0 to the defender.

The Foster Collection contains two Buttersworth paintings of the challenge. The first, Puritan *and* Genesta, *America's Cup, 1885* (Plate I.9), shows the two boats in proximity, close hauled, on the same tack, with *Puritan* shown larger in the foreground. The painting emphasizes the speed of the vessels on the wind rather than a dramatic change of heading. The long lines of the boats' sides run parallel to the horizon line, with their sails majestically driving the action forward. The horizontal emphasis of speed is amplified by a composition focused on two vessels, with only hints of a distant schooner on the horizon and a barely visible paddle-wheel steamer on the right. Buttersworth captures the clean, wind-driven speed of racing in all its power and beauty.

The second painting, Puritan *Leading* Genesta, *America's Cup, 1885* (Plate I.10), shows the challenger *Genesta* approaching the buoy with dramatically luffing sails. Rudolf Schaefer comments on Buttersworth's style: "Raising a sail, or taking it down, or trimming it, all are elements of action, and JEB takes full advantage of this device in many of his paintings."[7] Two paddle-wheel steamers are shown in the middle right background, giving a sense of the boat traffic in New York Harbor on race day.

The Foster Collection includes another painting, long considered to show the cutter *Genesta* but currently identified by Llewellyn Howland III as *The Seawanhaka Corinthian Yacht Club Cutter* Bedouin *off Execution Rocks Lighthouse* (Plate I.11), by Buttersworth's contemporary, marine painter Elisha Taylor Baker (1827–1890). *Bedouin* was the flagship of the Seawanhaka Corinthian Yacht Club in 1884–1885. She is portrayed by Baker sailing past Execution Rocks Lighthouse. Baker's few extant canvases recall the style of Buttersworth as well as the "Luminist" paintings of Fitz Hugh Lane. His treatment of the light on the towering sails and the "sensitively colored skies and cloud formations"[8] reflects this tradition.

The next America's Cup competition took place in 1886 in two races between the second Burgess-designed defender, *Mayflower*, and the challenger *Galatea*. The first race ran over the usual inside course of the New York Yacht Club, while the second was held twenty miles offshore near Sandy Hook Lightship. *Mayflower* finished ahead in both races to secure the Cup. In two depictions of the victorious vessel, Mayflower *Leading* Puritan, *America's Cup, Trial Race, 1886* (Plate I.12) and Mayflower *Leading* Galatea, *America's Cup, 1886* (Plate I.13), Buttersworth maintains his characteristic "narrative" style, with the vessels appearing to be closely matched and the race quite open. Both canvases were long thought to show *Mayflower* leading *Galatea*, but according to Llewellyn Howland III, Plate I.12 more likely shows *Puritan* instead of *Galatea* (see painting caption). The main difference between the paintings lies in the weather treatment, with light gray and blue skies in Plate I.13 forming a triangular fringe around the centered mass of *Mayflower*'s sails. Plate I.12 uses a split composition with clusters of darker storm clouds flanking a central opening from which light pours onto a group of recessed boats on the horizon.

The 1887 America's Cup saw the third defender designed by Burgess, *Volunteer*, pitted against George L. Watson's *Thistle*. *Volunteer* was designed narrower, deeper, and longer on the water than any of her predecessors. Both vessels were clipper-bowed sloops, though *Volunteer* was fitted with a centerboard. *Thistle* was launched in considerable secrecy with her keel draped and lines hidden, causing a great stir. On the day of the first race, a northeast breeze blew in cloudy gray skies and fog banks. Buttersworth emphasizes the wind and somber conditions of the race in Volunteer *versus* Thistle, *America's Cup, 1887* (Plate I.14), showing *Volunteer* leading *Thistle* with magnificent full sails beneath a foreboding sky.

OTHER BUTTERSWORTH YACHTING SCENES

IN ADDITION TO his brilliant paintings recording the early history of the America's Cup as it unfolded before his eyes, Buttersworth produced many admirable renditions of lesser-known races in the same familiar waters. Many of his commissions came from members of the New York Yacht Club, leading to dramatic recordings of more typical yachting scenes. The sloop *Irene*, for example, which participated in many New York Yacht Club regattas, is shown in the canvas The Sloop Irene (Plate I.15) upon beautiful choppy blue waters under a lowering gray sky. This painting is one of only a few Buttersworths that fully render the burgee of the New York Yacht Club.

Buttersworth frequently depicted racing scenes at the outermost point in the course, exhibiting great feeling for the drama that unfolds as the boats round a mark. Two paintings that focus on the action near Sandy Hook Lightship have already been mentioned (Plates I.5 and I.6). *Fetching the Mark* (Plate I.16) and *Yachts Rounding the Mark* (Plate I.17) are two other fine examples of such scenes.

A New York Yacht Club Regatta by Antonio Jacobsen

THE FOSTER COLLECTION includes an excellent canvas by prolific Danish-American ship portraitist Antonio Jacobsen (1850–1921). *New York Yacht Club Regatta* (Plate I.18) features three of the largest class of schooners of the New York Yacht Club rounding the mark at the Scotland Lightship. This painting is a wonderful example of Jacobsen's early period and was clearly painted in the 1870s. It can be dated by the treatment of the water, which exhibits a certain translucence at the crests of the waves. Foster considered the canvas to be Jacobsen's finest yachting scene. The vessels can be tentatively identified as George Kingsland's famous old campaigner *Alarm* and the schooner *Estelle*, shown leading.

Buttersworth's Views of New York Harbor

BUTTERSWORTH DELIGHTED IN using familiar landmarks from New York Harbor to establish the setting for many of his paintings. He was particularly fond of painting the Upper Bay at the tip of Manhattan, showing Castle Garden, the Battery, and Castle Williams. Rudolph Schaefer refers to this as his "most used and favorite setting."[9] In *New York from the Bay* (Plate I.19), Castle Garden appears on the horizon, with the American flag flying in the same wind that drives on the vessels before it. The painting depicts *Resolute*, a 114-foot schooner built by David Carll of City Island, New York, in 1871, and owned by A. S. Hatch, under a strong head of wind careening well ahead of the pack. The brilliant depiction of the driving force of the wind on the vessels, the powerful stretch of *Resolute*'s sails, and the exquisite rose and blue spread of the sky, combine to make this New York yachting scene by Buttersworth an artistic tour-de-force. Another rendition of a similar setting, *Yacht Race on Upper Bay, New York Harbor* (Plate I.20), shows a fuller panorama with Castle Garden at the middle left and Castle Williams on Governors Island at the right. The

busy maritime activity of New York Harbor is indicated by the line of masts and flags on the horizon. A less typical view of New York appears in *Chapman Dock and Old Brooklyn Navy Yard, East River, New York* (Plate I.21), a rare depiction by Buttersworth of the East River, and a unique glimpse of the Navy Yard.

FREDERIC SCHILLER COZZENS

THE FOSTER COLLECTION contains a matchless set of original watercolors of scenes by American marine artist Frederic Schiller Cozzens (1846–1928) as well a group of lithographs based on the same series. Like the Buttersworths in the collection, the watercolors by Cozzens capture the early history of American yachting from *America's* One Hundred Guinea Cup race in 1851 through the mid-1880s. These celebrated watercolors present an imaginative overview of American yachting during this classic period, ranging from America's Cup defenses to regattas held on New York courses to less familiar racing scenes in waters from Newport to Nantucket.

Frederic Schiller Cozzens began his career in the 1870s in New York as an illustrator of yachting articles for publications including *Harper's Weekly, Leslie's,* and *Century.* He provided yachting illustrations for *Harper's Weekly* consistently through the 1880s, taking advantage of the growing interest in the sport brought on by the drama of the America's Cup. Cozzens exhibited his work frequently at the American Watercolor Society in the early 1880s, becoming a well-established marine painter with frequent commission work from private individuals.

In 1884 Cozzens issued a magnificent volume of twenty-six yachting scenes under the title *American Yachts, Their Clubs and Races,* published by Charles Scribner's Sons in New York. The chromolithographs published in the portfolio were based on original watercolors that Cozzens had completed nearly a decade earlier. A second volume written by Lieutenant J. D. Jerrold Kelley of the U.S. Navy with descriptions of each print accompanied the first. The watercolors Cozzens painted for the series are, in the words of Anita Jacobsen, "among the strongest paintings the artist produced."[10] The Foster Collection contains a remarkable ten of the twenty-six original watercolors, as well as three limited-edition prints made from originals. In addition, the collection includes a watercolor by Cozzens completed in 1896 depicting the 1895 America's Cup match between *Defender* and *Valkyrie III.* They represent Cozzens at his finest, capturing "the very spirit of racing" in warm and brilliant compositions.

COZZENS'S NEW YORK
YACHTING SCENES

THE FOSTER COLLECTION includes two prints based on the original water-color series that show "crack racers" that had become famous in international competitions. In the color lithograph *The Early Racers* (Plate I.22), Cozzens depicts a regatta between the "brave old *America*," winner of the One Hundred Guinea Cup in 1851, the sloop *Maria*, her test racer before the cup, and two other centerboard sloops, the *Una* and the *Ray*, all of the New York Yacht Club. *America* appears grandly in profile on the return course, with *Maria* shown approaching the mark boat on the left, in a composition reminiscent of Buttersworth's painting of *America* and *Maria* (Plate I.1), with the vessels reversed.

In the print *The Finish off Staten Island—1870* (Plate I.23), Cozzens presents the finish of the first America's Cup defense in 1870, in which "the fair fame of the country was at stake."[11] The race was held on a course running from the anchorage to the buoy off the Southwest Spit, out to the Sandy Hook Lightship and return. Cozzens captures the conditions of the race, "with a fresh breeze from south-by-east to southward with smooth water."[12] *Magic* is seen crossing the line first ahead of the pack, which included the second-place *Dauntless*, third-place *Idler*, fourth-place *America*, and the challenger *Cambria*, which came in eighth overall (adjusted to tenth place with the time allowance).

In *A Breezy Day Outside* (Plate I.24), Cozzens portrays three of the four vessels that were named for the defense of the 1871 America's Cup against James Ashbury's *Livonia* trial racing in the waters off the Long Island coast. The centerboard schooners *Columbia* and *Palmer* and the keel schooner *Sappho* are engaged in a race in heavy weather. *Sappho* leads with *Columbia* chasing hard on the left and *Palmer* shown in profile approaching on the right. Cozzens draws attention to the beautifully filled sails of *Sappho* in the foreground with strong contrasting value, providing an example of what a contemporary reviewer called his "splendid pictures of billowing canvas and rolling sea."[13]

An 1896 watercolor by Cozzens, *Untitled View of Sloop* Defender *Leading the British Challenger* Valkyrie III (Plate I.25), has been identified by Llewellyn Howland III as the scene of the 1895 America's Cup race between the 124-foot Herreshoff-designed sloop *Defender* and the 118-foot Watson-designed challenger *Valkyrie III*

(see painting caption). Three controversial races, watched by an estimated 65,000 people, most of whom were aboard spectator boats crowding the contestants, were marred by spectator interference, near-collisions, and mutual accusations. *Valkyrie III* won the second race, but was disqualified for bearing down on *Defender* and fouling that yacht's starboard topmast shroud. Lord Dunraven walked away from the third race in disgust, and later charged the Americans with foul play.

A yacht race between vessels of different design, rigging, and tonnage always provokes interest and often leads to controversial discussions of time allowance, and the methods used for its calculation, which have varied so much in the history of racing. Cozzens's watercolor *Crossing the Line, New York Bay* (Plate I.26) treats a finish-line scene involving the centerboard sloop *Coming*, centerboard schooners *Montauk* and *Comet*, and the keel sloop *Kelpie*. *Montauk*, featured in the center of the composition leading with her sails gracefully swelling, was considered the "best schooner in American waters" at the time. Cozzens again displays his superb feeling for the movement and texture of sails. The finish-line scene led Lieutenant Kelley to reflect, "In my yachting and service lustrums, which now are many, I have yet to see the philosophic yachtsman who could bear the toothache of time-allowance defeat, patiently."[14]

The Seawanhaka Corinthian Yacht Club was organized in 1871. *By Sou'west Spit* (Plate I.27) shows a Decoration Day excursion of the fleet passing a buoy in New York Harbor. Sloops and schooners of the Seawanhaka Club and the Atlantic Yacht Club of Brooklyn—including *Roamer, Crocodile, Clytie, Grayling*, and *Fanita*—are shown in a busy variety of positions and degrees of sail trim, with a steamer observing the action in the left rear and a small craft with two figures waving in the lower left corner. Another yachting scene with beautifully rendered sails appears in *A Misty Morning—Drifting* (Plate I.28), in which Cozzens shows vessels clustered together drifting with their sails hanging lazily in light weather.

Frederic Cozzens lived on Staten Island and witnessed firsthand the changing atmosphere of light around the island. In *Robbins Reef—Sunset* (Plate I.29), Cozzens captures two centerboard sloops, *Albertina* and *Lady Emma*, with the cutter *Valiant* and a small canoe *Lita*, racing by Robbins Reef Lighthouse, which lies off the northeast corner of Staten Island in the Upper Bay. The scene is a classic rendition of the most characteristic New York Bay yacht—the shallow centerboard sloop—in an equally typical setting, a delicate sunset with fair winds and moderately calm waters. The softened, idyllic atmosphere of the painting typifies Cozzens's style, described by a contemporary as "mellowing as all good things should."[15]

Cozzens was capable of capturing all moods of the sea, including her darkest

storms and sudden tempests. In the dramatic *In the Narrows—a Black Squall* (Plate I.30), he shows the havoc wreaked by a "bursting squall" during a memorable New York Yacht Club regatta on June 15, 1877. Several of the race participants, including the keel schooners *Wanderer* and *Rambler*, the second-class sloop *Active,* and the catboat *Dora* are shown strewn across the sea in various states of distress caused by the storm. Lieutenant Kelley describes the scene:

> FOR AN INSTANT there was a flash of vivid, lurid brightness, followed by a moment of intense silence and then, with a roar and a bellow, the bursting squall struck them both…. The *Wanderer* reeled as if hurt to death, her bulwarks going under and the water flooding her breast high in the gangways; but down rattled the flashing sails, and righting defiantly, she stood there, quivering, palpitating, and daring the fury of the storm, a perfect sea picture. The *Rambler,* behind her, heeled over until half her deck was submerged, and then with a whip and a snap her flying jib-boom went by the board, while off to leeward, like the wounded wing of a seabird, flamed in the darkness the huge main-topmast staysail of the *Wanderer.*[16]

Cozzens also showed considerable interest in painting winter yachting scenes, with ice-bound boats and bracing, frosty skies. His famous series of *Ice Yachts* now hangs at the 44th Street clubhouse of the New York Yacht Club. The Foster Collection contains Cozzens's watercolor *Ice Boating on the Hudson* (Plate I.31), showing a remarkable Hudson River scene of four sloops and an iceboat, *Echo,* the only surviving yacht depicted in Cozzens's *American Yachts* volume, fitted out for the high-speed action of dashing along the ice. In this charming scene, Cozzens shows ice skaters navigating about the resting boats and the sweeping tracks that the iceboats' blades have cut into the ice—altogether a delightful winter vignette.

OTHER AMERICAN WATERS

IN ADDITION TO NEW YORK BAY SCENES, *American Yachts* includes a broad sweep of contemporary yachting in classic East Coast waters. In the beautiful and haunting *Moonlight on Nantucket Shoals* (Plate I.32), Cozzens portrays a moonlit moment in the ocean waters off Nantucket. Two steamer yachts, *Ibis* and *Tidal Wave,* the schooners *Estelle* and *Aeolus,* and the sloop *Sagita* are shown with their sails in bewitched silhouette caused by the light of the full moon. Kelley writes: "The long vista of moonlight trembles upon the wind-blown waters; at times the silver flood is broken with rippling waves of shadow, which gleam like banners against a field of

blue."[17] He also reminds readers of the dangers lurking in the shallow waters of Nantucket shoals and the many tragedies they have caused.

With the spectacular success of American centerboard sloops, continuous debate raged as to the merits of the sloop versus the cutter yacht design. In *Off Brenton's Reef* (Plate I.33), Cozzens shows a delightful group of vessels, including the extreme cutter *Wenonah*, pitching along in the waters near the Brenton Reef Lightship, which looms in the background at the right. Race after race, the defenders of the deeper, narrower cutters were disappointed, and faced with the aphorism of their foes, according to Kelley: "Brother, the cutter must die!"[18] Cozzens chooses a race in Newport to illustrate the superiority of the sloop. In *Before the Wind, Newport* (Plate I.34), the sloops *Vixen* and *Arrow* are shown in the foreground well in advance of the trailing cutter *Maggie*, seen in profile on the right, and the distant schooner *Social*, barely visible on the left horizon. The triumphant sloops pass by a steamboat with their proud sails fully billowing.

Another great center of American yachting lay in Massachusetts Bay, with clubs flourishing from Cape Ann to Cape Cod. The scene in the print *Around the Cape— Marblehead* (Plate I.35) shows some of New England's finest yachts of the time, including the cutter *Mona*; the keel sloop *Hera*; the centerboard schooner *Fearless*; a catboat *Fannie*, named in honor of Fannie Herreshoff; and the Herreshoff-built centerboard sloop *Shadow* engaged in a race from Marblehead Neck to Phillips Point. Cozzens's scene pays due tribute to the crack racers of the fifteen New England yacht clubs active in these waters.

CURRIER & IVES PRINTS

THE FOSTER COLLECTION includes seven well-known prints by lithographers Nathaniel Currier (1813–1888) and James Merritt Ives (1824–1895). These famous American artists and printers collaborated with James E. Buttersworth as early as 1845, leading to some of their most popular prints. They also based many of their plates on the work of in-house artists Charles Parsons (1821–1910) and "Fanny" Palmer (1812–1876). The print of *The Cutter Yacht* Maria (see Plate I.2 above), after Buttersworth's original painting (Plate I.1), became one of the most popular contemporary prints on both sides of the Atlantic. Another print in the collection of *The Yacht* Maria *216 Tons, 1861* (Plate I.36), based on Parsons's work, offers an interesting comparison.

A second print in the collection based on work by Buttersworth, *Regatta of the New York Yacht Club, June 1, 1854. The Start* (Plate I.37), shows an early club race with the

sloop *Irene* in the foreground. Another scene farther along in the race, *Regatta of the New York Yacht Club, June 1, 1854. Coming in; Rounding the Stake Boat* (Plate I.38), pictures the sloop *Una* rounding the stake boat, with *Ray* and *Irene,* following. The print *Regatta of the New York Yacht Club, "Rounding S. W. Spit"* (Plate I.39), based on Parsons, takes the action farther out by the buoy at Sou'west Spit, showing *Una, Ray, Alpha, Irene* and other yachts trailing along a vista of diminishing sails on the horizon.

The New York Yacht Club Regatta. The Start from the Stake Boat in the Narrows, off the New Club House and Grounds, Staten Island, New York Harbor (Plate I.40) shows the beginning of a local race from the grounds of the club's station on Staten Island. Three vessels that competed in the great transatlantic race of 1866, *Vesta, Henrietta,* and *Fleetwing,* are some of the notable starters. The print shows an elegantly dressed crowd assembled on the shore, testimony to the increasingly popular appeal of yachting in the wake of excitement surrounding the great Cup races. The print entitled *The Yacht Squadron at Newport* (Plate I.41) captures the variety of the fleet at Newport and the busy activity of a mid-nineteenth-century harbor.

A PAINTING BY JOHN MECRAY

CONTEMPORARY AMERICAN ARTIST John Mecray (b. 1937) is considered one of the premier yachting artists working today. An experienced yachtsman, Mecray helped found the Museum of Yachting in Newport, Rhode Island. He studied art at the Philadelphia College of Art, and worked as a freelance illustrator before turning to painting full-time. According to James Taylor in *Yachts on Canvas,* "His cool, classical style is in part a result of his training as an illustrator. He is fascinated by patterns and sculptural arrangements of masts, rigging, and sails."[19] Mecray has turned away from traditional modes of representing yachts, focusing instead on "close-up view points and cropped compositions [that] lend dynamism to his subjects."[20]

In *The* Enterprise (Plate I.42), Mecray based his illustration of the J-class sloop *Enterprise* on sketches he made from the model of the vessel in the New York Yacht Club. *Enterprise* defended the 1930 America's Cup in the first contest to be held in Newport, Rhode Island. *Enterprise,* skippered by Harold "Mike" Vanderbilt, raced to victory against Sir Thomas Lipton's *Shamrock V.* The disappointed Lipton was heard to say, "I canna win; I canna win." The J-class boats competed in the America's Cup from 1930 to 1937, during which time only ten were built. Mecray focuses the composition on a close angle, showing the crew actively engaged along the deck beneath the beautiful sculptural forms of the billowing sails.

1. Rudolph Schaefer, *J. E. Buttersworth, 19th-Century Marine Painter* (Mystic, CT: Mystic Seaport, 1975), p. 3. For the debate over the relation of James and Thomas Buttersworth, see Richard Grassby, *Ship, Sea & Sky: The Marine Art of James Edward Buttersworth* (New York: South Street Seaport Museum, 1994).

2. Tom Cunliffe, *Pilots: The World of Pilotage under Sail and Oar*, Vol. I, *Pilot Schooners of North America and Great Britain* (Brooklin, ME: WoodenBoat Publications, 2001), p. 79.

3. John Rousmaniere, *The Low Black Schooner: Yacht* America *1851–1945* (Mystic, CT: Mystic Seaport Museum, 1986), p. 19.

4. Richard C. Kugler, *William Bradford: Sailing Ships & Arctic Seas* (London and Seattle: New Bedford Whaling Museum and University of Washington Press, 2003), pp. 52, 61.

5. *Hunt's Yachting Magazine*, Vol. X, No. 9, pp. 377–81 (London, September 1861).

6. Schaefer, *J. E. Buttersworth*, p. 20.

7. Ibid., p. 206.

8. James Taylor, *Yachts on Canvas: Artists' Images of Yachts from the Seventeenth Century to the Present Day* (London: Conway Maritime Press, 1998), p. 94.

9. Schaefer, *J. E. Buttersworth*, Plate XVII.

10. Anita Jacobsen, *Frederic Cozzens: Marine Painter* (New York: Alpine Fine Arts Collection, 1982), p. 46.

11. J. D. Jerrold Kelley, *American Yachts: Their Clubs and Races* (New York: Charles Scribner's Sons, 1884), p. 100.

12. Ibid., p. 62.

13. The editor of *The Month at Goodspeeds*, quoted in Jacobsen, *Frederic Cozzens*, p. 46.

14. Ibid., p. 283.

15. Quoted in Jacobsen, *Frederic Cozzens*, p. 46.

16. Kelley, *American Yachts*, p. 124.

17. Ibid., p. 215.

18. Ibid., p. 369.

19. Taylor, *Yachts on Canvas*, p. 141.

20. Ibid., p. 141.

Next two pages:

PLATE I.1

The Sloop Maria *Racing the Schooner Yacht* America, *May 1851*
James E. Buttersworth (1817–1894)
Ca. 1851
Oil on canvas
18" x 24"
Signed "J. E. Buttersworth" (lower right)

PLATE I.2

Cutter Yacht Maria
F. F. Palmer (1812–1876), delineator
Nathaniel Currier (1813–1888), lithographer
1852
Color lithograph
19½" x 25"
Inscribed in the margins "Modelled by R. L. Stevens Esp./Owned by the Messrs. Stevens/ of New York/To John C. Stevens, Esq., Commodore/of the New York Yacht Club/Published by N. Currier,/152 Nassau Street, New York."
 Note: *Maria* was actually a sloop, not a cutter as indicated by this title.

AMERICA, THE MOST FAMOUS of all racing yachts because of her victory at Cowes on August 22, 1851, over the Royal Yacht Squadron, ran second to *Maria* in her tune-up races against the big sloop (*Maria* was a beamy one-master, not a narrow, one-masted cutter) in May of that year. *Maria* had been designed in 1844 by Robert L. Stevens, in collaboration with Commodore John Cox Stevens and Commodore Edwin A. Stevens. The three brothers were founders of the Stevens Institute of Technology. As originally built, *Maria* was the largest sloop of her day. As later lengthened, she had a waterline length of 107 feet, her topmast head rose 130 feet above the water, her main boom was 97 feet long, her jibboom 70 feet. With twin centerboards, bored spars, and a draft with board up of just 5 feet, she was an innovative and uncompromising racing machine. Named for John Cox Stevens's wife and nicknamed "Black Maria" by the sporting fraternity, she was a difficult boat. Her fifty-five-man crew fought to trim her sails, she was hard to steer, and she was dogged by constant rigging failures. However, when she did finish, she usually finished first. In order to take advantage of intense public interest in the contest between the two yachts, Buttersworth painted the trial race with an eye toward having it reproduced as a lithograph by Nathaniel Currier. *Maria* beat *America* badly, and there was trepidation about sending the new schooner across the Atlantic to take on England's best. But although she was arguably faster than *America*, *Maria* was never intended to make the Atlantic crossing. *America* sailed to England as she was built to do.

 To correct the improbable direction in the original, Fanny Palmer reversed the heading of *America* in creating the lithographic reproduction of Buttersworth's painting. But she took the same pains as Buttersworth had to show the horizontal (some would say cross-cut) sailcloths of *Maria*'s mainsail and jib. *America*'s sails, on the other hand, follow the custom of the day, with the cloths running parallel to the leech.

Llewellyn Howland III

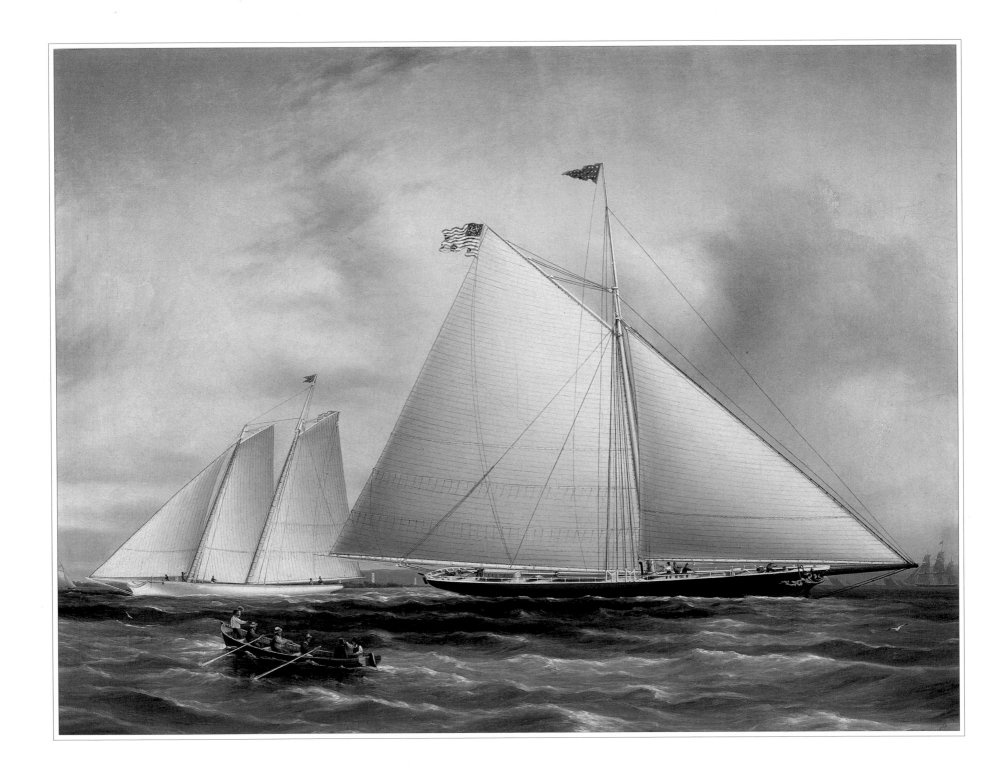

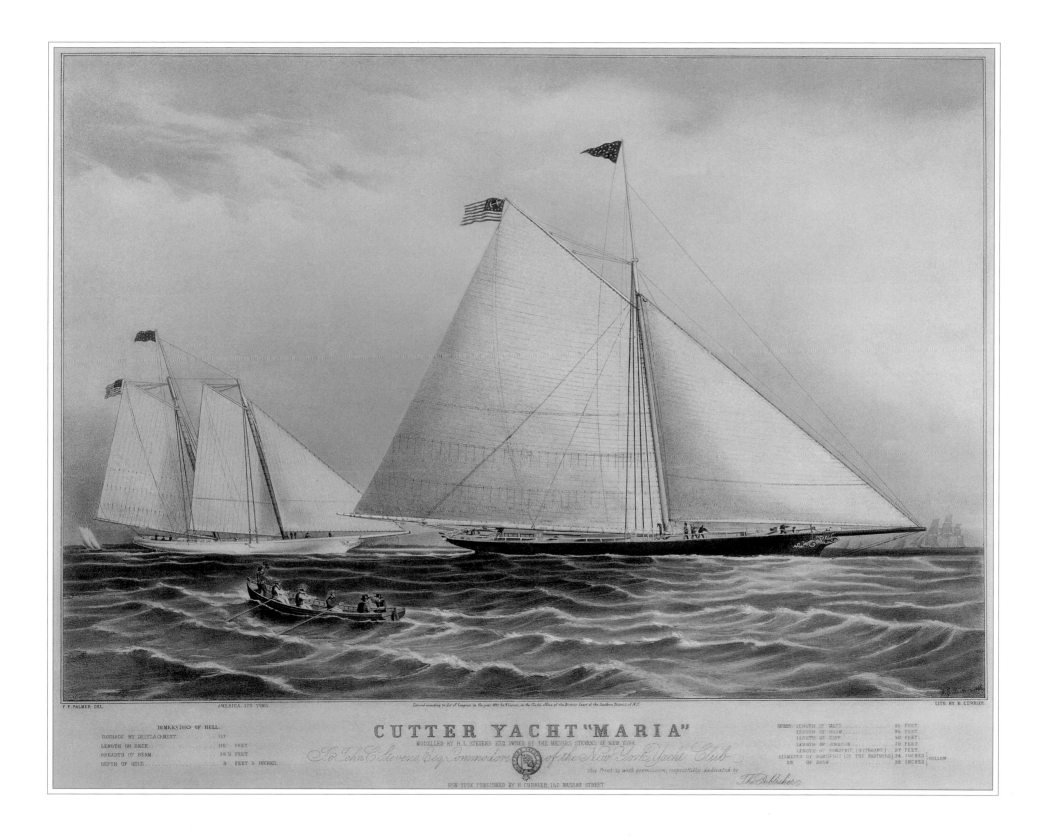

F. F. PALMER, DEL. AMERICA, 170 TONS. Entered according to Act of Congress in the year 1852 by N Currier, in the Clerks office of the District Court of the Southern District of N.Y. LITH BY N. CURRIER.

DIMENSIONS OF HULL.

TONNAGE BY DISPLACEMENT	157
LENGTH ON DECK	110 FEET
BREADTH OF BEAM	26 ½ FEET
DEPTH OF HOLD	8 FEET 3 INCHES

CUTTER YACHT "MARIA"

MODELLED BY R. L. STEVENS ESQ. OWNED BY THE MESSRS STEVENS OF NEW YORK.

To John C Stevens, Esq. Commodore of the New York Yacht Club

this Print is with permission, respectfully dedicated by

The Publisher

NEW YORK PUBLISHED BY N. CURRIER, 152 NASSAU STREET.

SPARS:
LENGTH OF MAST	91 FEET.
LENGTH OF BOOM	95 FEET.
LENGTH OF GAFF	50 FEET.
LENGTH OF JIMBOOM	70 FEET.
LENGTH OF BOWSPRIT, (OUTBOARD)	27 FEET.
DIAMETER OF BOWSPRIT (IN THE PARTNERS)	34 INCHES } HOLLOW
DO. OF 280 W	28 INCHES }

PLATE I.3

Schooner Yacht America *Winning the Cup at Cowes, 1851*
Attributed to William Bradford (1823–1892)
Ca. 1852
Oil on canvas
18" x 24"
Unsigned, formerly attributed to Fitz Hugh Lane

ALTHOUGH UNSIGNED, this painting of the schooner yacht *America* is attributed to William Bradford on stylistic grounds, as well as being in keeping with his early efforts at self-instruction by copying illustrations in English drawing books. In this case, however, his subject came not from a book, but from a popular lithograph by Thomas G. Dutton of *The Schooner Yacht* America *Winning the Match at Cowes*, based on a sketch made on the scene by Oswald W. Brierly. Published in London in October 1851, the lithograph quickly became available in the United States. Responding to popular excitement over *America*'s triumph, Fitz Hugh Lane painted a copy in oils before the year was over.

Lane's *America* (in the collection of the Peabody Essex Museum) faithfully reproduced the compositional elements of the lithograph, but did so in colors much brighter than the subdued tints of his model. Bradford may have painted his version as early as 1852, the initial year of his career as an artist. Possibly having seen Lane's painting on exhibition in Boston, he adopted a color scheme close to it. In other respects, he took considerable liberties with the composition, especially in eliminating the stake boat in the right foreground. In doing so, he projected *America* to the front of his canvas, but also obscured the fact that she was crossing the finish line of a race. He also introduced his own sea and skies, but, as Erik Ronnberg has noted,[1] he painted his billowing clouds advancing into the wind, a mistake he would not repeat as he gained experience at sea and at his easel.

Except for a label on the reverse of the canvas, indicating that "Mr. Buck purchased the painting from a second-hand store on Tremont Street in Boston in 1890," the history of the painting before it entered Glen Foster's collection is unknown.

Richard C. Kugler

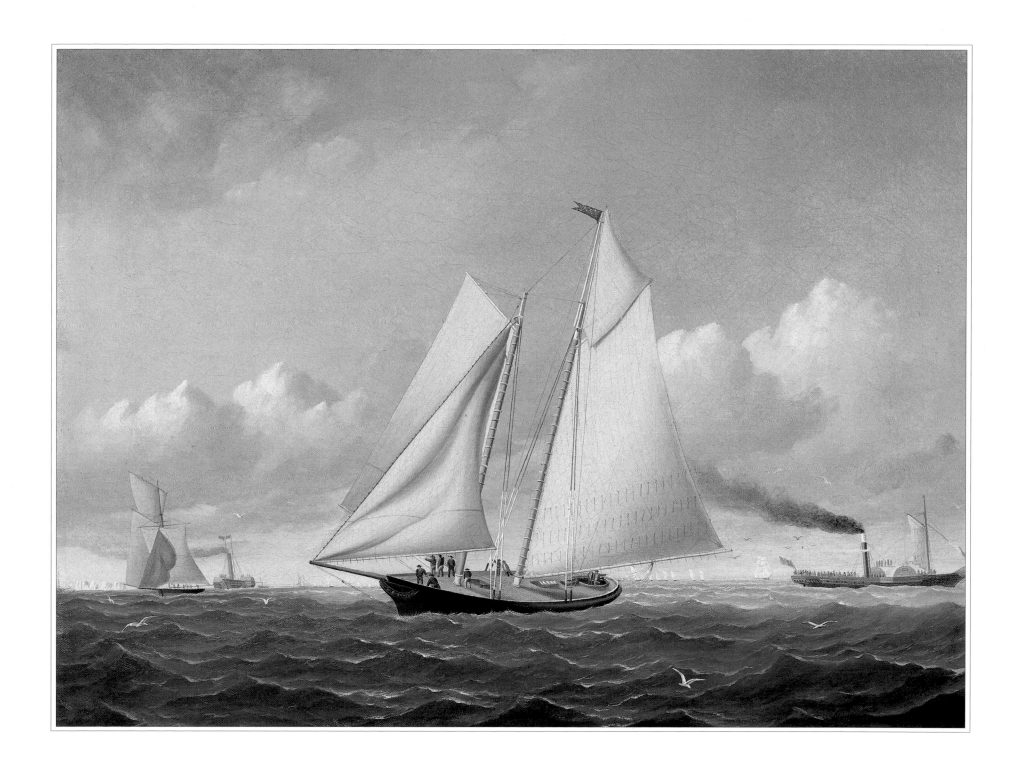

PLATE I.4

Untitled View of Match Race between Schooner Yachts America *and*
Alarm, *Cowes, August 5, 1860*
James E. Buttersworth (1817–1894)
Ca. 1860
Oil on artist's board
10" x 14"
Signed "J. E. Buttersworth" (lower right)

IT WAS ONE OF THE most eagerly awaited match races in yachting history. Joseph Weld's crack English cutter *Alarm* (along with his former yacht *Arrow*) had been a favorite to win the One Hundred Guinea Cup against a large fleet including the schooner *America* on August 22, 1851. Subsequently lengthened and re-rigged as a schooner, *Alarm* finally took her revenge against the American schooner in their second meeting off Cowes nine years later, on August 5, 1860.

According to *Hunt's Yachting Magazine*, the yachts started "off the R.Y.S. Castle, thence proceeded round the Warner Light Vessel, thence to the northward of the Calshot Light Vessel, passing to the northward of the Brambles...thence round a mark vessel moored off Egypt, thence to pass between the Station vessel and the Castle, twice round." The race started at 11:00 A.M. in a steady westerly. By noon, *Alarm* had worked to weather of *America* off Quarantine Ground. By 1:00 P.M., thanks in part to a major sail-handling lash-up aboard *America*, *Alarm* led the famous schooner by some 12 minutes. By the time *Alarm* took the finish gun after the second rounding of the course, *America* was 37 minutes 5 seconds astern. In the words of the *Hunt's* reporter, the owner of *Alarm*, "Mr. Weld, and his captain, John Nicholls, have now achieved a triumph they have long deserved."[1]

For some years, this small painting by James E. Buttersworth was believed to have been a view of *America* in the original One Hundred Guinea Cup race of 1851. However, the *Hunt's* account of the 1860 match includes a lithograph of the event from a painting by A. W. Fowles. This leaves little doubt that both artists were recording the same celebrated 1860 race—and that *Alarm* was well on her way to beating *America* by a humiliating margin.

Llewellyn Howland III

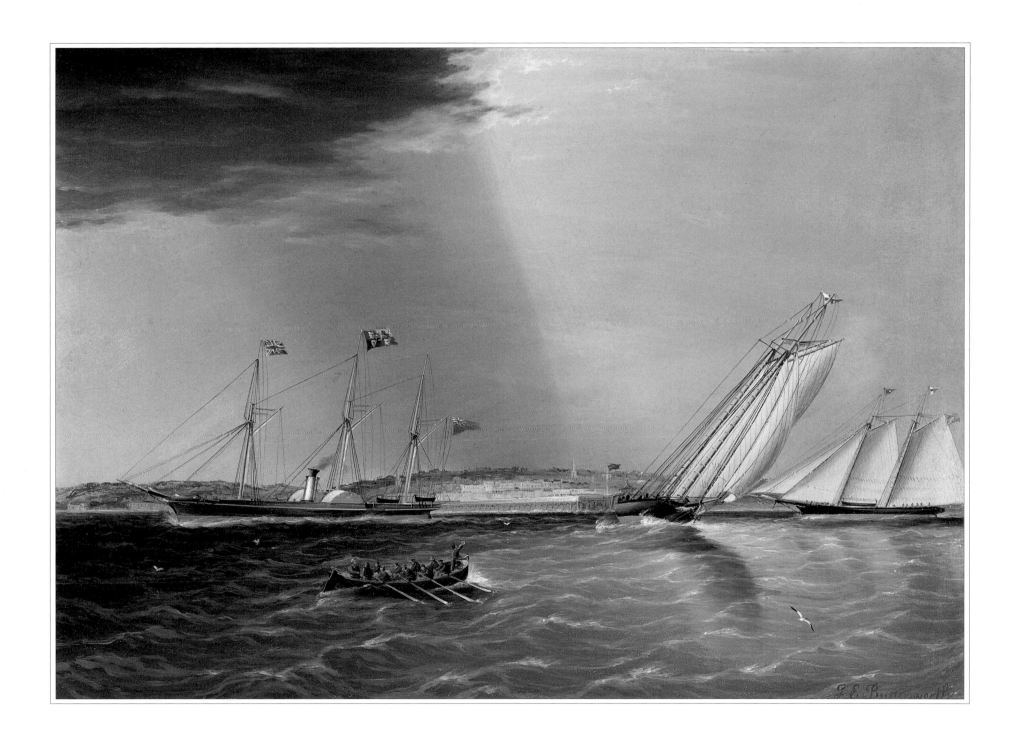

PLATE I.5

Schooner Yacht Magic *Passing Sandy Hook Lightship, America's Cup, 1870*
James E. Buttersworth (1817–1894)
Ca. 1871
Oil on canvas
18" x 24"
Signed "J. E. Buttersworth" (lower right)

BUILT IN 1857 BY R. T. LOPER and originally rigged as a sloop, *Magic* was later lengthened, rebuilt, and given a schooner rig. She was the first defender of America's Cup, beating not only the British challenger, James Ashbury's *Cambria*, but some twenty-two other American schooners that started (and thirteen that finished) the winner-take-all Cup race on August 8, 1870. *Magic* is shown here rounding Sandy Hook Lightship at the head of a procession of racers, with the lightship dressed for the occasion. But whether this was the 1870 Cup race is uncertain. In Buttersworth's portrait of *Magic* entitled *First America's Cup Race*, reproduced as the frontispiece of Rudolph J. Schaefer's *J. E. Buttersworth*, *Magic* is shown flying a very different house flag, and not from the main truck, but from a hoist on the peak of the main gaff. In other respects, the paintings are similar, though hardly identical.

Llewellyn Howland III

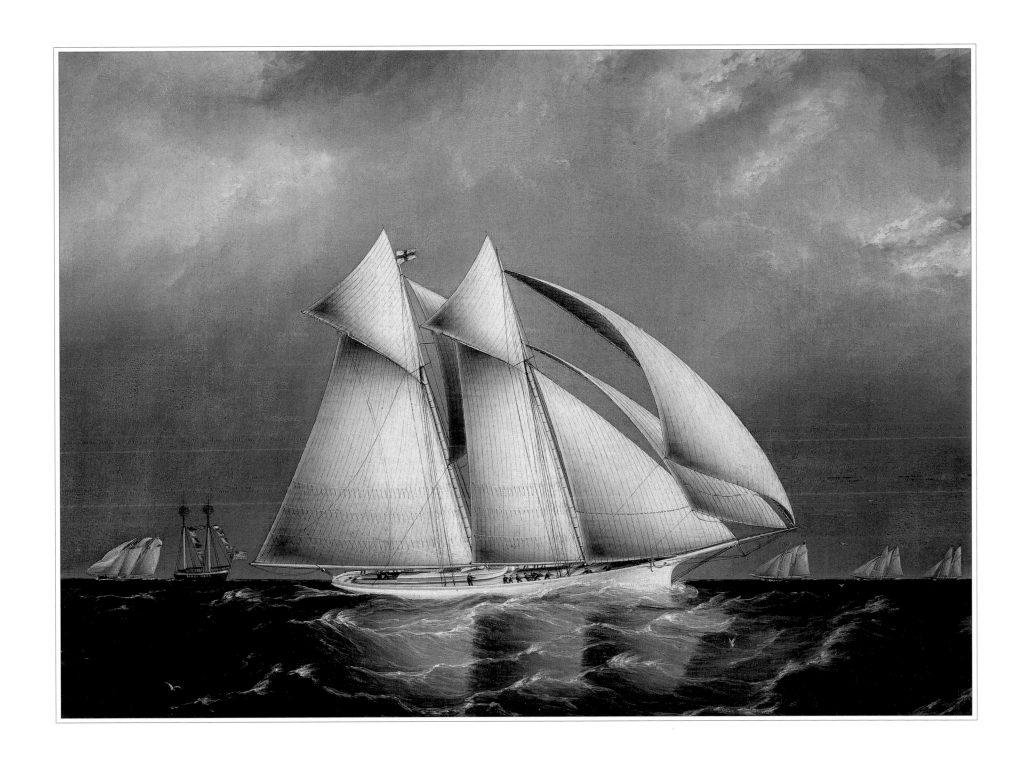

PLATE I.6

Columbia *Leading* Dauntless *Rounding Sandy Hook Lightship in the Hurricane Cup Race*
James E. Buttersworth (1817–1894)
Ca. 1875
Oil on canvas
21" x 31¼"
Signed "J. E. Buttersworth" (lower right)

THE BRAND-NEW SCHOONER YACHT *Columbia* was selected as one of four New York Yacht Club schooners for the second defense of the America's Cup in October 1871. James Ashbury, owner of the schooner *Livonia* and unsuccessful challenger in 1870, was again faced with daunting odds. However, instead of having to race against the combined fleet of the New York Yacht Club (as *America* had done at Cowes in 1851), he would be given the opportunity to match-race. Unfortunately for the Royal Harwich Yacht Club challenge, the New York Yacht Club reserved the right to send to the line, depending on weather conditions, any member of its team of four. The centerboard schooner *Columbia*, built by J. B. Van Deusen at Chester, Pennsylvania, in 1871 and owned by Franklin Osgood, was considered to be the fastest light-air yacht of her day. She raced *Livonia* three times, winning the first two, and losing the third when she was partially disabled due to heavy weather. Buttersworth's striking portrait of *Columbia* is of a later date and a later race.

The New York Yacht Club yearbook for 1876 lists *Columbia* as flying a swallowtail cross of St. George as her owner's private signal. This is the same private signal flown by *Magic* six years earlier when she defended the America's Cup. This use of the same owner's private signal has often resulted in misidentification of both yachts.

Llewellyn Howland III
Betty Krulik
Karl Gabosh

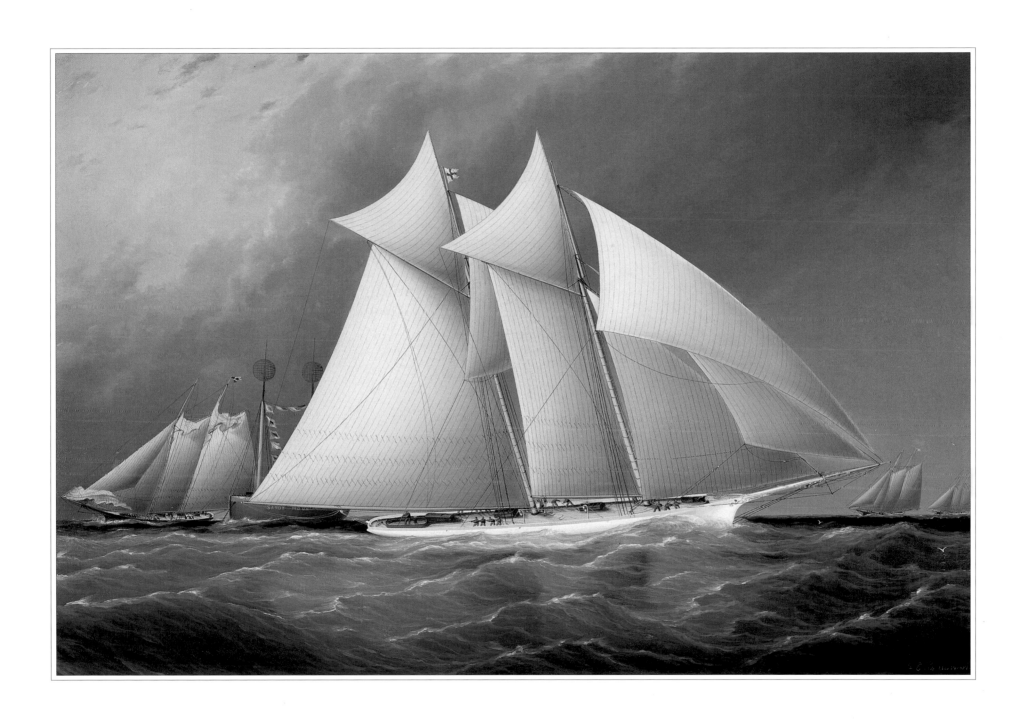

PLATE I.7

Mischief *and* Gracie, *America's Cup Trial Race, 1881*
James E. Buttersworth (1817–1894)
Ca. 1881
Oil on panel
11½" x 18"
Signed "J. E. Buttersworth" (lower right)

IN 1881 ALEXANDER CUTHBERT of Canada's Bay of Quinte Yacht Club challenged for the America's Cup a second time. In response, the New York Yacht Club agreed for the first time to name, in advance of racing, a single defender for the entire race series. John Parkinson, Jr., suggests that the club was not particularly apprehensive about the quality of the new Canadian challenger, *Atalanta*, to beat their best 70-footers. However, the flag officers did form a syndicate and built the centerboard sloop *Pocahontas* for insurance. As a result, trials to select an America's Cup defender were held for the first time: on October 13, 19, and 20. The first two races were over the club course, and the third 16 miles to leeward and return off Sandy Hook. It would appear that Buttersworth here depicted the third race, which took place in a strong southeaster in rough seas outside. The archrivals *Mischief* and *Gracie* had a great time of it, *Mischief* winning by 14 seconds on corrected time. The slow and unlucky *Pocahontas* withdrew from the race—and from active competition with the club—after a rigging failure. *Mischief* went on to defend the Cup, defeating *Atalanta* by margins of 28 minutes 20 seconds and 38 minutes 54 seconds. As John Parkinson, Jr., points out, however, there was more than a little irony in *Mischief*'s victory. She was an American boat in design and build, but her owner, Joseph R. Busk, though a member of the New York Yacht Club, was an English citizen.

Llewellyn Howland III
Betty Krulik
Karl Gabosh

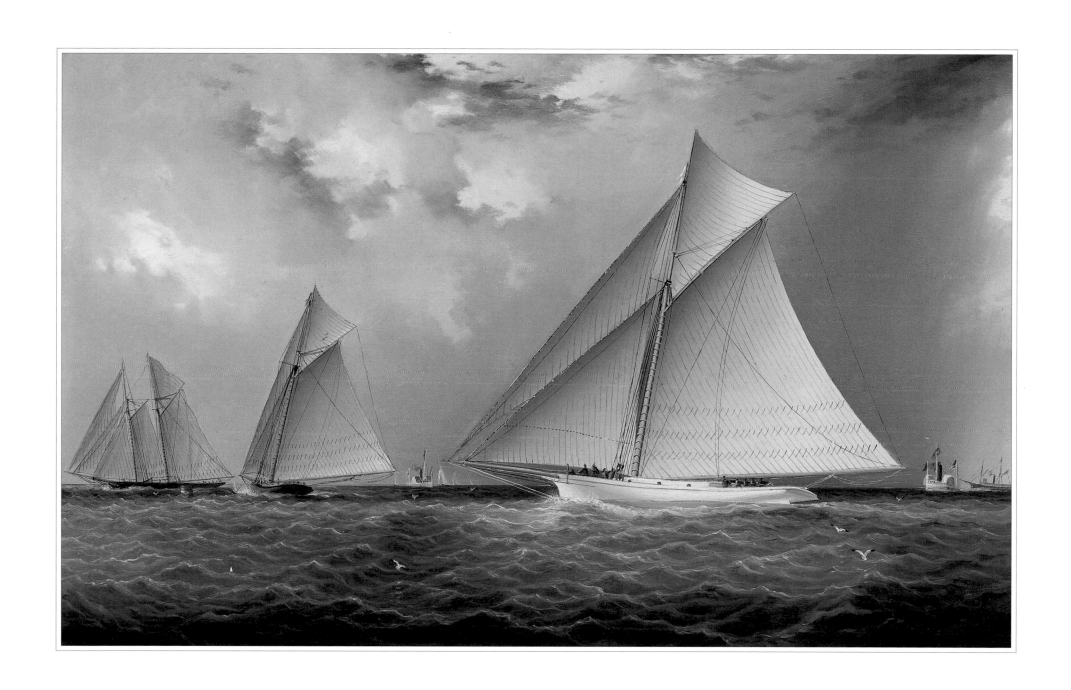

PLATE I.8

The Yacht Race
James E. Buttersworth (1817–1894)
Ca. 1880
Oil on academy board
13¾" x 23¾"
Signed "J. E. Buttersworth" (lower right)

DURING THE 1870S the number of sloops enrolled in the New York Yacht Club exceeded the number of the great keel and centerboard schooners that had established the club as America's premier yachting organization, and New York Harbor as its yachting locus. After organizing the fleet into sloop and schooner classes based on tonnage, the club sponsored annual regattas that were held in June. Buttersworth has portrayed such a competition in *The Yacht Race*. The yachts are rounding Southwest Spit buoy, or perhaps buoy #5 off Sandy Hook, as they race over the old club course. The lead yacht is a keel cutter, possibly *Mischief*. Just rounding the mark is an unidentified first class schooner. Fetching the mark are two first-class sloops. The rest of the fleet trails out to the horizon, suggesting a great sense of depth and space in the painting. On the far horizon is the club's committee boat, flying an oversize burgee at her main truck.

Llewellyn Howland III
Betty Krulik
Karl Gabosh

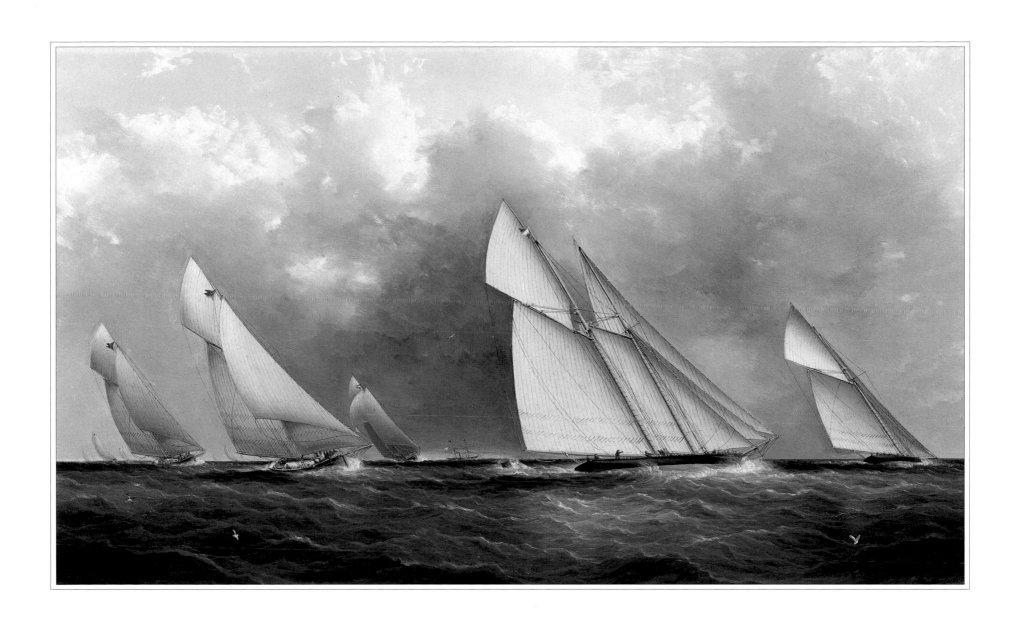

29

PLATE I.9

Puritan *and* Genesta, *America's Cup, 1885*
James E. Buttersworth (1817–1894)
Ca. 1885
Oil on canvas
24" x 30"
Signed "J. E. Buttersworth" (lower right)

GENESTA WAS THE FIRST America's Cup challenger to represent the Royal Yacht Squadron, and she created a stir at the New York Yacht Club even before the passage across the Atlantic in 1885. Designed by J. Beavor-Webb, the deep, narrow cutter *Genesta* was reputed to be unbeatable. The same claim had been made for *Madge*, an English cutter designed by the brilliant George Watson that had been shipped across the Pond in 1881 and had won seven of eight races against American centerboarders. In May 1885 the New York Yacht Club reacted to the uncertainty about just how fast the English designs were by appealing to other American clubs for potential defenders—this, even though its flag officers Commodore James Gordon Bennett and Vice-Commodore W. P. Douglas had commissioned the club's measurer, A. Cary Smith, to design the iron sloop *Priscilla* especially for the defense.

Members of the Eastern Yacht Club, Marblehead, Massachusetts, met to consider building their own defense candidate. They agreed that J. Malcolm Forbes would pay for her, General Charles J. Paine would manage her, and Edward Burgess, the Eastern's secretary, would design her. Thus was born the first modern America's Cup defense syndicate. The Forbes–Paine syndicate's boats would represent the New York Yacht Club in Cup races.

The yacht *Puritan* came down the ways at the George Lawley yard a few months later. She was a 94-foot compromise between the American and English traditions: narrow by New York and Boston standards, shoal of draft by Cowes standards. She was criticized, but handily defeated *Priscilla* in the Cup trials and successfully defended the Cup. This Buttersworth painting shows Burgess's great compromise sloop pulling away from *Genesta* in the first official race, September 14, 1885, which *Puritan* won by a commanding 16 minutes 19 seconds.

Llewellyn Howland III
Betty Krulik
Karl Gabosh

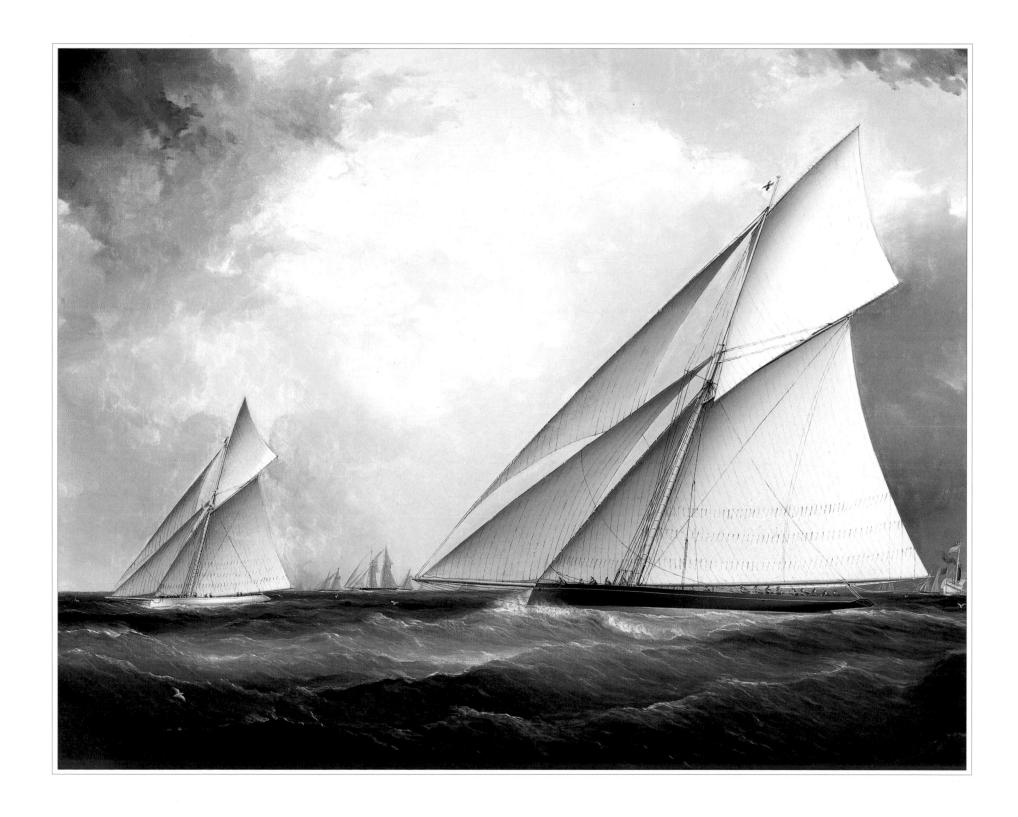

PLATE I.10

Puritan *Leading* Genesta, *America's Cup, 1885*
James E. Buttersworth (1817–1894)
1885
Oil on canvas
24" x 30"
Signed and dated "J. E. Buttersworth 1885" (lower right)

BUTTERSWORTH'S PAINTING depicts the deciding race of the 1885 America's Cup match. After two attempted races had been canceled for lack of wind, one had been aborted following a foul against *Genesta* by *Puritan,* and the first official race had been won by *Puritan* by 16 minutes 19 seconds on corrected time, the two boats met for the last time on September 16 and raced twenty miles to leeward to Scotland Lightship and return in a strong autumn northwester. The "cutter cranks," who favored the narrow "knife-edge" cutter designs, were sure *Genesta* would prevail on this occasion when she got the best of the start. The lead changed hands twice on the long run. *Genesta* led by 2 minutes at the outer mark. Sailing a little faster and pointing a little higher, *Puritan* gradually caught up to *Genesta* on the twenty-mile beat to the finish. The wind was gusting to thirty knots as both boats buried their lee rails deep into the ocean. *Puritan* gained some 4 minutes on the beat, winning by 1 minute 38 seconds on corrected time. The 1885 match offered the best racing in the history of the Cup to that date. The goodwill it produced did much to encourage future challenges.

<div style="text-align: right">

Llewellyn Howland III
Betty Krulik
Karl Gabosh

</div>

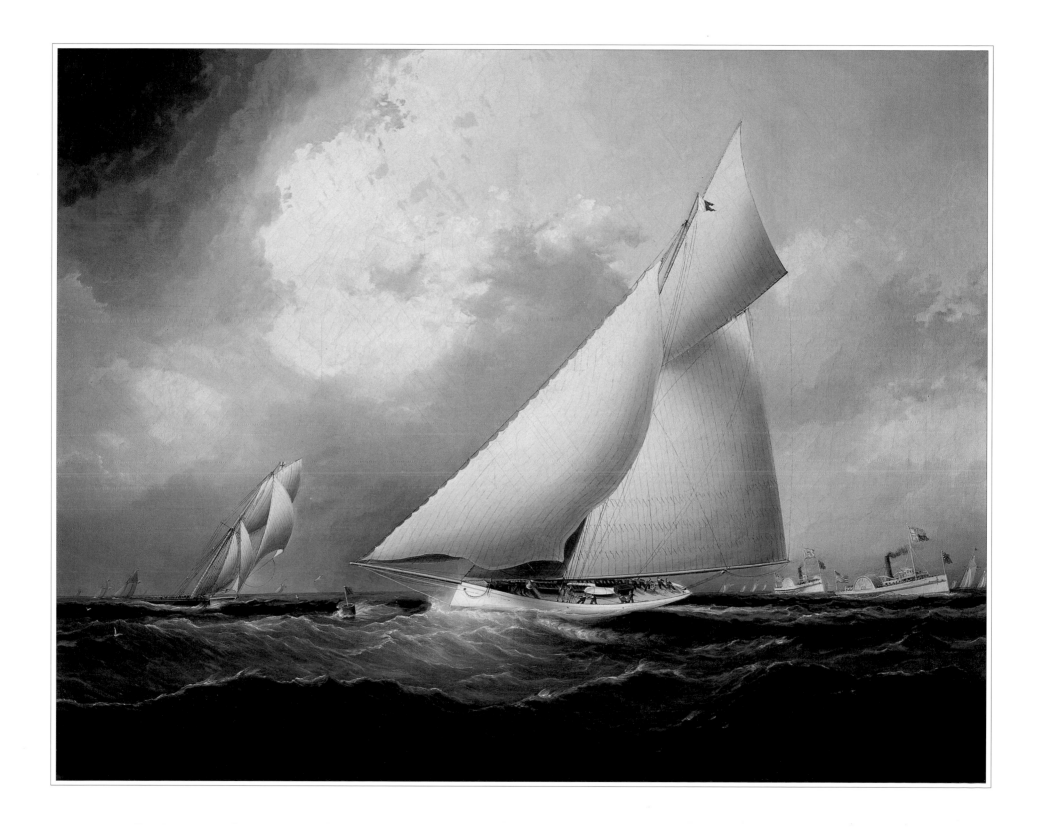

PLATE I.11

The Seawanhaka Corinthian Yacht Club Cutter Bedouin *off Execution Rocks Lighthouse*
Elisha Taylor Baker (1827–1890)
Ca. 1885
Oil on canvas
24½" x 29"
Signed with monogrammed initials and artist's insignia (lower left)

ENGLISHMAN JOHN HARVEY designed the cutter *Bedouin* for wealthy sportsman and neophyte yachtsman Archibald Rogers (1851–1928). Henry Piepgras built her at Brooklyn, New York, in 1882. *Bedouin* measured 83 feet 0 inches LOA, 70 feet 0 inches LWL, 15 feet 8 inches beam, 11 feet 6 inches draft, with 5,196 square feet sail area. In August 1885 she competed unsuccessfully against *Puritan*, *Priscilla*, and *Gracie* in the America's Cup trials. Elisha Taylor Baker, a housepainter, paperhanger, and self-taught marine artist, portrayed the cutter believed to be *Bedouin* in his trademark Luminist style, as she sailed past Execution Rocks Lighthouse. *Bedouin* was the flagship of the Seawanhaka Corinthian Yacht Club in 1884–1885 when Rogers was commodore. This portrait was long thought to be of the British America's Cup challenger *Genesta*, and to compound problems of identification the house flag Baker shows on the leech of the cutter's mainsail is not conclusively identifiable as that of Archibald Rogers. The choice of subject matter, palette, and key stylistic and compositional elements suggests that the painting dates from the last years of Baker's active career.

Llewellyn Howland III
Betty Krulik
Karl Gabosh

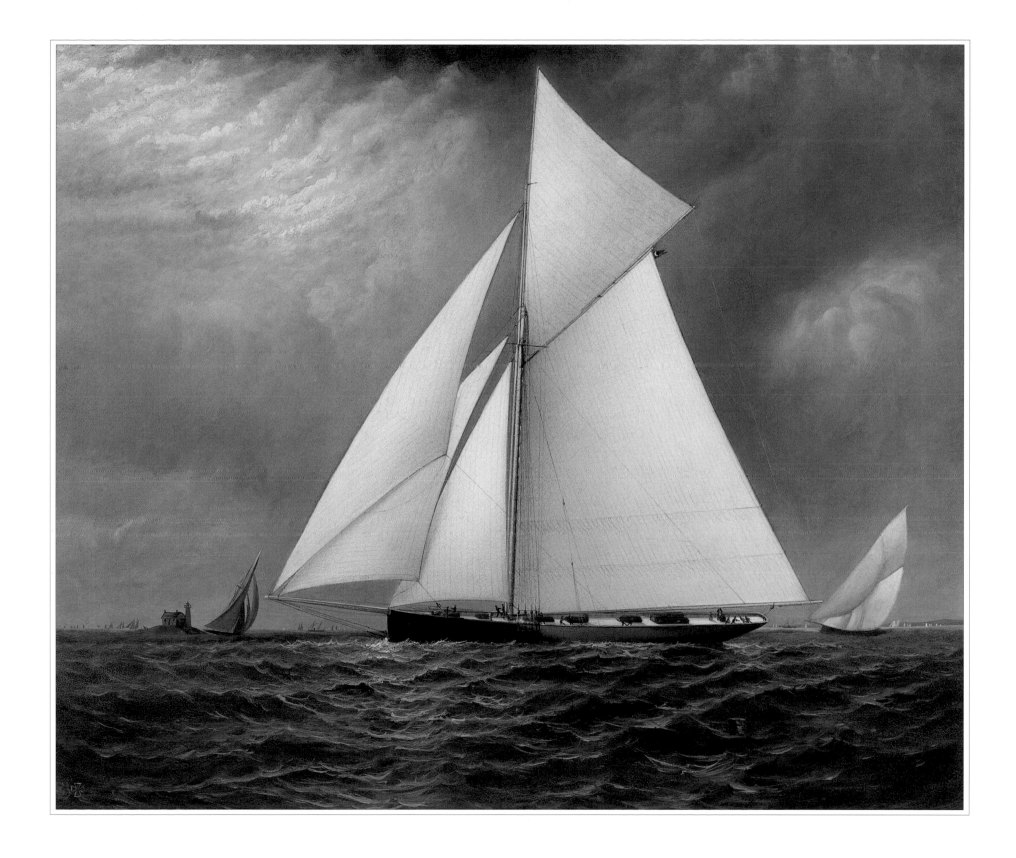

PLATE I.12

Mayflower *Leading* Puritan, *America's Cup Trial Race, 1886*
James E. Buttersworth (1817–1894)
Ca. 1886
Oil on canvas
19½" x 30"
Signed "J. E. Buttersworth" (lower right)

IN EARLY 1886 General Charles J. Paine commissioned Edward Burgess to design a new defense candidate, *Mayflower*, because Lieutenant William Henn's challenger, *Galatea*, was 6 feet longer than the previous year's challenger, *Genesta*. J. Malcolm Forbes bought the 1885 defender, *Puritan*, and planned his own campaign. *Puritan* challenged for the right to defend the America's Cup along with a revamped *Priscilla* and the new centerboard sloop *Atlantic* representing the Atlantic Yacht Club of Brooklyn, New York. There were two trial races off New York, on August 21 and 25. The first was over the club course in a fresh southeaster, the second fifteen miles to windward and return off Sandy Hook in a moderate to fresh northeaster. The first race order of finish was *Mayflower, Atlantic, Puritan,* and *Priscilla. Mayflower* won the second race, followed by *Puritan, Priscilla,* and *Atlantic.* The Cup trials in 1886 were, in fact, far more closely contested than the actual America's Cup match. Having won the right to defend, *Mayflower* defeated *Galatea* in two straight races by winning margins of 12 and 29 minutes. Buttersworth's painting of the second trial race captures all the drama of *Mayflower's* victory over *Puritan* on August 21, 1886.

Note: The house flag flying on the sloop to the left is *not* J. Malcolm Forbes's, which was composed of blue on white triangles. Lieutenant Henn's house flag was a red cross on a white field, square. Identity of the sloop can only be proven by further study of her model at the NYYC.

Llewellyn Howland III
Betty Krulik
Karl Gabosh

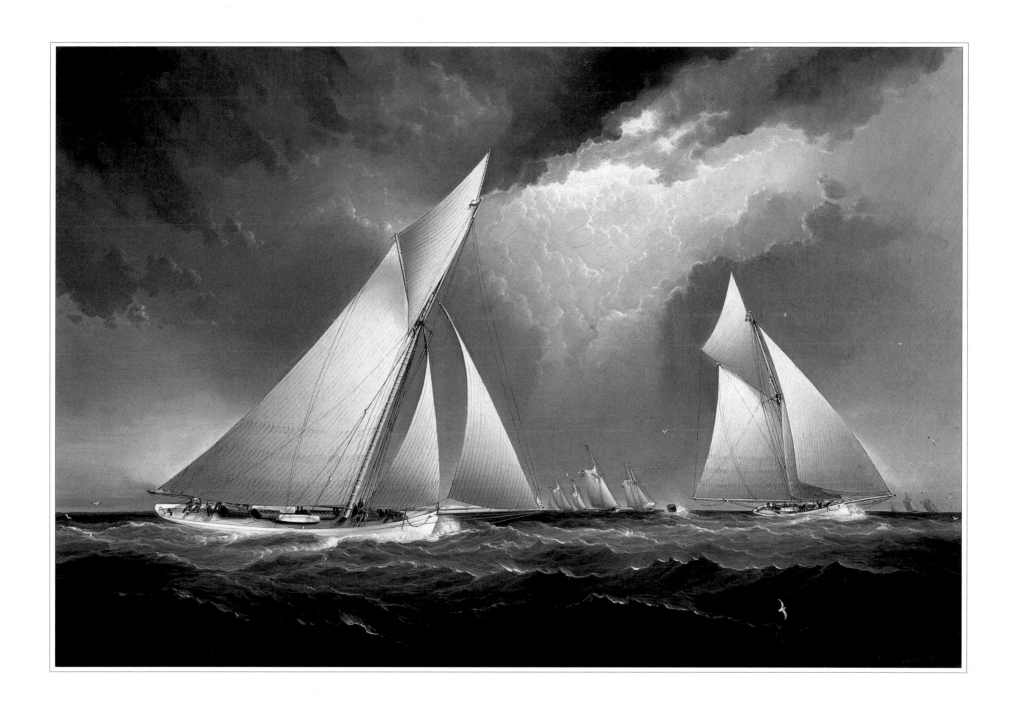

PLATE I.13

Mayflower *Leading* Galatea, *America's Cup, 1886*

James E. Buttersworth (1817–1894)
Ca. 1886
Oil on canvas
24½" x 29¾"
Signed "J. E. Buttersworth" (lower right)

THE BOSTON BOAT *MAYFLOWER* is shown leading *Galatea* past the Southwest Spit buoy during the first race of the 1886 America's Cup match, held on September 7 over the regular New York Yacht Club course. *Galatea* was steered by her designer, J. Beavor-Webb, but to no avail. *Mayflower* rounded Sandy Hook Lightship and ran home to win by 12 minutes 2 seconds.

The 1886 match is fascinating not because of the racing, but rather because of the contrasting styles of the two principals. The challenger, William Henn, was a liveaboard cruising sailor. He was so consistent in his laid-back attitude that the newspapers of the day interpreted it as a smoke screen for *Galatea*'s blazing speed. J. Beavor-Webb took the helm in a last-ditch effort to make his creation go, but light conditions or otherwise, there was nothing he could have done to turn *Galatea* into a winner. She may have been shipshape and Bristol fashion on deck; below she was furnished like a Victorian mansion. General Paine, on the other hand, was devoted to wringing the last knot of speed out of a boat. Once, concerned that his boat was too heavy, he had the crew plane a quarter-inch off her deck to lighten her by a few hundred pounds. The difference between Paine and Henn was in what they wanted to get out of racing. Paine wanted to win, and so, in three successive defenses of the America's Cup, he did.

Note: The painting shows a problematic house flag on *Mayflower*, whose deck plan looks to be identical with that of *Puritan* in Plate I.10.

Llewellyn Howland III
Betty Krulik
Karl Gabosh

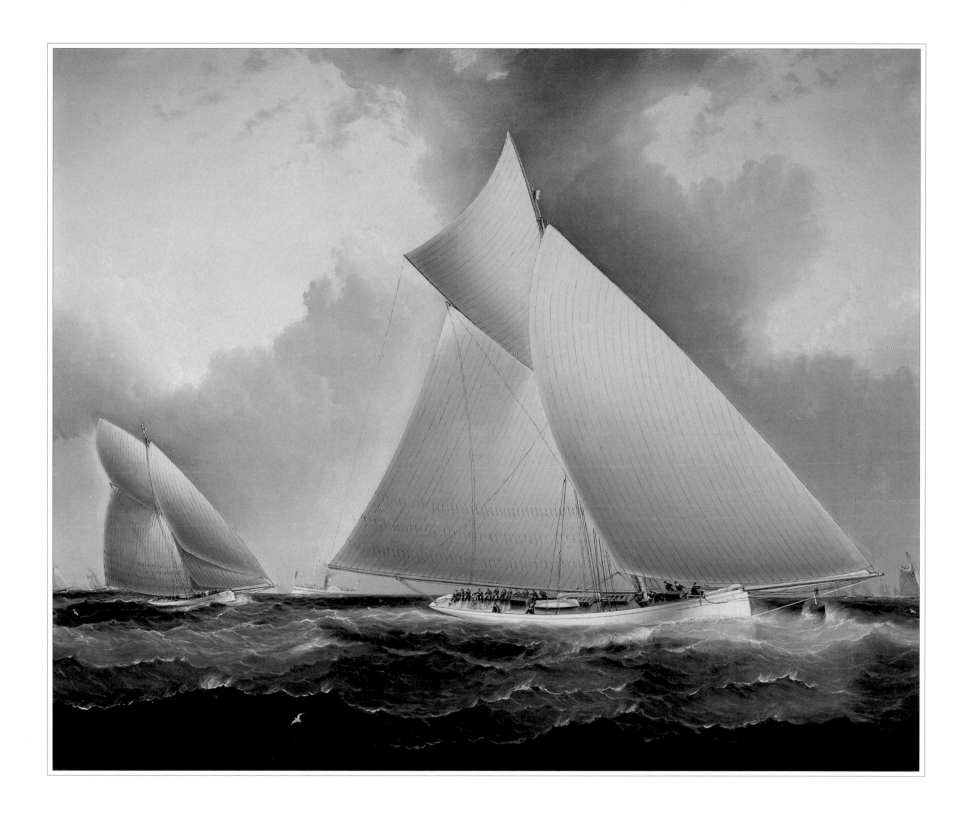

PLATE I.14

Volunteer *versus* Thistle, *America's Cup, 1887*

James E. Buttersworth (1817–1894)
Ca. 1887
Oil on canvas
20" x 29½"
Signed "J. E. Buttersworth" (lower right)

FOR THE THIRD YEAR IN A ROW, Edward Burgess designed a defense candidate for the Boston syndicate headed by General Charles J. Paine. Named *Volunteer* in recognition of Paine's Civil War service, the defender met the challenger from the Royal Yacht Squadron, *Thistle*, in September of 1887. *Thistle*, designed by the brilliant Scottish naval architect George Watson, was conceived with an eye toward specific New York sailing conditions. Watson anticipated light winds and therefore piled on the canvas, and cut away the lateral profile of *Thistle*'s keel. When the two boats finally came together in the same waters, observers were astonished that they were so similar.

The 1887 America's Cup races were the last to be sailed over the old New York Yacht Club course. The first meeting between *Volunteer* and *Thistle* took place on September 27th. "There is no question," John Parkinson, Jr., wrote, "that this was a bad course, which took the yachts down the harbor on a winding inshore track around Southwest Spit buoy, out to Sandy Hook Lightship, and back. Local knowledge was important, and it was generally resented by the yachtsmen of challenging countries."[1]

Buttersworth portrayed *Volunteer* running toward the finish on September 27th. Lower Manhattan, Castle Garden, and Castle Williams can be seen in the far distance. To heighten the drama of the picture, Buttersworth shows *Thistle* off *Volunteer*'s starboard quarter. In fact, *Thistle* finished the race 19 minutes 23 seconds behind the Boston boat.

Llewellyn Howland III
Betty Krulik
Karl Gabosh

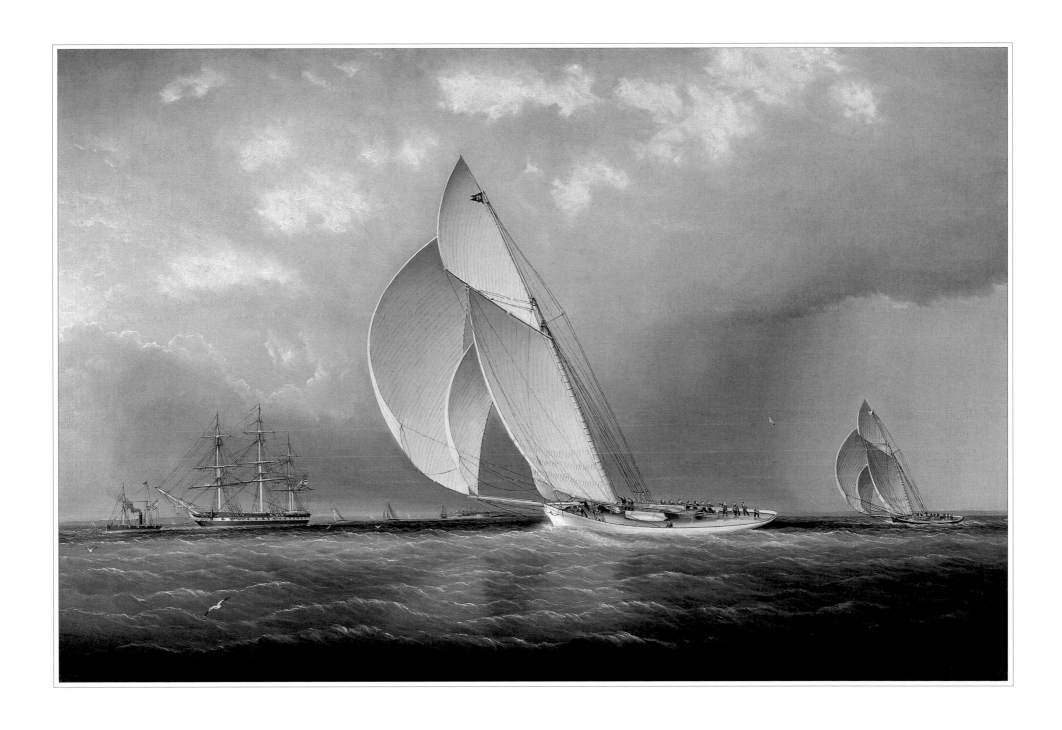

PLATE I.15

The Sloop Irene
James E. Buttersworth (1817–1894)
Ca. 1854
Oil on canvas
24" x 32"
Signed "Buttersworth" (lower right)

THE 70-FOOT SLOOP *IRENE* was built in 1852 by J. M. Bayles of Port Jefferson, who was better known as a shipbuilder. Her original owner was Thomas B. Hawkins. *Irene* regularly competed in New York Yacht Club regattas during her first few years in commission, leading the second class in a drifter on June 2, 1854, and coming in first in Narragansett Bay on August 14, 1855 in another light-air race.

In the middle distance a homeward-bound square-rigged vessel carries a cloud of studding sails, perhaps engaged in an informal race with another stunsail-clad vessel off her starboard quarter.

Irene's flying jib is flogging, and it appears that the sheet has parted. The foredeck crew will have to lower the sail and replace the sheet before she can make any ground on the schooner to windward.

Completing this active afternoon scene, Buttersworth shows an American-flag passenger liner steaming on the horizon.

Llewellyn Howland III

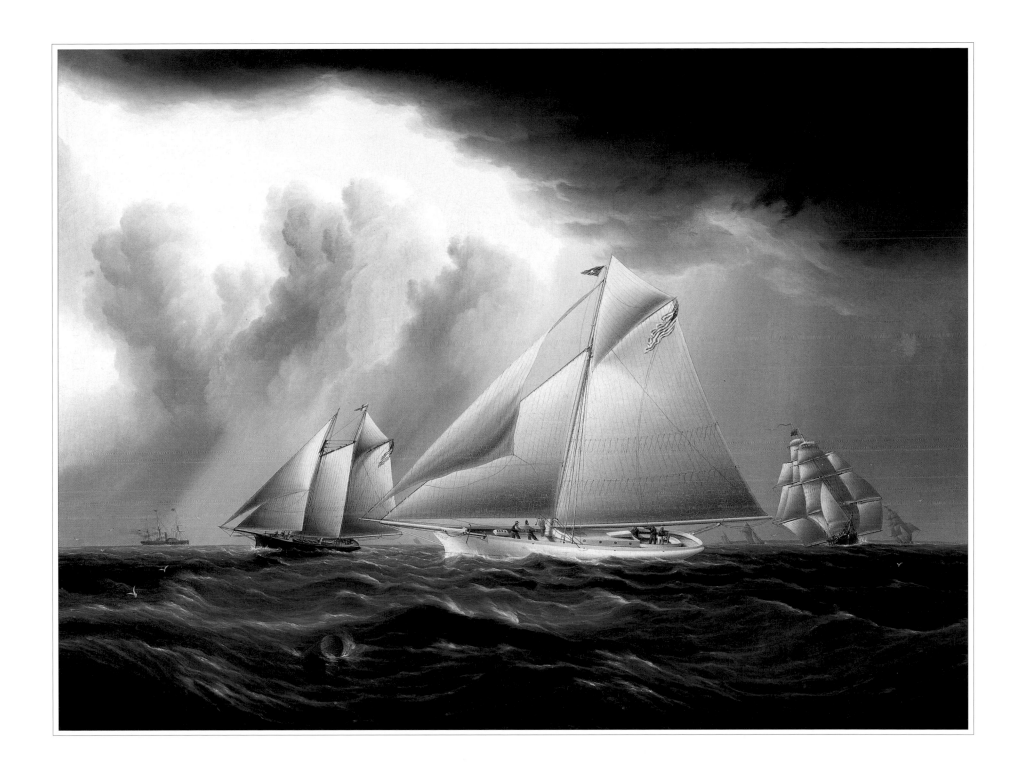

PLATE I.16

Fetching the Mark
James E. Buttersworth (1817–1894)
Ca. 1855–60
Oil on canvas
13¾" x 20"
Signed "J. E. Buttersworth" (lower right)

WITH JIB AND MAINSAIL deep-reefed and foresail being hastily furled in anticipa-
tion of a squall, the little schooner yacht in the foreground has done well to reach
the mark in first place. Or perhaps the larger black schooner on the port tack in
the middle distance is merely an onlooker. Racing or not, these are not sailing
conditions for the faint of heart, and the lead schooner's owner may shortly be
commissioning J. E. Buttersworth to memorialize the occasion on canvas. Alas, var-
ious researchers have struggled unsuccessfully over several decades to identify the
visible house flags or any of the yachts depicted.

Llewellyn Howland III

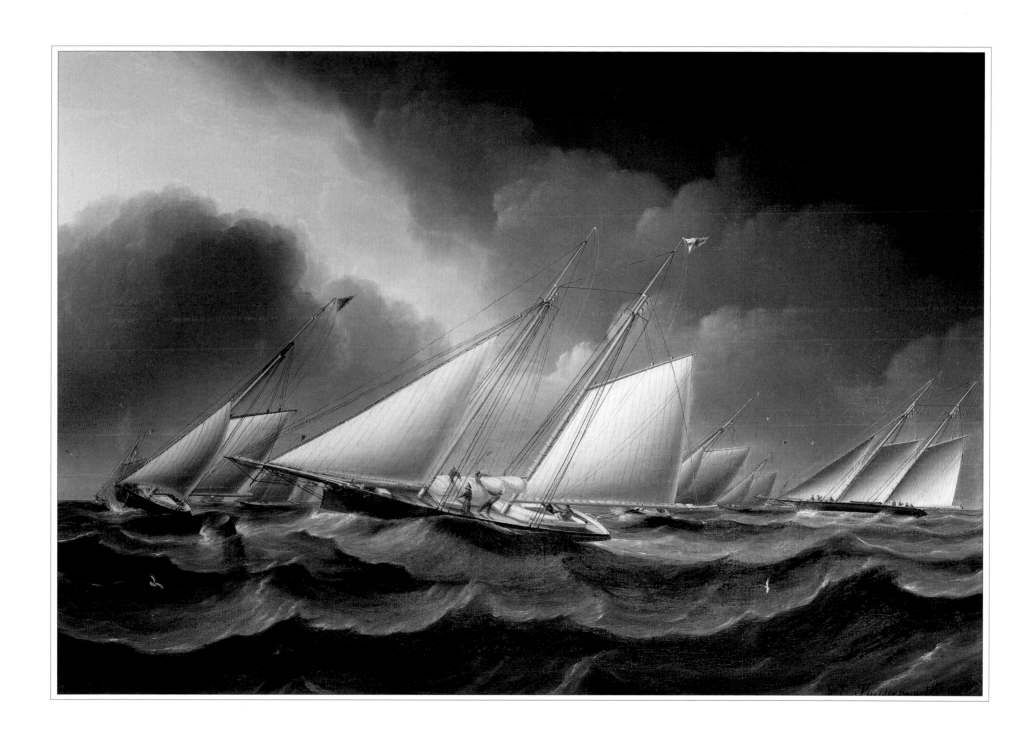

PLATE I.17

Yachts Rounding the Mark
James E. Buttersworth (1817–1894)
Ca. 1875
Oil on academy board
7¾" x 10"
Signed "J. E. Buttersworth" (lower right)

BUTTERSWORTH'S STOCK-IN-TRADE was little yachting paintings, usually oil on academy board and measuring roughly 8 by 10 inches, which he painted on speculation. Every picture was filled with exacting detail, a keen appreciation of atmospheric and sea conditions, and a flair for the dramatic that combine to make each picture a small gem. *Yachts Rounding the Mark* is one such painting. The artist records an unknown race on the old New York Yacht Club course. The painting is perfectly balanced: two first-class sloops on the port tack heading for the stakeboat, two first-class schooners on the starboard tack advancing toward the viewer with sheets started. The flag-bedecked stakeboat and its bright signal flags provide a focal point in the middle distance. This composition creates a great depth of field in the painting that belies its small size. The lead schooner, almost certainly the famous 123-foot 11-inch keel schooner *Dauntless* with blue cross private signal, has a yard rigged and will hoist a squaresail for the run home if conditions allow.

Llewellyn Howland III
Betty Krulik
Karl Gabosh

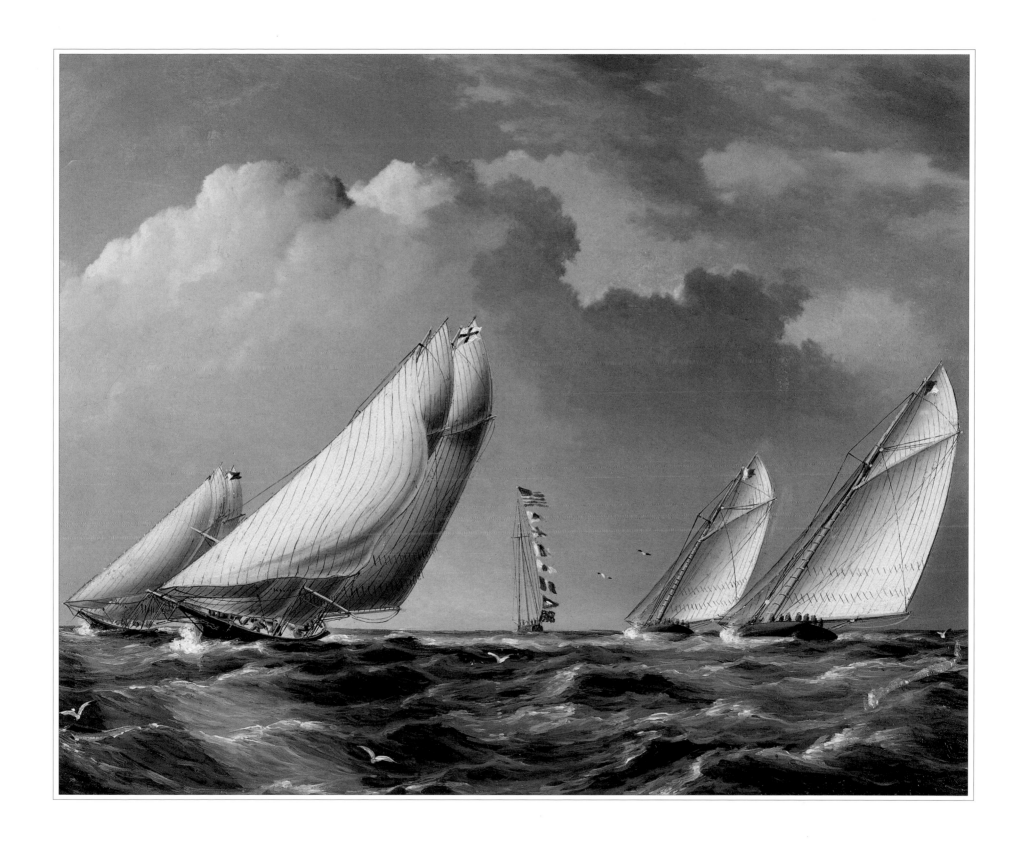

PLATE I.18

New York Yacht Club Regatta
Attributed to Antonio Jacobsen (1850–1921)
Ca. 1878
Oil on canvas
17½" x 29½"
Unsigned and undated

QUITE CERTAINLY PAINTED BY the prolific ship portraitist Antonio Jacobsen at the height of his powers, this grand yachting scene features three big schooners of the New York Yacht Club with all sail set and sheets well started, after rounding the windward mark at Scotland Lightship well ahead of the pack. The clearly rendered private signals should make the leaders readily identifiable. Perhaps the schooner to the left is George Kingsland's famous old campaigner *Alarm* and the schooner in leading, *Estelle*. However, these remain tentative attributions.

Whenever it took place and whoever the entrants, the race was sufficiently important to rate two large sidewheel excursion steamers under charter to the New York Yacht Club, as well as a committee boat at the lightship. And what a splendid day for the race it was!

It is said that Glen Foster spent several years waiting to purchase an appropriate Jacobsen yachting scene. He passed on a number of possibilities in the period. But his patience was rewarded when this picture came on the market. Foster regarded it as the finest of all Jacobsen's yachting canvases.

Llewellyn Howland III

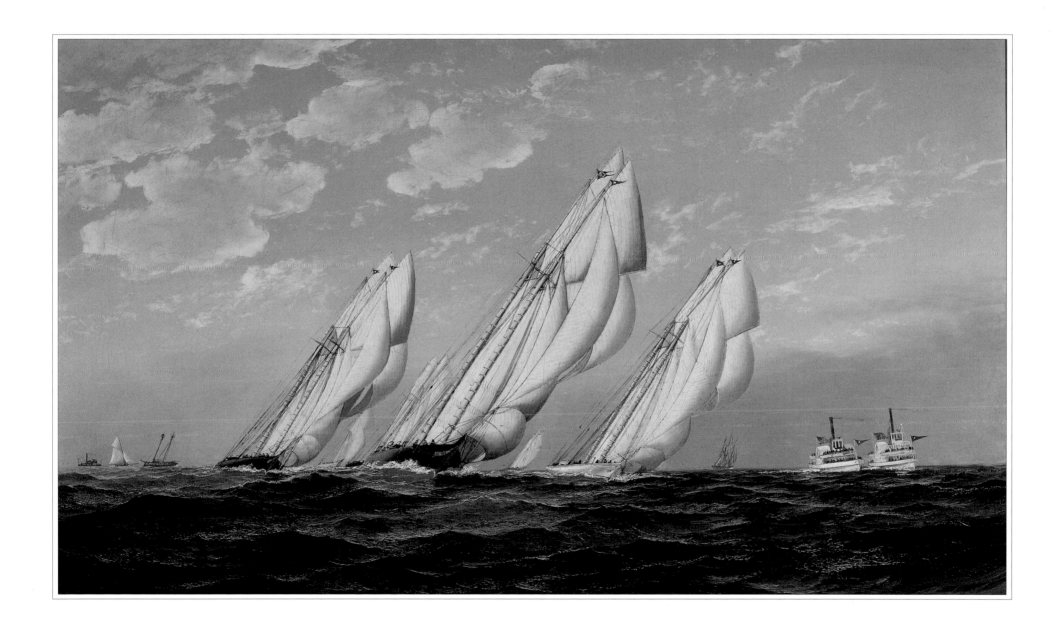

PLATE I.19

New York from the Bay
James E. Buttersworth (1817–1894)
Ca. 1878
Oil on canvas
21½" x 36"
Signed "J. E. Buttersworth" (lower right)

BUTTERSWORTH'S DEPICTION OF the New York Yacht Club schooner *Resolute* reaching off Castle Garden in the Upper Bay on what is likely an autumn afternoon is an artistic tour de force. *Resolute*, a 114-foot schooner built by David Carll of City Island, New York in 1871 and owned by A. S. Hatch, appears to be sailing off the canvas as a procession of schooners and sloops engage in futile pursuit. Boldly backlit with strong contrasts of light and shadow, the painting captures the essence of day racing in the large yachts of the day. This race may have been one of the series of match races described by John Parkinson, Jr., in his magisterial *History of the New York Yacht Club* as having been entered—and mostly won—by *Resolute* in October 1875.[1]

Llewellyn Howland III
Betty Krulik
Karl Gabosh

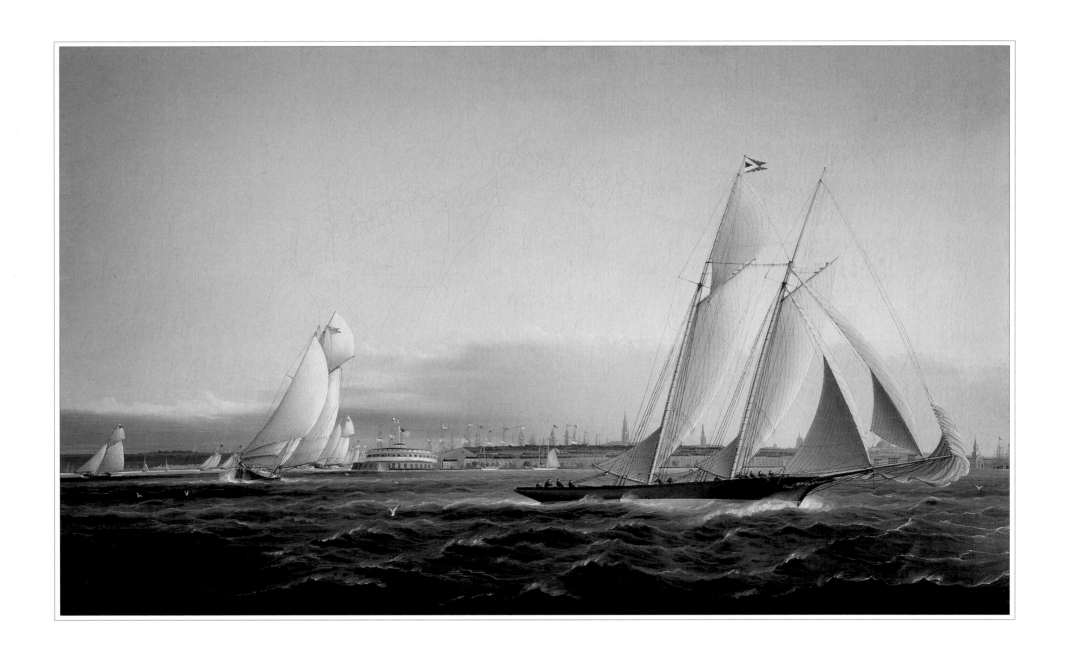

Plate I.20

Yacht Race on Upper Bay, New York Harbor
James E. Buttersworth (1817–1894)
Ca. 1875
Oil on artist's board
8" x 11¾"
Signed "J. E. Buttersworth" (lower right)

TWO FIRST-CLASS SCHOONERS and a first-class sloop, all unidentified, reach past Castle Garden and Castle Williams on Manhattan's Upper Bay. This is the perfect breeze and the ideal point of sailing for these racers, but another five knots of wind would overburden them. Buttersworth boldly renders the foreground schooner's flying jib sheet, which is evidently bearing on the leech of both the inner jib and the staysail before passing under the fore-boom. The flying jib of the schooner to windward evidently leads somewhat farther forward. In these small oils, Buttersworth's heavily drawn rigging is sometimes distracting, even, to some tastes, a fault.

Llewellyn Howland III

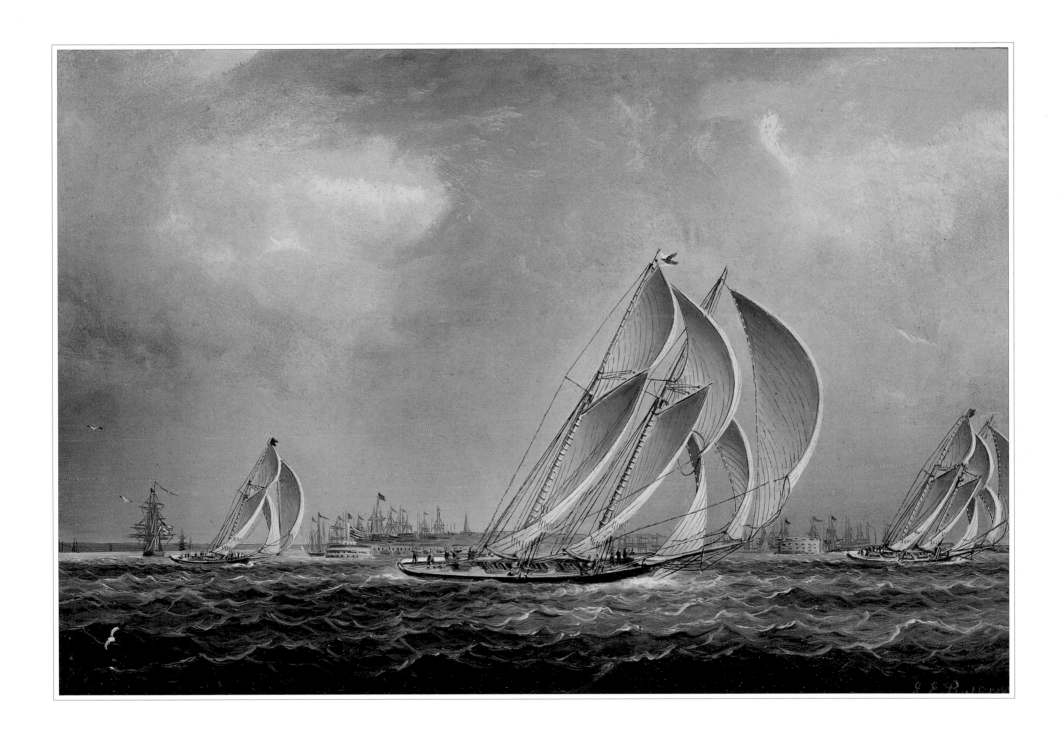

PLATE I.21

Chapman Dock and Old Brooklyn Navy Yard, East River, New York
James E. Buttersworth (1817–1894)
Ca. 1870
Oil on panel
7¾" x 18"
Signed "J. E. Buttersworth" (lower right)

IN 1781 THE THREE JACKSON BROTHERS, John, Samuel, and Treadwell, bought a large tract of land in northeast Brooklyn and started what would become the Brooklyn Navy Yard. In 1798, the yard built the first U.S. government-financed vessel, the frigate *Adams*, and by the War of 1812 it had fitted out and supplied more than 100 ships. During the Civil War, the Brooklyn Navy Yard outfitted 416 ships for wartime purposes. By war's end, 6,000 men worked at the yard, which boasted an annual payroll of $4,000,000.

Buttersworth would have been acutely aware of the significance of the yard, which features prominently in this brilliantly realized small painting of a Brooklyn Yacht Club cruising sloop reaching down the East River on a brisk day. Yet Rudolph Schaefer, commenting on a slightly larger painting on the same theme, noted that views by Buttersworth of Chapman Dock and the Navy Yard were as rare as his views of scenes in other parts of New York Harbor were common.

The ship-of-the-line visible behind the yacht's jib figure is shown in the same location in the view of the Navy Yard described in Schaefer's *J. E. Buttersworth*, p. 127. With the advent of John Ericcson's *Monitor*, which had been constructed at the yard, the days of fighting sail were winding down. Few could have understood this better than James E. Buttersworth.

Llewellyn Howland III
Betty Krulik
Karl Gabosh

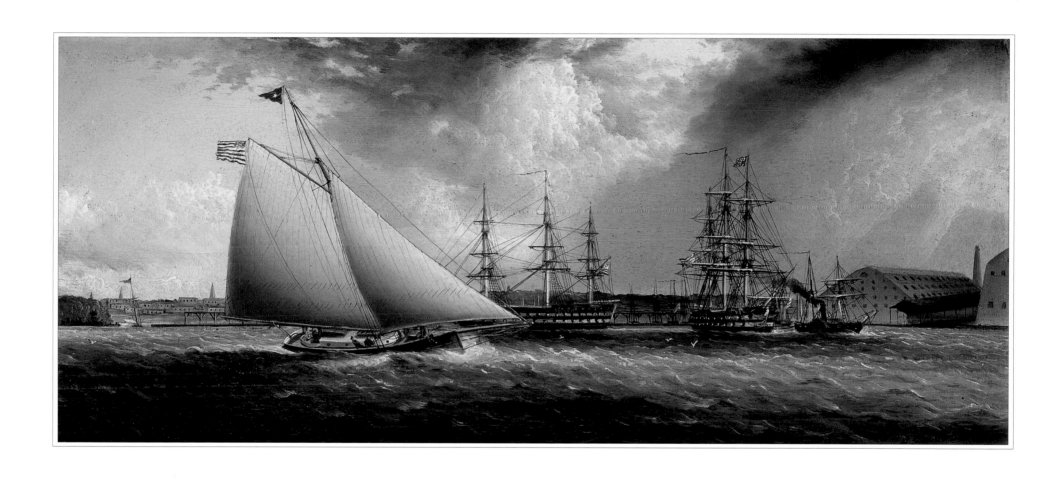

PLATE I.22

The Early Racers
Frederic Schiller Cozzens (1846–1928)
1884
Color lithograph
13¾" x 21½"
Signed and dated on stone "Fred S. Cozzens 84" (lower left)

LIEUTENANT J. D. JERROLD KELLEY paid homage to the early history of the New York Yacht Club in his account of *The Early Racers*:

> American yachting dates from the organization of the New York Club, on the 30th of July, 1844, aboard the *Gimcrack*. To recall the history of this club is to tell the story of the sport in this country. From the earliest days it had upon its list famous vessels, even in the beginning of the fifties there being such crack racers as the *Cornelia, Sylvia, Maria, Lancet, Siren, Cygnet, Spray, La Coquille, Dream, Una, Cornelia,* and *America*. What memories clustered about the *America*, both for her victories and for the revolution she caused in ship-construction. It was her success which gave to yachting the greatest impetus it has ever known, and even yet she is the most famous yacht in the world, and the winner of victories, the remembrance of which still fires the American heart.[1]

In a composition reminiscent of J. E. Buttersworth's painting of *America* and *Maria* (Plate I.1) and the Currier lithograph based on Buttersworth's original (Plate I.2), both of which show the vessels in full profile, Cozzens presents the two famous racers with *America* featured in profile at center (she was originally painted white but was repainted to her characteristic black in 1851) and *Maria* in the background at left. *America*, a schooner designed by George Steers along the lines of New York Harbor pilot boats, had a narrow 23-foot beam, a draft of 11 feet, a distinguished concave bow, with her masts raked sharply aft. *Maria* was a shallow centerboard sloop with 7,800 square feet of sail (2,500 more than *America*), a 95-foot main boom, and required a crew of fifty-five men (five just to work her 12-foot tiller). She was a thoroughbred racer, extremely fragile, but usually victorious when she did manage to finish.

The two formidable vessels competed in a trial match in New York Harbor that *Maria* won handily before the more seaworthy *America* made the trip across the Atlantic to Cowes where she challenged for the One Hundred Guinea Cup in 1851. In characteristic fashion, Cozzens shows the racers on a breezy day with dark, choppy waters and wafting clouds. He replaces the small rowboat in Buttersworth's foreground with a markboat flying the American flag at the extreme left, and adds the outline of two vessels in the far distance at right. His painting presents a less idealized, more blustery setting for the racers than Buttersworth's original, but perhaps with less sense of the enormous sculptural stretch and driving power of *Maria* and *America*'s sails.

Ben Simons

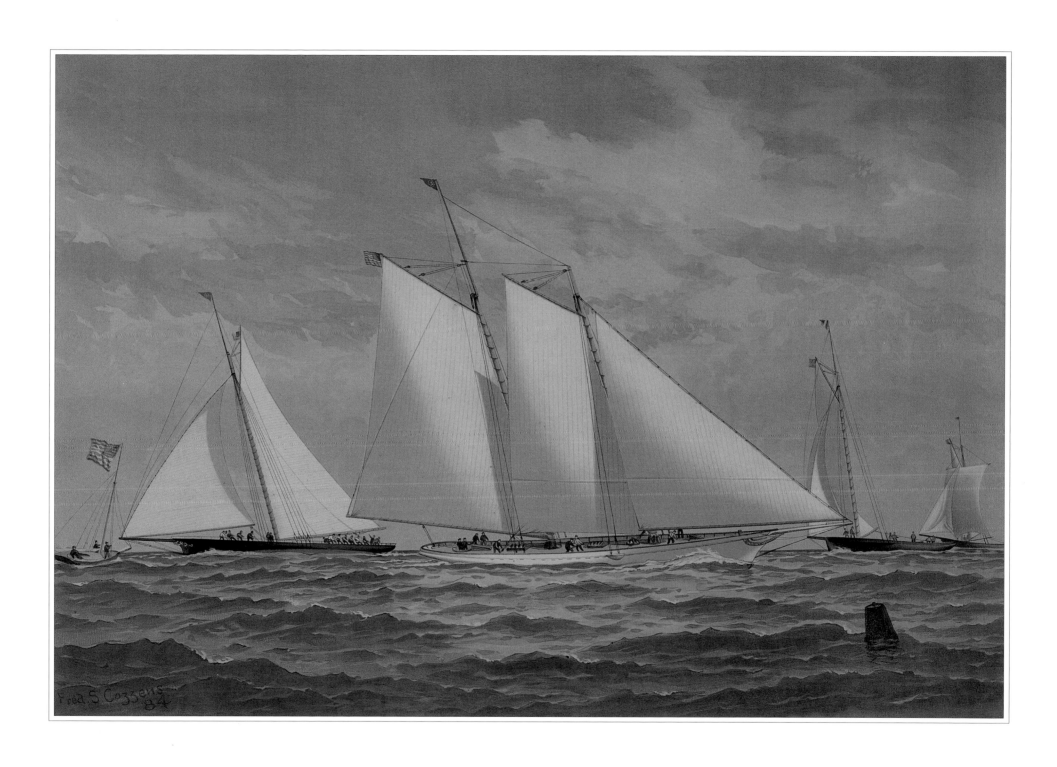

PLATE I.23

The Finish off Staten Island—1870
Frederic Schiller Cozzens (1846–1928)
1884
Color lithograph
14" x 20"
Signed and dated on stone "Fred S. Cozzens/84" (lower left)

IN THE FIRST DEFENSE of the America's Cup in 1870, James Ashbury presented the 108-foot schooner *Cambria* (right of the tugboat in the background) against a field of twenty-two American racers, thirteen of which finished the race, with *Magic* (center) in first place, 42 minutes ahead of the challenger on corrected time (*Cambria* finished tenth overall). Previous to her departure for American waters, *Cambria* had lost to the 135-foot *Sappho* in three consecutive encounters. One of these races fell by default (the other two were decisive victories), which led the British to protest, and Lieutenant Kelley to reflect on the difficulties of the transatlantic relationship: "[In the default race, the British lodged] that same old protest which American sportsmen have learned to expect as a probable result of competition with our kin across the sea. For we are never credited with winning on our merits. In every form where American pluck or enterprise takes up a foreign challenge, the victory is decried as the result of what they call 'Yankee cuteness.' And they are always intending to give us such a thrashing."[1]

Cambria defeated another 1870 Cup competitor, the centerboard schooner *Dauntless*, in a closely run ocean race from Daunts Rock, Cork Harbour, Ireland, to Sandy Hook Lightship on July 4, 1870. Public interest during the Cup defense swirled around *Cambria, Dauntless,* and the other famous vessel to compete, *America,* which everyone hoped would repeat her performance at Cowes in 1851. In the event, *Magic* crossed the finish line first, with *Dauntless* (third to the left of *Magic*) in second place, *Idler* (left of *Magic*) in third place, and *America* (second to the left of *Magic*) in an honorable fourth place. Cheers erupted when *Magic* crossed the line first, securing the Cup with "a glorious victory," but when *America* came across the line the crowd let fly an even "greater paean of joy, for the *America,* fourth in the race, flew by the finish line, showing that as the sons were worthy of the sire, so were the brains and skill of the old greater than the story had told."[2] Cozzens increases the drama of the actual finish-line situation by showing *Cambria* much closer to the leaders than she ever was during the race. In truth she logged only a distant tenth-place finish (eighth overall adjusted to tenth with time allowance).

Ben Simons

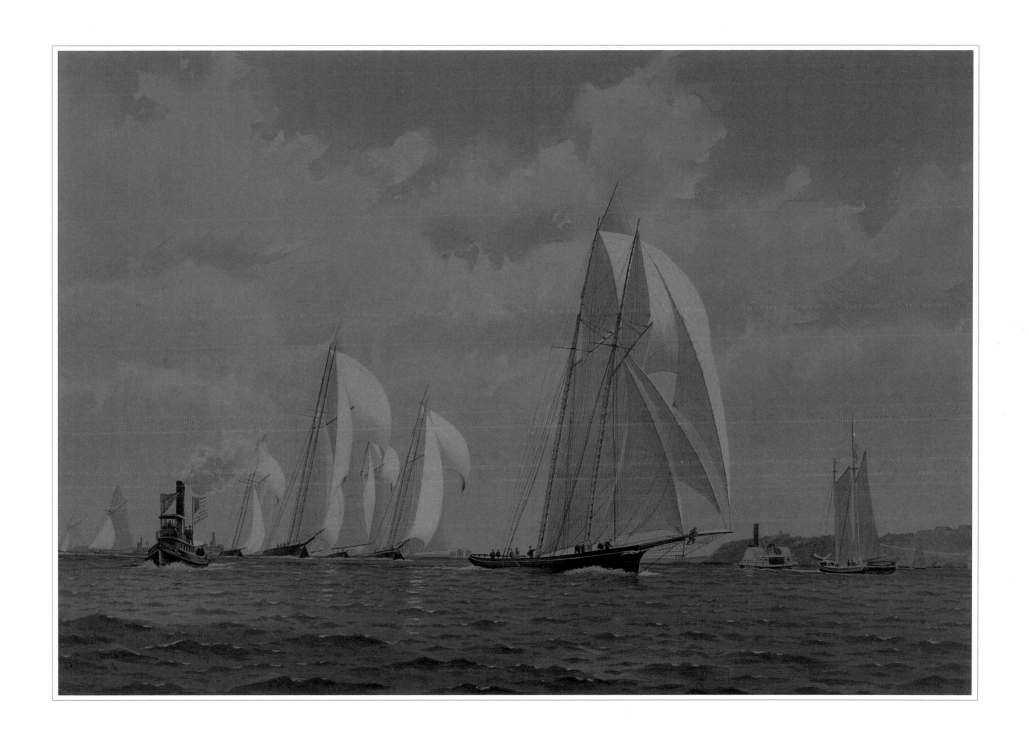

PLATE I.24

A Breezy Day Outside
Frederic Schiller Cozzens (1846–1928)
1883
Watercolor on paper
14" x 19¾"
Signed and dated "Fred S. Cozzens 83" (lower left)

COZZENS SHOWS A RACE between three of the four co-defenders of the 1871 America's Cup against James Ashbury's *Livonia*: the centerboarders *Columbia* (left) and *Palmer* (right), and the keelboat *Sappho* (center). In the first Cup race, sailed on the club's inside course on October 16, 1871, the 108-foot schooner *Columbia*, owned by Franklin Osgood, defeated *Livonia* by 27 minutes 4 seconds on corrected time. On October 18, the same two boats sailed over a course 30 miles to windward of Sandy Hook and return, with *Columbia* once again proving victorious. The wind was light at first, but picked up during the race, with *Livonia* leading nearing the mark. With her big sprit-topsails aloft, she jibed with difficulty around the mark, keeping it on her starboard quarter, but lost speed and ground to windward in the process. *Columbia* cut in between the stern of *Livonia* and the markboat, luffed close around it, and took the lead upwind of her to win the race. Ashbury protested, arguing that *Columbia* had violated the rules by tacking instead of jibing around the mark, demanding that the race be repeated, but the committee rejected his protest. The next day, *Livonia* won the inside race sailed once again against *Columbia*, chosen much to her crew's surprise after rigging failures and other difficulties made *Palmer*, *Dauntless*, and *Sappho* unavailable. *Livonia*'s victory was the first for any challenger.

The 135-foot schooner *Sappho*, modeled by Townsend and built by Poillon Brothers, and altered in 1869 by Robert Fish, won the fourth race by 20 minutes 21 seconds corrected time, and the fifth race by 25 minutes 27 seconds corrected time, leading to an overall victory of 4–1 against *Livonia*. Ashbury protested after both of these races, and showed up on the day after *Sappho*'s second victory for race six. When no defender appeared, he claimed the victory of America's Cup for himself, and left for England grumbling against what he called "unsportsmanlike proceedings." Needless to say, the Cup remained in the possession of the New York Yacht Club.

Palmer was a centerboard schooner built at Philadelphia by T. Bryerly and Sons. Though she never raced in the 1871 defense, she was victorious over a fleet of ten schooners including *Sappho* in two races over the Block Island and Sow and Pigs courses on September 8, 1870, and placed second to *Sappho* in the regatta of the New York Yacht Club at Newport in 1871.

Cozzens portrays the three schooners managing a boisterous breeze, with *Sappho* leading with her outstretched sails washed in a brilliant light, and *Columbia* trailing on her starboard stern quarter with equally expressive sails, while the more subdued profile of *Palmer* is visible at right. The watercolor is an example of what a contemporary called Cozzens's "splendid pictures of billowing canvas and rolling sea."[1]

Ben Simons

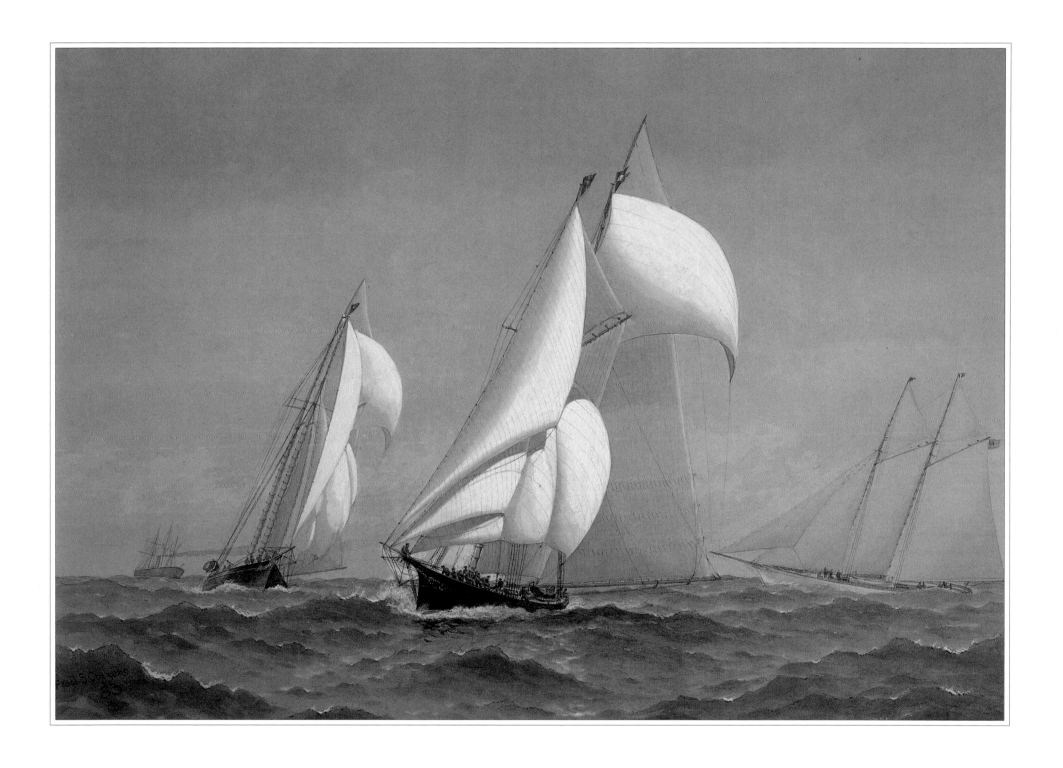

PLATE I.25

Untitled View of Sloop Defender *Leading the British Challenger*
Valkyrie III, *America's Cup, 1895*
Frederic Schiller Cozzens (1846–1928)
1896
Watercolor on paper
14" x 20¼"
Signed and dated "Fred S. Cozzens 96" (lower left)

THE LARGE FLOTILLA OF spectator boats proclaims this to be an America's Cup
race, and the painting's 1896 date and the shape of the leading sloop's bow very
strongly suggest that Fred S. Cozzens is depicting the first race (of three called
for) in September 1895 between the 124-foot Herreshoff-designed *Defender* and
the 118-foot Watson-designed British challenger *Valkyrie III*. The strongest argu-
ment against such an identification is the spectator fleet, which here appears to be
keeping a respectful distance from the contestants. History tells us that at least at
the start of the first and second Cup races of 1895, the fleet was, to the fury of
Valkyrie III's owner, Lord Dunraven, anything but respectful. It was not until the
third race, from which *Valkyrie III* withdrew right after the start, that order pre-
vailed along the course.

Lord Dunraven's decision to withdraw was not his last hostile act in relation to
the *Defender* syndicate or the New York Yacht Club. When he returned to London
that fall he publicly charged that the American sloop had, to quote Herbert L.
Stone, "surreptitiously added ballast after being measured for the series...a most ser-
ious charge, involving our national honor and sportsmanship."[1]

The dimensions of this handsome watercolor and Cozzens's treatment of the
scene would have made it a perfect companion to the twenty-six watercolors (later
augmented by a twenty-seventh) completed by Cozzens a decade earlier that were
reproduced as chromolithographs published in a portfolio in 1884 under the title
American Yachts: Their Clubs and Races. Glen Foster recognized that this portfolio was
among the most important pictorial works ever published on nineteenth-century
American yachting. The Foster Collection contains eleven of the lustrous original
watercolors from which the great chromolithographs were reproduced.

Llewellyn Howland III

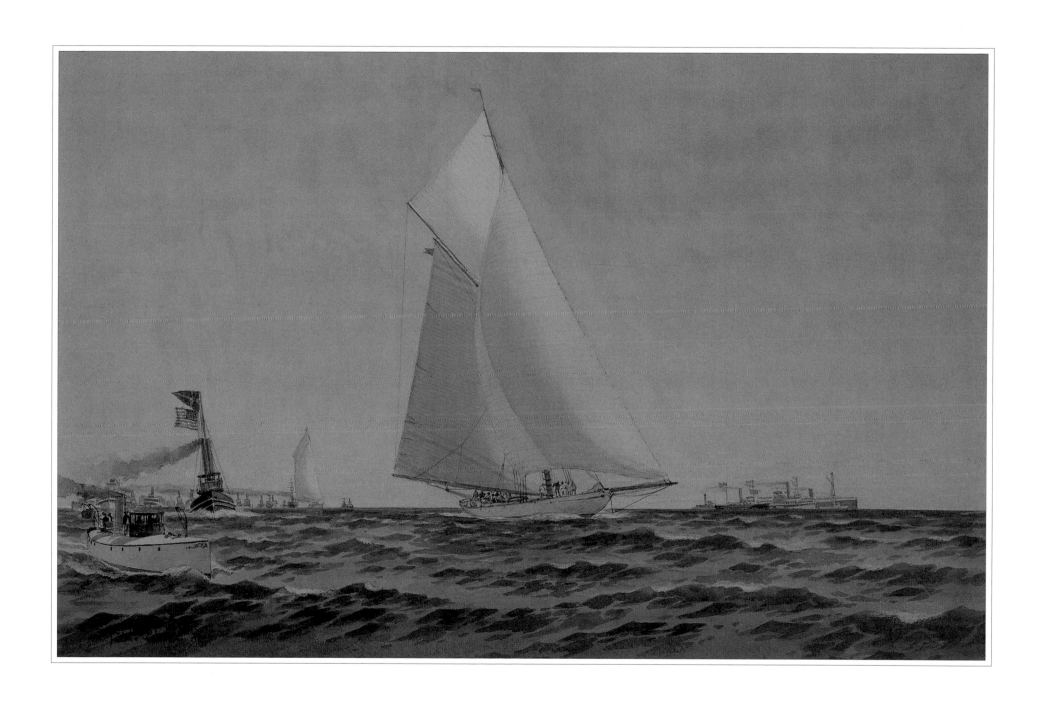

PLATE I.26

Crossing the Line, New York Bay
Frederic Schiller Cozzens (1846–1928)
1883
Watercolor on paper
13¾" x 20¼"
Signed and dated "Fred S. Cozzens 83" (lower left)

THE SCENE OF THIS WATERCOLOR is a finish-line situation in New York Bay with Castle Williams shown in the background at left. Cozzens captures the magnificent projecting pyramid of *Montauk's* sails (center) moving directly into the plane of the composition. Kelley comments on the particular vessels shown:

> Of the boats grouped in the picture, it can only be said that the *Montauk* has proved herself the best schooner in American waters. The *Comet* [right of *Montauk*] probably won more silver in her racing days than any other boat ever sailed in this country. For the past few years she has not been in any races, but if her genial owner again enters her, we may look in her class for a repetition of those unparalleled victories which were made up of equal parts of good boat and unrivaled seamanship. The *Kelpie* [left of *Montauk*] is a sturdy sloop, lately altered into a keel, and under her new rig and construction is sure to prove a good all-around boat. The *Coming* [right of *Comet*] is a boat with an excellent record, and is especially notable for having ridden out a gale under circumstances which are among the strangest and most exciting in yachting history.[1]

Ben Simons

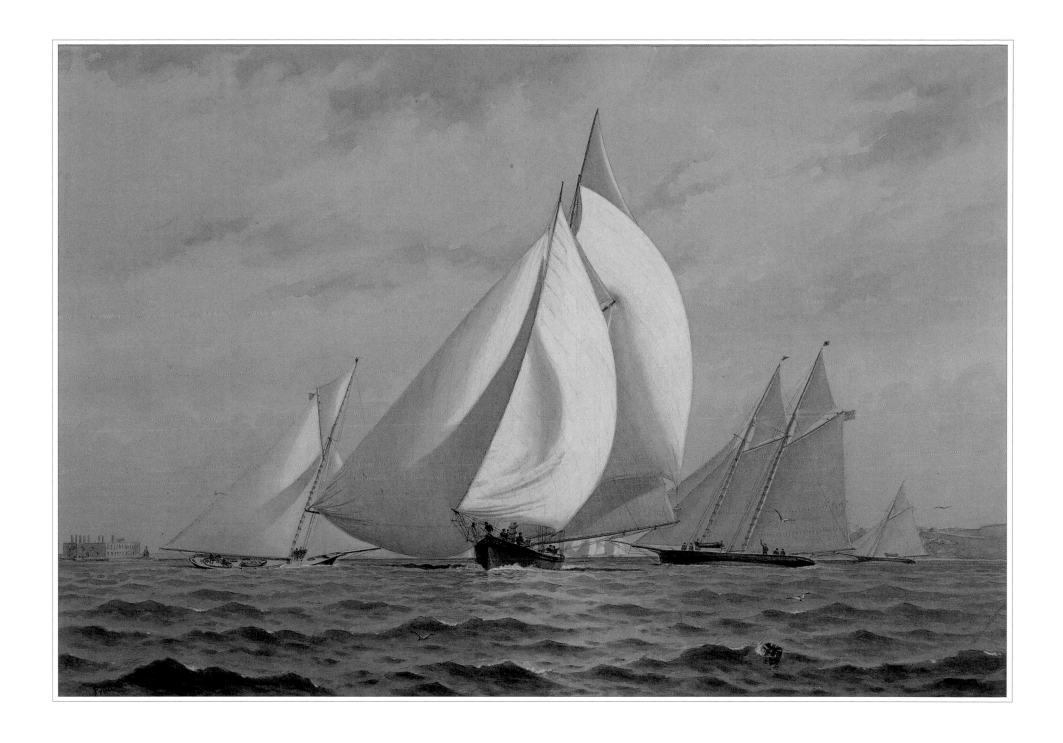

PLATE I.27

By Sou'west Spit
Frederic Schiller Cozzens (1846–1928)
1883
Watercolor on paper
13¾" x 20"
Signed and dated "Fred S. Cozzens 83" (lower left)

THE SEAWANHAKA CORINTHIAN YACHT CLUB was organized in 1871 on the model of the Corinthian Boatmen of Bristol, England. In Corinthian races, helmsmen were required to be amateurs. The Sewanhaka Corinthian Yacht Club was then in New York but later moved to Oyster Bay, Long Island.

Cozzens chooses to depict a full field at the point of the race passing by Buoy No. 10 on the Southwest Spit. The schooner *Clytie*, belonging both to the Seawanhaka Corinthian Yacht Club and the Atlantic Yacht Club of Brooklyn, is shown foremost just left of center with four crew members out on her bowsprit. Other vessels depicted include *Roamer* (right of steamer), *Crocodile* (right of *Roamer*), *Grayling* (right of *Clytie*), and *Fanita* (right of *Grayling*). The Atlantic Yacht Club was organized in 1866 by many of the defecting members of its predecessor club, the Brooklyn Yacht Club. Kelley comments, "While the New York Club is, and probably ever will be, the leading representative of American yachting, yet in the two leading junior organizations, we have both members and yachts that will be ready at all times to enter worthily any contest where the success of our countrymen may be imperilled."[1]

Ben Simons

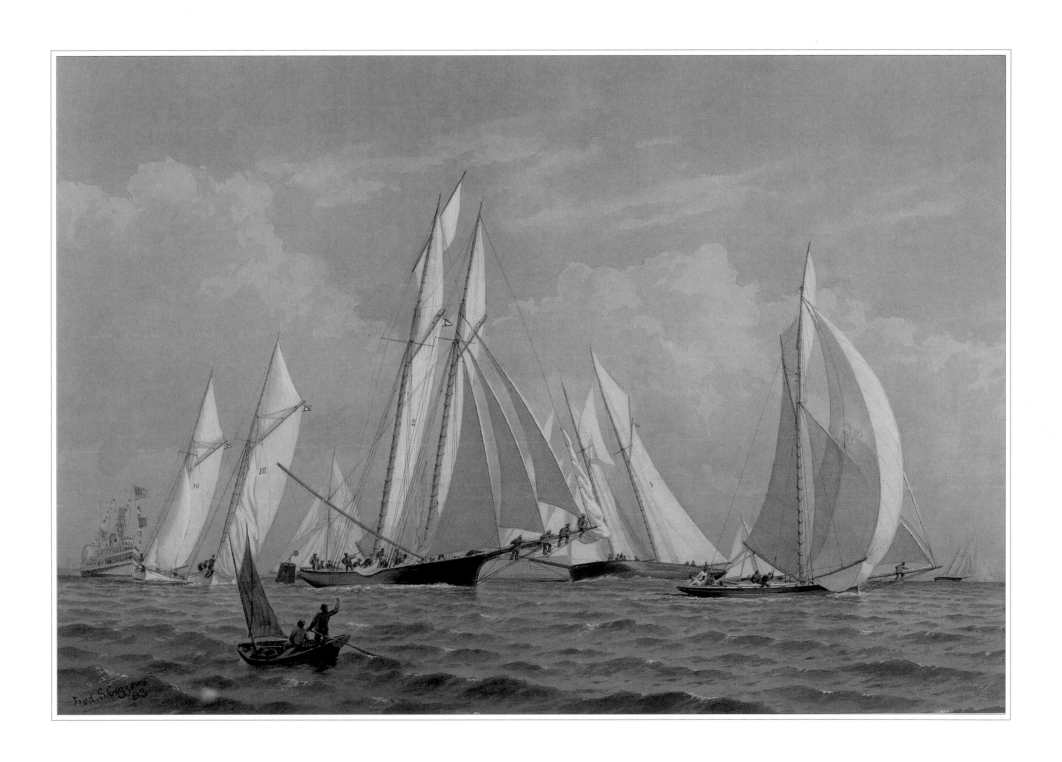

PLATE I.28

A Misty Morning Drifting
Frederic Schiller Cozzens (1846–1928)
1883
Watercolor on paper
13 ¾" x 20"
Signed and dated "Fred S. Cozzens 83" (lower left)

IN AN EXQUISITE SETTING of calm waters and slack sails under still skies, Cozzens displays the full force of his ability to capture the mood of a yachting scene. A sail edge of the vessel *Crusader* (right foreground) hangs lazily into the water, casting a white shadow on the gentle ripples, while the figure of a crew member adjusting a topsail sits nearly motionless high above in the background. To further emphasize the calm, Cozzens provides a note of contrast in the figure of a canoer gliding by the yachts in the right foreground. Lieutenant Kelley waxes poetical:

> There is nothing more trying to the patience of those who go down to the sea in ships and escape business on the mighty waters, than the forced idleness of a calm when hour after hour, often day after day, the changeless minutes crawl, under a hot sun that beats pitilessly, from a sky of gleaming steel, upon a sea which sears like molten lead. Nowhere is there a whisper of wind; nowhere a moving thing save the heaving of the wave or the flight of a thrice-blessed seabird. Even when the twilight is jeweled with the eternal stars, there is no hope in that dusk, cool line of horizon where the sea and heaven join, of breezes that wait somewhere below the verge for tired sails.[1]

Ben Simons

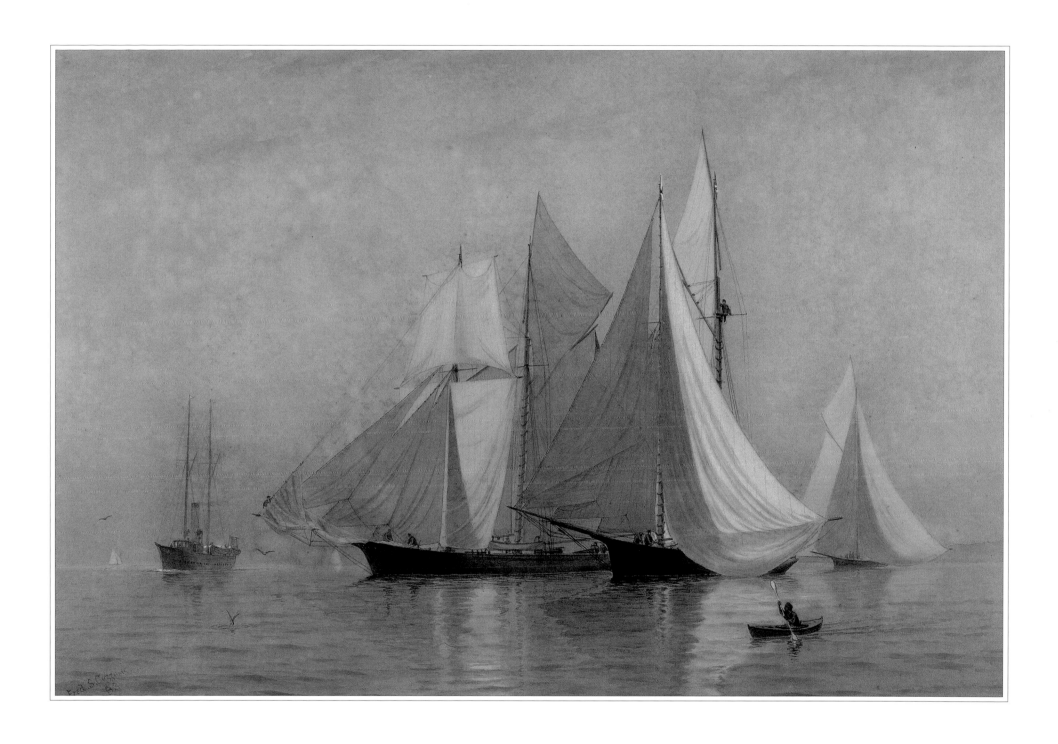

PLATE I.29

Robbins Reef—Sunset
Frederic Schiller Cozzens (1846–1928)
1883
Watercolor on paper
13¾" x 20½"
Signed and dated "Fred S. Cozzens 83" (lower left)

COZZENS SELECTS A glorious late-afternoon sunset aglow in clear pinks and oranges for the setting of this race between *Albertina* (left) and *Lady Emma* (center), two of the type of small, shallow centerboard yachts that became characteristic of New York waters, and a third cutter *Valiant* (right background). The Robbins Reef Lighthouse, visible in the background at left, lies on the northeast corner of Staten Island in the Upper Bay. Lieutenant Kelley remarks upon the nature of the typical American centerboard yacht:

> Our light-draft centre-board yachts, —"jib and mainsail boats," as they are called—are unsurpassed in moderate breezes and smooth water; and whatever theorists may say, we will always build them. But they would be useless upon such a coast as that of England,—off Brighton, for example—where there are no sheltered anchorages and vessels must be hauled up on the beach. The same conditions obtain on all seaboards...each locality produces the boat best suited to its necessities, though the types may differ as radically as do the English racing 40-tonners from the sharpies of the Connecticut shore, or the sneak-boats of Barnegat.
>
> Our yachting may be defined as smooth-water sailing, for nowhere in the world is there that combination of land and sea which is needed for this special work, as in the waters surrounding Long Island.[1]

Ben Simons

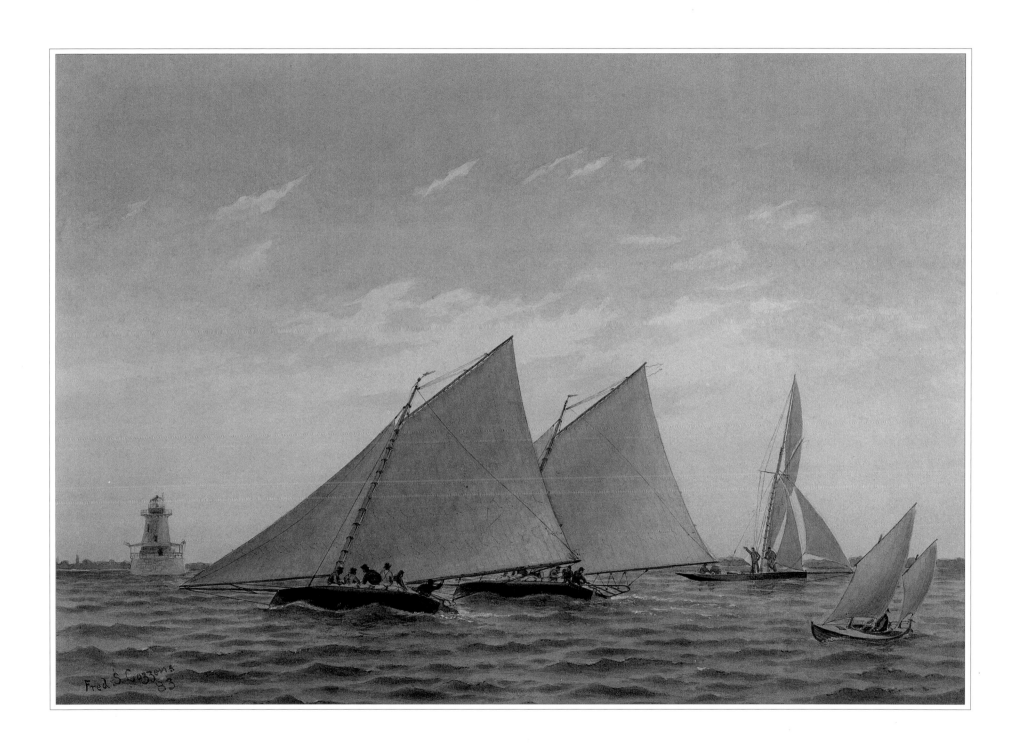

PLATE I.30

In the Narrows—a Black Squall
Frederic Schiller Cozzens (1846–1928)
1883
Watercolor on paper
13¾" x 20"
Signed and dated "Fred S. Cozzens 83" (lower left)

IN THIS DRAMATIC SCENE, Cozzens depicts the aftermath of a sudden squall during a New York Yacht Club regatta on June 15, 1877. The vivid portrayal of the scene suggests that Cozzens may have witnessed it firsthand. The keel schooners *Wanderer* (right) and *Rambler* (center), the second-class sloop *Active* (left background), and the catboat *Dora* (foreground) appear strewn across the sea in various states of distress. Lieutenant Kelley describes the scene:

> Both [*Wanderer* and *Rambler*] had every stitch of canvas set, the former leading; and though from their crowded decks not a word came, yet by every sheet and halliard and down-haul men were stationed, for in a moment the race would be ended, and the squall had almost reached them.
>
> For an instant there was a flash of vivid, lurid brightness, followed by a moment of intense silence and then, with a roar and a bellow, the bursting squall struck them both.... The *Wanderer* reeled as if hurt to death, her bulwarks going under and the water flooding her breast high in the gangways; but down rattled the flashing sails, and righting defiantly, she stood there, quivering, palpitating, and daring the fury of the storm, a perfect sea picture. The *Rambler*, behind her, heeled over until half her deck was submerged, and then with a whip and a snap her flying jib-boom went by the board, while off to leeward, like the wounded wing of a seabird, flamed in the darkness the huge main-topmast staysail of the *Wanderer*.[1]

Ben Simons

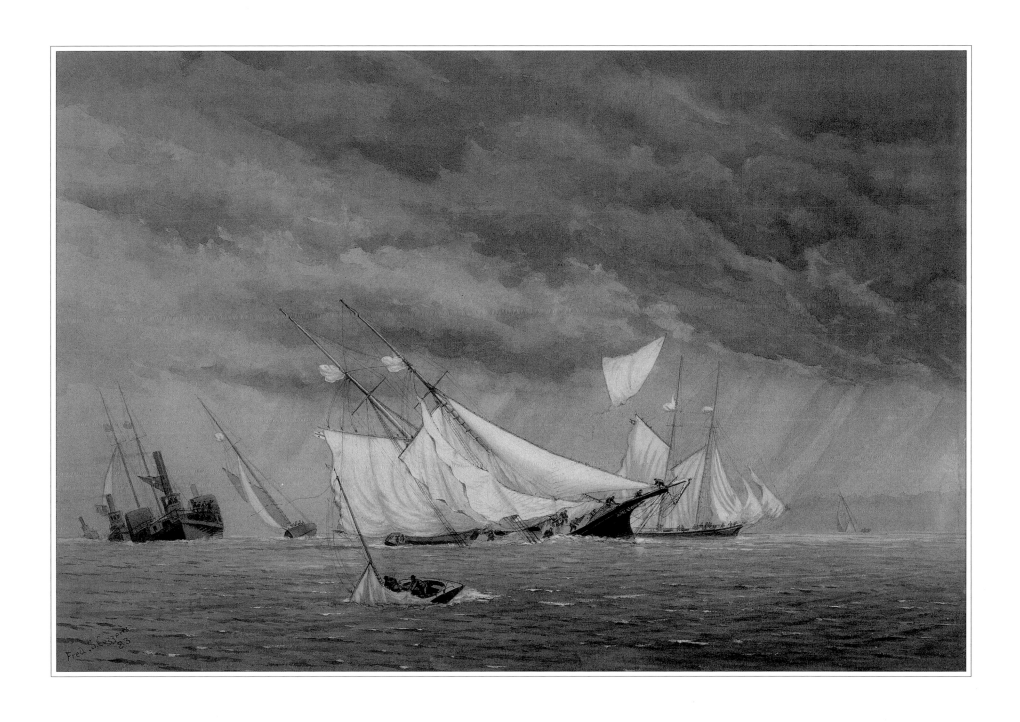

PLATE I.31

Ice Boating on the Hudson
Frederic Schiller Cozzens (1846–1928)
1884
Watercolor on paper
14" x 20"
Signed and dated "Fred S. Cozzens 84" (lower left)

IN A WATERCOLOR REMINISCENT OF his series *Ice Yachts* now hanging at the 44th Street clubhouse of the New York Yacht Club, Cozzens presents a charming winter scene of iceboats competing on the frozen surface of the Hudson. The central boat leaning high up on one of its runners is the ice yacht *Icicle*, while in the far right background appears *Echo*, the only surviving yacht from the *American Yachts* series. Iceboats attained speeds from sixty-five to seventy miles an hour, were occasionally subject to capsizing, and handled very differently than a regular yacht. Lieutenant Kelley describes the process:

> The sailing of an ice-boat is so totally different from that of the ordinary water craft, that the tarriest of tars would be a double lubber on board, because of the ideas he has to unlearn before he "can be in anything" but nobody's watch and everybody's way. The mainsail is nearly always trimmed flat aft, the sheets being hauled taut and well in, unless a beam wind is so strong as to make the yacht slop sideways, or "rear." The boat is anchored under sail, or hove-to would be better, by shoving her head quickly into the wind, lifting the jib-sheet and jamming the rudder across the stern. To get under way, or to fill away, the sheet is flattened aft, and the stern swung around until the sails fill, and then, if any one of the crew is not aboard, he will be permitted to console himself in a very few seconds with an enlivening view of the winter landscape, while his late shipmates are accentuating the distance as more or less agile dots upon the back of a diminishing spider. The boat minds its helm perfectly, and of necessity; for the great speed demands quick control, and the presence of dangers due to bad ice, hummock, and cracks, make it vital, of all things, that the yachtsman who steers should have a head cooler than the ice he sails on.[1]

Ben Simons

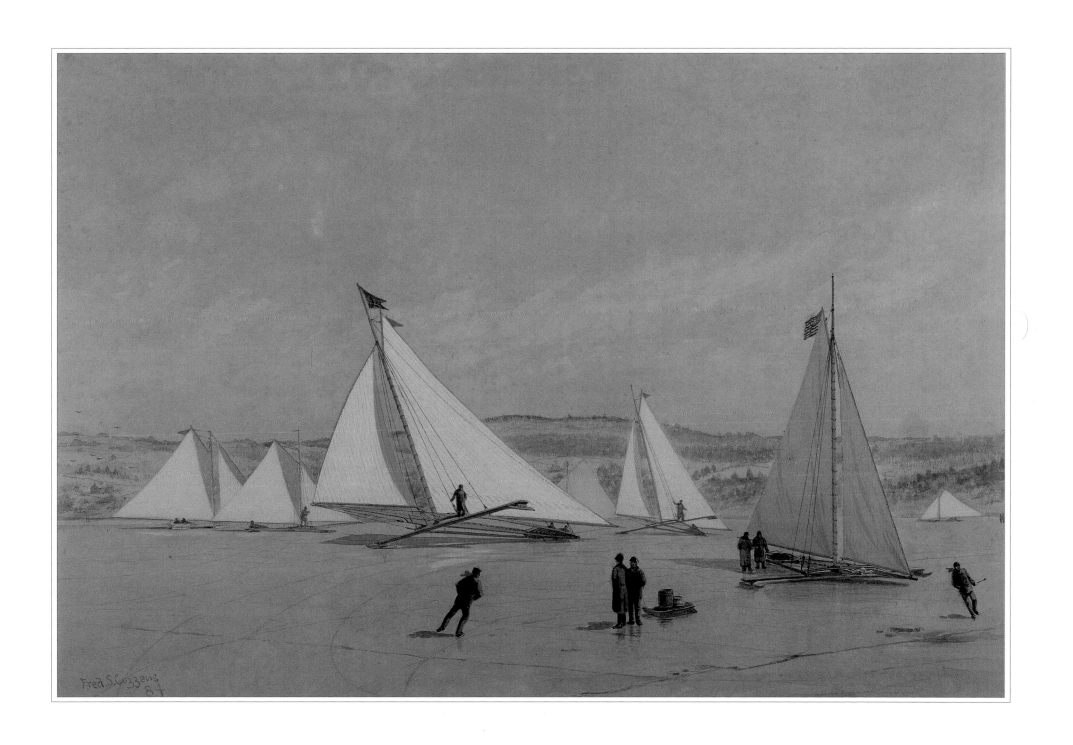

PLATE I.32

Moonlight on Nantucket Shoals
Frederic Schiller Cozzens (1846–1928)
1883
Watercolor on paper
14" x 20¼"
Signed and dated "Fred S. Cozzens 83" (lower left)

IN A BEWITCHING MOONLIT SETTING, Cozzens portrays the steamer yachts *Ibis* (left background) and *Tidal Wave* (right of *Ibis*), the schooners *Estelle* (center) and *Aeolus* (right of *Estelle*), and the sloop *Sagita* (right background) floating over the dark blue waters of Nantucket Shoals, which Kelley describes as "that large extent of sand-banks and rips which extend to the eastward and southeastward of Nantucket Island; they are feared by the coaster who leaves the pleasant waters of the Sound for the boisterous open."[1] The yachts' sails form jagged silhouettes against the evening sky, while silvery moonlight plays upon the waters below.

Lieutenant Kelley imagines the effects of such a night:

If it be a night of breezes, brave with the sonorous chant of wave, the long vista of moonlight trembles upon the wind-blown waters; at times the silver flood is broken with rippling waves of shadow, which gleam like banners against a field of blue; but always in the shimmering pools beyond, as far as eye may reach, the flooding waters spread with an unmarred sheen of light, until the sea and sky are merged in one.[2]

Ben Simons

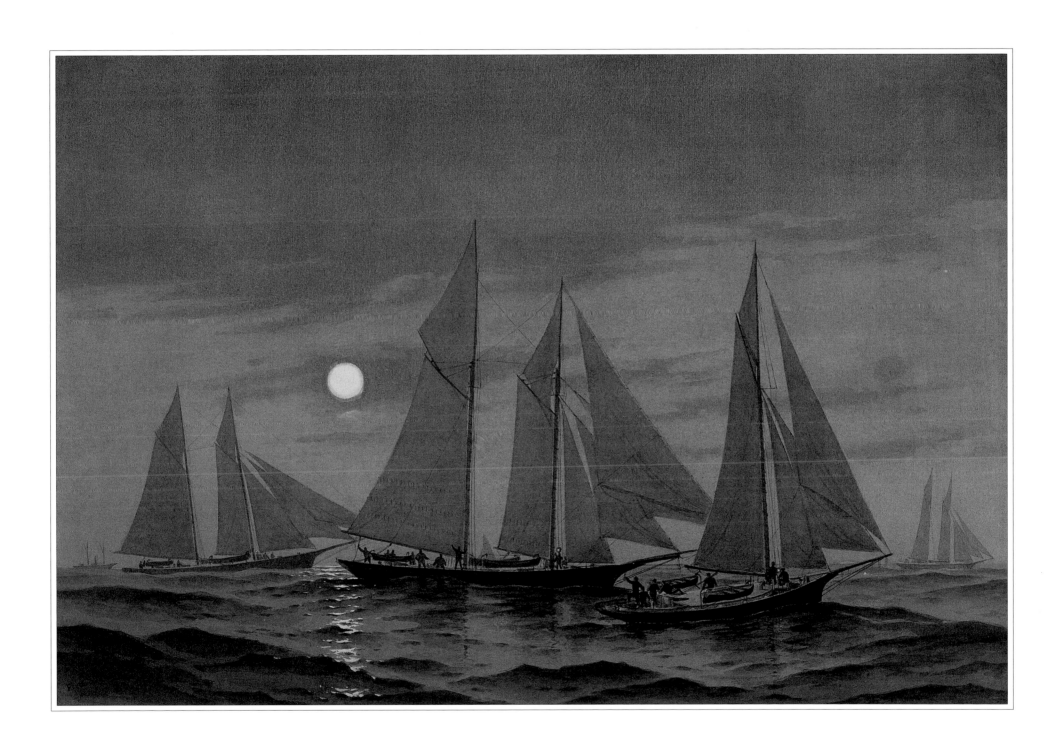

PLATE I.33

Off Brenton's Reef
Frederic Schiller Cozzens (1846–1928)
1883
Watercolor on paper
14" x 20¼"
Signed and dated "Fred S. Cozzens 83" (lower left)

THIS WATERCOLOR SHOWCASES several yachts of the cutter type racing off Brenton's Reef with the Brenton Reef Lightship visible in background at right. As the century progressed, cutter design grew increasingly radical in the pursuit of speed, and the "knife-edges" of top racing cutters resulted into the "extreme cutter" style. In 1883, the cutter *Wenonah* (center left) won four of the five competitions she entered. Vessels were prohibited from receiving American registry if built in England, the home of the cutter style. *Wenonah* was registered as an American yacht but was built by Piepgrass on the design of Harvey and Prior of London, with sails made by Lapthorne, and was sailed by an English crew with an English master. She is 72 feet overall length, 60 feet on the water, 14 feet on the beam, with a draft of 10.6 feet.

The two other vessels pictured are the cutter *Oriva* (right), "which has done well since her second year," and the cutter *Ileen* (left), "which is the most extreme cutter yet built in the country."[1]

Ben Simons

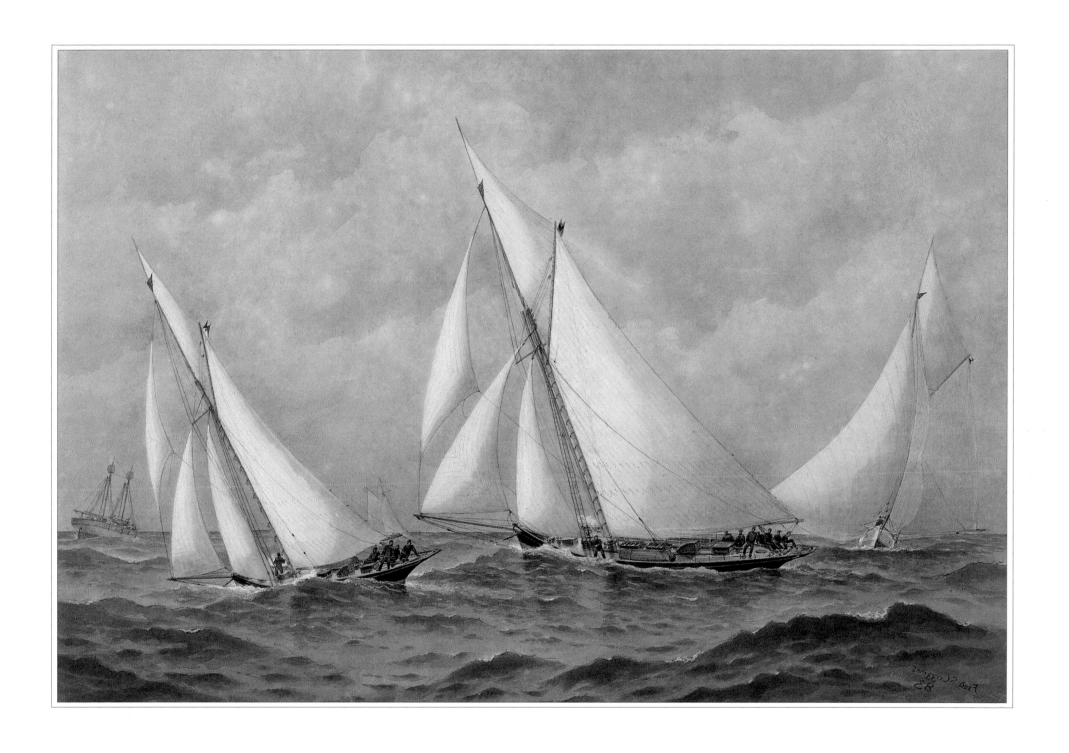

PLATE I.34

Before the Wind—Newport
Frederic Schiller Cozzens (1846–1928)
1883
Watercolor on paper
13½" x 20"
Signed and dated "Fred S. Cozzens 83" (lower left)

COZZENS PRESENTS A CONTEST between the centerboard sloops *Vixen* (left), *Arrow* (center), the keel cutter *Maggie* (right background), and the trailing keel schooner *Social* (late *Cornelia*, far left background) under a clear sky and strong winds off Newport, Rhode Island. The 37-ton "medium sloop" *Vixen* was a strong performer in New York Yacht Club regattas from the 1870s to 1880s. In her victory over the English-designed cutter *Maggie*, Lieutenant Kelley says, "It was claimed that the triumph of the American sloop was complete; that the relative value of the types was definitely settled, and that nothing more was left to advocates of deep boats but that monastery where, meditating upon their sins, they might pass their days in melancholy grave-digging, and in a cheerful exchange of information, which began and ended with the aphorism, 'Brother, the cutter must die!'"[1]

In addition to emphasizing the dazzling set of the leading sloops' sails, Cozzens gives prominent place in the composition to the James Brown Herreshoff-designed composite-screw steamer *Permelia* (late *One Hundred*, right). Herreshoff became completely blind at fifteen years of age, but went on to a legendary career of yacht design, establishing his plant at the former Burnside Rifle Factory at Bristol, Rhode Island, in 1864. By 1870, the year in which he launched his first steamer, he had designed and produced some 1,500 boats, many with the light machine-manufactured duplicate parts for which he became famous. By 1873 his design interest was drawn to the coil generator technology first invented by the French, which he used in the design of the steamer-yacht *Permelia*.

Ben Simons

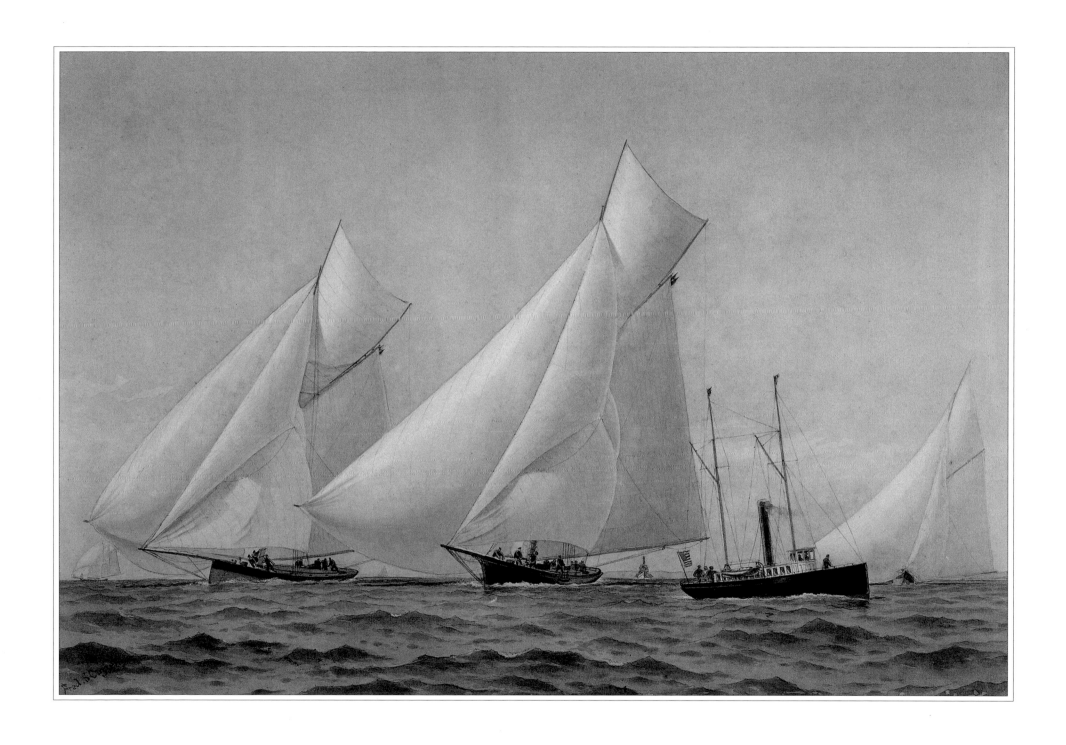

Plate I.35

Around the Cape—Marblehead
Frederic Schiller Cozzens (1846–1928)
1884
Color lithograph
14" x 20"
Signed and dated on stone "Fred S. Cozzens 84" (lower left)

COZZENS SHOWS A CROWDED FIELD approaching the mark in a race in waters off Marblehead. Lieutenant Kelley describes the setting and the vessels:

> Of the fifteen regularly organized yacht clubs cruising and racing in the waters to the northward of Cape Cod, the majority hail from ports upon Massachusetts Bay—that second division of the Great Eastern Gulf which extends from Cape Ann on the north to Cape Cod on the south, or over a distance of forty miles in a straight line, from Light to Light...here; for years and years, has been the nursery where sailors were taught the difficulties and dangers of their calling.... Midway between Boston and Cape Ann Lights, Salem Bay opens into the land, with an entrance four miles wide, between Gale Head and Marblehead; and on the shore line of this deep, irregular indentation, are the towns of Manchester, Beverly, Salem, and Marblehead.[1]
>
> No keel-schooner which has appeared within the last two years, has given greater promise of speed and capacity than the *Gitana* [center], which was built at East Boston, by Lawlor, for William F. Weld, Esq. [*Adrienne* is shown left of *Gitana*.] The *Shadow* [right foreground] is a crack centre-board sloop, built by the Herreshoffs thirteen years since [1871], every one of which had upon its roll the record of some notable victory won by her. The *Fearless* [second from left] is one of the old-time centre-board schooners, built down Bath way in 1870, and with a most creditable history in American yachting; while the *Fannie Herreshoff* [far right], a catboat, and the *Hera* [far left], a keel-sloop, represent the antithesis of purely American yachting. The *Mona* [third from right] is a cutter which is not far from being five lengths to one beam, and though a narrow, deep boat, of the proportions scornfully derided as knife-edged, by the keen partisans of the skimming-dish, yet she knocks all about our coast, manned by a crew so small, and yet so contented, that it is high jinks to watch her owner, captain, mate, and one-third of all hands rolled into one, as he recites her virtues.[2]

Ben Simons

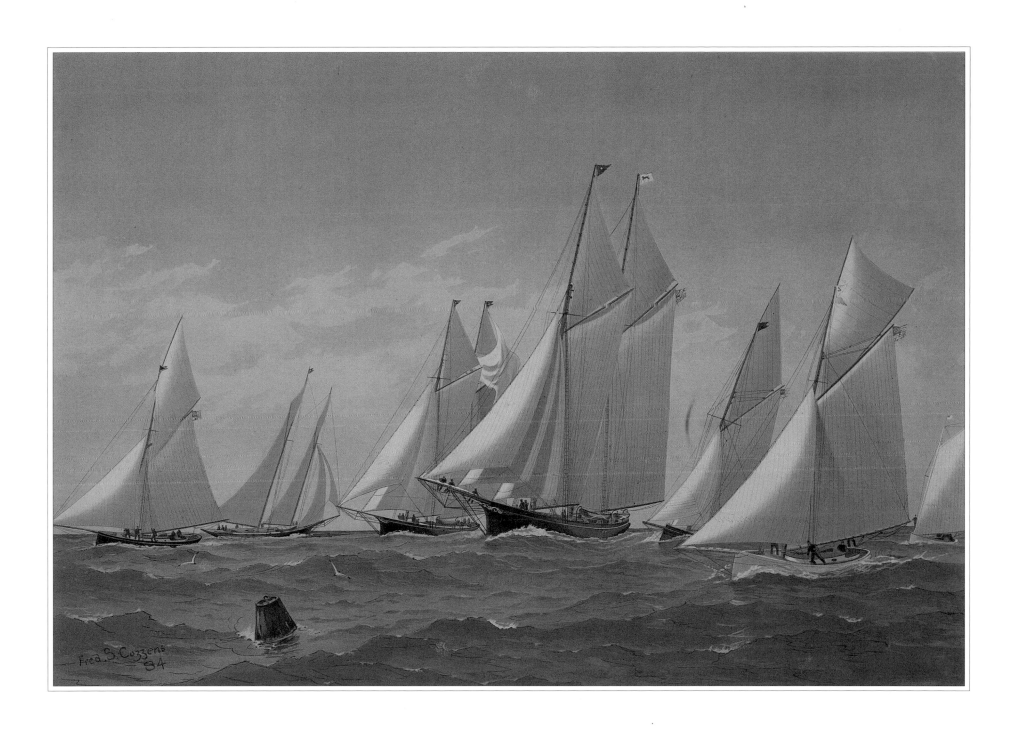

PLATE I.36

The Yacht Maria *216 Tons*
Charles Parsons (1821–1910), delineator
Nathaniel Currier (1813–1888), lithographer
1861
Lithograph in color
20¼" x 28¾"
Inscribed "Modelled by R. L. Stevens Esq. Built by Mr. Capes 1844 and owned by Messrs. J. C., R. L., & E. A. Stevens, of Hoboken, N.J."

PERHAPS BEST REMEMBERED as the big sloop that regularly beat the schooner *America* in the 1851 Cup trials, *Maria* was subsequently re-rigged as a schooner in 1861. She became the flagship of the New York Yacht Club in 1859, under the ownership of E. A. Stevens. Stevens continued as commodore, with *Maria* as the flagship, until 1865.

The 70-foot sloop *Irene*, built in 1852, is off *Maria's* port quarter, but there is no indication that the two boats are racing. At least rigged as a sloop, *Maria* carried upwards of 50 men for racing.

It is notable that *Maria* continues to carry horizontal-cut (W. P. Stephens called them "cross-cut") lowers in an era when sails with vertical cloths running parallel with the leech were standard on fore-and-aft-rigged yachts.

Llewellyn Howland III

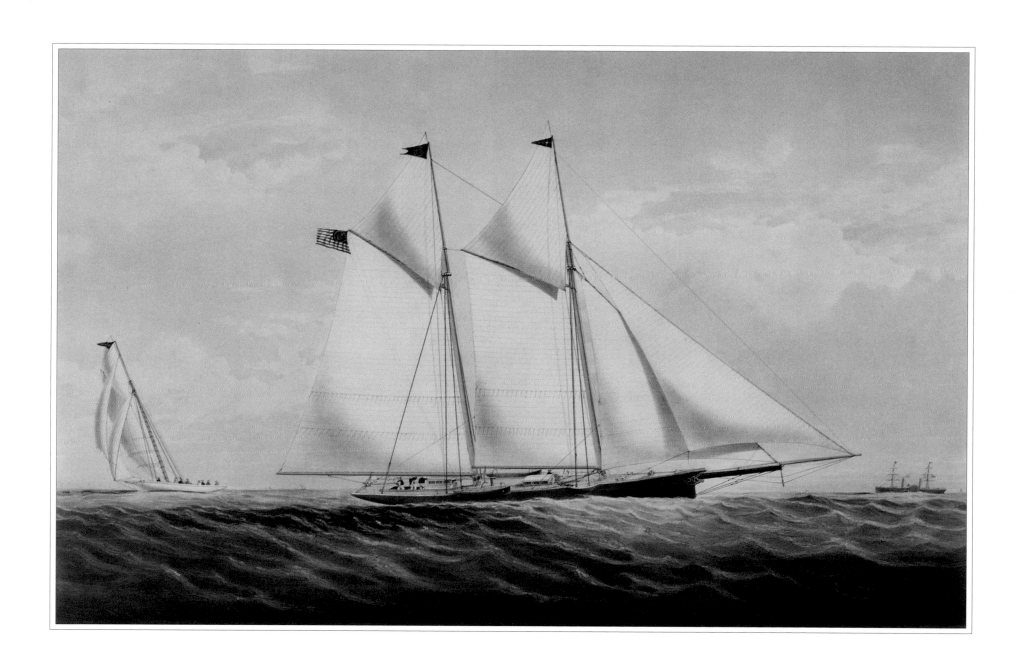

PLATE I.37

Regatta of the New York Yacht Club, June 1, 1854. The Start
Charles Parsons (1821–1910), delineator
Nathaniel Currier (1813–1888), lithographer
1854
Lithograph with color added
20¼" x 28½"
Signed on stone "J. E. Buttersworth" (lower right)

ACCORDING TO JOHN PARKINSON, Jr., some thirteen yachts showed up at the start on the first day of the New York Yacht Club's annual regatta on June 1, 1854.[1] But if we are to believe the artist, there were actually fourteen: *Prima Donna, Ceres, L'Esperance, Mystery, Alpha, Sibyl, Ray, Spray, Irene, Twilight, Una, Haze, Cornelia,* and *Gertrude.* The sloops *Una, Ray* (owned by T. M. Ray), and *L'Esperance* were winners in the three classes on that first day. On the second day, only two yachts finished before the wind completely died: W. Butler Duncan's big schooner *Haze,* and, in the second class, the 48-ton sloop *Irene.*

The private signals of the various yachts are wonderfully easy to identify in this lithograph. James Buttersworth was not always at such pains to make them so.

Llewellyn Howland III

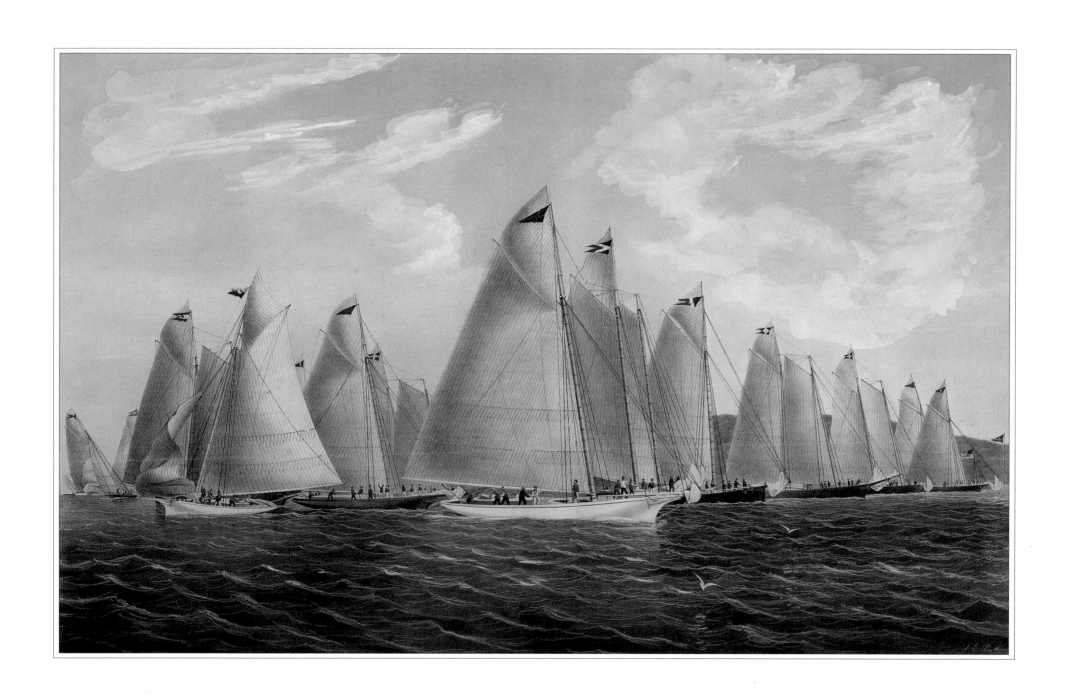

PLATE I.38

*Regatta of the New York Yacht Club, June 1st, 1854. Coming in;
Rounding the Stake Boat*
Charles Parsons (1821–1910), delineator
Nathaniel Currier (1813–1888), lithographer
1854
Lithograph in black and white with color added
19¾" x 28¾"

FUELED IN PART BY *AMERICA*'S VICTORY at Cowes three years earlier, the New York Yacht Club and its fleet grew rapidly in the 1850s, adding forty-two members in the spring of 1854 alone. Some of the new members and their yachts were presumably among the thirteen (or fourteen, counting sloop *Maria*, which was not a formal entrant) shown in this lithograph heading for the stake boat on the first day of their annual regatta. *Una* is the black sloop rounding the mark in first place (and indeed she won the large-sloop class). Close behind are *Ray* (which won *her* class), *Irene*, *Maria* (shown hardening up to get out of the way of the racers), *Haze*, *Twilight*, *Esperance* (winner in the third class), and a barely visible *Alpha*.

The club had voted that spring to remove all restrictions of the carrying of racing sails. At least three of the boats in this race have square-rigged reaching sails; most or all carry club topsails and ballooners.

Llewellyn Howland III

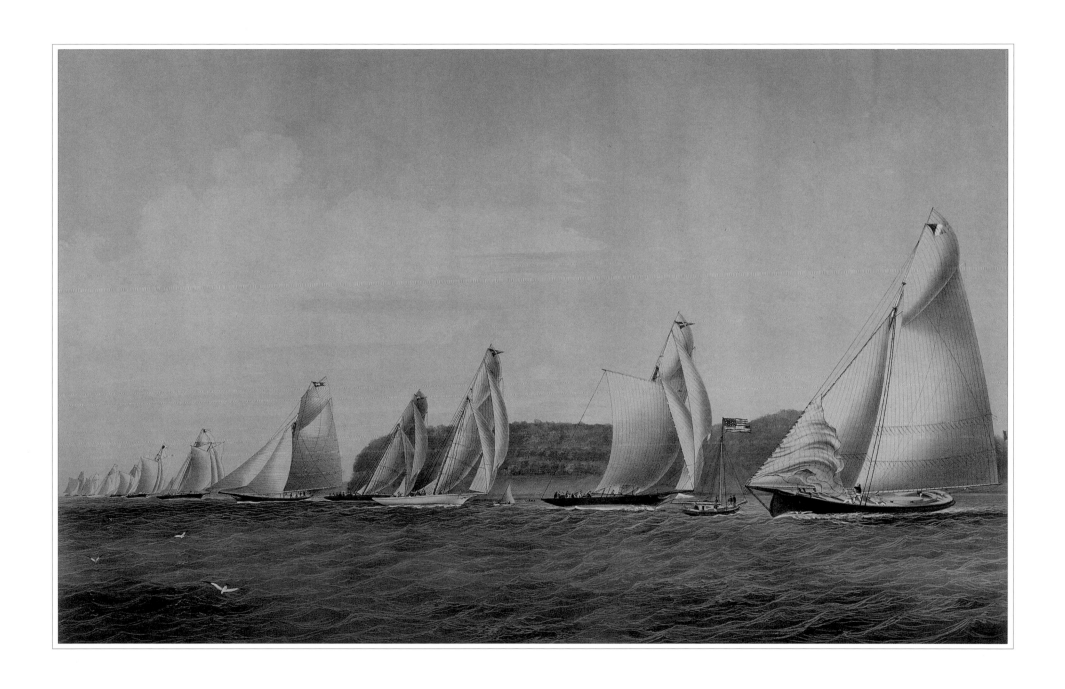

PLATE I.39

Regatta of the New York Yacht Club, "Rounding S. W. Spit"
Charles Parsons (1821–1910), delineator
Nathaniel Currier (1813–1888) and James Merritt Ives (1824–1895), lithographers
1854
Lithograph in black and white with color added
14¾" x 28"
Signed on stone "J. E. Buttersworth" (lower right)

ON THIS FIRST DAY OF THE club's annual regatta, June 1, 1854, thirteen boats contended for honors in three classes, with the big sloop *Maria* sailing over the course, but not actually racing. At the turn at Southwest Spit, the eponymous *Ray* (owned by T. M. Ray) is the first boat around, followed by *Una* (Lewis M. Rutherford), *Alpha, Irene, Ceres, Sibyl, Haze,* and *Maria.* Because of a wind shift, the second leg of the course was downwind as this leg had been. By the time it was over, *Una* had finished before *Ray,* and *Alpha* was bringing up the rear.

In this lithograph, *Una* has just jibed, and her crew is working hard to trim her headsails. One of the older sloops in the New York Yacht Club fleet, *Una* was designed and built in 1847 by George Steers, designer of the schooner yacht *America.* She was 60 feet LOA had a beam of 17 feet 8 inches, and drew 6 feet 6 inches. She was still competitive and winning races twenty-five years later. Lengthened, rebuilt, altered, *Una* was in commission in 1945, rigged as a schooner.

Llewellyn Howland III

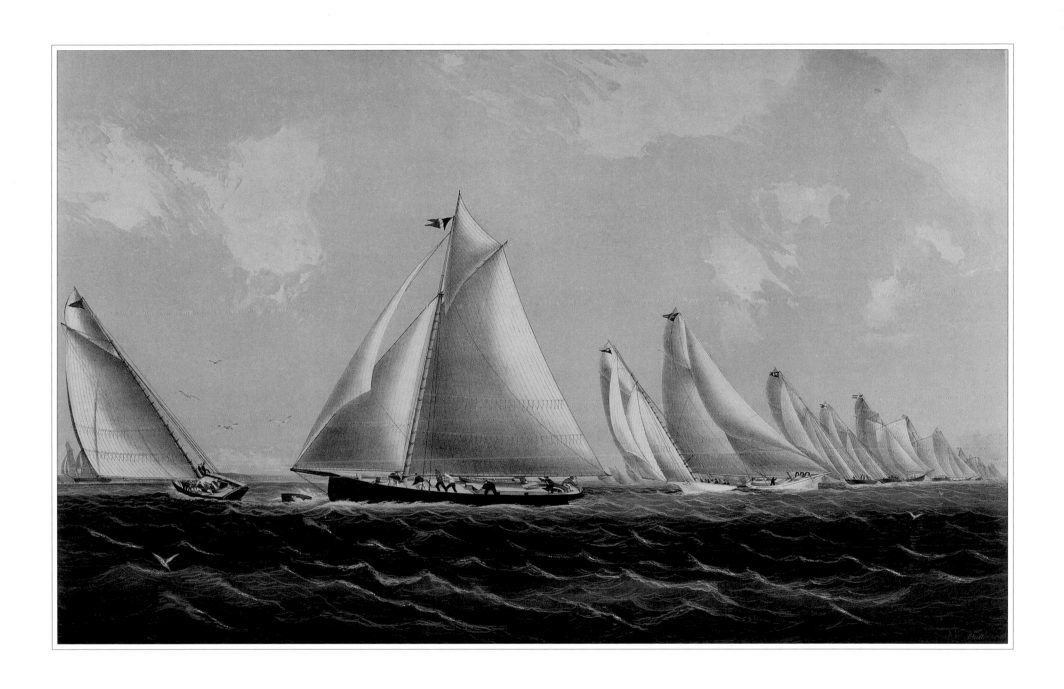

PLATE I.40

The New York Yacht Club Regatta. The Start from the Stakeboat in the Narrows, off the New Club House and Grounds, Staten Island, New York Harbor
Charles Parsons (1821–1910) and Lyman Atwater (dates), delineators
Nathaniel Currier (1813–1888), lithographer
1869
Lithograph with color added
20¼" x 28¾"

DESPITE THE PARASOLS AND summer finery on display along the shore, John Parkinson, Jr., writes that the New York Yacht Club's annual regatta on June 10, 1869 featured "wind very strong southeast with rain squalls, and the yachts sailed so fast across the usual Southwest Spit–Sandy Hook Lightship course that the judge's steamer could not keep up with them."[1] More likely, then, this scene depicts the annual regatta of the club on June 19, 1868, which finished in "a fine, fresh southwester." The winner in the big schooner class was tobacco millionaire George Lorillard's newly acquired *Magic. Gussie* won in the sloop class. Neither boat appears among the named yachts in this lithograph: *Vesta, Henrietta, Dauntless, Phantom, Fleetwing, Addie V, White Wing, Geraldine,* and *Annie.*

Or possibly the artists had in mind the club's twentieth regatta, which took place on June 8, 1865, in a "light and baffling" breeze. For that race there were six starters in the schooner class, three in the sloop class, with *Annie* the winning sloop.

Llewellyn Howland III

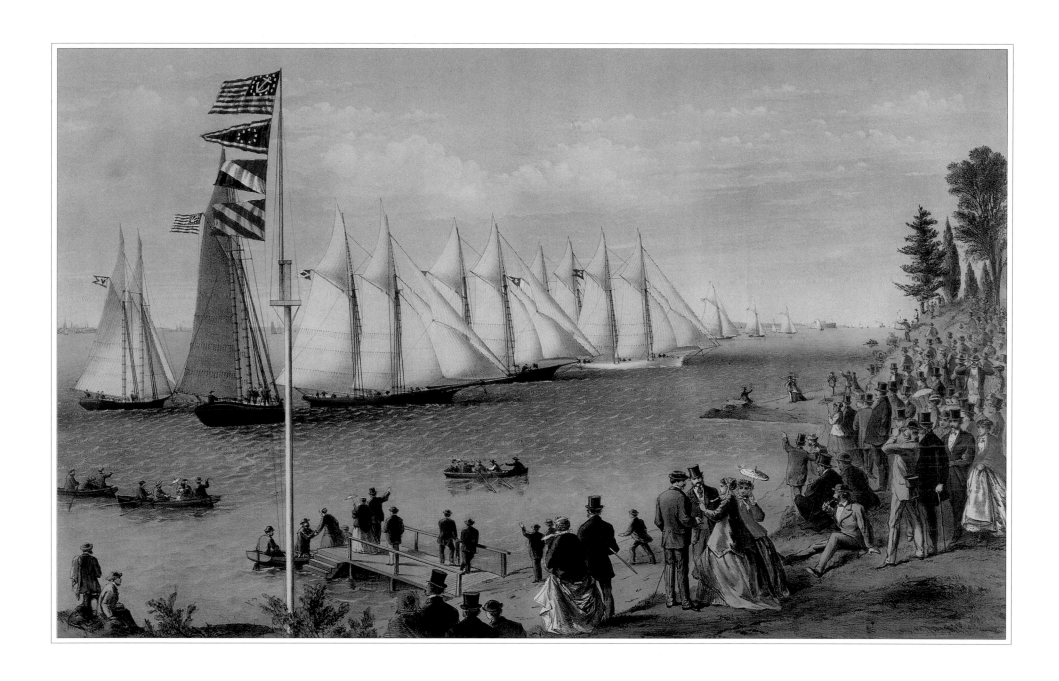

PLATE I.41

The Yacht Squadron at Newport
Nathaniel Currier (1813–1888) and James Merritt Ives (1824–1895),
lithographers
1872
Lithograph in black and white with color added
18½" x 28"

IN 1872 THE NEW YORK YACHT CLUB concluded its annual cruise with a six
day visit to Newport. It was, in the words of John Parkinson, Jr., "a gala occa-
sion."[1] It was also the occasion for four days of spirited racing, including two days
of competition for a challenge cup put up by twenty-seven-year-old commodore
James Gordon Bennett, a regatta race with fourteen starters, and an eleven-boat
race from Brenton Reef Lightship around Sow and Pigs Lightship and return for
the Newport Citizens Cup.

This marvelous lithographic view of the fleet gathered at Newport on the first
afternoon of the visit is a reminder that yachting was a major spectator event in the
latter half of the nineteenth century—and that lovers of the sport still knew how
to row. Identified yachts, left to right: *Dauntless, Peerless, Fleetwing, Palmer, Wanderer,
Magic, Rambler, America* (still owned by the U.S. Navy and in use by the Naval Acad-
emy), *Dreadnought, Olympeo, Columbia, Tarolinta, Sappho,* and *Madeleine.* There is not a
sloop on the list.

Llewellyn Howland III

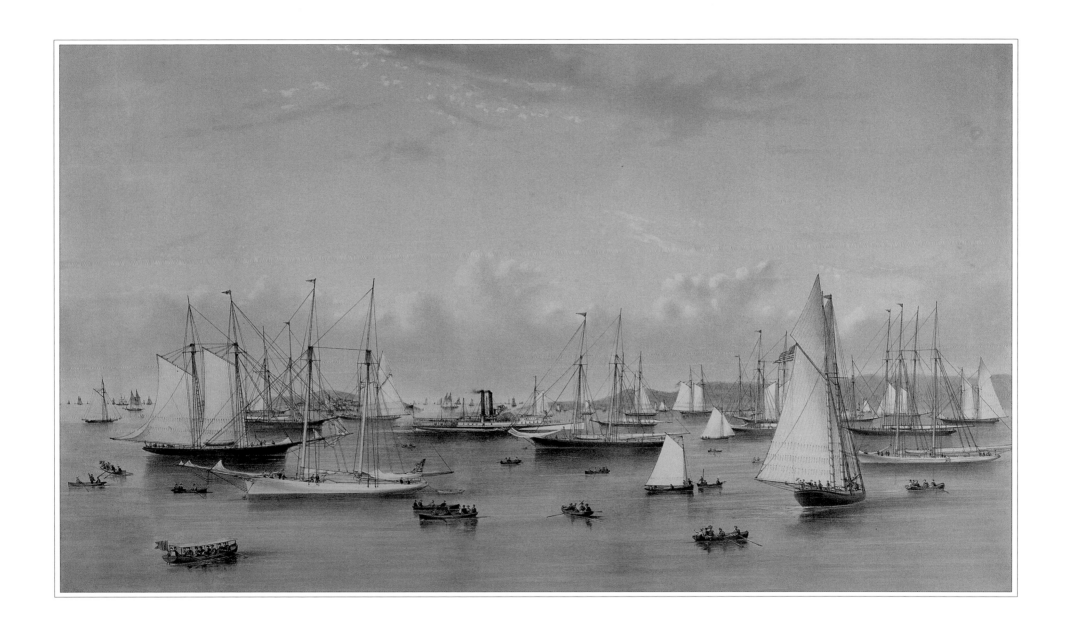

95

Plate I.42

The Enterprise
John Mecray (b. 1937)
1982
Graphite on paper
11¼" x 22¼"
Signed, dated and inscribed "John Mecray © 82" (lower right)

THE FOURTEENTH DEFENSE of the America's Cup took place in Newport in 1930, and was the first match to witness the use of J-class boats. *Enterprise*, designed by Starling Burgess, son of legendary designer Edward Burgess, was skippered by Harold "Mike" Vanderbilt, scion of the Vanderbilt fortune. Leading *Enterprise* against Sir Thomas Lipton's *Shamrock V*, Vanderbilt said, "I'll be damned if I'll be the first skipper to lose the America's Cup." In the event, he proved victorious against his determined, but unsuccessful opponent, who was heard to lament, "I canna win; I canna win."

The artist John Mecray writes:

The drawing of the J-class sloop *Enterprise* was developed with the intention of doing a painting. I compiled sketches of *Enterprise* from the model in the New York Yacht Club, but in the end decided on another angle better to display the steamer *Mount Hope* that I wanted to include in the background. That view became the painting and subsequent print entitled *"Mount Hope" and "Enterprise"*— you might note the similarities of hull and crew. I recall liking the sketch, and, realizing I was not going to use that angle for the painting, did not discard it, but developed it into the finished drawing in the Foster collection entitled *Enterprise* (I've always loved that name).

Ben Simons

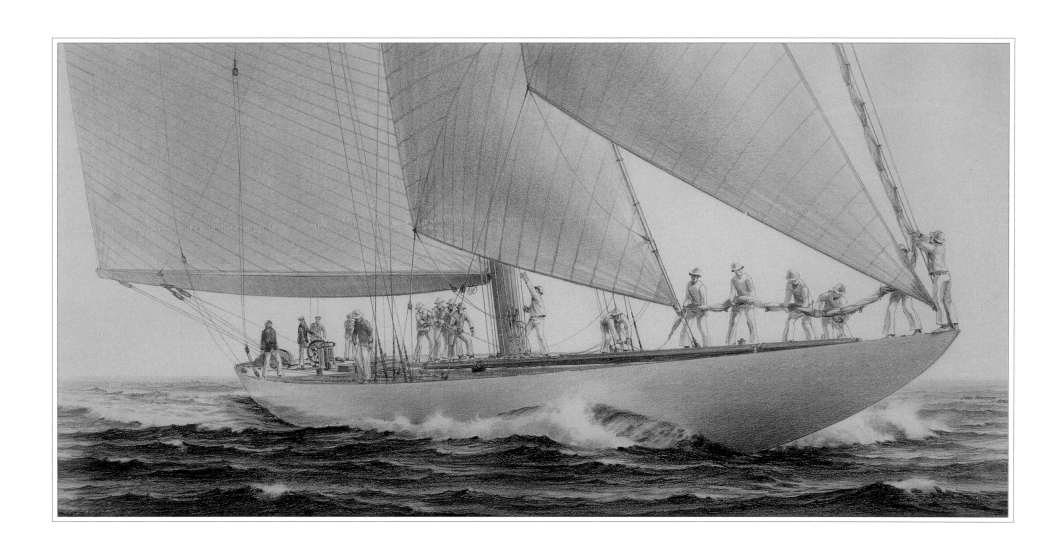

BRITISH YACHTING ART

THE GLEN S. FOSTER COLLECTION contains a fine selection of works by British marine artists depicting yachts under sail in traditional British racing waters. Foster gathered representative works by nineteenth-century British marine painters of yachting scenes at race settings from Plymouth to Cowes. The collection includes portraits of America's Cup competitors, historic Royal Yacht Squadron craft, and other private yachts. It features a rare deck scene aboard a private vessel by British marine artist Nicholas Matthews Condy. In addition to works by nineteenth-century artists James Haughton Forrest, William Joy, and Arthur Wellington Fowles, the collection includes a twentieth-century America's Cup scene by contemporary yachting artist John Steven Dews.

NICHOLAS MATTHEWS CONDY

NICHOLAS MATTHEWS CONDY (1818–1851) was a precocious and accomplished marine painter born in Plymouth. Like James Buttersworth, Condy learned the art of painting from his father, Nicholas Condy (1799–1857). The younger Condy earned praise for his work at the age of thirteen from one of J. M. W. Turner's patrons, the Earl of Egremont, who purchased his sketch of the yacht *Kestrel*. After his schooling was complete, Condy joined the army, but soon abandoned it to pursue a career in marine painting. He quickly developed into one of the most popular and successful marine artists of his time. Many of his paintings were made into lithographs by Thomas Goldsworthy Dutton and others. Condy went on to become the official marine painter of the Royal Thames Yacht Club and the Royal Western Yacht Club.

It is a curiosity of yachting art that few deck scenes exist showing owners, crew, or close-up details of the self-contained world on board a vessel. Three such scenes by Condy are known, and the Foster Collection includes a canvas considered to be one of the artist's finest works: *Mr. Ward and His Family on Board His Cutter* Guerrilla (Plate II.1). *Guerrilla*, the name of which is visible on the stern of the tender, was a 35-ton cutter owned by Captain Charles Ward, a member of the Royal Yacht Squadron from 1827 to 1833. His wife and two daughters are shown in a delightful central grouping, while Mr. Ward sits with a telescope in an admiring posture to the left. A crewman raises a signal flag in the background, just above the fresh face of Mrs. Ward and her two somewhat quizzical daughters. The grouping and the lighting suggest a studio visit rather than an onboard sitting. It is possible that Condy collaborated with his father on the canvas.[1]

Even in the years before the 1851 One Hundred Guinea Cup propelled the transatlantic rivalry to prominence, club races succeeded in capturing the public's imagination. In 1843 a competition occurred between two Royal Thames Yacht Club vessels, General Lord Alfred Paget's *Mystery* and A. Fountaine's *Blue Bell*. Lord Paget was Clerk Marshall to Queen Victoria, and served as Commodore of the Royal Thames Yacht Club from 1846 to 1873. Condy painted the scene of the Thames race in which *Mystery* sails on to victory after *Blue Bell* has run aground. The Foster Collection contains the Thomas Goldsworthy Dutton watercolor entitled Mystery *(Lord Alfred Paget) Beating* Blue Bell *(A. Fountaine) on a Race in the Thames, May 23rd 1843* (Plate II.2), done after Condy's original painting, which remains in the collection of the Royal Thames Yacht Club.

The Foster Collection includes another probable portrayal of the yacht *Mystery* in *A Racing Cutter of the Royal Thames Yacht Club Passing Astern of an Anchored Three-Decker, Perhaps the Guardship of the* Nore (Plate II.3) attributed to British marine artist William Joy (1803–1867). The cutter depicted by Joy passing the *Nore* guardship displays the ensign of the Royal Thames Yacht Club, including the distinctive crown in the fly used from 1842 to 1848. Her lines and features suggest a strong likelihood that the portrait shows Lord Paget's 25-ton *Mystery*, which won many competitions in her weight class, including the 1844 Royal Yacht Squadron Cup for vessels under 35 tons. The collection also includes the striking James E. Buttersworth painting *Rounding the* Nore (Plate II.4), the only known rendition by Buttersworth of the Nore Lightship (see the "American Yachting Art" chapter for further details of Buttersworth's life and career and other Buttersworth paintings in the collection).

Regattas between rival clubs were also a popular subject of yachting portraiture. In *The Royal Yacht Squadron's Schooner* Fair Rosamond *Running up the Channel after Rounding the Eddystone Lighthouse in Stormy Weather* (Plate II.5), Condy illustrates a race between the 125-ton schooner *Fair Rosamond*, with the burgee and St. George ensign of the Royal Yacht Squadron clearly visible, and her rival sporting the burgee of the Royal Thames Yacht Club. The blustery brown weather in the background, with the Eddystone Lighthouse on the horizon, gives a depth to the canvas, further enhanced by the wave spilling across *Fair Rosamond*'s bow in the foreground.

Yachting art often presents an enclosed imaginative setting in which sail and wave form a complete world. Occasionally, harbor traffic intrudes in a scene, but it is the rare painting that includes the busy industrial life of a nation as an element of the composition. Condy's *Cutter Yachts Racing at Plymouth* (Plate II.6) shows two cutters competing off Plymouth against a background of factories churning out dark clouds of smoke and square-riggers docked and departing with fresh cargo. The black smoke from the factory mills trails horizontally with the wind, as dark storm clouds threaten the two racers, one of which has lowered her topsail in response while the other prepares to do the same. The contrast between the light, the clouds of the breaking storm, and the wisps of factory smoke choking the horizon creates a spectacularly dramatic scene.

CAPTAIN JAMES HAUGHTON FORREST

CAPTAIN JAMES HAUGHTON FORREST (1826–1925) is a lesser-known marine artist born to English parents at Boulogne-sur-Mer, France. Going to England as a

young man, he entered into a five-year commission in the Honourable Artillery Company before pursuing a career as a yachting artist. In 1876, he moved to Tasmania with his family and continued to paint marine subjects, including yachting and British coastal scenes.

One of the Royal Yacht Squadron's earliest and most famous yachts was the cutter *Arrow*, built for Mr. Joseph Weld in 1821, one year after the club's foundation. In her early design, *Arrow* was "as bluff forward as a Symondsite brig!"[2] She would be refitted many times throughout her sixty years of sailing. In 1825, she raced against the Marquis of Anglesey's cutter *Pearl*, and lost the £500 wager for her owner on a fluke. She saw victory in 1826 in the One Hundred Guinea Gold Cup, becoming the first yacht to capture the club's famous prize. She changed hands twice during the 1830s, ending up under the ownership of Thomas Chamberlayne, who had her "replanked, altered, and lengthened by the bow."[3]

In the historic One Hundred Guinea Cup Race around the Isle of Wight in 1851, *Arrow* formed part of the fleet of vessels sent against the challenger *America*. She was considered the race favorite, but was fated to run aground during the race. *Arrow* later beat *America* by 1 minute and 50 seconds in a race around the Isle of Wight on July 22, 1852. She continued to sail and regularly win prizes up to 1880. The Foster Collection contains Haughton Forrest's portrait of *The Yacht* Arrow *of the Royal Yacht Squadron* (Plate II.7), in which *Arrow* is depicted engaged in a regatta with her Royal Yacht Squadron burgee and ensign clearly visible, along with her clean "knifing" lines.

ARTHUR WELLINGTON FOWLES

PROLIFIC BRITISH MARINE ARTIST Arthur Wellington Fowles (1815–1883) was born at Ryde on the Isle of Wight, and is frequently referred to as Arthur Wellington Fowles of Ryde. Like his contemporary James Buttersworth, he was deeply impressed with the scenery of his early years, and would always favor the legendary waters around the Isle of Wight as the background for his paintings. In addition to depicting yacht races and naval vessels, Fowles frequently painted scenes of Queen Victoria's visits to her official residence on the Isle of Wight, Osborne House. He received regular commissions from members of the Royal Yacht Squadron and the Royal Dart Yacht Club, founded in 1866. Fowles's paintings were frequently lithographed by Thomas Goldsworthy Dutton, and his designs were made into wood engravings for publications such as the *Illustrated London News*.

FOUR FOWLES PAINTINGS OF THE SCHOONER YACHT *CAMBRIA*

THE FIRST CHALLENGE in response to the New York Yacht Club's July 21, 1857, invitation to yacht clubs around the world for a "spirited contest for the championship" of the America's Cup came from Royal Thames Yacht Club member James Ashbury, M.P. In spite of Ashbury's wealth, resulting from his father's invention of grouping wheels on the undercarriage of railroad cars, it was said of him that "His social standing was not high. His efforts to win the Cup were in the nature of a bid for social and popular favor."[4] Ashbury's contender was the 228-ton schooner *Cambria*, designed and built by Michael Ratsey, 108 feet overall with 21 feet on the beam. In her maiden races in the summer of 1868, *Cambria* proved a formidable vessel, finishing with four firsts and two seconds. In the two years leading up to her 1870 America's Cup challenge and defeat, *Cambria* seemed prepared for all comers.

In a remarkable quartet of paintings in the Foster Collection, Fowles abandons his typically subdued palette, and turns to magically bright greens and blues in his waters and dramatic skyscapes of spreading pinks. In Cambria *Winning the International Race, Cowes, 1868* (Plate II.8), the artist shows *Cambria* leading the August 1868 Anglo-American Race around the Isle of Wight against the other British contenders *Aline, Condor,* and *Oimara. Sappho* (not shown), *Cambria's* future America's Cup rival, trailed badly in an embarrassing performance after her jibboom carried away. The Stars and Stripes and the Union Jack flutter gently from stakeboats on the right, while a magnificent arch of sunlight breaks through a delicate pink cloud bank on the left horizon, revealing a trailing group of sails. Observers are shown in small craft to the left, along with the smoke of a cannon salute from the shoreline.

In another race in her first summer, *Cambria* captured the Town Cup at Ryde. Fowles portrays her in a full profile in Cambria *Winning the Town Cup, Ryde, 1868* (Plate II.9), with her topsails flying as she runs past the stakeboat with its crowded deck and charmingly rendered signal flags. Fowles shows two mastheadmen who have paused for a moment from their struggle with the topsails to join a portion of the crew on the foredeck in saluting the race committee and spectators.

In a painting that extends his palette even further, Cambria *off the Needles, Isle of Wight, 1868* (Plate II.10), Fowles shows *Cambria* in profile on green waters under a drifting pink and blue sky rounding toward the Needles with no sign of the trailing pack. It is likely that the scene depicts the 1868 Anglo-American Race around the Isle of Wight, in which *Cambria* left the damaged *Sappho* far behind in a decisive victory. The

stunning curved white face of a cliff appears in the background behind *Cambria's* jib, lending a delicate, magical quality to the canvas. The cliff's curve ends in jagged points that meet with the rising line of rocks terminating in the Needles Lighthouse.

The fourth depiction of *Cambria* by Fowles in the Foster Collection is Cambria *Winning at Cowes* (Plate II.11). Like many of his contemporaries, Fowles frequently used the Royal Yacht Squadron's headquarters at Cowes as a backdrop in his paintings. In this case he includes a glimpse of its candy-striped steel awning on the left. Fowles shows *Cambria* crossing the finish line as a throng of spectators cheers along the shore. *Cambria's* elegantly curving foresail and jib continue a visual line created by a downward-drifting cluster of clouds at the upper left of the canvas. The steady outlines of her topsails tower elegantly above the busy scene below, creating a composition of triangular structural lines. Fowles displays remarkable skill in arranging the direction of masts and sails in relation to cloud shapes and the spars of the squadron's flagpole.

The Foster Collection also includes a painting by Fowles entitled *Yachts Racing for the Mark at Cowes* (Plate II.12). The painting portrays a race, presumably in Osborne Bay below Queen Victoria's beloved residence Osborne House, with Castle Norris visible on the hilltop to the left. The Royal Yacht Squadron cutter shown in the left foreground has passed the windward mark and leads a pack of vessels still making their way to windward. The Royal Standard and the Lord High Admiral's flag are shown in the left middleground flying from the main- and foremasts of the Royal steam yacht, which frequented the waters of the Solent in the years of Victoria's reign.

A PAINTING BY CONTEMPORARY ARTIST JOHN STEVEN DEWS

GLEN FOSTER REMAINED INTERESTED in the continuing tradition of marine painting exemplified by the outstanding work of contemporary artists. English painter John Steven Dews (b. 1949) is widely regarded as a present-day master of yachting art. Dews leads the field of artists known for meticulous rendering of water, rigging, and sail in a technique approaching photorealism. Like Foster himself, Dews believes that "To paint marine scenes, you have got to be a sailor. You have got to feel how the wind moves, how it affects the sea and how it affects the boat. You have also got to know the rules of the road."[5]

Dews's painting entitled Stars and Stripes *versus* Kookaburra III, *America's Cup, 1987* (Plate II.13) shows the 1987 competition between Dennis Conner's *Stars and Stripes* and the Royal Perth Yacht Club's *Kookaburra III,* the last America's Cup competition sailed in the 12-Meter class. In a legendary America's Cup performance, Conner redeemed his previous loss of the Cup with a 4–0 victory. Dews manages to breathe a great deal of life into the scene, taking advantage of the complex pattern in the high-tech sails of the 12-Meter sloops created by their computer-designed seams and progressive coloring, set against the uniform background of rich blue water and a tranquil sky.

1. James Taylor, *Yachts on Canvas: Artists' Images of Yachts from the Seventeenth Century to the Present Day* (London: Conway Maritime Press, 1998), p. 79.

2. B. Heckstall-Smith, *Yachts and Yachting in Contemporary Art* (London: Studio Limited, 1925), p. 25.

3. B. Heckstall-Smith, Plate LXII.

4. Winfield M. Thompson and Thomas W. Lawson, *The Lawson History of the America's Cup* (Boston: Private Edition, 1902), p. 46–47.

5. Quoted in Taylor, p. 140.

PLATE II.I

Mr. Ward and His Family on Board His Cutter Guerrilla
Nicholas Matthew Condy (1818–1851)
Ca. 1840
Oil on wood panel
13¾" x 18"

THE 35-TON YACHT *GUERRILLA* was owned by Captain Charles Ward, a member of the Royal Yacht Squadron from 1827 to 1833. In an unusual setting, Condy portrays Captain Ward with his wife and two daughters on the deck of *Guerrilla*, with a crew member hoisting a signal flag behind the seated family group. The yacht's tender with the name *Guerrilla* visible on the stern appears at right. The artist has taken pains to capture the soft features of Mrs. Ward's expression along with the abundant folds of her dress, introducing a more delicate, domestic accent to the otherwise regimented milieu of a yacht deck. Condy includes details such as the red-and-white striped ribbon on her daughter's bonnet, and the bouquet of flowers hanging from her other daughter's right hand. The artificial lighting suggests that Condy may have completed the painting in his studio, where the sitters would more naturally have posed.[1] Mr. Ward appears seated in elegant dress with a top hat, holding a telescope and gazing admiringly at his wife and two somewhat distracted daughters.

Ben Simons

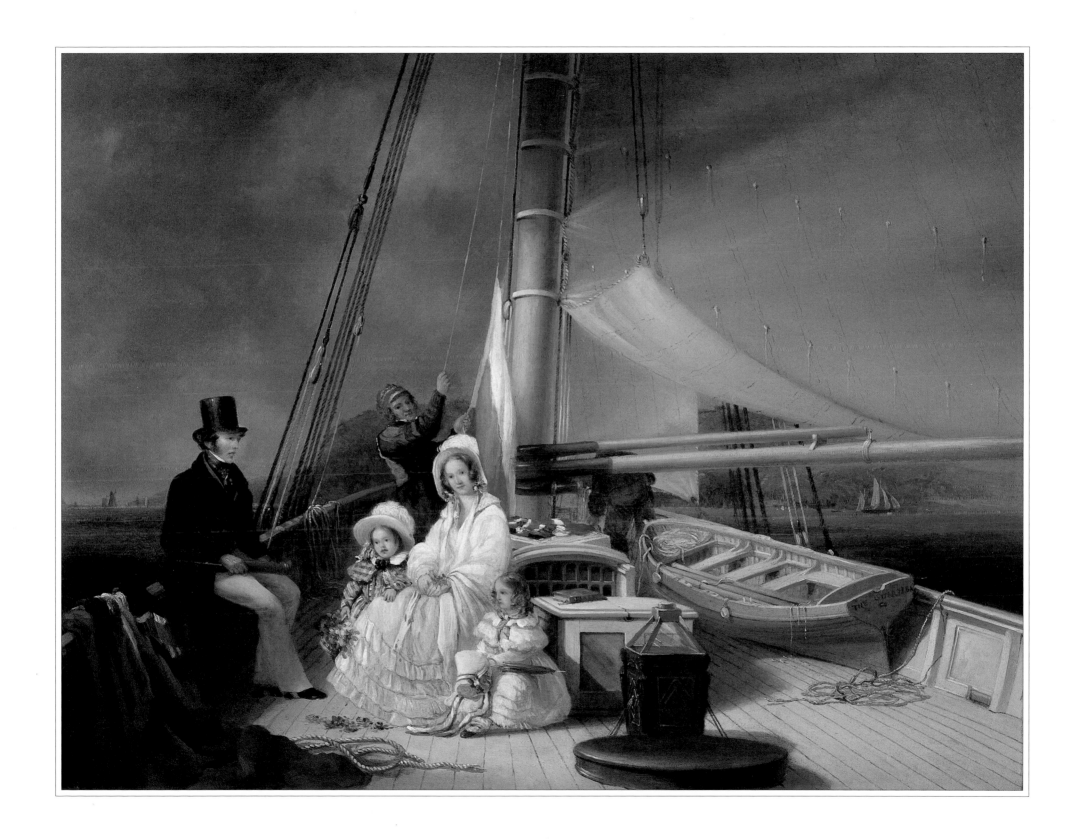

PLATE II.2

Mystery (Lord Alfred Paget) Beating Blue Bell *(A. Fountaine) on a Race in the Thames, May 23, 1843*
Thomas Goldsworthy Dutton (1819–1891)
Signed and dated 1851
Watercolor on paper
6¾" x 10"
Signed "T. G. Dutton" (lower right)

T. G. DUTTON WAS ENGLAND'S finest and most prolific lithographer of shipping scenes and ship portraits. The originals for his lithographs seem always to have been watercolors. He exhibited at Suffolk Street between 1858 and 1879. The National Maritime Museum at Greenwich has a nearly complete collection of his published lithographs and some original watercolors.

This work records a celebrated match on the Thames between two of the Royal Thames Yacht Club's closest rivals. Lord Alfred Paget, son of the first Marquess of Anglesey, was an enthusiastic yachtsman who, in 1842, ordered a pioneering 25-ton iron cutter, *Mystery*, with which he enjoyed some notable successes. Andrew Fountaine, a rich Norfolk squire and great art connoisseur, also owned one of these early iron cutters, the 25-ton *Blue Bell*. Between such perfectly matched yachts a match race was inevitable.

The race took place in the Thames estuary on May 23, 1843, and although no details have survived, it seems likely that a handsome wager was involved. The two cutters sailed most of the course neck-and-neck. The *Blue Bell* ran aground on a shoal off False Point. Paget daringly took *Mystery* past her through the inshore passage and won the race. Whether as a result of this incident or not, Fountaine joined the Royal Yacht Squadron the following year, selling *Blue Bell* for the 60-ton cutter *Gauntlet*.

Nicholas Matthew Condy also painted a version of this race for which Dutton produced a lithograph.

Llewellyn Howland III
Alistair Laird

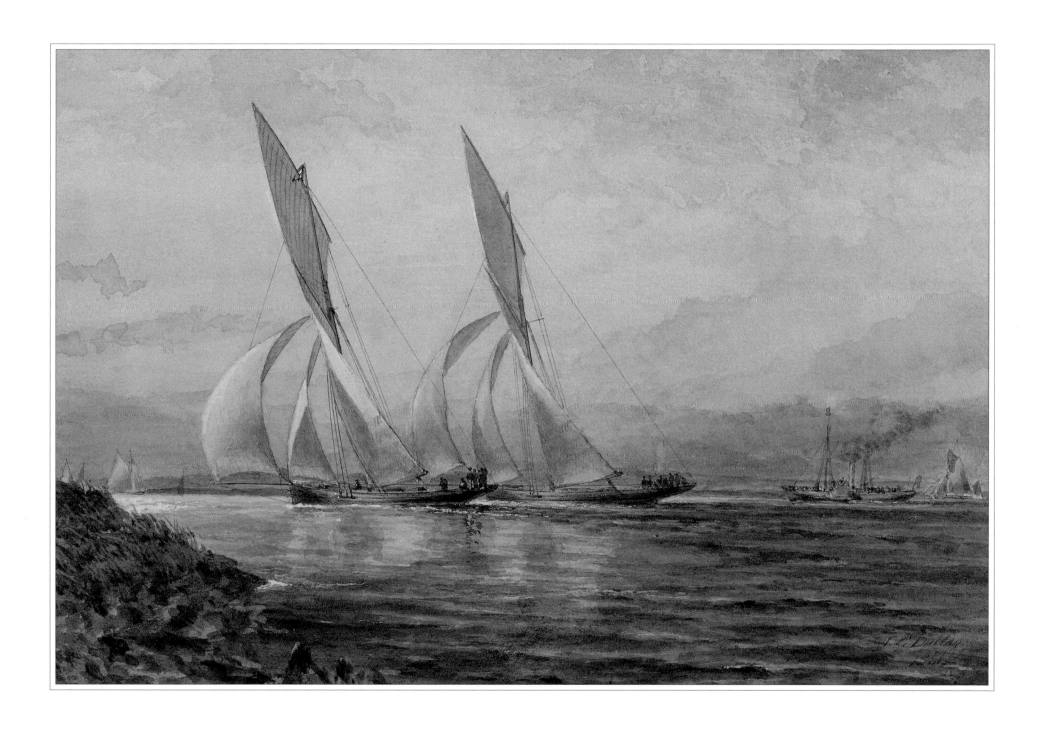

PLATE II.3

*A Racing Cutter of the Royal Thames Yacht Club Passing Astern of an
Anchored Three-Decker, Perhaps the Guardship of the* Nore
Attributed to William Joy (1803–1867)
Ca. 1842–48
Watercolor on paper
10½" x 16¼"

IN THE ABSENCE OF HER OWN individual racing flag or signal, one cannot identify the yacht with any degree of certainty. There is, however, no mistaking the ensign of the Royal Thames Yacht Club, which for only a few brief years—from 1842 to 1848—included a distinctive crown in the fly. Using this narrow window of time as the basis for research, one finds that her lines and general appearance closely resemble those of Lord Alfred Paget's famous *Mystery* (see Plate II.2 for T. G. Dutton's rendering of the cutter). The pioneering 25-ton iron cutter was built in 1842 and brought Paget many successes. Most notable was *Mystery*'s victory at Cowes in August 1844, when she won the Royal Yacht Squadron's Cup for yachts under 35 tons and from any royal yacht club in the kingdom. No less than 14 Royal Thames boats took up the challenge and later followed *Mystery* in a victory procession up the Solent. Nicholas Matthew Condy captures the scene in one of several oils he painted of the cutter.

Lord Paget later sold *Mystery* to Lord Seaham for £500. Paget served as commodore of the Royal Thames Yacht Club from 1846 to 1873.

Llewellyn Howland III
Alistair Laird

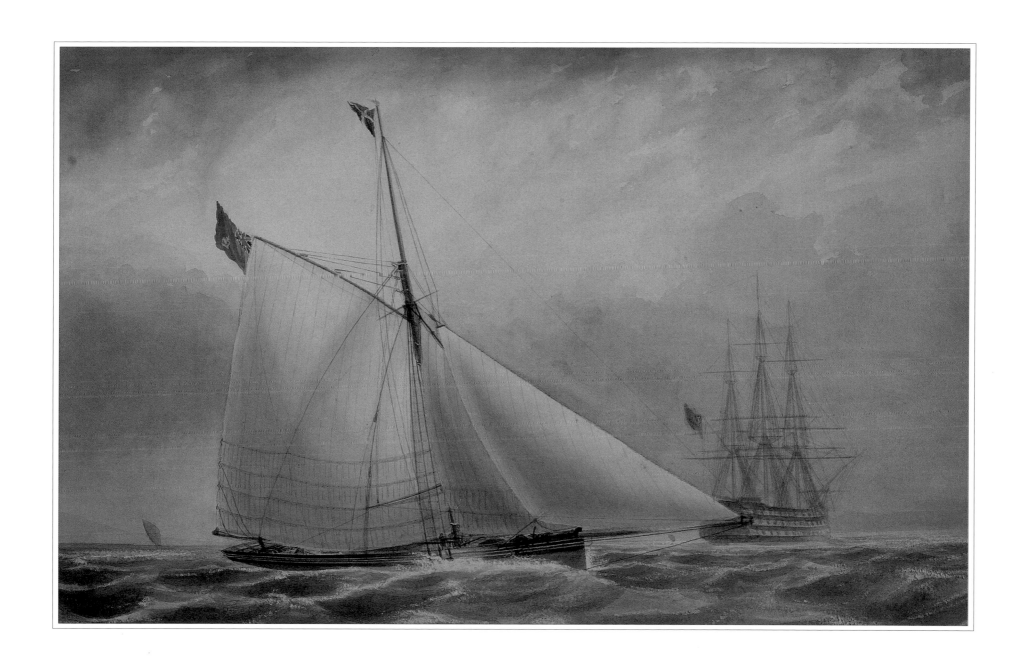

PLATE II.4

Rounding the Nore
James E. Buttersworth (1817–1894)
Ca. 1851
Oil on academy board
$6\frac{1}{4}$" x $11\frac{1}{2}$"
Signed "J. E. Buttersworth" (lower right)

IN 1851 JAMES BUTTERSWORTH executed a series of seventeen signed and dated pencil sketches of important English racing yachts. Known as the "Dauntless Club drawings," the highly detailed sketches support the belief that the artist was in England during the summer when *America* won the One Hundred Guinea Cup off Cowes. It was presumably also during the summer of 1851 when he painted this small oil of yachts racing off the *Nore* light vessel—the only known painting by Buttersworth, according to Rudolph Schaefer, in which the *Nore* is featured. As is so typical in these small yachting oils, a portion of the sky is darkened, suggesting that a major squall is in the offing or has just passed. Some fifteen figures line the weather rail of the unidentified large English cutter in the foreground. The topmasts of all the racing boats are housed, although the boats still carry full lowers.

Llewellyn Howland III

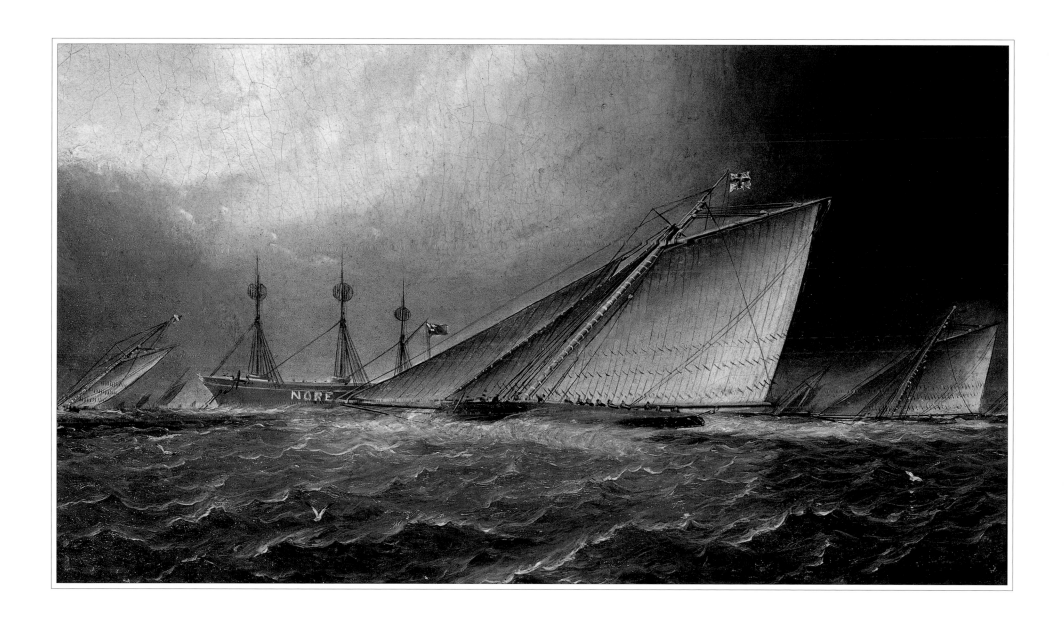

PLATE II.5

The Royal Yacht Squadron's Schooner Fair Rosamond *Running up the Channel After Rounding the Eddystone Lighthouse in Stormy Weather*
Nicholas Matthew Condy (1818–1851)
1848
Oil on artist's board
12" x 16"
Signed and dated "N. M. Condy 1848" (lower left)

BORN IN PLYMOUTH, Nicholas Matthew Condy was intended for the army, which he entered but did not serve with for long. He then joined with his father to paint for the balance of his short life. The National Maritime Museum, Greenwich has five of his works.

This oil-on-board painting by Condy depicts the 120-ton schooner *Fair Rosamond*, built by Marshall in 1846 for John Winston, Marquis of Blandford (later the seventh Duke of Marlborough). He kept her for only two years, selling her after the end of the 1847 season to Charles, Viscount Canning, the youngest son of Prime Minister George Canning. After a distinguished career in England, Viscount Canning was appointed governor-general of India in 1855 and its first Viceroy in 1858. He died in 1862.

In 1855 Canning sold *Fair Rosamond* to the Earl of Gifford, who in turn sold her to John Wardlaw in 1859. After three seasons with Wardlaw, then two with Captain Percy Smith, she changed hands for the last time in 1864 and was bought by Frederic P. D. Radcliffe, who kept her until his death in 1875. In addition to being an excellent actor and writer, Radcliffe was reputedly the best amateur jockey in England and the best shot and angler of his day.

Although *Fair Rosamond* never achieved the fame of some of her contemporaries, the colorful personalities of some of her owners ensured that her name was heard in yachting circles quite as frequently as many of the more notable yachts. In this painting, *Fair Rosamond*'s curved gaffs, and those of her rival to weather, are deserving of notice. Her loose-footed mainsail has been triced up and a spinnaker or whisker pole has been rigged from her foremast. She flies the burgee and the St. George ensign of the Royal Yacht Club Squadron, while her rival, lacking topmasts, flies the burgee of the Royal Thames Yacht Club. The three signal flags at her foremast identify her by number as 57.

Llewellyn Howland III
Alistair Laird

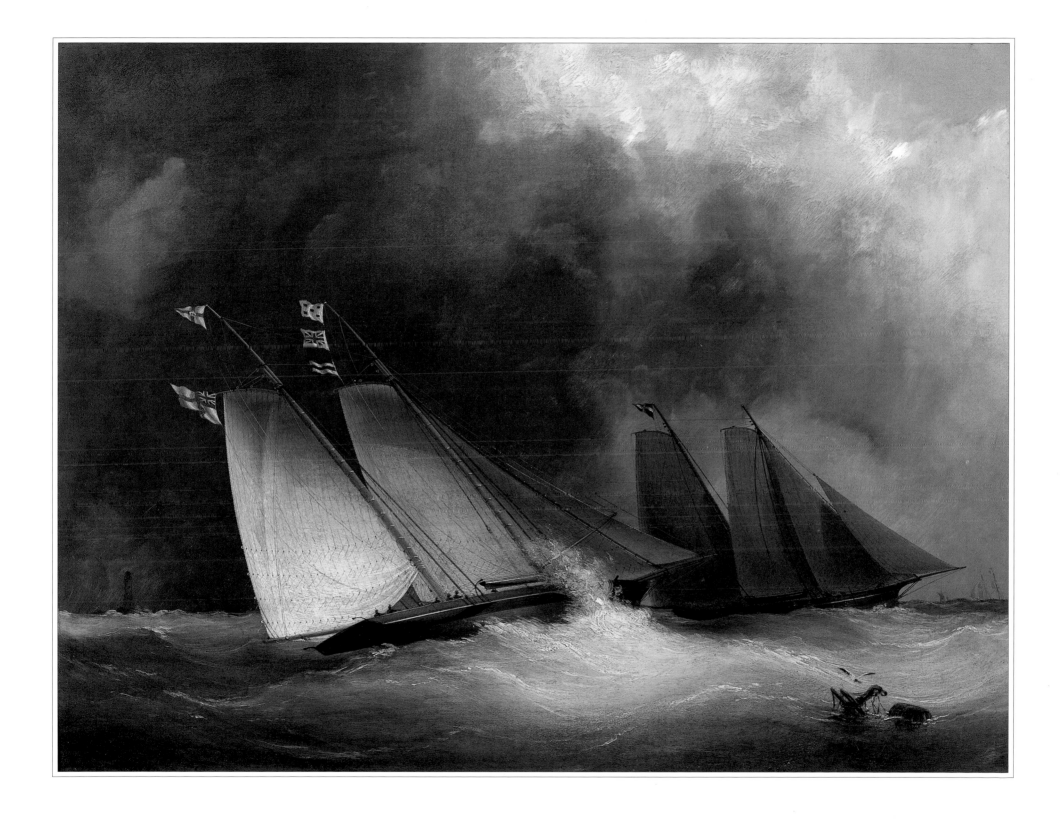

PLATE II.6

Cutter Yachts Racing at Plymouth
Nicholas Matthew Condy (1818–1851)
Ca. 1845
Oil on artist's board
7" x 12"

AGAINST A BACKGROUND OF "dark satanic mills," two English cutters on a broad reach, and a trailing cutter hard on the wind and about to fetch the weather mark, compete off Plymouth. The cutter to the left is lowering her topsail on the yard. The lead cutter is about to follow suit (or the gathering squall will lower it for her). Condy brilliantly suggests shoal harbor waters in the foreground and the storm about to overtake the hard-pressed racers. His handling of sails and rigging is deft, accurate, and dramatic. In both style and handling of technical detail, the painting bears direct comparison with similar scenes by James E. Buttersworth, and for some the comparison will favor Condy. The low horizon is an especially effective element.

Llewellyn Howland III

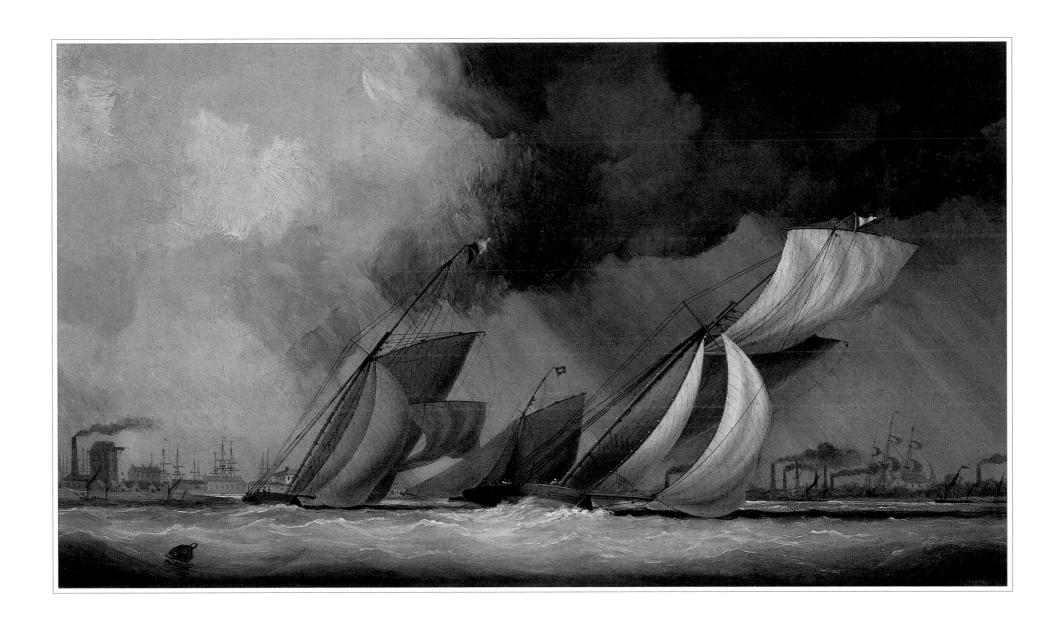

PLATE II.7

The Yacht Arrow *of the Royal Yacht Squadron*
Capt. James Haughton Forrest (1826–1925)
Ca. 1851
Oil on canvas
16" x 17"
Signed "H. Forrest" and inscribed "Cowes" (lower left)

BORN IN BOULOGNE into a military family, Forrest, himself an army officer, did much of his early work on commission. The Prince of Wales was one of his patrons. He left England in 1875 and finally settled in Hobart, Tasmania, where he continued to paint for the rest of his very long life.

Before the legendary *Britannia* burst upon the yachting scene in 1893, Britain's most famous cutter had been *Arrow.* Built by Inman at Lymington in 1821 for Joseph Weld of Lulworth Castle, Dorset, she was, in her original appearance, 61½ feet LWL with a beam of 18½ feet. She was largely the product of her owner's theories of design at a time when he was a vociferous champion of the cutter rig. There is no doubt that he was one of the earliest blue-water yachtsmen in the modern sense.

From the outset of her long career, *Arrow* proved more than a match for all comers. In a race in July 1825 she was only narrowly beaten by Lord Anglesey's *Pearl*, which was a larger boat by nearly 20 tons. Against yachts of comparable size and tonnage, *Arrow* was unbeatable.

Her first great triumph came in 1826 when she won the £100 Gold Cup at the annual regatta of the Royal Yacht Squadron (then known as the Royal Yacht Club, of which Joseph Weld was a founder). This made *Arrow* and her owner the first ever to win a cup offered by the club.

Anxious to improve on *Arrow*'s success with an even larger cutter, Weld sold her after the 1828 season—a decision he came to regret bitterly—to fellow RYS member George Ackers. Then in 1834, Ackers sold her to Lord Godolphin, who in turn sold her, for a bargain price, to Thomas Chamberlayne. In 1847, restored and altered, *Arrow* made her reappearance at Cowes. This was the beginning of a remarkable renaissance for the cutter.

On August 23, 1851, *Arrow* was one of the flotilla to sail around the Isle of Wight against *America* in a race for possession of the One Hundred Guinea Cup. A favorite to win, *Arrow* went hard aground and had to quit the race. But when

America returned to Cowes in 1852, *Arrow* beat her soundly in an identical race for the Queen's Cup at Ryde Regatta. Still competing and frequently winning in the next decade, the continuously altered and upgraded old cutter took ten prizes in seventeen starts in 1879. Brooke Heckstall-Smith tells us that she also "made a good race" with the cutters *Samoena* and *Vanduara* in 1880, six decades after her original launching.

As to her age, Heckstall-Smith quotes designer George Watson on the subject, "I have often been asked about this wonderful vessel, and how a yacht sixty years old can travel with yachts of the present day. She has been remodeled time and again, and it is about as reasonable to talk of her as being an old boat as for Paddy to boast 'Bedad! I wore the same pair of stockings for twenty years,' when on cross examination it turns out that the wife knitted new feet into them one year and new legs the next."

Llewellyn Howland III
Alistair Laird

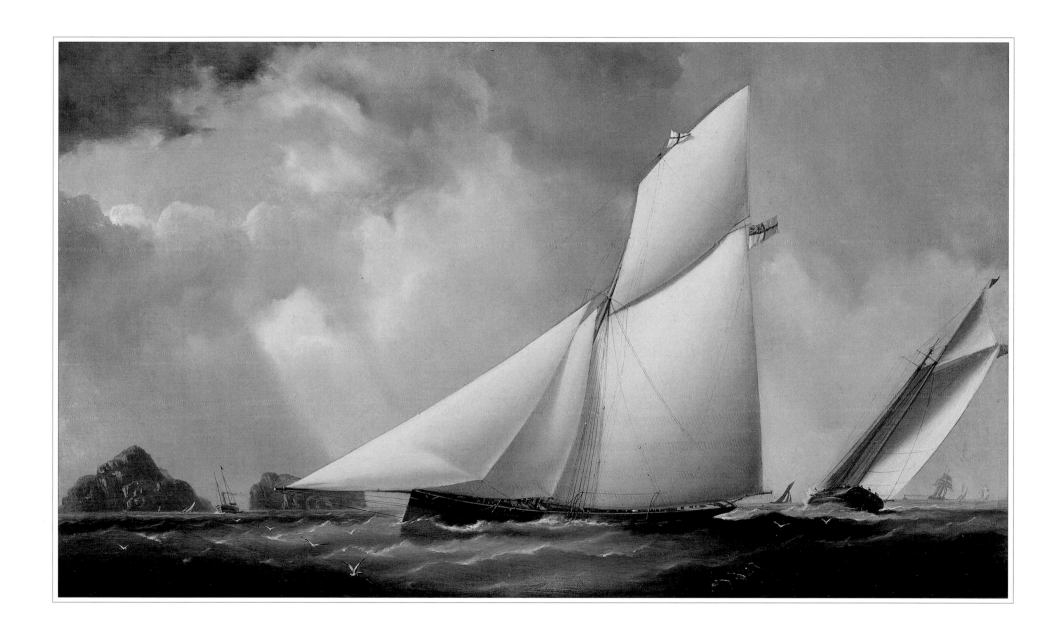

INTRODUCTION TO PLATES II.8–11

A Quartet of Paintings Commissioned from the Artist A. W. Fowles
by James Ashbury, M.P., to Commemorate the Triumphant Season
of his Schooner Yacht *Cambria* in 1868

AT THE HALFWAY POINT of the nineteenth century, the fastest commercial sailing ships in the world were the new breed of American clippers. By comparison, the sport of sailing—where speed and the thrill of winning were rewarded solely by honor and pleasure—was dominated by Great Britain, most particularly by the Royal Yacht Squadron and its members. It was probably inevitable that American yachtsmen would in time want to challenge the status quo. The time came in 1851, when extraordinary events unfolded in the waters around the Isle of Wight.

America's win that summer soon became the stuff of legend. When Commodore Stevens, representing the syndicate that owned her, returned home in the autumn, he carried with him the ornate One Hundred Guinea Cup that the Royal Yacht Squadron had put up for the famous race. Ultimately deposited with the New York Yacht Club, the trophy not only acquired status over the years as the world's premier yachting prize, but also shed its original name to become known as the America's Cup.

A few American yachts came to Cowes in the decade or two after 1851, but none was able to repeat *America*'s triumph. In the summer of 1868, however, the new American schooner *Sappho* arrived off Cowes determined to emulate *America*'s success. She was the largest sailing yacht to have been built in the United States. Great things were expected of her.

Designed and built on speculation by the Poillon brothers of Brooklyn, *Sappho* displaced 310 tons and measured 135 feet overall, with a 27-foot beam. In her first race around the Isle of Wight she was soundly beaten by *Cambria*, an equally new British yacht owned by James Ashbury, M.P., a member of the Royal Thames Yacht Club who had made his fortune with an innovative railroad carriage. *Cambria*, designed and built by Michael Ratsey at Cowes, was 108 feet overall with a 21-foot beam. She was rated 228 tons.

In fact, *Sappho* was hardly at her best in the race, since she was still carrying her reduced ocean rig after the North Atlantic crossing. She also carried several tons of extra stone ballast from the trip. For all that, it was a great victory for *Cambria*. Other victories followed (one of them depicted by A. W. Fowles and illustrated here) making the 1868 season a brilliant one for her. Indeed, by late summer, Ashbury had convinced himself that *Cambria* could beat any sailing yacht afloat. Seizing his chance to restore the supremacy of British yachting and thereby enhance his own quite low social status, he decided to challenge the New York Yacht Club to a series of matches, one of which was to be for the cup won at Cowes by *America* in 1851.

Initially, the New York Yacht Club declined to accept the challenge on the grounds that they could do so only from a yacht club, not an individual. A protracted correspondence ensued that eventually resulted in the first official challenge for the trophy in 1870. Meanwhile, *Sappho*, under the new ownership of William P. Douglas and following significant alterations made to improve her stability, was back in fighting trim. *Sappho* and *Cambria* were to meet again in English waters, this time in May 1870, for a series of three match races in the English Channel. The first race went to *Sappho* after *Cambria*, hopelessly behind in the 60-mile contest, withdrew. The second race became *Sappho*'s by default when James Ashbury refused to start because he did not wish to cross the Channel with the wind ahead. *Sappho* led in their final pairing by some two hours.

Cambria redeemed her loss to *Sappho* by winning her transatlantic match race against James Gordon Bennett's crack schooner, *Dauntless*. However, against the seventeen New York Yacht Club schooners that the club unyieldingly required *Cambria* to race on August 8, 1870, nine boats finished ahead of her on elapsed time, eight on corrected time. And so James Ashbury became the first (and in 1871, with the schooner *Livonia*, the second) in a long line of Quixotes obsessed with winning back the America's Cup for Great Britain.

Fowles was born in Ryde, Isle of Wight, and seems to have lived and worked there all of his life. His pictures often depict local yachting scenes. He also liked to commemorate royal occasions, especially Queen Victoria's connection with the island. The National Maritime Museum, Greenwich has five of his paintings. The yacht designer L. Francis Herreshoff was a great admirer of his work.

Llewellyn Howland III
Alistair Laird

PLATE II.8

Cambria *Winning the International Race, Cowes, 1868*
Arthur Wellington Fowles (1815–1883)
1869
Oil on canvas
28" x 39"
Signed "A. W. Fowles," inscribed "Ryde I. of W." and dated "1869" (lower left)

THE SLIGHTLY AMBIGUOUS TITLE of this painting refers to the influential Anglo-American race around the Isle of Wight following Cowes Week, August 1868. The race was won by *Cambria* in a fast 6 hours 17 minutes 50 seconds. The three other British contenders, *Aline, Condor,* and *Oimara,* all finished within 7 minutes of *Cambria. Sappho,* already handicapped by her small cruising rig and excessive ballast, limped home more than an hour and a half later, having lost first her martingale and then her jibboom. Conditions were considered light at the time. Her embarrassing performance belied her considerable racing qualities, all of which James Ashbury chose to ignore as he planned his first challenge for the America's Cup.

Fowles is often restrained in his palette, favoring earth colors. But all the paintings in this cycle are remarkable for their bright greens and blues—and in this painting for the abundant presence of pink, as well. Note also the brightly painted American flag flying from the stake boat's mizzen.

Llewellyn Howland III

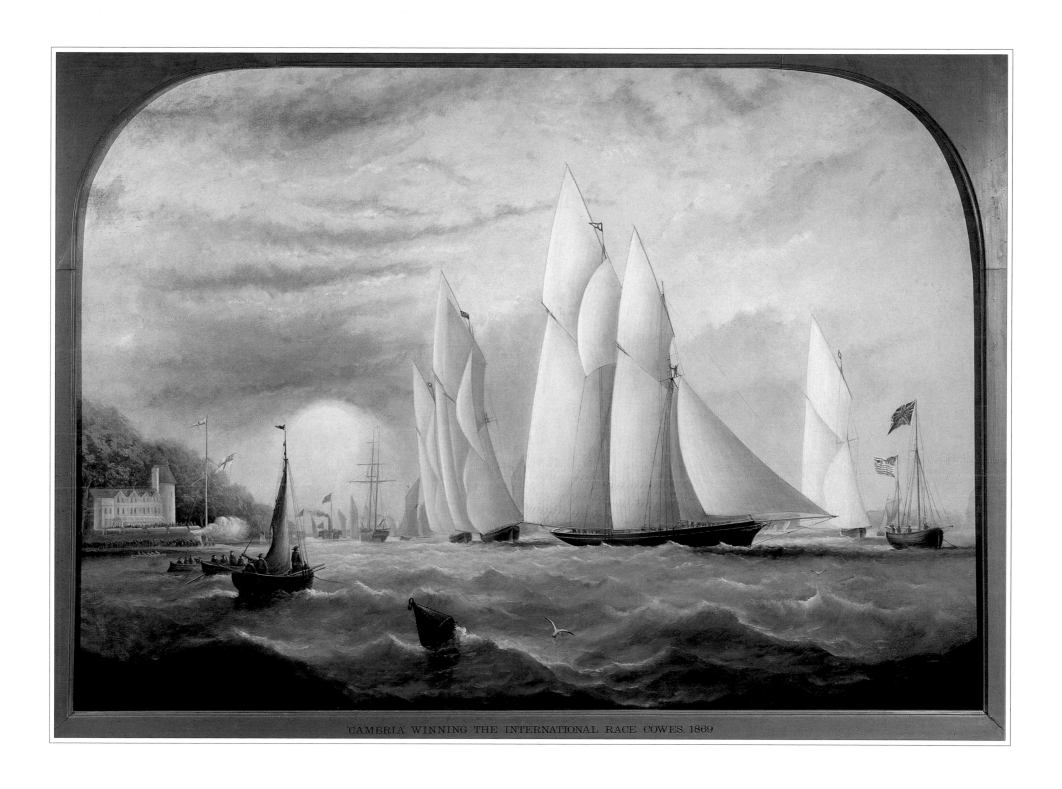

'CAMBRIA' WINNING THE INTERNATIONAL RACE. COWES. 1869

Plate II.9

Cambria *Winning the Town Cup, Ryde, 1868*
Arthur Wellington Fowles (1815–1883)
1869
Oil on canvas
28" x 39"
Signed "A. W. Fowles," inscribed "Ryde I. of W." and dated "1869" (lower left)

WINNING THE TOWN CUP at Ryde brought a momentous season to a fitting climax for *Cambria.* Other good seasons followed, but none was to match her vintage performance in that maiden summer of 1868.

 In this and in two of the three other paintings in the series, Fowles has depicted masthead men on *Cambria's* spreaders saluting the race committee and spectators. Wrestling with big jackyard topsails was among the hardest of all duties for yachting professionals in this period. Spectators and race committee members would have done well to salute them in return.

Llewellyn Howland III

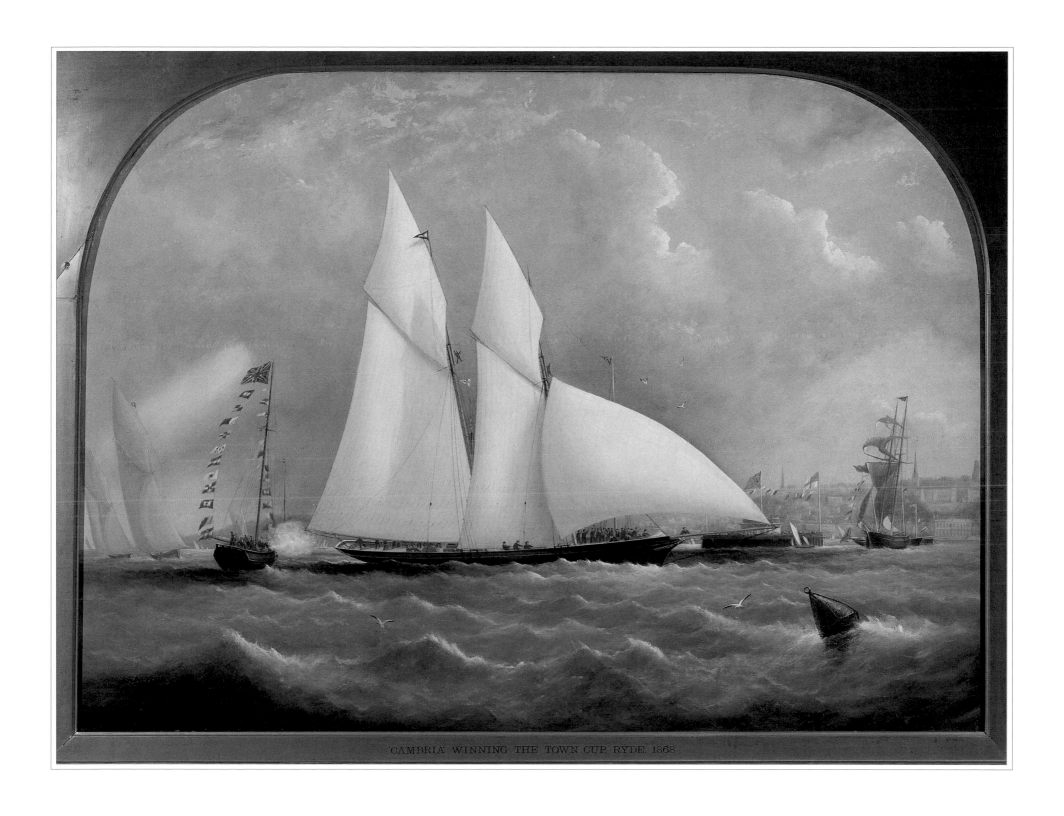

'CAMBRIA' WINNING THE TOWN CUP, RYDE, 1868

PLATE II.10

Cambria *off the Needles, Isle of Wight, 1868*

Arthur Wellington Fowles (1815–1883)
1869
Oil on canvas
28" x 38½"
Signed "A. W. Fowles," inscribed "Ryde I. of W." and dated "1869" (lower left),
bears inscription on reverse

CAMBRIA APPROACHES THE NEEDLES under full sail and comfortably ahead of
the pack. The occasion is most likely the Anglo-American Round-the-Island Race
of 1868, in which *Cambria* trounced *Sappho.* But indeed there were few races that
season in which *Cambria* did not lead a procession to the finish.

Fowles shows *Cambria* carrying a gig in her port davits. All five crewmen with
heads visible wear red caps. The gilt billethead and scrollwork are distinctive
features of the schooner that Fowles depicts in all four paintings in the cycle.

Llewellyn Howland III

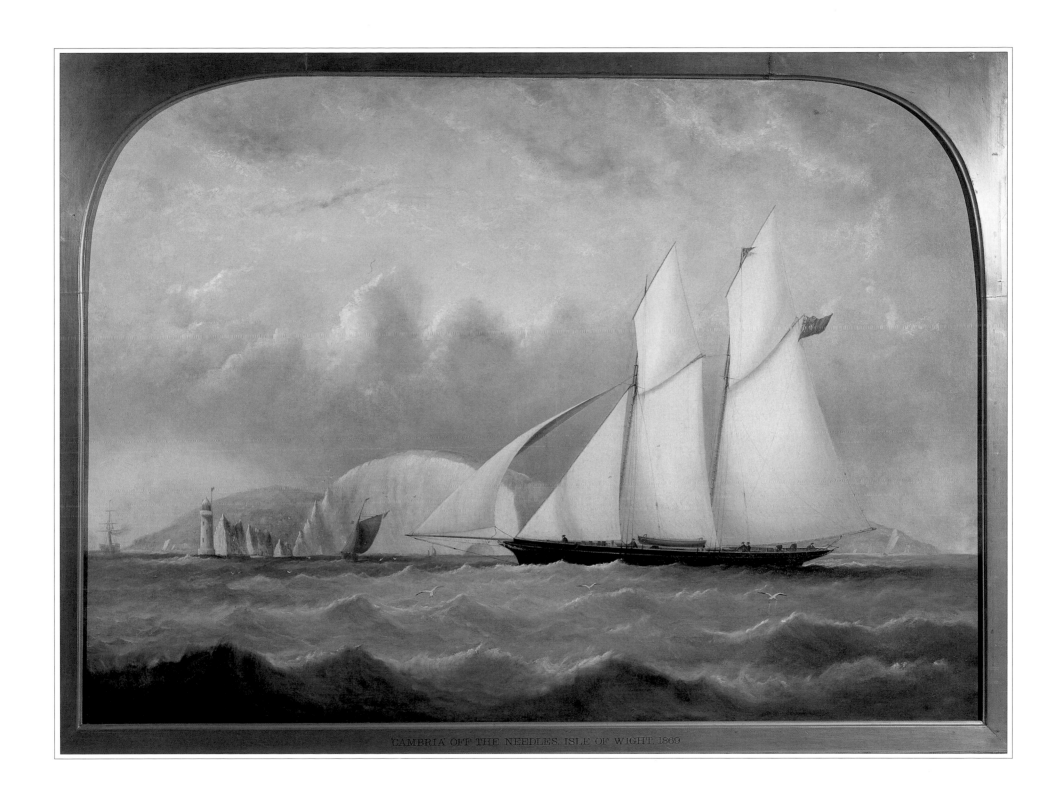

'CAMBRIA' OFF THE NEEDLES, ISLE OF WIGHT, 1869

Plate II.11

Cambria *Winning at Cowes*
Arthur Wellington Fowles (1815–1883)
1868
Oil on canvas
28" x 39"
Signed "A. W. Fowles," inscribed "Ryde I. of W." and dated "1869" (lower left)

EVIDENTLY A DIFFERENT CONTEST from the Anglo-American Round-the-Island Race of 1868, this work depicts *Cambria* romping home across the Royal Yacht Squadron's finish line at Cowes to the delight of onlookers ashore and afloat. Newly built for the 1868 season, *Cambria* proved the most successful schooner that year and ended her season with four firsts and two seconds to her credit.

Fowles depicts the scene from a location not far from shore. The celebrated candy-striped steel awning of the Royal Yacht Squadron is shown from a somewhat unfamiliar angle. All in all, this is an exceptionally good example of his best work.

Llewellyn Howland III

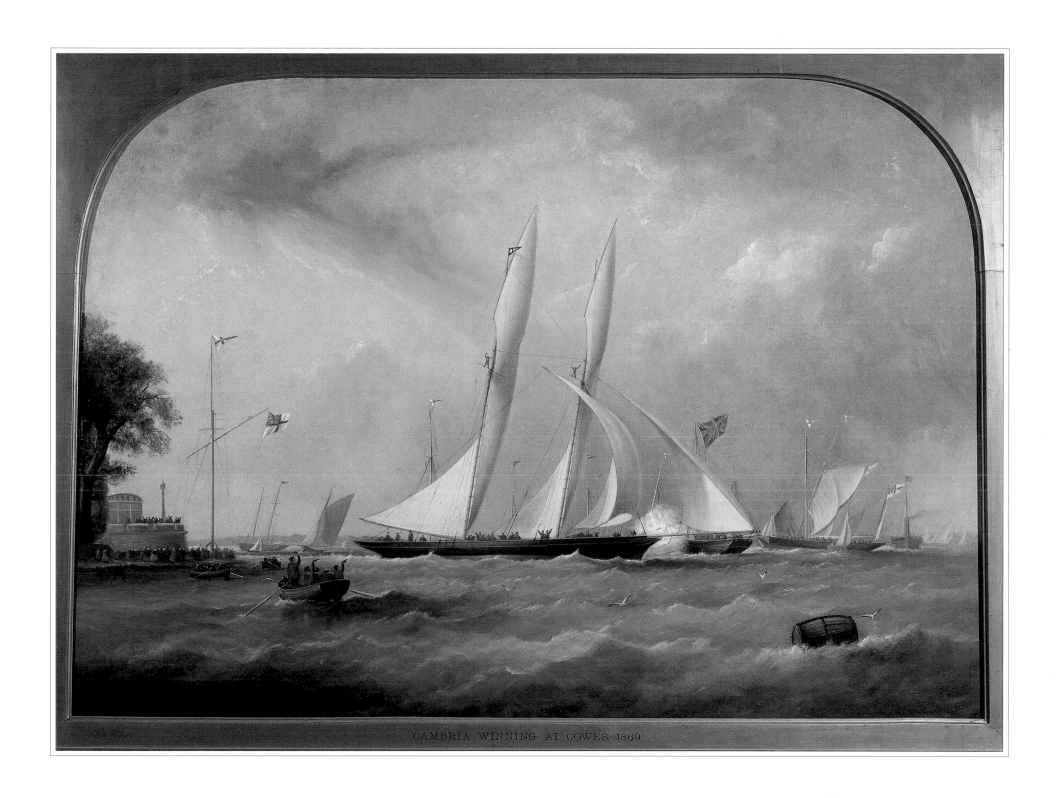

'CAMBRIA WINNING AT COWES 1869'

129

PLATE II.12

Yachts Racing for the Mark at Cowes
Attributed to Arthur Wellington Fowles (1815–1883)
Ca. 1860
Oil on canvas
11¾" x 20"

RECOGNIZABLE FROM THE Royal Standard at the head of her mainmast and the distinctive red flag of the Lord High Admiral at the head of her foremast, the royal steam yacht in the left middleground of this lively racing panorama suggests that the race is taking place in Osborne Bay below Osborne House, Queen Victoria's much-loved Isle of Wight residence and the place where she spent much of her time after the death of Prince Albert in 1861. The Lord High Admiral's flag indicates that the yacht is carrying the queen herself, rather than the Prince of Wales. All the queen's several steam yachts were familiar sights in the Solent for much of her long reign. The hilltop structure on the headland at left is presumably Norris Castle, a favorite childhood haunt of Victoria.

It appears that the Royal Yacht Squadron cutter in the left foreground has rounded the windward mark ahead of the pack, while the rest of the fleet has more windward work ahead of it. Had the race been important in the fixture list, there would probably have been more spectator boats in evidence. Or perhaps the boisterous conditions discouraged the faint of heart.

Llewellyn Howland III
Alistair Laird

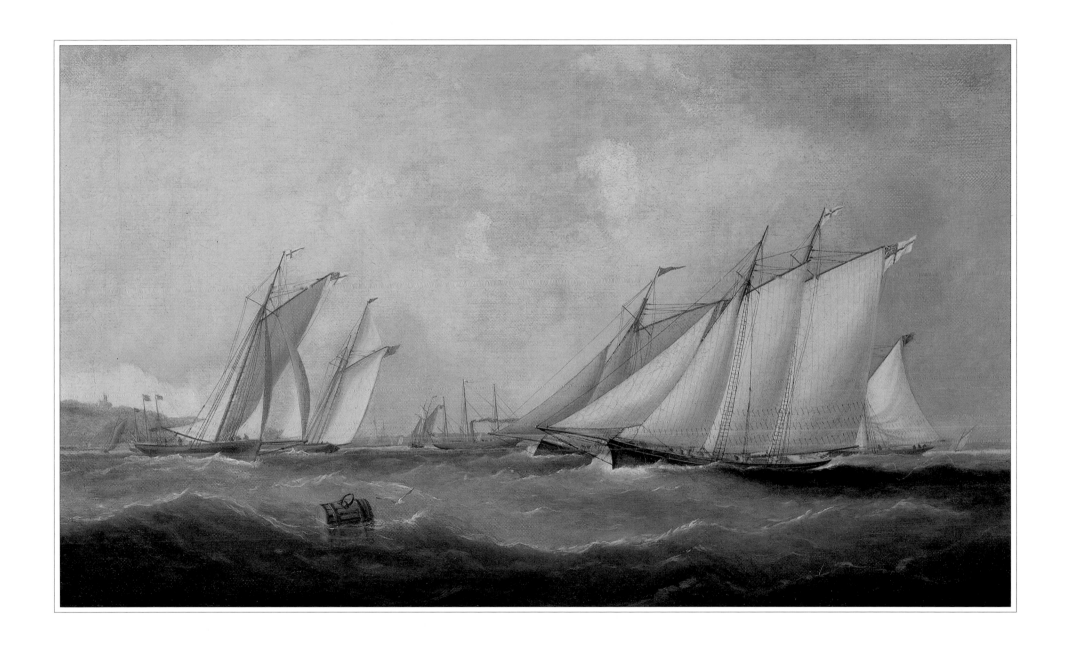

PLATE II.13

Stars and Stripes *versus* Kookaburra III, *America's Cup, 1987*

John Steven Dews (b. 1949)
Dated 1987
Oil on canvas
23½" x 35½"
Signed "J. Steven Dews" (lower left)

A COMMANDING FIGURE AMONG contemporary marine artists, John Steven Dews is perhaps best known for his painstaking evocations of traditional big class racing in British waters. Like the late John Chancellor, he excels at painting water, rigs, and sails: the elements whose accurate and expressive handling define success or failure for the painter of sailing vessels.

Even so talented and technically proficient an artist as Dews, however, has his work cut out for him to make attractive the computer-designed Mylar/Kevlar sails of a space age 12-Meter sloop.

In this painting the fabled "Fremantle Doctor" prevails on the America's Cup race course in Western Australia, giving the American challenger, *Stars and Stripes* with Dennis Conner at the helm, just the conditions it needs to beat the Royal Perth Yacht Club's defender, *Kookaburra III,* in four straight races.

Llewellyn Howland III

AMERICAN MARINE ART

THE GLEN S. FOSTER COLLECTION contains outstanding examples of marine paintings of American scenes by American, British, and French artists. The American marine paintings in the collection date from the early to late nineteenth century, and include works by Charles Wilson Peale, Ambroise Louis Garneray, Thomas Birch, Robert Salmon, Fitz Hugh Lane, William Bradford, James E. Buttersworth, and a rare marine work by Edward Hopper. The collection also contains an unusual painting of the American vessel *United States* attributed to the Chinese artist Spoilum.

The marine art tradition evolved from the humble ship portrait, commissioned by the private owner, or the business concern that had built the vessel. Many marine artists began their careers with such commission work, only to tire of it, like New Bedford artist William Bradford: "For eighteen months, I painted portraits of whalers and merchantmen, till the broadside of a vessel became absolutely loathsome to me."[1] In the nineteenth century, the documentary aspect of ship portraiture gave way to the artist's need "to reproduce specific optical effects of light and air."[2] Glen Foster collected paintings that aspire to express what John Wilmerding refers to as the "less tangible conditions of nature."[3]

SPOILUM AND THE *UNITED STATES*

SPOILUM WAS A CANTONESE ARTIST active in the period from 1774 to 1806. He began his career as a painter of reverse portraits and landscapes on glass, a technique for which Cantonese artists were renowned. Spoilum is credited as the first Chinese artist to move away from traditional Chinese watercolor techniques and produce western-style portraiture in oil on canvas. Some of the earliest examples of Chinese broadside ship portraiture from the first period of American contact with China, from 1785 to 1815, have been attributed to Spoilum.

The extraordinary oil-on-canvas painting *The* United States (Plate III.1), probably by Spoilum, is based on an English print, *The King's Ship Dressed with Colours of Different Nations,* engraved in 1794, with the original vessel altered to match its purchaser's demand for a portrait of the *United States.* The painting shows the flags of all maritime nations of the world at the time of composition draped in a stylized fashion along the rigging, with keys to the individual flags in lozenges around the border. According to Carl L. Crossman in *Decorative Arts of the China Trade,* the ship is anchored against a "rather Pearl River-like background and handsome sky. The details of the ship are very well handled, and those flags which were coloured gold or yellow are here painted with real gold, exactly like the buttons on the jackets of Spoilum's sitters."[4] Two primitive American versions of the painting from the same period are known to exist, suggesting an unknown interim American print as a common source.

CHARLES WILSON PEALE

ANOTHER EARLY PAINTING IN THE Foster Collection is the portrait by Charles Wilson Peale (1741–1827) of *Captain James Josiah* (Plate III.2). Formerly a captain on the brig *St. Croix Packet,* Josiah signed as first mate aboard the first Philadelphia vessel designed for the China Trade, the 290-ton ship *Asia.* He had served as a naval captain during the Revolution, and is portrayed by Peale in the striking blue and red uniform of a Continental navy captain. Captain Josiah appears seated in a ship's cabin with a brig visible through the windows in the distance, and a captain's "tell-tale" compass—used to verify the ship's course from the cabin—attached to the ceiling above. Josiah's noble and stern countenance suggests a pride in the accomplishments of his patriotic past, while the charts of Asian waters laid out on the table before him indicate the promise of his current undertaking.

AMBROISE LOUIS GARNERAY

AMBROISE LOUIS GARNERAY (1783–1857) was a French marine painter born in Paris. At the age of thirteen, he convinced his father to let him ship on a man-o'-war commanded by a cousin. He was later captured aboard the frigate *Belle Isle* and remained a prisoner of war in Portsmouth, England, until the end of the Napoleonic Wars. Garneray used his time in captivity to further his artistic training. He learned English, became an interpreter, and eventually moved to a parole quarter onshore, where he executed a group of views of Portsmouth Harbour. He attempted escape in 1813, but was recaptured while on a boat in the Channel. After his release in 1814, he returned to France and pursued a career as a marine painter, exhibiting in the Paris Salon beginning in 1817.

The three Garneray paintings in the Foster Collection depict scenes from various engagements during the War of 1812. In *The Battle of Lake Erie, September 10, 1813* (Plate III.3), Garneray presents the encounter that took place on Lake Erie between rival squadrons of the American and British fleets. The Americans had sent U.S. Navy officers to the Great Lakes in 1812 to oversee the construction of fleets on Lake Erie and Lake Ontario. The British responded by building their own fleets on opposite banks of the same lakes. Both fleets were made up mainly of brigs, sloops-of-war, and armed cutters. After venturing close to the enemy's position at Malden, the American Master Commandant Oliver Perry anchored his fleet at Put-in-Bay and awaited an engagement. On the morning of September 10, English Commodore Barclay met the opposing squadron on the open waters of Lake Erie. Garneray shows the lines of battle evenly spread, with badly damaged sails on either side. The fire of the guns is well distributed, conveying a sense of the localized action within the larger tableau of battle.

A second canvas by Garneray in the collection shows a famous engagement of the War of 1812 conducted in Atlantic waters west of Madeira: *The Capture of HMS Macedonian by the American Frigate United States, October 25, 1812* (Plate III.4). The encounter between the large American forty-four-gun frigate under the command of Commodore Stephen Decatur and the thirty-eight-gun Royal Navy frigate commanded by Captain John Carden, resulted in the first American capture of the war. Commodore Decatur spied the larger vessel early in the morning and decided to engage her in spite of her greater firepower. *United States* delivered a ferocious barrage as *Macedonian* closed around her larboard side and managed to destroy her rival's mizzen topmast. The English captain refused to surrender his vessel even after it

continued to be ripped through with *United States's* fire. Garneray shows the stalwart captain on the quarterdeck of his ravaged ship refusing to capitulate. Eventually, he struck his colors and turned *Macedonian* over to the Americans. Garneray's composition bears a strong resemblance to a well-known depiction of the same scene by Thomas Birch, which was engraved and published in 1813 by Benjamin Turner.

A remarkable painting by Garneray entitled *The USS* Hornet *Attempting to Save HMS* Peacock *after Their Duel on February 24, 1813* (Plate III.5) shows the victorious eighteen-gun brig-sloop *Hornet* assisting in the evacuation of the eighteen-gun brig-sloop *Peacock*, which it has just destroyed in battle. The action between the equally matched vessels, each incorrectly illustrated by Garneray with three masts instead of two, took place off the South American coast of Demerara. The two vessels exchanged broadsides, but the American brig-sloop's fire was so extensive and accurate that it subdued its opponent quickly. *Peacock's* Captain William Peake having been killed earlier, his first lieutenant surrendered the vessel but flew its ensign upside down to indicate distress. The American ship-of-war sent men over to relieve the sinking vessel, rescuing most of the British crew but losing three of its own in the effort. Garneray shows the struggling men aboard the sinking *Peacock* and two lifeboats ferrying the survivors to safety.

THOMAS BIRCH

THOMAS BIRCH (1779–1851) was born in Warwickshire, England, the son of accomplished enamel painter and engraver William Russell Birch. Birch emmigrated to the United States with his father at the age of fourteen as a result of the Napoleonic Wars. He settled in Philadelphia in the early decades of the nineteenth century when the city was experiencing a rebirth of artistic and literary activity. He was soon elected to the Pennsylvania Academy of Fine Arts and successfully exhibited his work throughout the next decades, becoming one of the first American ship painters to gain widespread acclaim. Birch's style developed from the traditions of the Dutch and French schools, inspired by such artists as Ruisdael, the Van de Veldes, and Joseph Vernet, copies of whose works were found in his father's collection. Birch's early landscapes and ship portraits gave way to depictions of American naval battles in the War of 1812. His subject matter in the 1830s shifted to topographic views of major city harbors.

Birch composed several offshore views of Philadelphia and the Delaware River beginning in the 1820s. In the 1830s, he completed several similar views of New York Harbor showing boat traffic set against the well-known landmarks of Castle

Williams and Castle Garden. In *View of New York Harbor* (Plate III.6), Birch demonstrates his mature style, showing "a mastery in understanding the fluid movements of waves and in reproducing the luminosity of light reflected on the water."[5] Although not a sailor himself, Birch achieves his characteristic "clear coloring and clean palette" in this composition, conveying the "open, airy" experience of vessels on water in light weather. The canvas is organized horizontally with contrasting fields of light and shadow and a neat horizon line punctuated by Castle Williams, Castle Garden, and the spire of Trinity Church. Though the scene appears restful, Birch portrays a variety of harbor traffic, including a paddle-wheel steamer on the left, a merchantman in profile, a small rowboat and sailboat in the foreground, and a topsail schooner on the right.

In *The Battery and Harbor, New York* (Plate III.7), Birch incorporates multiple figures engaged in leisurely activity along the rail of the Battery looking out onto a placid scene of anchored ships and light water traffic with Castle Williams to the left, and the gentle hills of the New Jersey shoreline in the distance. Birch shows a gallant young officer strolling with a lady on each arm, one of whom gestures to a playful dog. Other groupings include two young tars chatting against the rail, a central cluster of two women supervising three curious young children, a sitting group of a family on a bench with a dog, a young couple in the center shadows, and a well-dressed gentleman and lady looking out to the right. The sky is filled with a delicate glowing light that plays across the clouds and against the topsails of the ship resting near the center of the composition. Several anchored vessels off in the distance convey a sense of calm across the scene. The full, glowing light with which Birch suffuses the whole composition is a premonition of the generous, optimistic light of the generation of painters that would soon follow.

ROBERT SALMON

ROBERT SALMON (1775–after 1845) was born in Whitehaven, England, on the Cumberland coast. He worked in Liverpool for a number of years before moving to the port town of Greenock on the west coast of Scotland. He traveled frequently, moving back to Liverpool, spending time in London, on the Welsh coast, and on the eastern coast of Scotland and eastern and southern coasts of England. In June of 1828, he traveled aboard the packet ship *New York* of the Black Ball Line to New York with a large stock of work in hand for sale to the American market. Salmon soon made his way to Boston eager to make a name for himself. He found enthusiastic patronage from some of Boston's leading citizens, exhibiting his work to

growing acclaim throughout the 1830s and '40s. He was widely praised in the newspaper notices of his time: "As a marine Painter, Mr. Salmon has never been excelled by any artist in this country."[6]

The majority of Salmon's work during his American period consisted of views along the English and Scottish coasts (see the "British Marine Art" chapter for the English Salmons in the collection). The Foster Collection includes four remarkable Salmon canvases of American scenes, showing rare and unique views of Boston Harbor. In *The Bark* Marblehead *Coming into Port* (Plate III.8), Salmon depicts the bark driving in heavy weather into Boston Harbor with its mainsail being clewed up and a homeward-bound pennant twirling playfully in the wind. A bright, glowing light breaks suggestively through the gray clouds, revealing a foreground of ordered but surging waves chopping against *Marblehead's* hull. Salmon's attention to the details of rigging and sail trim is noteworthy, though for an unknown reason the painting was rejected by the patron who commissioned it, as revealed in Salmon's own catalog of his paintings: "Portrait of the Bark Marbell head for Mr. Hoper. Not liked, returnd and repaint for self."

A more detailed view of the Boston Harbor skyline emerges in *A Schooner with a View of Boston Harbor* (Plate III.9), in which a merchant topsail schooner is depicted with a busy crew lowering the foresail and preparing to lower the mainsail. In the background, the dome of the Massachusetts State House appears along the peak of the rising outline of Beacon Hill. A crew member on the topsail yard prepares to furl the topsail, while a sailor midway up the main shrouds surveys the bustling activity below.

The influence on Salmon of the Italian master Canaletto's cityscapes of Venice and London is well noted.[7] Nowhere does Salmon achieve the panoramic artistry of his predecessor with greater success than in the miniature *View of Boston Harbor* (Plate III.10), which counts among his last works, painted in 1843 not long before his death. Using contemporary maps, historian Erik A. R. Ronnberg, Jr., has located the scene of the painting as looking down from a hill on Noddle's Island with a view of East Boston, showing the mouth of the Mystic River and the shipyard of Samuel Hall (see painting caption). Two steamboat piers for the steam-powered ferry service that operated to Lewis Wharf are visible in the center and left of the painting. A great variety of harbor traffic spreads out against the backdrop of the burgeoning port city, crowned by the dome of Charles Bulfinch's State House, with Dorchester Heights visible in the left background.

Samuel Hall's shipyard in the foreground shows several merchant ships in various states of construction being fitted out and readied for launch. The central ship in the yard displays flags on its masts nearly ready to be stepped. A ship with its

foremast stepped is visible in the right middleground along with the stern of a ship awaiting the same process. At the time of the painting, Boston was still the young nation's leading shipbuilding center, home to such famous shipbuilders as Donald McKay. The painting conveys the prosperity of the city and the bustling but orderly activity of its maritime commerce. It also presents a sweeping vista of Boston during a period of great cultural influence and commercial expansion.

The fourth painting of an American subject by Salmon in the collection, *American Schooner under Sail with Heavy Seas* (Plate III.11), depicts what according to the artist's inventory was originally an "Inglish schooner," which he repainted to depict an American vessel. The schooner in the painting has not been conclusively identified, though according to Erik A. R. Ronnberg, Jr., two candidates exist (see painting caption). The first is the USS *Alligator*, built at Boston in 1821, which sailed to the west coast of Africa to negotiate land for the colonization of American slaves. *Alligator* was abandoned and burned by its crew in November 1821 after it ran aground on Caryford Reef near Islamorada, Florida, and was hence not viewable at the time Salmon came to America. The second candidate is the naval schooner *Boxer*, built in 1831 and seen by Salmon, though not all of its details correspond. Whatever the schooner's true identity, it is shown with American flagging, probably in the English Channel, with a French-bound ship in the background to the left, and a ship with a Norwegian merchant ensign in view to the right. Salmon shows one sailor climbing the main shrouds and another inching out on the bowsprit, while a huge wave crashes across the bow.

FITZ HUGH LANE

FITZ HUGH LANE (1804–1865) was born in Gloucester, Massachusetts, and contracted polio as a child, leaving him immobile without the assistance of a wheelchair or crutches. Lane was primarily a self-taught artist, though he later received instruction from leading Boston lithographer William S. Pendleton. It was likely at Pendleton's printing house that Lane met the recently migrated British marine artist Robert Salmon, who would prove a major influence on his painting. Lane was an excellent draftsman from the beginning, with a detailed knowledge of naval architecture and a strong awareness of weather conditions and the effects of light at varying times of day. He developed a style that expressed a sense of "stilled time"[8] within a surrounding of calm, luminous light. Lane exhibited frequently throughout New England, and became a popular artist during his lifetime. He was, according to John Wilmerding, "our first native marine painter of real stature."[9]

One of the centerpieces of the Foster Collection is the magnificent and stately painting by Lane entitled Star Light *in Boston Harbor* (Plate III.12). Commissioned ca. 1855 by the Baker and Morrill Shipping Company of Boston, owners of the clipper ship *Star Light*, built for the China Trade, the portrait presents the enormous vessel with its sails "hanging in the gear," anchored in harbor while awaiting its next journey. The beautiful pyramidal composition of its lazily draped sails, shining with a brilliant whiteness, rises into a serene and expansive blue sky. The vessel appears frozen in a momentary grandeur, as if the crystalline perfection of the light has transcended the element of time. The painting expresses the "new purity" and "stillness and lucidity" of Lane's mature style.[10] In the foreground, a minor note of discord arises in the figures of two contending stevedores, at least one of whom appears to be black, perhaps a hint of the approaching social troubles that would lead to the Civil War. The drifting log in the foreground provides the only other contrast to the fresh optimism projected by the newly built clipper. The painting rises to the level of other works by Lane that count "among the best American paintings of the nineteenth century."[11]

One of the few other Lane paintings of an identified vessel is the broadside portrait of *The Ship* Michael Angelo *Entering Boston Harbor* (Plate III.13). The painting presents a port view of the ship approaching the harbor, probably east of Cape Ann, with the twin lighthouses of Thatcher's Island visible in the background. A Boston Harbor pilot boat, identified by its distinctive white and blue flag, approaches to guide the *Michael Angelo* into port from the western end of Broad Sound. A topsail schooner and a square-rigger appear to the left of the vessel as another mast with sails in the far distance emerges between *Michael Angelo*'s fore- and mainmasts in a characteristic detail of Lane's style. The mainmast flies the vessel's name pennant, and a quarterboard with the ship's name is painted in gold lettering on the bow. The painting is an excellent example of Lane's handling of a harbor approach, in which he is careful not simply to show the details of the ship's construction and rigging, but to suggest a fuller narrative with the advancing harbor-pilot boat.

The Foster Collection contains a rare and curious painting of the yacht *America* attributed to Lane, *Yacht* America *from Three Views* (Plate III.14). In spite of the difficulties of dating and some details of the vessel (see painting caption), it appears that Lane produced this popular portrait of *America* in three different positions at the time of her trials in New York Harbor before crossing the Atlantic to Cowes where she raced for the One Hundred Guinea Cup. The painting's one-time owner, L. Francis Herreshoff, son of legendary American yacht designer Nathanael Herreshoff, wrote of it: "This painting by the accurate artist, Fitzhugh [*sic*] Lane, is very interesting. In

the view from astern you can see that her sails are almost perfect airfoils, just twisted aloft correctly for the higher wind velocities there."[12] The American setting of the painting is identifiable by the hull and gear of the dory in the foreground.[13]

WILLIAM BRADFORD

WILLIAM BRADFORD (1823–1892) grew up in Fairhaven, Massachusetts, and briefly attempted to earn a living as a wholesale clothier in the neighboring city of New Bedford. His interest in marine painting proved a distraction to his business, and he admitted later in life that he "spent too much time in painting to succeed."[14] His early marine paintings drew on his abundant firsthand experience of whalers and merchant vessels in New Bedford and Fairhaven. Bradford met the marine artist Albert Van Beest in New York City in 1854, and invited the Rotterdam-born artist trained in the Dutch marine tradition to live with him and his family in New Bedford. The two men shared Bradford's Fairhaven studio, where on October 3, 1855, Van Beest received a visit from Henry David Thoreau, who reported:

> Visited the studio in Fairhaven of a young marine painter, built over the water, the dashing and gurgling of it coming up through a grating in the floor. He [Bradford] was out, but we found there painting Van Best [sic], a well-known Dutch painter of marine pieces whom he has attracted to him. He looked and talked particularly Dutchman-like.[15]

Tutored in the Dutch tradition by Van Beest, Bradford was also strongly influenced by the works of Robert Salmon and Fitz Hugh Lane, with whom he came to share many stylistic qualities. According to John Wilmerding, Bradford "is equal to Lane and Salmon in his feeling for the fluidity of water, luminosity of light, and precision of drawing."[16] Later in his career, Bradford explored the exotic territories of the Labrador and Greenland coasts, producing brilliant photographs and paintings of those desolate, alien landscapes that were so thrilling to contemporary audiences. His style became more open and grandiose as his popular success increased, but he never strayed from the realist foundations of his earlier work.

The Foster Collection contains four paintings by William Bradford, including a depiction of the schooner yacht *America*, which is discussed in the chapter on "American Yachting Art" (see Plate I.3 above). An early work by the artist, *Schooner Yacht* Bessie *off Newport* (Plate III.15), shows *Bessie* at anchor in calm weather over a placid stretch of water broken only by tiny ripples. A U.S. revenue cutter under auxiliary steam power occupies the middle background behind another anchored

vessel. The black wisps of the revenue cutter's exhaust together with the skimming forms of seabirds above the water and the approach of a small rowboat create the only hints of motion in the expansive stillness of the scene. An even, radiant light coats the horizon and plateau of water, producing clusters of curious shadows on its otherwise undisturbed surface. The painting was the result of one of Bradford and Van Beest's sketching excursions to Newport.

The growing maturity and individuality of Bradford's style can be traced in *The Mary of Boston Returning to Port* (Plate III.16). Van Beest's influence led Bradford to create more narrative interest in his paintings with the inclusion of working crew aboard, more realistic rendering of weather and water, and by emphasizing the interaction between vessels in the composition.[17] Here the packet sloop *Mary* with three men aboard approaches an outbound half-brig that passes in turn before the receding shapes of two inbound schooners. The result is a pleasant progression of decreasing forms ending in the distant outline of Castle Island and Fort Independence in the right background. With his skillful treatment of the pressing waves and the palpable motion of the light winds, Bradford achieves an impressive scene in a characteristic style.

Fitz Hugh Lane's early 1850s harbor views under varying light conditions had an important influence on Bradford. In some of his compositions, Bradford even seems to be painting "out of Lane's handbook."[18] In 1859, Bradford and Lane held a two-man show in Boston. Lane's influence on Bradford is clearly visible in the magnificent sunset harbor painting *Ships in Boston Harbor at Twilight* (Plate III.17). An inbound square-topsail schooner and an outbound half-brig rest against an immense horizon of glowing yellow-orange light. As daylight recedes, the fading sunlight washes over the vessels and the buildings along the Boston skyline in the distance, including the dome of the State House visible at the far right. The level stillness of the water and the radiant air surround the entire scene in a transitory brilliance that seems to preserve a moment in time.

Two Marine Paintings by James E. Buttersworth

The Foster Collection includes two American marine paintings by James E. Buttersworth (1817–1894) (see the "American Yachting Art" chapter for further details of Buttersworth's life and career and other Buttersworth paintings in the collection). The canvas entitled *The Clipper Ship* N. B. Palmer *at Anchor* (Plate III.18) shows the impressive A. A. Low & Brother extreme clipper ship *N. B. Palmer*, de-

signed and built by Westerveldt & Mackay at New York, using the ideas of shipmaster and New York Yacht Club member Nathaniel Brown Palmer. Launched in 1851, the 1,399-ton vessel proved to be one of the swiftest of the new generation of China clippers. Buttersworth experiments here with a technique of rendering water and wave resembling the work of Robert Salmon and his Dutch predecessors. In *American Ships under Sail with Vessels to Port and Starboard* (Plate III.19), Buttersworth combines a New York yachting scene with the portrayal of a merchant ship. The merchant vessel is shown shortening its sails as it approaches the Narrows, splitting the schooner and sloop racers down the middle of the composition as all vessels struggle through the same forceful seas.

A YACHTING SCENE BY EDWARD HOPPER

THE FOSTER COLLECTION INCLUDES a rare yachting scene by American artist Edward Hopper (1882–1967). Although better known for his cityscapes, Hopper occasionally turned his attention to marine subjects such as abandoned lighthouses, dune scenes, sailboats, and views of open sea. Columbia *and* Shamrock, *America's Cup, 1899* (Plate III.20) is his only known portrayal of a yachting scene. It shows the 1899 America's Cup defender *Columbia* pitted against Sir Thomas Lipton's *Shamrock* in a crowded setting surrounded by steamboats and observation vessels. The loose, fluid handling of the water and rigging and the busy fanfare of boat traffic in the background provide an interesting contrast to the more technical and reserved watercolor approach of Frederic Schiller Cozzens (see chapter on "American Yachting Art"). Hopper's rendering of the America's Cup scene provides an excellent illustration of an American master venturing into the subject matter of marine painting.

1. Richard C. Kugler, *William Bradford: Sailing Ships & Arctic Seas* (London and Seattle: New Bedford Whaling Museum and University of Washington Press, 2003), p. 7.

2. John Wilmerding, *A History of American Marine Painting* (Boston: Peabody Museum of Salem, 1968), p. 68.

3. Ibid., p. 68.

4. Carl L. Crossman, *The Decorative Arts of the China Trade* (Woodbridge, Suffolk, U.K.: Antique Collectors' Club, 1991), p. 116.

5. Wilmerding, *History of American Marine Painting*, p. 113.

6. John Wilmerding, *Robert Salmon: Painter of Ship & Shore* (Boston: Peabody Museum and Boston Public Library, 1971), p. 113.

7. Wilmerding, *Robert Salmon* p. 62, and *A History of American Marine Painting*, p. 129.

8. Wilmerding, *A History of American Marine Painting*, p. 158.

9. Ibid., p. 158.

10. Ibid., p. 165.

11. Ibid., p. 165.

12. From *An Introduction to Yachting* (New York: Sheridan House, 1963), pp. 60–61, quoted in James Taylor, *Yachts on Canvas: Artists' Images of Yachts from the Seventeenth Century to the Present Day* (London: Conway Maritime Press, 1998), p. 63.

13. Erik A. R. Ronnberg Jr., "Imagery and Types of Vessel," in John Wilmerding, ed., *Paintings by Fitz Hugh Lane* (Washington, DC: National Gallery of Art, 1988), p. 77.

14. Quoted in Richard C. Kugler, *William Bradford: Sailing Ships & Arctic Seas* (London and Seattle: New Bedford Whaling Museum and University of Washington Press, 2003), p. 4.

15. Quoted in Kugler, *William Bradford*, p. 7.

16. Wilmerding, *A History of American Marine Painting*, p. 194.

17. Kugler, *William Bradford*, p. 12.

18. Wilmerding, *A History of American Marine Painting*, p. 194.

PLATE III.1

The United States
Attributed to Spoilum (active 1774–1806)
Ca. 1800
Oil on canvas
14¾" x 19½"

THIS REMARKABLE PAINTING attributed to Canton artist Spoilum (active 1774–1806) is based on an English print, *The King's Ship Dressed with the Colours of Different Nations,* engraved in 1794. The artist has altered the English ship to resemble the *United States,* shown at the celebration of her commission fully decorated with the flags of all nations and flying an oversized American flag from the stern and a banner from the top of the main mast. Numbers adjacent to most of the flags correspond to oval and triangular designs around the painting's perimeter margins. There are eighty different identified flags. Carl L. Crossman suggests the possibility of an intermediate source print, "This Chinese painting may in fact be derived from an unknown American print which has been altered to resemble the *United States,* since other American versions of the painting exist."

Alan Granby

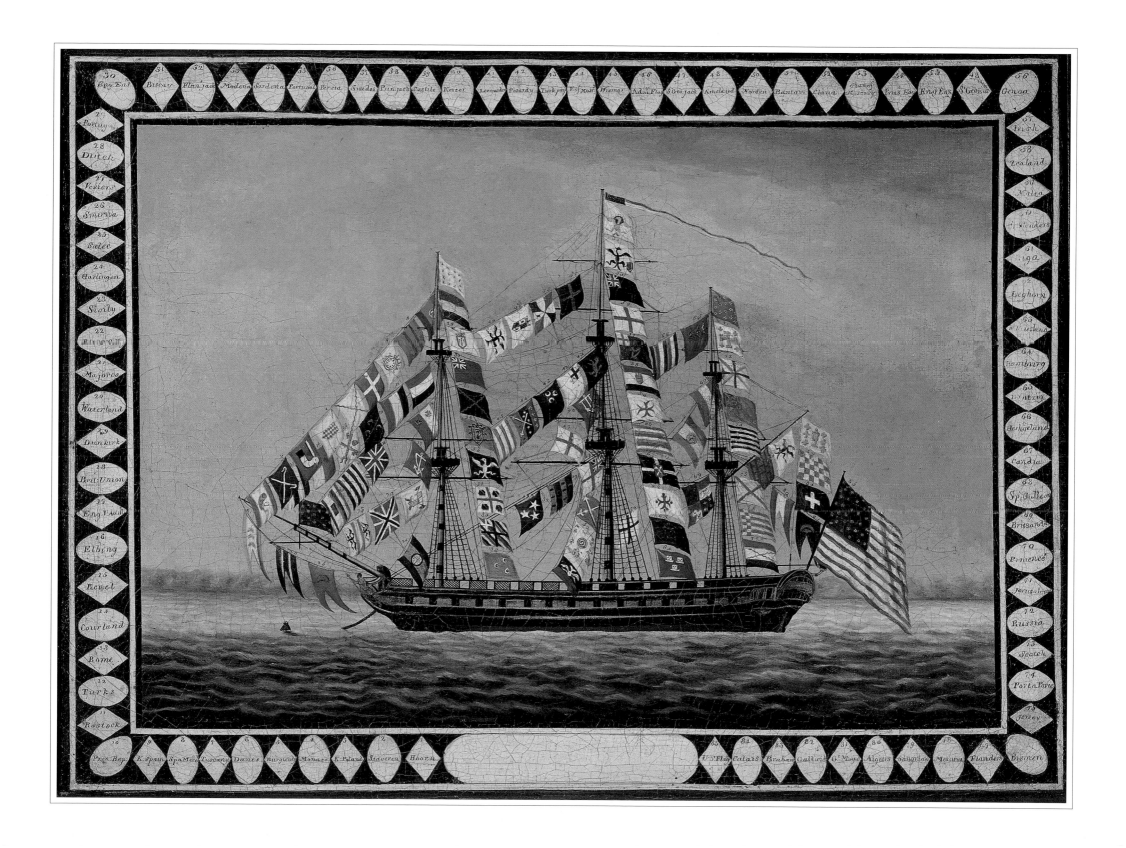

149

PLATE III.2

Captain James Josiah
Charles Wilson Peale (1741–1827)
1787
Oil on canvas
35½" x 26"
Signed, dated and inscribed "Painted by C. W. Peale, 1787"

CAPTAIN JAMES JOSIAH, a master mariner, was the captain and part owner of the brig *St. Croix Packet* which made regular voyages to the West Indies. He was in Philadelphia in March 1787 and returned to the West Indies in early June. At this time, Josiah was persuaded to join the crew of the 290-ton ship *Asia*, whose builder was Josiah's father-in-law, Joseph Marsh. *Asia* was the first Philadelphia vessel specifically built for the China trade. Josiah must have been enamored of the prospect of such an adventurous undertaking, for he agreed to be first mate, or second in command, in order to make the voyage to China. *Asia* was launched on August 16, and Josiah was "put in pay" on August 29. The ship sailed from Philadelphia on December 10, 1787.

Josiah is posed as though in the cabin of a ship, with a brig that may be meant to represent *Asia* visible in the distance. He wears the uniform of a Continental navy captain, as described in the uniform regulations issued in September 1776. Since Josiah had served as a captain during the Revolution, his use of this uniform is appropriate, especially in a portrait that highlights his competency as a ship's officer. On the table is a chart of Asian waters. The inscribed images and words are to some extent illegible, but include "Bonea Bradranca...Motape...Nono...Japan." On the chart is a pair of dividers, and a "tell-tale" compass is secured to the ceiling above.[1]

Alan Granby

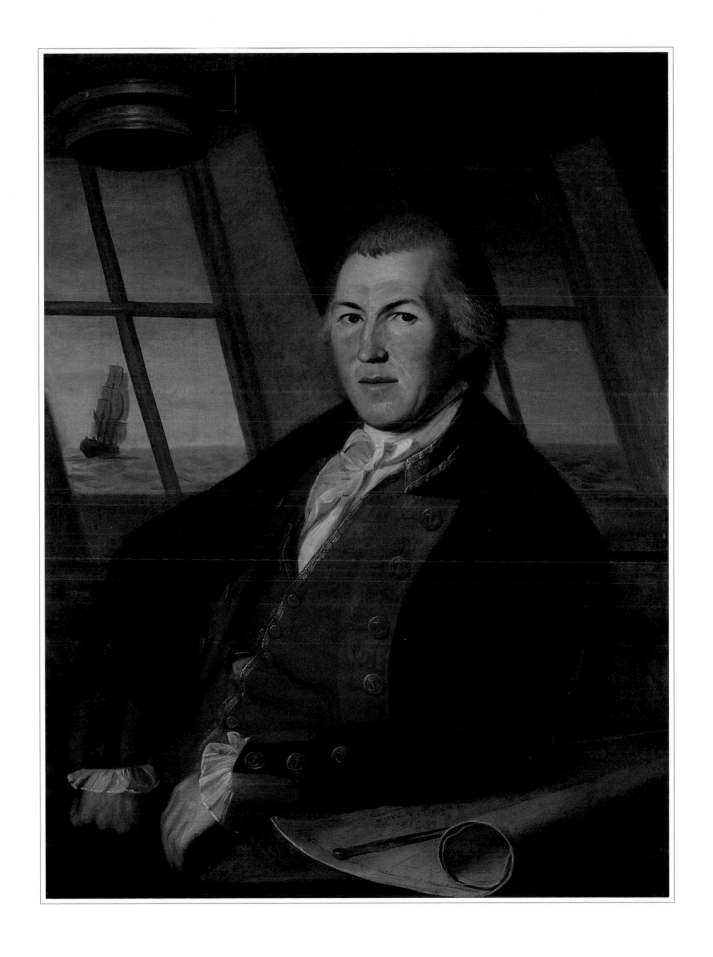

PLATE III.3

The Battle of Lake Erie, September 10, 1813
Ambroise Louis Garneray (1783–1857)
Ca. 1815
Oil on panel
9¼" x 18"

DURING THE WAR OF 1812, Canada remained fiercely loyal to Great Britain and therefore found itself the scene of most of the land-based action of the conflict. In an effort to support the American military campaign in the north, two U.S. Navy officers were sent to the Great Lakes in August 1812 to supervise the building of two separate fleets on Lake Ontario and Lake Erie. The British had no alternative but to follow suit, and with remarkable speed constructed their own fleets on opposite banks of the huge lakes. In the event, no major engagement took place on Lake Ontario, whereas the two fleets stationed on Lake Erie eventually met in a decisive battle almost unique in the annals of waterborne warfare.

The two squadrons—neither quite large enough to justify the term "fleet"—were fairly evenly matched and consisted mostly of brigs and sloops-of-war supported by armed cutters. By the middle of 1813, Master Commandant Oliver Perry's American flotilla of two brigs, two sloops-of-war, and five smaller craft was fully manned and ready for action. On August 12 it sailed from Erie and anchored at Put-in-Bay (near Sandusky) from which point Commodore Barclay's English squadron could be observed at its base at Malden across the lake. After a month's wait, the two sides sailed out on the morning of September 10 and Perry prepared to engage the enemy using a previously agreed plan. Unfortunately, Perry's flagship, the *Lawrence* (named for the deceased Captain Lawrence of the *Chesapeake*), soon became the target of the three largest British vessels, and was reduced to a wreck within two hours. Perry transferred his flag to the undamaged *Niagara*, the *Lawrence*'s sistership, and gave the signal for close action. The American fire proved so accurate that within an hour every British vessel had surrendered and Perry was able to send his famous message, "We have met the Enemy and they are ours," to the commanding general ashore. It proved an historic victory and put all of Lake Erie and its strategic hinterland under American control.

Numerous prints and engravings were produced to commemorate this victory. Garneray's work closely resembles the second pair of views of the battle painted by James Webster and subsequently engraved for publication on July 26, 1815, by Murray, Draper, Fairman & Co. of Philadelphia.

Alistair Laird

Plate III.4

The Capture of HMS Macedonian *by the American Frigate*
United States, *October 25, 1812*
Ambroise Louis Garneray (1783–1857)
Ca. 1813
Oil on panel
9" x 13¾"
Signed "Garneray" (lower left)

THE ANGLO-AMERICAN WAR OF 1812 witnessed several justly famous frigate
actions, the second of which was fought out in the Atlantic, west of Madeira on
October 25. The American forty-four-gun frigate *United States*, under the command
of Commodore Stephen Decatur, was under orders to attack and destroy British
merchant ships when she encountered HMS *Macedonian*, a thirty-eight-gun frigate
of the Royal Navy and one of the newest in the fleet. *Macedonian*, commanded by
Captain John Carden, had sighted the strange ship just after daybreak, and by 7:30
A.M. had identified her as a large American frigate of superior firepower. Never-
theless, Carden prepared to engage her, and the two frigates exchanged broadsides
at about 9:00 A.M. *Macedonian* then wore round and closed the *United States* on her
larboard quarter, thereby provoking a furious bombardment from the American's
longer 24-pounder guns and powerful 42-pounder carronades. *Macedonian*'s mizzen-
topmast was soon shot away and when its rigging fouled her maintop, she lost
much of her maneuverability. For the next hour and a half, the *United States* poured
a relentless fire into the British frigate, ripping her rigging to shreds, shattering her
hull, and bringing down her mizzenmast along with her fore- and maintopmasts.
All but two of her upper deck guns were dismounted and she had a large number
of casualties, but still Carden fought on. After a failed attempt to board *Macedon-
ian*, the *United States* then made ready to rake her adversary's stern. At that point,
Carden realized that further resistance was useless, and struck his colors. Decatur
accepted his surrender gracefully, the second British capitulation in two months,
and sent *Macedonian* into Newport, Rhode Island, under command of Lieutenant
W. H. Allen. She was the first American prize of the war—the captured *Guerrière*
taken in August being too damaged to save—and another bitter blow to British
prestige on the high seas.

This work is a very similar composition to the famous oil of this engagement
by Thomas Birch of Philadelphia, subsequently engraved by Benjamin Turner and
published on October 25, 1813.

Alistair Laird

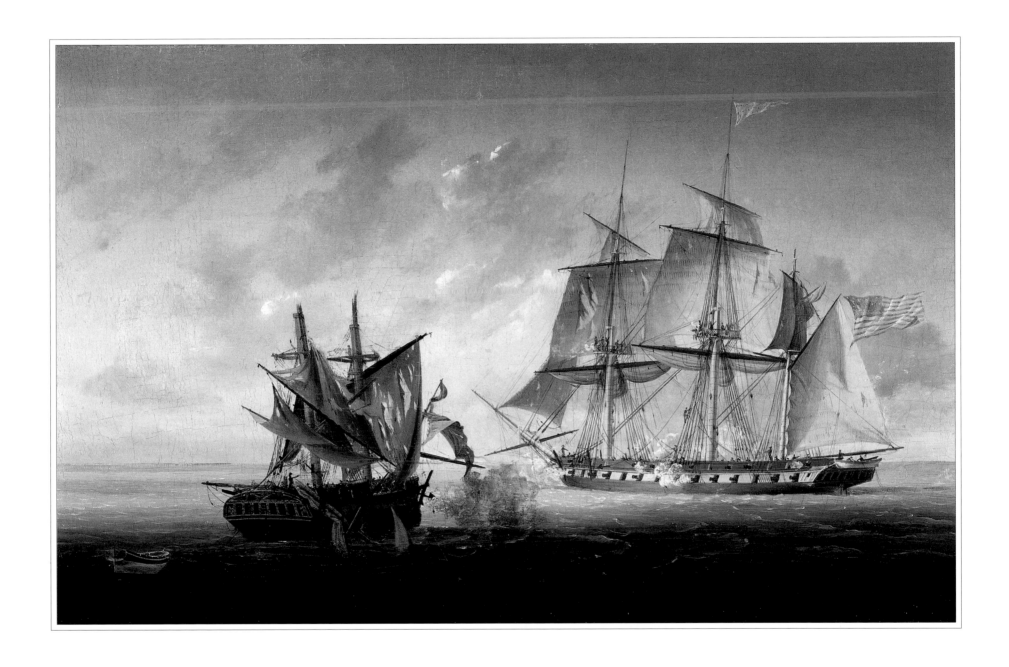

PLATE III.5

The USS Hornet *Attempting to Save HMS* Peacock *after Their Duel on February 24, 1813*
Ambroise Louis Garneray (1783–1857)
Ca. 1813
Oil on panel
9" x 14¼"

AFTER LOSING THREE VALUABLE frigates to the American Navy in the second half of 1812, the Royal Navy got off to an equally bad start the following year. In mid-afternoon on February 24, 1813, off the South American coast of Demerara, the eighteen-gun brig-sloop HMS *Peacock* sighted an unknown vessel heading toward the anchorage she had just left where her companion, the brig-sloop *Espiègle*, still lay at anchor. The stranger was yet a third eighteen-gun brig-sloop, the USS *Hornet*, under command of James Lawrence, on her way home from blockading the Brazilian port of Bahia. *Peacock* was commanded by Captain William Peake. By four o'clock, he could see that the vessel approaching him was an American ship-of-war. After exchanging broadsides from opposite tacks at 5:25 P.M., *Hornet* ran under *Peacock*'s starboard quarter and commenced firing a bombardment so accurate and well directed that within 15 minutes it reduced *Peacock* to a wreck. With Captain Peake already dead and other casualties mounting, *Peacock*'s first lieutenant not only surrendered but also hoisted the ship's ensign upside down as a signal of distress. Both ships then anchored, but it soon became clear that *Peacock* was sinking. Lawrence sent men over to assist her, first with repairs and then with evacuation, but despite these strenuous efforts, *Peacock* sank and three Americans still aboard her were lost. The captain of *Espiègle* was later court-martialed for failing to engage *Hornet*, although he was acquitted due to conflicting reports as to whether he was actually near enough to witness what was occurring.

Commandant Lawrence returned home to receive promotion to captain and a new command, the frigate *Chesapeake*, in which he met his death during her celebrated fight with HMS *Shannon* barely three months later.

Interestingly, Garneray has inaccurately portrayed both vessels in this scene with three masts, when each, as brig-sloops, would have had only two. The confusion probably arose over the term "sloop," which until circa 1780 usually meant a naval vessel of three masts. Contemporary paintings and engravings of this action (as well as another involving *Hornet*) frequently make the same error and ambiguously refer to the two vessels as "sloops-of-war" rather than as the technically correct "brig-sloops."

Alistair Laird

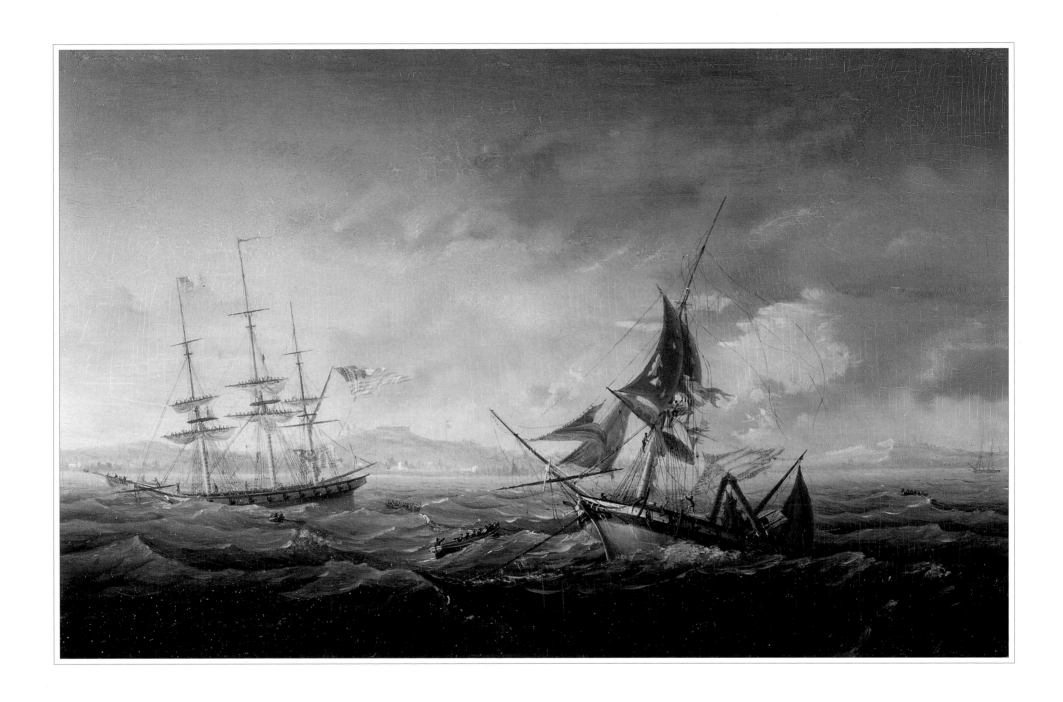

PLATE III.6

View of New York Harbor
Thomas Birch (1779–1851)
Early 1830s
Oil on canvas
19½" x 30"

BASED ON HIS SUCCESS with paintings of naval engagements of the War of 1812, Birch was not afraid to repeat a good composition when demand arose. This version of *View of New York Harbor* is nearly identical to one in the Karolik Collection at the Museum of Fine Arts, Boston. The only significant differences lie in the two merchant ships (left and center middleground) that are sailing in opposite directions, and the merchant sloop in this version (extreme right) is absent in the other. Wave and cloud formations also differ slightly, but the overall effect is the same in both paintings.[1]

Birch was an enthusiastic painter of ships and certainly the first artist in America to make them a specialty and to depict them with accuracy. Like Fitz Hugh Lane, he was not a sailor, so his technical knowledge was gained at wharfside from sailors and officers willing to tutor him and criticize his efforts.[2] Also like Lane, he was receptive to watercraft of all types, from small boats to large square-riggers to the early steamships.

In this painting, the foreground is occupied by two small boats, one under oars and the other under sail. The right middleground depicts two common types of smaller sailing vessels used in coastwise commerce: a sloop (with a single mast) and a schooner (with two masts). The schooner—actually a variant of the type called a topsail schooner—carries two yards at the foremast for setting square topsails. These extra sails indicate that she is intended for longer coastal voyages, possibly venturing into the Caribbean.

The two large sailing ships (three-masted square-riggers) are typical of large freight carriers in the transatlantic trade, sailing to Europe with raw materials (such as cotton and furs) and returning with finished goods unobtainable in America.

At far left is an early steamship in the coastal trade, carrying passengers and high-value goods to ports in southern New England or the Delaware Bay region. This example represents the second generation of pioneering steamships, fitted with a pair of boilers (hence two smokestacks). The boilers were mounted on the paddle-wheel sponsons (support frames) abaft the paddle wheels for better safety. Boiler explosions were all too frequent at that time, and this arrangement lessened the risk of rupturing the hull and sinking as a consequence.

Glen Foster, a skilled navigator with a navigator's sixth sense of direction, must have sensed the complementary nature of this painting and *The Battery and Harbor, New York* (Plate III.7), which Birch must have painted about the same time. The two views and vantage points are in precise opposition to each other. *The Battery and Harbor* looks to the southeast and *View of New York Harbor* looks to the northwest on almost exactly the same line of sight.[3] Only the disparity in size of the two canvases would rule out the possibility that they were originally a pair.

Erik A. R. Ronnberg, Jr.

158

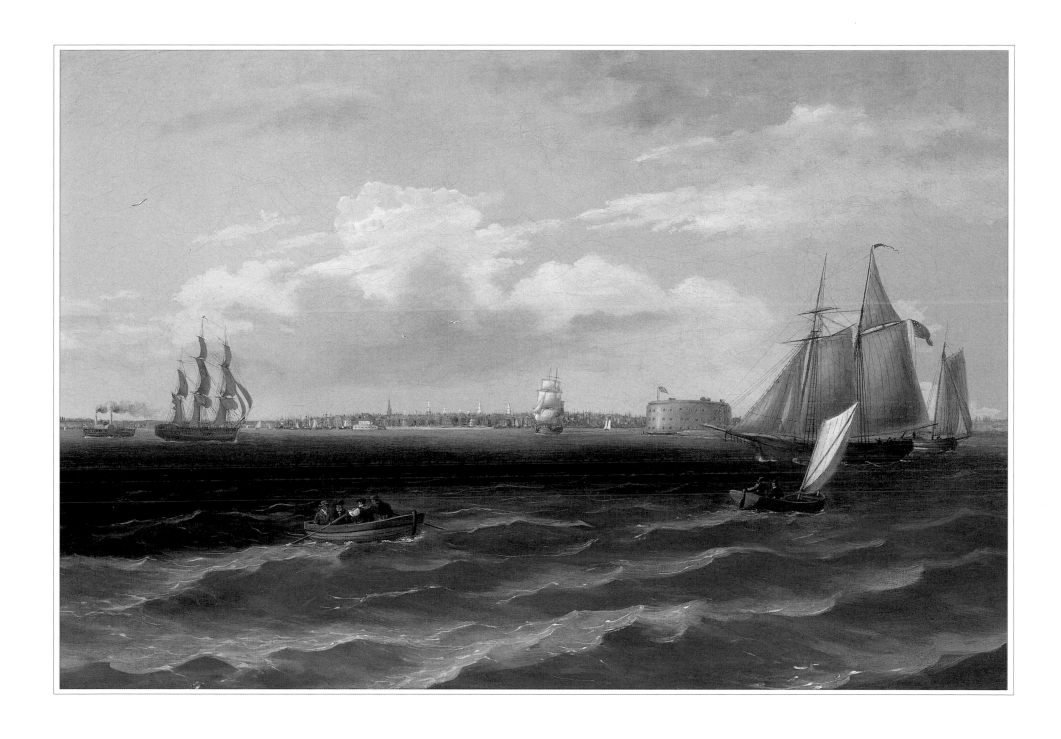

PLATE III.7

The Battery and Harbor, New York
Thomas Birch (1779–1851)
Early 1830s
Oil on canvas
29" x 41"

FROM THE VANTAGE POINT of the Battery, the viewer is looking southwest, toward Staten Island with Castle Williams in the left middleground and the New Jersey shore rising in the distance.[1] At the extreme left, a merchant sloop with a square topsail is tacking out of the entrance of the East River. The merchant ship at left center is hove-to, possibly to await berthing at a wharf. In the right background are two ships at anchor; the one at right is possibly a naval frigate. Numerous smaller vessels under sail are probably coastal traders, following the Staten Island shoreline to and from destinations in New Jersey via the Kill Van Kull.

Birch's expansive vistas and uncluttered compositions are typical of his port scenes from the late 1820s and 1830s. A bright, sunny atmosphere, combined with the cheerful crowd in the foreground, gives a foretaste of the depth, atmosphere, and play of light so much admired in American paintings of two decades later.[2]

Erik A. R. Ronnberg, Jr.

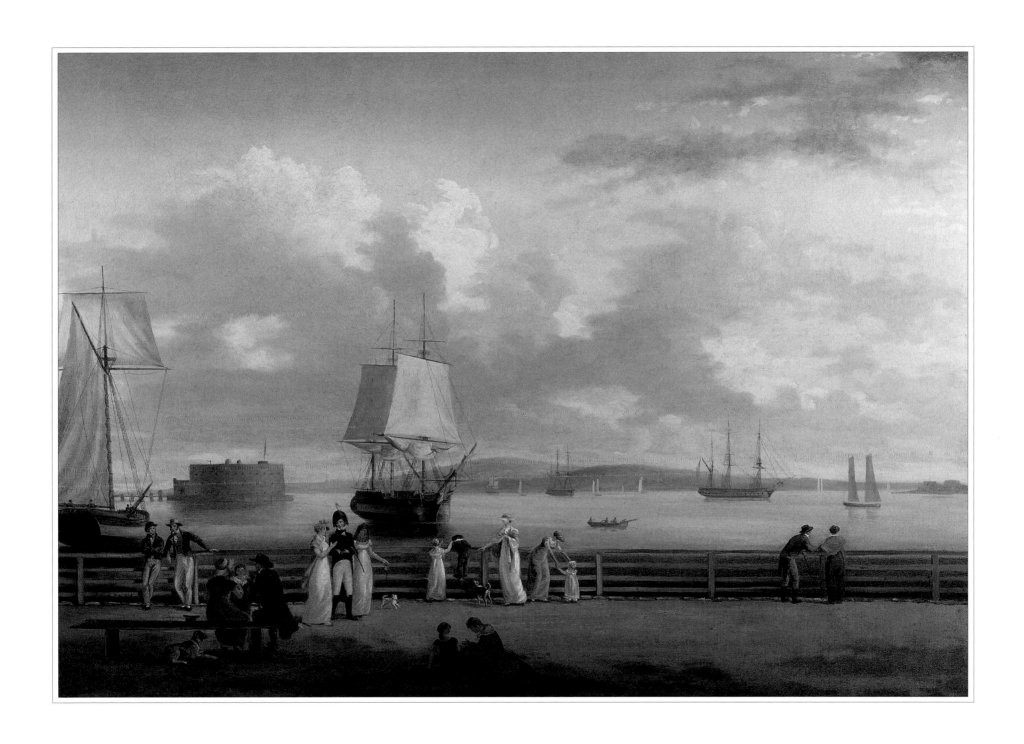

PLATE III.8

The Bark Marblehead Coming into Port

Robert Salmon (1775–after 1845)
1832, revised 1836
Oil on panel
15½" x 23½"
Inscribed "No. 771 painted by R. Salmon, 1832, and no. 851 1836 R.S." (on reverse)

IN HIS LIST OF PAINTINGS, Salmon wrote the following entry for this painting: "No. 771 12½ Day, 24 by 16, Portrait of the Bark Marbell head for Mr. Hoper. Not liked, returnd and repaint for self."[1] The bark *Marblehead* was built at South Boston in 1832; her owners have not been found in published records.

As she enters the main shipping channel at the entrance to Boston Harbor, *Marblehead* leaves Boston Light on her starboard quarter. Home from her voyage, she flies the Union Jack at the fore truck, a homeward-bound pennant from the main truck, and the American ensign from the ensign gaff. The crew has begun to shorten sail, having clewed up the main course and preparing to clew up the fore. Next will come the spanker topsail and the fore- and maintopgallant sails. *Marblehead* will sail the final leg to her mooring under fore- and maintopsails, the jibs, and the spanker.

Salmon has portrayed his subject as the epitome of good seamanship with sails properly trimmed; the weather fore sheet is nipped to the chainplates so it will not trail in the water. The weather shrouds and backstays are under tension while their leeward counterparts hang slack; most of the running rigging hangs in graceful catenaries. Given the attention to detail, why did Mr. Hoper reject this painting?

The most likely reason is the painting's unusual vantage point and the trim of the bark's sails. The composition is a distinct departure from the customary ship portrait—a broadside view with all the sails in outline form, like a sailmaker's plan. In fact, many ship portraits were little more than colored sail plans, and, for clients with little imagination or desire for anything more, they became the accepted standard of the genre. For artists like Salmon, standard ship portraits were a deadly tedium to be avoided. One way to lessen, if not avoid, the tedium was to portray a vessel from an unusual angle with sails and gear conforming to real situations and correct seamanship—if the client was agreeable.

On the return of the painting from Mr. Hoper, Salmon kept it until 1836, reworked it, and assigned it a new number: "No. 851 24 by 16. 2 Day Portrait of the Bark Marbell head, not liked, Repaint for self on specu. Solld Auction in Boston, 1835 [should be 1836]. $25."[2] Salmon did not give up on his creations, but neither did Mr. Hoper give up his quest for a Salmon portrait of his ship. In his entries for paintings done in 1833, Salmon wrote: "No. 787 6 Day, 24 by 16, Ship Marbell head, second time, for Mr. Hoper. $35."[3]

There is no indication of further dissatisfaction on Mr. Hoper's part. It would be interesting to locate the second painting of *Marblehead*, if for no other reason than to find out by comparison what kind of ship portrait pleased this customer. More interesting yet would be to study this painting under X-ray to see what kind of changes Salmon made to please himself.

Erik A. R. Ronnberg, Jr.

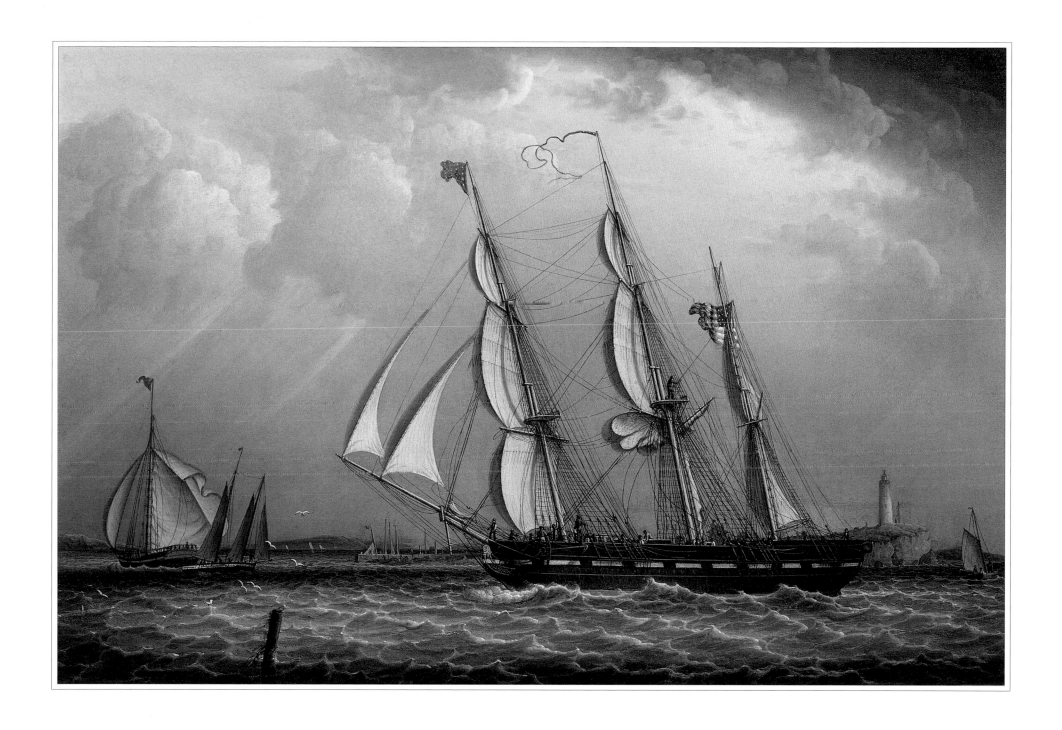

PLATE III.9

A Schooner with a View of Boston Harbor
Robert Salmon (1775–after 1845)
1832
Oil on panel
16" x 23½"
Signed "RS 1832" (lower right) and inscribed "No. 756/Painted by R Salmon/
Anno 1832" (on reverse)

SET AGAINST A BOSTON SKYLINE shaped by Charles Bulfinch, Asher Benjamin, and Alexander Parris, an American merchant topsail schooner has come to anchor just to the west of Governor's Island. The dome of the Massachusetts State House looms in the cloud shadows of a late-afternoon sky.

The schooner's large, active crew is in the process of lowering the foresail, while aloft, a man on the topsail yard is clearing a fouled buntline in preparation for furling it. Out on the bowsprit, the forestaysail is being gathered into neat, loose bights (folds), which, when snugged down with stops (ropes for furling), will shed water instead of trapping it in the fabric and starting mildew. Farther out on the jib-boom, the jib awaits a similar treatment.

The mainsail, hanging by the throat halyard and with its tack still triced up, is about to be lowered. Midway up the starboard main shrouds, a sailor pauses to glance at the activity around the foremast before proceeding aloft to clear the homeward-bound pennant, which has gotten fouled in the main boom topping lift. Alongside, the captain's gig is preparing to take the skipper ashore with his business papers for shipping agents, and the logbook, cargo manifest, and other documents for customs officials.

Salmon's record for this painting, which reads, "No. 756. 7 Day, 24 by 16. A schoner with a View of Boston. Solld to Mr. Langdon. $30."[1] gives no clue to the vessel's identity or her owner or agent, whose house flag at the foretruck has not been identified. Was "Mr. Langdon" one Joseph Langdon, a shipping agent operating at Smyrna in the late 1820s, who employed Robert Bennet Forbes in his first voyage to China with a cargo of opium?[2] This schooner does not match any of the vessels Forbes commanded in this period, but may have been managed by Langdon on voyages under other shipmasters. In size and rig, she is very similar to other fast schooners employed in the opium trade.

Whether an opium trader or not, this vessel's appearance betrays a willingness to go in harm's way, to destinations where an armament—or the appearance of being armed—was essential to survival. Lucrative trade brought American merchantmen to parts of the world where they were fair game for pirates or corrupt governments, or—in the case of the slave trade—where they were viewed as outlaws. Painted gunports were a favorite ruse for unarmed or lightly armed vessels like this one, some of whose ports are obstructed by chainplates, which would have made them unusable.

Stylistically, Salmon's painting shows his indebtedness to Canaletto: in the panoramic setting of the harbor; in the adept handling of perspective; in the wave patterns and reflections on the water; and in the faceless figures whose gestures and purposeful activity make them human anyway. The results are convincing, the seamanship is believable, and the painting is all the more charming for the narrative contained in its details.

Erik A. R. Ronnberg, Jr.

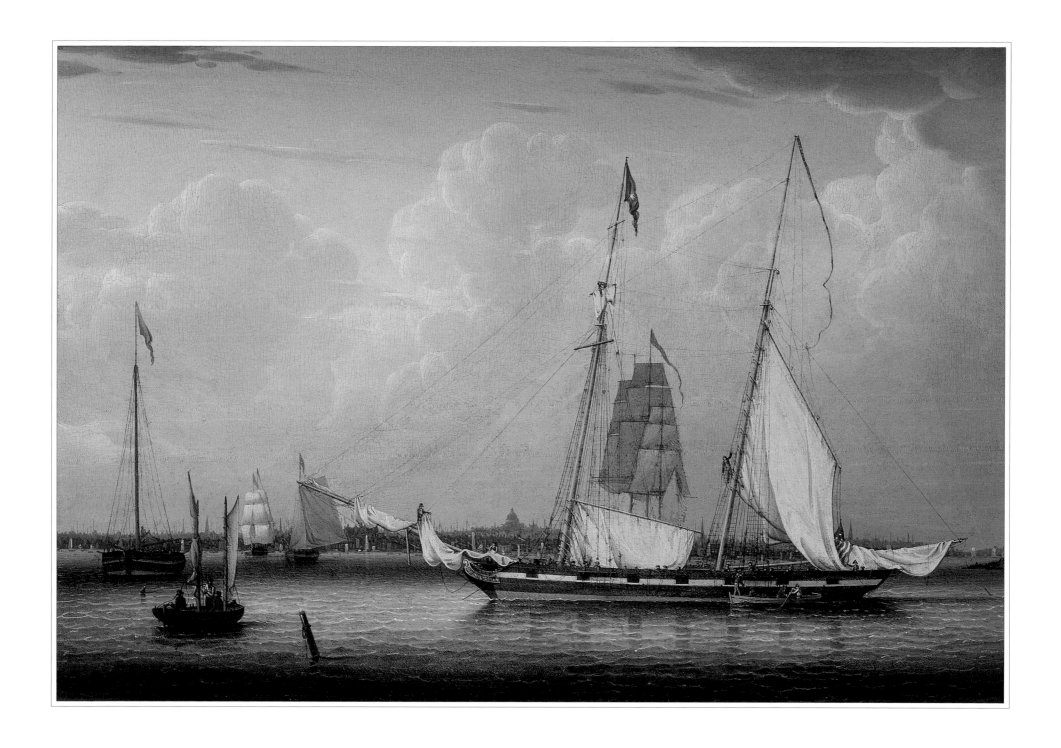

PLATE III.10

View of Boston Harbor
Robert Salmon (1775–after 1845)
1843
Oil on panel
9½" x 11½"
Inscribed "Painted by R.S.A.T. 1843 No. 125" (on reverse)

WHAT MAY BE SALMON'S LAST DEPICTION of Boston Harbor is certainly one of the most delightful paintings in his oeuvre. The high viewpoint from the hill on Noddle's Island is perhaps more imaginary than real, but it affords a wonderful glimpse of East Boston in its early development. If the date of this painting is correct, Salmon had returned to England when he made it and so must have relied on his sketches and memory to reconstruct the geography.

Contemporary maps of Boston and the orientation of Boston's wharves leave no doubt that it is East Boston, and not Charlestown, in the foreground. The shoreline is on the west (Mystic River) side with Boston Harbor at left and center and the mouth of the Mystic River at right. The mouth of the Charles River, Charlestown, and the Boston Navy Yard are too far to the right of this view to be included.[1]

The shipyard in the foreground can only be that of Samuel Hall, the first of dozens of shipbuilders to have yards in East Boston. Hall moved to this location in 1839. A new merchant ship bedecked with flags is being readied for launching; next to her, bow to water, is a vessel hauled out for repairs. At far right, a new hull lies at the fitting-out wharf getting ready to have her masts stepped. Moored just beyond is another with her foremast stepped and its standing rigging being set up.

Two of the finger piers at left and center are landings for steam-powered harbor ferries, a service instituted at the very outset of East Boston's development. The ferry at left (approaching the pier) had been operating between Lewis Wharf and this landing since 1833. The ferry at center is stopping at a midway point between Boston and Winnisimmet, a village soon to be renamed Chelsea.

Harbor traffic, ever busier in this seaport, is dominated by several merchant vessels—three ships, a brig, and a topsail schooner; no naval vessels are present as they would be moored closer to the Navy Yard. The American merchant ship at left is en route to a wharf for unloading; the British ship at right has just anchored and is lowering sail. The third ship (center), the brig, and the topsail schooner are leaving port. Their sails obscure much of Boston's waterfront, save for the prominent buildings on Long and Central Wharves.

Scattered about the harbor are numerous merchant sloops—a type very common to the New England coastal trade in the early nineteenth century. Ideally suited for carrying small cargoes to and from neighboring ports, they were the waterborne equivalent to today's delivery trucks, and as vital to commerce then as trucks are today.

This painting sums up in miniature what Salmon had learned from studying Canaletto's great cityscapes of Venice and London: the elevated viewpoint, the panoramic skyline, the deft handling of perspective, and the human presence. The overall result is a splendid vista of a thriving seaport on the verge of major expansion and industrial growth—all on a wood panel that is three-quarters of a square foot in area!

Erik A. R. Ronnberg, Jr.

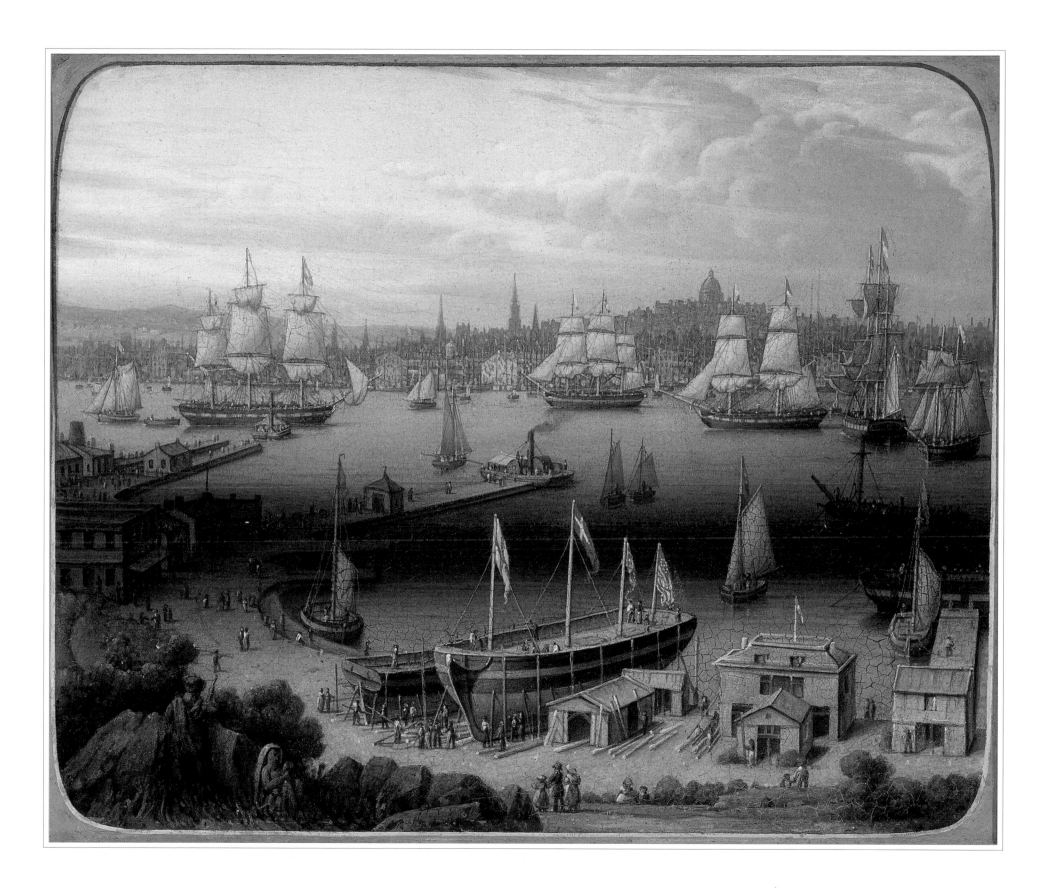

PLATE III.11

American Schooner under Sail with Heavy Seas
Robert Salmon (1775–after 1845)
1834
Oil on panel
15½" x 23½"
Signed and dated "R. S. 1834" (lower right), inscribed "No. 799/Painted by R. Salmon 1834" (on reverse)

CAUGHT IN A FRESHENING BREEZE, an American naval schooner heels dangerously as her crew struggles to douse the jib and gets ready to put another reef in the square fore-topsail. The tack of the mainsail has been triced up to spill some wind and allow the vessel to right herself.

The title of this painting finds itself in heavy seas when the entry for Number 799 in Salmon's list of paintings is consulted: "No. 799. 7 Day, 24 by 16, Inglish schoner, strong brise, on specul. soll private, 1836, $30."[1] Evidently, this painting originally depicted an English naval schooner and then languished in Salmon's studio unsold for two years. A "re-flagging" and presumably other minor changes would have made it more appealing to an American buyer. As in the case of Salmon's first painting of the bark *Marblehead*, the artist was willing to revise his work to make it more saleable.

Arguments have been made (presumably without consulting Salmon's list) that this painting depicts either the American naval schooner *Alligator*, built at Boston in 1821, or the naval schooner *Boxer*, built at Boston in 1831. In the case of *Alligator*, there is no resemblance to the bow and figurehead carvings in the painting; moreover, this vessel was lost at sea before Salmon arrived in America. *Boxer* does bear a stronger resemblance, and Salmon would have seen her, but there are still differences. If Salmon had reworked this painting to depict one of these vessels with accuracy, why did he not give the schooner its identity? Lacking better evidence, it is pointless to speculate further.

The setting for this painting is almost certainly the English Channel, hence the heavy traffic and multitude of nationalities. The ship at far left is bound for a French port, the French flag at her main truck indicating her destination. At right, a ship flies what seems to be a confused version of the Norwegian merchant ensign used after that country went from under Danish to Swedish sovereignty.[3] In the far right background, a ship under topsails flies the British merchant ensign. The signal flags at the naval schooner's foretruck do not belong to any of the more common signal systems, English or American, so they are components either of a short-lived system or of Salmon's imagination.

Erik A. R. Ronnberg, Jr.

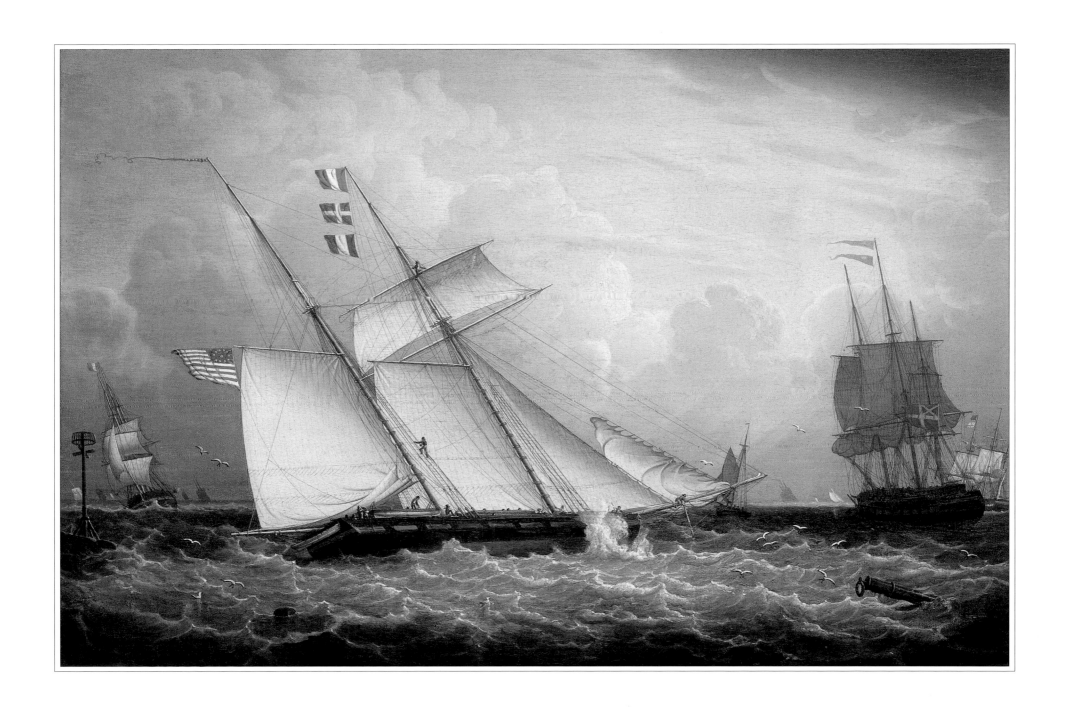

PLATE III.12

Ship Star Light *in Boston Harbor*
Fitz Hugh Lane (1804-1865)
Ca. 1854
Oil on canvas
23¾" x 25½"
Unsigned

LYING AT ANCHOR IN BOSTON HARBOR, the clipper ship *Star Light* dries her sails in the warm still air of a summer morning. Other vessels lie becalmed except for the ship in the right background being assisted by a "steam propeller" as tugboats were then known. In the left foreground, an open boat with a cargo of miscellaneous objects has given up on the wind and returned to shore under oars.

With *Star Light*'s jibs partially raised and her yards in lowered positions, the squaresails "hanging in the gear," Lane is demonstrating his knowledge of practical seamanship; *Star Light*'s master is taking care of the new ship's sails. Some of the cotton canvas is almost ⅛ inch thick and all of the sails are hand-stitched, but they must be correctly treated or they will not draw properly. Any dampness in furled sails was an invitation to mildew, so it was necessary on calm, dry days to unfurl them to dry out.

Star Light was built for the Boston firm of Baker & Morrill and was launched from the South Boston shipyard of E. & H. O. Briggs on February 11, 1854. Regarded as a medium (as opposed to extreme) clipper, she made several fast passages to San Francisco, returning via the Far East.[1] Lane probably saw and sketched her after her launch and fitting-out, returning to his Gloucester studio to do the painting. He may well have had access to the sailmaker's plan to establish accurate proportions for the rigging and sails.

Lane's ship portraits are highly individualistic in terms of composition and narrative content, reflecting a style full of curiosity and little patience with the highly repetitive ship portraits ground out by other artists. The careful posing of the vessels, the pier head, and the drifting log in the foreground all lead the eye to the main subject which, unlike other ship portraits, remains gracefully confined to her setting instead of straining to sail out of it.

Equally important is the narrative which Lane worked into his compositions. His pictures tell stories which add meaning to the whole when the portrayed aspects of seamanship are understood. Each of his ship portraits shows its subject in a different situation which creates a different composition. The narrative content even extends to the surrounding elements (sea, weather, other vessels, wharves, etc.) that behave in ways consistent with the subject's activity. The only other artist equal to Lane in this aspect was Salmon, which is why the relationships between these two artists, their work habits, and their paintings deserve further study.

Erik A. R. Ronnberg, Jr.

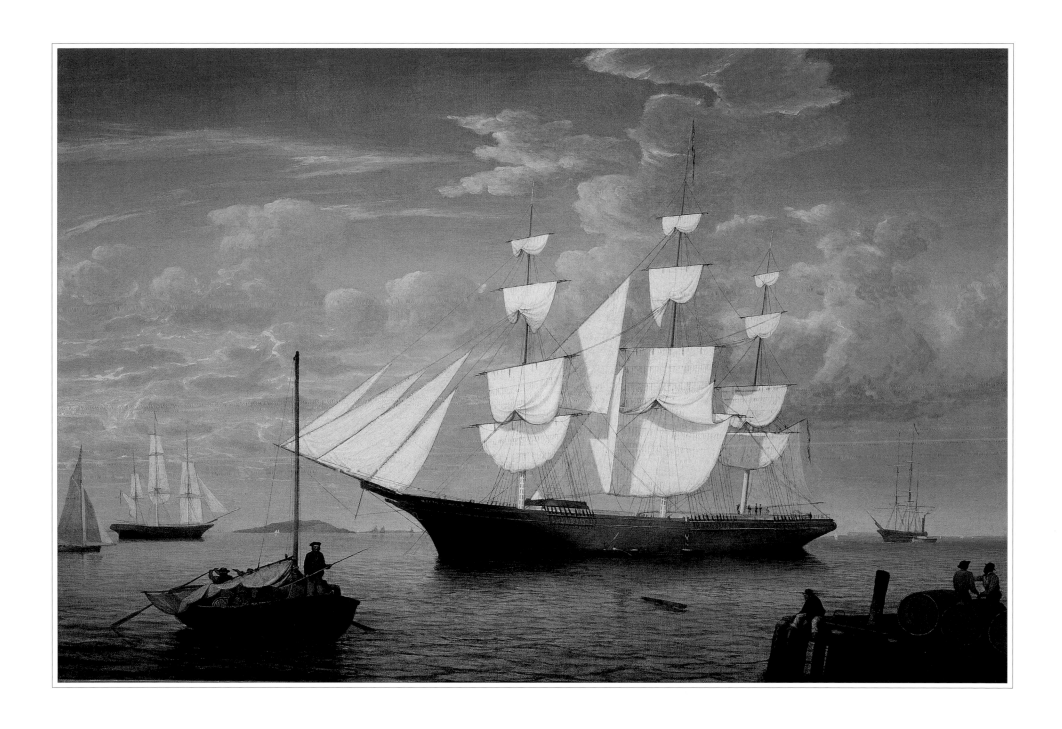

PLATE III.13

The Ship Michael Angelo Entering Boston Harbor

Fitz Hugh Lane (1804–1865)
1849
Oil on canvas
26" x 36"
Signed and dated "F H Lane 1849" (lower right)

The following is excerpted from a letter from Erik A. R. Ronnberg, Jr. to Glen Foster dated December 30, 1998:

LANE'S PAINTING OF THE Boston merchant ship *Michael Angelo* depicts the vessel in-bound to Boston, hove-to to pick up a pilot before proceeding into port. The land in the background suggests the north shore of Boston, possibly east of Cape Ann, looking to the west northwest. It is still morning with the sun in the southeast. The lighthouse in the background may be the south tower of the twin lighthouses on Thatcher's Island.

The pilot schooner at right, flying the blue and white flag, is about to head up under the ship's stern and send a pilot over in the "canoe" she is towing astern. Lane's depiction of the ship heaving-to is a textbook example of this maneuver. The sails of the fore and mizzen masts are drawing normally with the ship on a beam reach (wind blowing at 90° to the vessel's long axis); the main topsail and topgallant sail have been heaved aback, thus diverting their driving power in a direction opposite to, and counteracting the other sails. The only jib still set (the flying jib was just hauled down and the inner jib is snugly furled) is luffing, adding nothing to motive power, but ready to be hauled taut for tacking maneuvers after the pilot has boarded and the ship's course resumed.

Another sign of a returning vessel is the port anchor at the cathead (the starboard anchor is presumably in the same state). So rigged, it is ready to release when the anchorage is reached. There are men at work at the cathead, possibly getting the anchor ring stopper ready so at a signal, it releases the anchor ring and the anchor drops.

At the main masthead is the vessel's name pennant, flown in place of the house flag. At the mizzenmasthead are four codes flags from Elford's Marine Telegraphic flag system, which was very popular with Boston-owned ships and appears frequently in Lane's pictures of them. The flags in this case read "1 1 2 4" which I have been unable to check for lack of a copy of the code directory. In my research on other Lane ship portraits, I've found that he used the codes accurately, so I'd be surprised if this example were in error.

The one oddity in Lane's depicting these flags is that they are red and white, whereas Elford described his system as using only blue and white flags. Some historians have suggested artistic license, pointing out Lane's fondness of clothing his figures with red shirts, but this subject seems too technical to have permitted the artist such freedom. Elford's system used only seven different flag patterns to produce four-digit codes, so the numeral combinations were limited, to the point of forcing the use of duplicate codes by vessels of different rigs (a ship and a schooner could fly the same flag combinations, their rigs being the only distinguishing characteristic). Different flag colors may have been resorted to by Boston merchants to accommodate the system to more vessels. This happened with other early American signal systems, and Lane's paintings may well document an otherwise unrecorded modification to the Elford flags.

At the spanker gaff is the American ensign with the stars in the canton arranged in a circle with one large star in the center. This was a common alternative to the star-shaped constellation found in other merchant ensigns from this period.

The rest of the picture is authentically busy in fine "coaster fashion" with typical examples of half-brig (hermaphrodite brig) and a (full-rigged) brig in the left background. The vessel behind *Michael Angelo* is another half-brig with her square topsail and topgallant sail set on the foremast, but only the gaff-headed mainsail is set; her main gaff topsail is apparently furled. Even though these vessels are background elements their sails are set and trimmed correctly and with purpose, reflecting Lane's attention to minor detail and his large store of knowledge on matters of seamanship.

The small boat in the foreground is a puzzle. At first sight, it suggests a dory, but the bow profile and stem head are not those of a common fishing dory that Lane depicted so frequently. On the other hand, the gent is sitting in her stern as only a dory could allow, so this must be some local species of coastal dory—maybe an ancestor of the Swampscott dory and others of that type which evolved on the North Shore between Boston and Cape Ann. That's nifty boat handling, steering with an oar, whaleboat fashion, and with that early jib-headed sail!

In sum, I admire the accuracy and detail in Lane's ship portraits, but I am also struck at how much of a story or sequence of action is also contained in these formal images. It's never just a broadside of a ship under sail with no specific situation in mind. I think Lane probably did this to counter the boredom of a highly conventionalized genre. In every one of his pictures, I can feel him chafing against this convention and trying to find something different to add to the scene so it would keep him absorbed in his work. Lane's creativity must have made him impatient with the tedium of repetition, hence his limited output of ship portraits and the surprising degree of innovation we find in each one. Lane painted just enough of them to set a standard by which to judge all other ship portraits.

Erik A. R. Ronnberg, Jr.

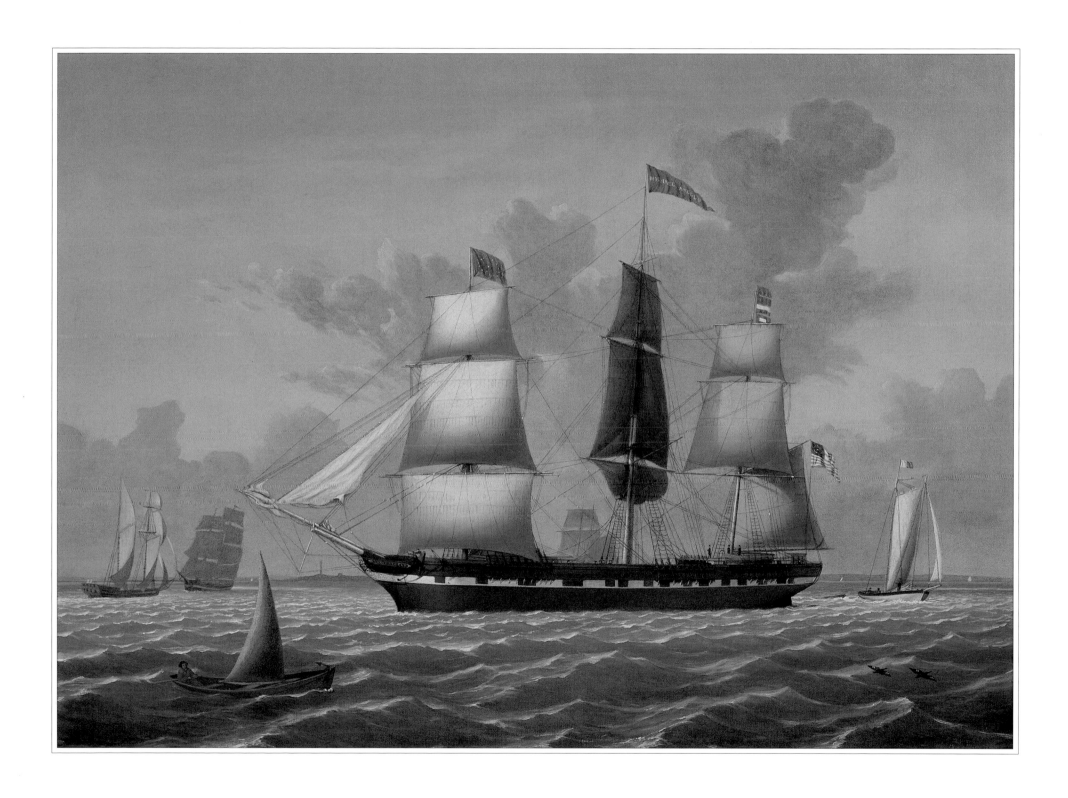

PLATE III.14

Yacht America *from Three Views*
Fitz Hugh Lane (1804–1865)
Ca. 1851
Oil on canvas
18½" x 27½"
Unsigned

FROM THE DATE OF HER launching (May 3, 1851) to the date of her departure for England (June 21, 1851), the schooner yacht *America* was afloat in American waters for only seven weeks.[1] Lane would have been aware of her building, but it is unlikely that he would have taken time to travel to New York to sketch an unproven vessel, particularly if he was preparing another visit to Maine that summer. Under such circumstances, graphic sources for a painting would have been limited and not very accurate. Buttersworth portrayed *America* quite accurately in his painting of her race with the sloop *Maria* (Plate I.1), but its date of completion is uncertain and its derivative lithograph (Plate I.2) wasn't published until 1852.

Lane's painting of this schooner is one of his most unusual ship portraits and one of his most puzzling. While the hull profile and sail plan are unmistakably those of *America,* many details do not agree or are simply absent, raising questions about his sources and when he painted the picture.

The most striking differences are in the deck arrangement, which is devoid of two skylights, a round hatch, a capstan, and a small anchor windlass on the bowsprit heel bitts. The cockpit is long and oval, instead of round, and extends too far forward. In addition, there appears to be a break in the deck forward of the foremast instead of at the main. The most conspicuous error in the rigging is that the shrouds are single instead of double. Also, the forestay sets up to the stem, parallel to the bobstay, and there was an iron rod and turnbuckle connecting the forestay to the fore-masthead. Other minor points are arguable, but not crucial.

The time frame in which Lane painted this picture is quite a narrow one. It has to be before the Dutton lithograph (from the Brierly sketch) arrived in America;[2] otherwise, Lane would have been able to correct many mistakes. That would put the latest date around early November. This leaves May to early November 1851, minus August when Lane was in Maine, as the likeliest period when this painting was done.

Of this picture's many charms and strengths, the artist's attention to the sails is the most attractive, aesthetically and technically. The yacht designer L. Francis Herreshoff, who owned this painting for many years, wrote that Lane had given the sails the shape of perfect airfoils, but one does not need to understand aerodynamics to appreciate the beauty of their forms.[3] Lane became better at depicting sails than any of his contemporaries, including Salmon, giving them not only correct form, but going further in detailing their construction and in exploring the play of light and shadow on canvas in all types of weather conditions. Sadly, his applications of paint in fine lines and thin glazes are so delicate that heavy-handed restorations have obliterated these delicate tones and details in some paintings—a reminder that the conservation of paintings is a heavy responsibility. On a happier note, this painting has received much better treatment than most.

Erik A. R. Ronnberg, Jr.

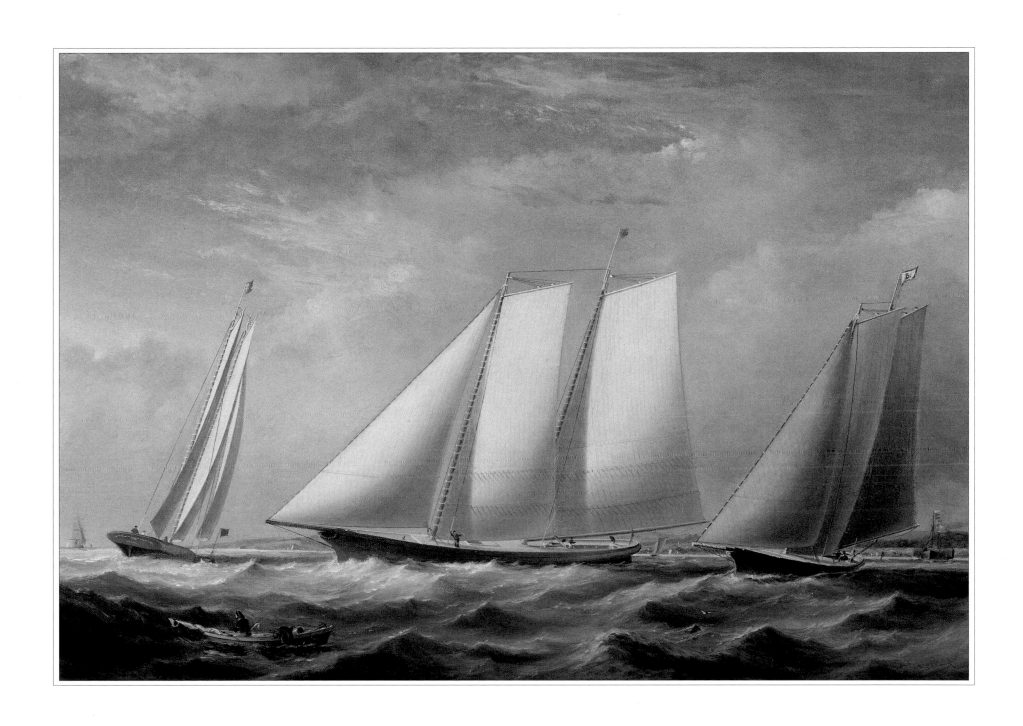

PLATE III.15

Schooner Yacht Bessie *Off Newport*
William Bradford (1823–1892)
1850s
Sepia wash drawing on paper
12" x 18"
Signed and dated "Wm Bradford / 185 [illegible]" (lower right)

THE IDENTIFICATION OF THE schooner yacht in this wash drawing as the *Bessie* is based on William Bradford's notation on a large, undated pencil study of vessels and small craft in the Hart Nautical Collections at the M.I.T. Museum. The setting of the drawing is believed to be Newport, Rhode Island, where the number and type of assembled vessels, including a U.S. revenue cutter with auxiliary steam power and a number of yachts, might be found. Bradford selected *Bessie* as the focal point of the scene, depicting her at anchor in calm air. Besides identifying her by name, he took or obtained measurements of the height and on-deck placements of her masts, as well as the length of their gaffs and booms, presumably for use in reproducing the yacht in a finished painting. Although no such painting is known to exist, the wash drawing may have been a further preparatory study of the *Bessie*.

The wash drawing is likely to date from the mid-1850s, when Bradford and Albert Van Beest, his teacher at the time, made several sketching excursions to Newport. A painter in a looser style than Bradford, Van Beest was much admired for his sepia wash drawings, especially for the rich brown tones he achieved by soaking cigar butts in saucers of water, a practice vexing to Mrs. Bradford when she came upon them in her living room. Bradford made such drawings throughout his career, both in sepia and in black and gray washes, which he found especially useful in capturing passing atmospheric effects.

Richard C. Kugler

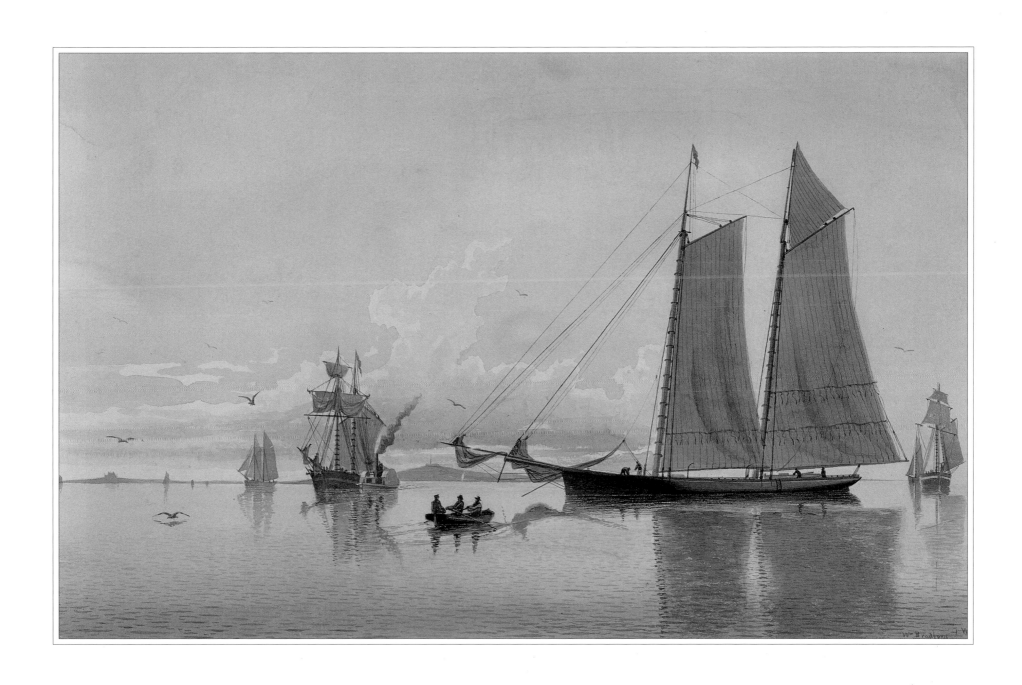

PLATE III.16

The Mary *of Boston Returning to Port*
William Bradford (1823–1892)
1857
Oil on canvas, mounted on panel
19¾" x 29¾"
Signed and dated "Wm Bradford 1857" (lower right)

AFTER TWO YEARS OF PAINTING formal portraits of whalers and clipper ships, William Bradford realized the limitations of the port painter's trade. Recalling how "the broadside of a vessel became absolutely loathsome to me," he set out to develop the painterly skills that would lead him in surprisingly short time to the foremost ranks of American marine artists. Soon after his friend and fellow townsman Albert Bierstadt left New Bedford in 1853 for instruction in Europe, Bradford went to New York City in 1854 and met Albert Van Beest, a recent arrival from Rotterdam trained in the tradition of Dutch sea paintings. At Bradford's invitation, Van Beest came to Fairhaven and for three years worked by his side in a waterfront studio overlooking New Bedford Harbor.

First as teacher, then as colleague and collaborator, Van Beest not only improved Bradford's technical skills, but also introduced him to a broader concept of marine painting. The Dutchman's influence was quickly apparent in Bradford's first expansive seascape, *The Port of New Bedford from Crow Island* (New Bedford Whaling Museum), with its variety of shipping and wharfside activity at a time when the whaling industry approached its peak of prosperity. By the time Van Beest returned to New York in 1857, Bradford's paintings included more realistic skies and water, carefully developed backgrounds, and the animation derived from including men at work at sea.

The Mary *of Boston Returning to Port*, painted in 1857, reflects Van Beest's influence, although in a manner modified by Bradford's more exact and disciplined method of painting. With Castle Island and Fort Independence in the right background, an array of vessels makes its way in and out of the harbor in a fresh breeze under billowing clouds. Three sailors man the packet sloop *Mary* as she reaches across the channel, while a half-brig, outward bound, passes two inbound schooners, one carrying a square-topsail. Within a format now common to him—approximately 18 by 30 inches—Bradford achieved a finely realized scene in a style now recognizably his own.

Richard C. Kugler

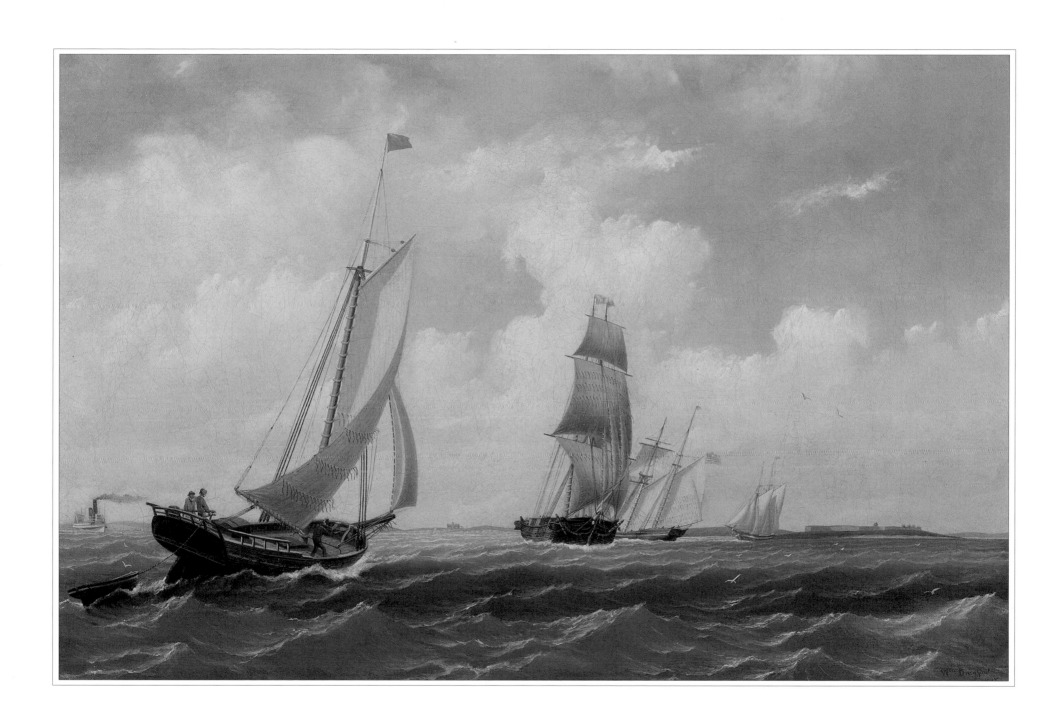

179

PLATE III.17

Ships in Boston Harbor at Twilight
William Bradford (1823–1892)
1859
Oil on prepared millboard
11¾" x 18¾"
Signed and dated "Wm Bradford/1859" (lower right)

BY 1859 BRADFORD'S REPUTATION as a marine artist was well established in Boston. For several years, he had been exhibiting paintings and watercolors at the Boston Athenaeum, and with such dealers as Cotton's Picture Store and the Williams and Everett Gallery. During the winters of 1858 through 1860, he also kept a studio in the Tremont Street Studio Building, participated in its Artists' Receptions, and acquired well-connected patrons. In December 1859, Williams and Everett sponsored a two-man show of his marine views and those of Fitz Hugh Lane, the master marine painter of the time.

Lane's influence on the younger artist, eighteen years his junior, is evident as early as Bradford's first portraits of Boston clipper ships. It can also be seen as Bradford began to paint views of Boston Harbor. His first such effort, *Boston Harbor* of 1856, a large-scale collaboration with Van Beest, relies for its vantage point and measured placement of vessels on Lane's great sunset views of the harbor of the early 1850s. It is Van Beest, however, who leaves his imprint on the painting, with its focus on men at work in small boats in the foreground.

Ships in Boston Harbor at Twilight, on the other hand, is a painting hardly imaginable without the example of Lane's tranquil views of the harbor at the end of the day. Bradford's subject here is a quality of light and stillness, captured at a moment in time when hues of yellow-orange suffuse both sky and water. The city, seen in a purple haze, is on the right, with the dome of the State House barely visible between the masts of two distant ships. A square-topsail schooner in the left center and a half-brig at right lead the eye to the last golden glow of the sun as it disappears below the horizon. It is a fitting painting with which to leave Glen Foster's Bradfords, on the eve of the artist's adventures in the colder waters and harsher contrasts of Labrador and the Arctic.

Richard C. Kugler

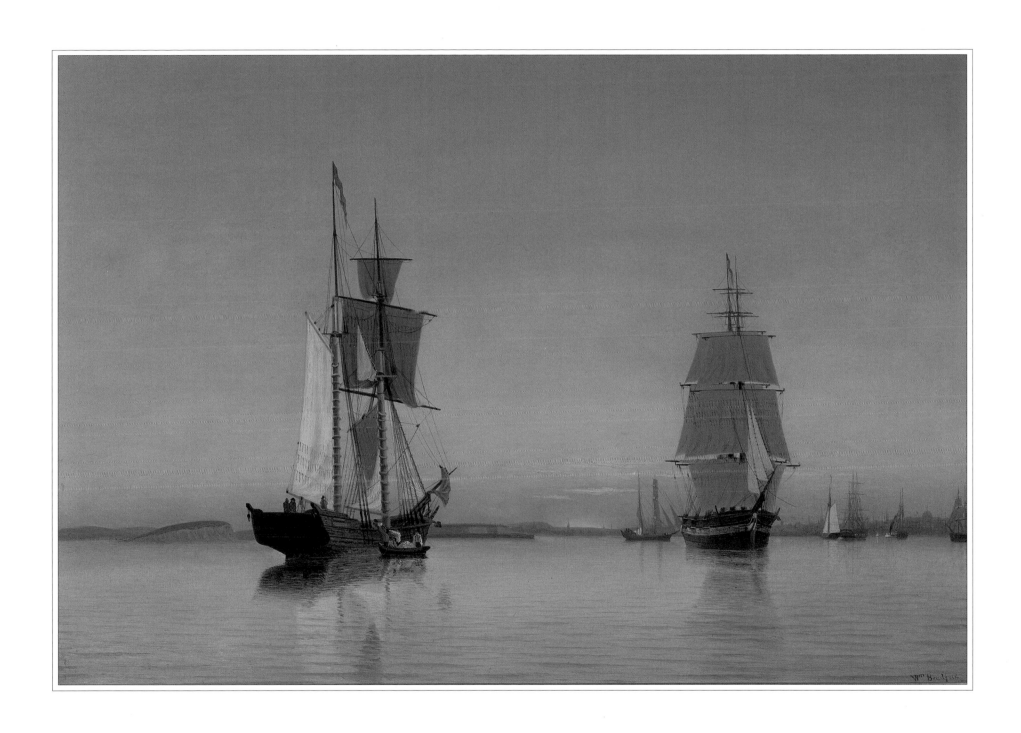

PLATE III.18

The Clipper Ship N. B. Palmer *at Anchor*

James E. Buttersworth (1817–1894)

Ca. 1851

Oil on canvas

12" x 16"

Signed "J. E. Buttersworth" (lower right)

HAVING ENTERED NEW YORK HARBOR under topsails, topgallant sails, two jibs, and clewed-up courses, the deep-laden clipper ship *N. B. Palmer* has dropped her anchor and is swinging into the wind as a busy crew lowers the topgallant yards, leaving the sails "hanging in the gear." Next, the topsails will be lowered; they and the topgallants will be clewed up like the courses. After hauling and belaying the clewlines and buntlines, the crew will swarm aloft to do the actual furling— gathering the heavy sails into tight folds and lashing them neatly to the yards to make a neat "harbor furl." This has already been done to the royals—the uppermost sails on the royal yards.

The two lowered jibs, hanging loosely from the jibboom, will soon be gathered in and furled neatly. The spanker, which has been brailed up to the spanker gaff, will likewise be stowed and the crew will then go about the deck, bracing the yards square, coiling lines, and getting the ship in perfect order for the expected arrival of the owners and port officials.

The *N. B. Palmer* was built by the New York shipbuilding firm of Westerveldt & Mackay in 1851 for A. A. Low & Brother, measuring 202 feet 6 inches length, 38 feet 6 inches breadth, 21 feet depth of hold, and 1,399 tons. The ship was named for Nathaniel Brown Palmer, a shipmaster of great distinction who commanded several of the Lows' ships.[1] It was reputed that he designed the ship named for him as well as other vessels, but this claim is disputed and many historians feel that master shipwright Jacob Westerveldt did the design work, incorporating Palmer's ideas.[2]

Erik A. R. Ronnberg, Jr.

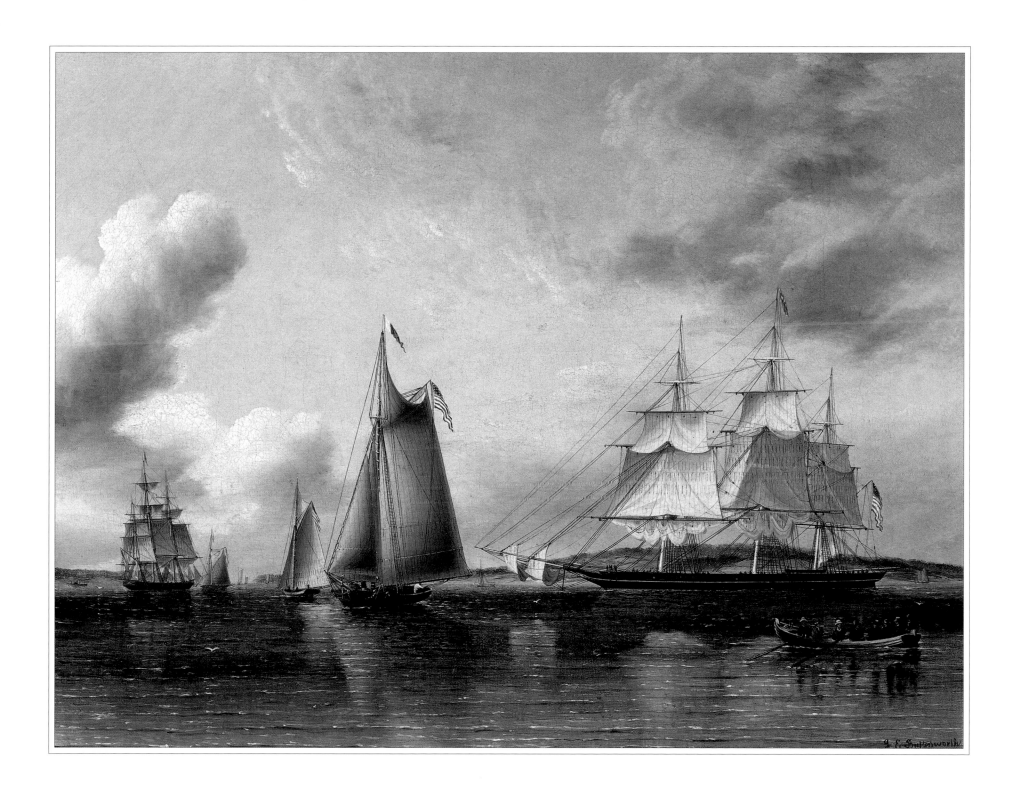

PLATE III.19

American Ships under Sail with Vessel to Port and Starboard
James E. Buttersworth (1817–1894)
1860s
Oil on panel
12" x 18"
Signed "J. E. Buttersworth" (lower right)

BUTTERSWORTH CHOSE A BREEZY DAY for this merchant ship to sail through a yacht race, held "outside" New York Bay, en route to her destination at a Manhattan wharf. This picture has been dated ca. 1875, but that seems too late by a decade, given the ship's heavy single-topsail rig which was already going out of fashion in the late 1850s. The rigs of the schooner yachts and the sloop fit in the 1860s time frame as well.[1]

As the ship nears her destination, the process of shortening sail has begun. Aloft, the royals have been lowered and clewed up in preparation for furling. Alow, the fore and main courses have been clewed up, but the heavy canvas will not be furled in case the wind drops and they need to be reset quickly to provide maneuverability.

Once the ship approaches the Narrows, she will have the tides and the Hudson River's current to work against, together with winds whose strength and direction will be modified by the Long Island and Staten Island shorelines. If those forces work too strongly against her, the services of a towboat will be a last resort.

Buttersworth was fond of dramatic scenes with rough seas and threatening weather conditions, heeling the ships over, almost on their beam-ends. In this example, he restrained himself just enough to make the conditions believable, yet taut with anxiety and exhilaration.

Erik A. R. Ronnberg, Jr.

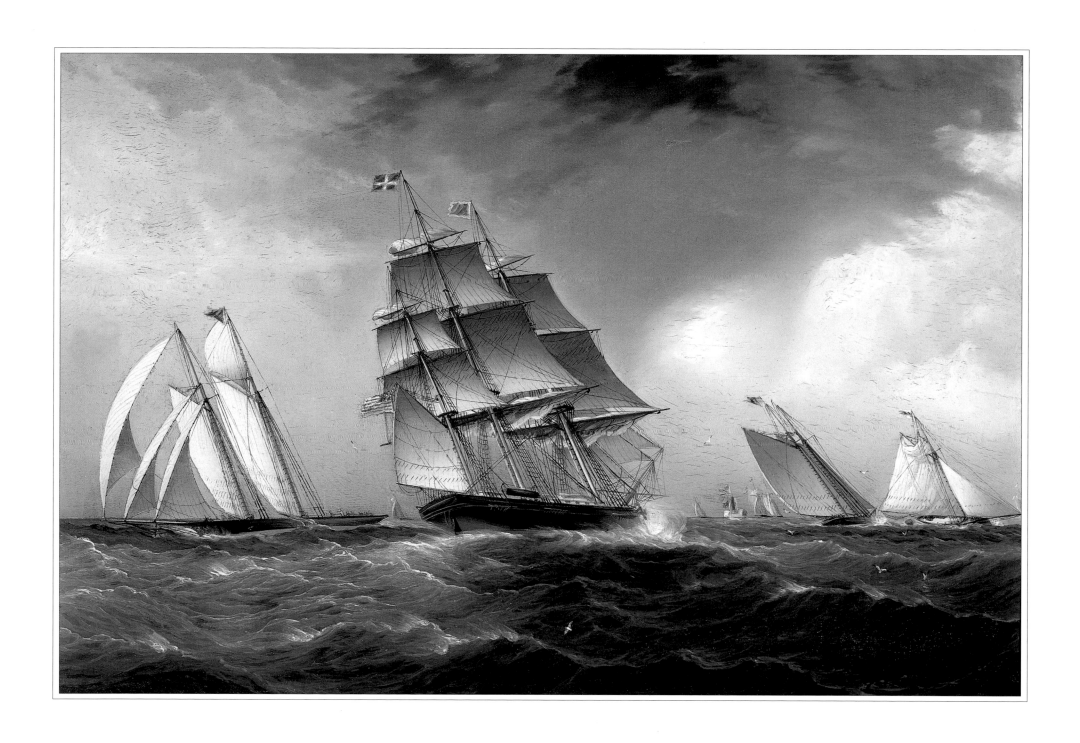

PLATE III.20

Columbia *and* Shamrock, *America's Cup, 1899*
Edward Hopper (1882–1967)
Watercolor on paper
9" x 10¾"
Signed and dated "E. Hopper '99"

EDWARD HOPPER IS AN UNDISPUTED master of twentieth-century American art, and most of his marine paintings have a timeless, mythic quality that one does not associate with the work of even the most accomplished yachting illustrators. This small watercolor of the defender *Columbia* and the first of Sir Thomas Lipton's yachts named *Shamrock* racing for America's Cup in 1899 may not be characteristic of Hopper's mature work. It does, however, combine accuracy of technical detail and documentary substance with an exciting freedom and fluency of watercolor technique. The painting bears comparison with the tighter, more restrained expressive means displayed in the work of Fred S. Cozzens, which is well represented in the Foster Collection (see "American Yachting Art" chapter). Cozzens could never, one supposes, have brought himself to render the water so loosely or the vast spectator fleet so impressionistically. Hopper would never have drawn rigging with Cozzens's obsessive concern.

Flying the burgee of the Royal Ulster Yacht Club, the 128-foot pea-green *Shamrock* fell to the 131-foot *Columbia* in three completed races by large margins. Sir Thomas would be back again with a new *Shamrock* in 1901. *Columbia* would be back to take her on. The America's Cup races would be closer than in 1899. The result would be the same.

Llewellyn Howland III

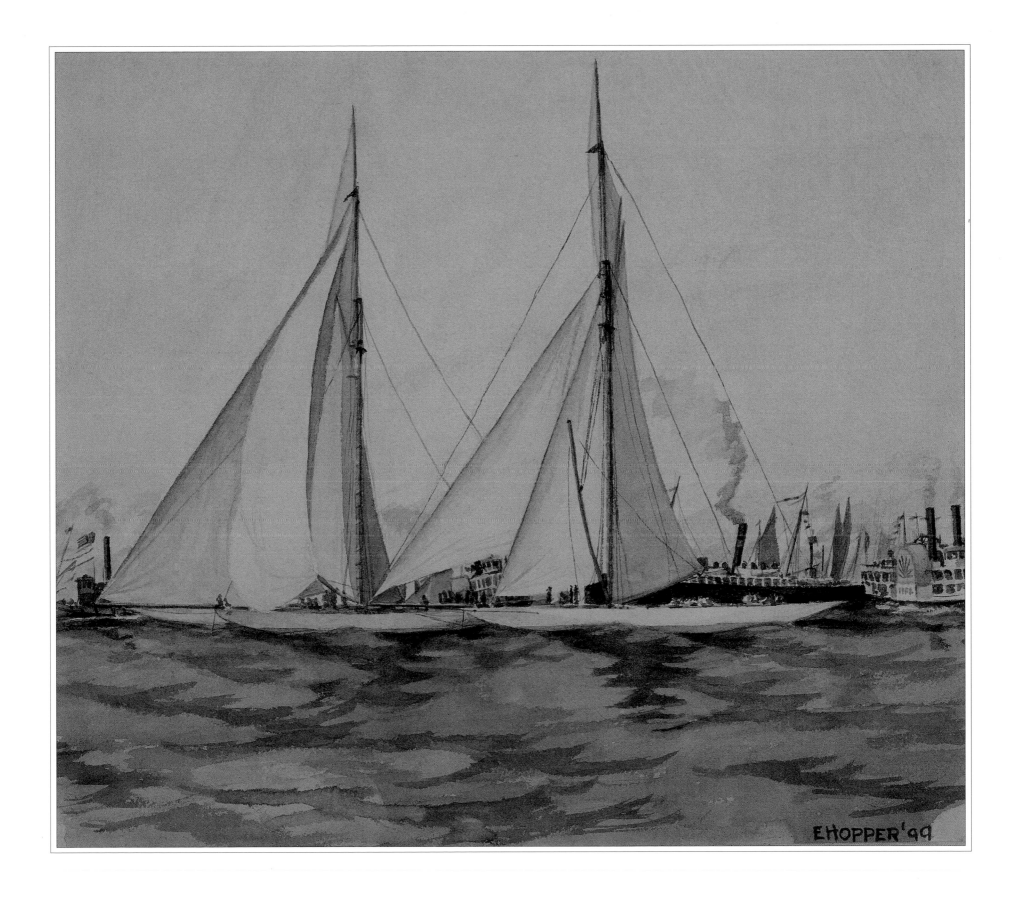

BRITISH MARINE ART

THE BRITISH MARINE PAINTINGS in the Glen S. Foster Collection present an overview of the development of the British marine tradition from the glorious era of British naval success in the late eighteenth and early nineteenth centuries to the time of its own stylistic influence on the emerging American school. The British marine collection includes dramatic portrayals of naval engagements by esteemed marine artists Dominic Serres, Thomas Whitcombe, and Nicholas Pocock, leading exponents of the English marine tradition in the second half of the eighteenth century. It also contains two representative canvases by Thomas Buttersworth and six harbor paintings with views of ports from Liverpool to Greenock from the British period of marine artist Robert Salmon.

DOMINIC SERRES

DOMINIC SERRES (1719–1793) was born at Auch in Gascony, France, but ran away from home at an early age to join the crew of a Spanish ship bound for South America. He soon found himself in Havana, Cuba, the flourishing capital city of the western Spanish dominions. In about 1745, Serres was taken prisoner while aboard a Spanish ship captured by a British frigate and brought to England, where he was confined in the Marshalsea prison. He married during his imprisonment, and upon his release established a shop on London Bridge.

Serres received no formal training in marine painting, but there is evidence that he was influenced by English marine painter Charles Brooking (1723–1759). He participated in public exhibitions during the 1750s and '60s and collaborated with printmaker Richard Short to provide prints for the growing public interest in marine art created by the Seven Years' War (1756–1763). Serres gained the attention of senior British naval commanders and received many commissions for oil paintings to commemorate their naval victories. In 1768 Serres was chosen as a founding member of the Royal Academy and its only marine artist at the time. In 1791, two years before his death, he was appointed Marine Painter to George III. In 1784 a friend of Serres's noted his success: "Dom is grown a very great man, has been to Paris, seen the grand exhibition, dined with the King's architect, and is going to paint for the Grand Monarque. Alas! poor Paton [Richard Paton (1717–1791)], hide your diminished head, your topsails are lowered."[1]

A remarkable set of six paintings by Dominic Serres in the Foster Collection presents an episode from the Seven Years' War involving an expedition by the British in 1761 to capture the French island fortress of Belle Isle, which guarded significant anchorages in the rivers Vilaine and Charente, as well as in the Loire at St-Nazaire. On March 29, 1761, a Royal Navy transport fleet made up of fifteen ships-of-the-line, eight frigates, three sloops, three bomb vessels, and two fireships under the command of Commodore the Honorable Augustus Keppel, sailed from St. Helen's Roads, Isle of Wight, to deliver an expeditionary landing force of 7,000 men commanded by Major-General Studholm Hodgson.

Upon sighting Belle Isle on the 6th of April, Keppel detached six frigates to patrol the waters between the island and the mainland to disrupt enemy communications. He then sent a squadron under Captain Buckle to cruise off Brest and prevent the French fleet at anchor there from joining in Belle Isle's defense. On April 7 Keppel and Hodgson reconnoitered the coastline before anchoring the fleet at Palais Roads. The first painting in the set, *First Attack at Port Andro, 8th April, 1761* (Plate IV.1), shows the attempted landing the following day, which was rebuffed with heavy losses. The ships-of-the-line *Achilles*, *Dragon*, and *Prince of Orange* were directed to destroy the

fort there, and then hoist a Dutch flag as a signal to the landing boats. Several managed to make land, but found themselves overpowered by the well-positioned enemy and were forced to retire in the first action of the engagement.

After the initial failure, the attack on Belle Isle was interrupted by two weeks of poor weather. When it resumed on April 22, Keppel and Hodgson directed the fleet to Port d'Arsic, where the landing ultimately proved successful. In *Second Attack at Port d'Arsic* (Plate IV.2), Serres shows the ships *Sandwich, Dragon,* and *Prince of Orange* along with two bomb ketches, two armed transports, and a variety of additional vessels supporting the landing forces during their first advance on the shoreline. During this attempt, a signal was given around Locmaria point, shown in *The* Swiftfire, Essex, Hampton Court *and* Lynn (Plate IV.3), to come to the assistance of a unit of marines, two grenadier companies, and a detachment of Royal Volunteers who were attempting to land at that location. Serres shows in convincing detail the loading of the landing craft and the steady advance of the small craft of expeditionary forces to the shoreline.

As a result of the successful landing, the French were driven back into the heavily fortified town of Palais. In the fourth painting in the set, *View from Raminet Battery* (Plate IV.4), Serres shows a fairly tranquil view of the British fleet in the harbor before Palais from a vantage point high up on Raminet Battery. Windmills appear on the horizon to the left, while Point Trelefar is visible in the distance to the right. *Land View of the Citadel* (Plate IV.5) presents the approach to the citadel from inland, showing details of its fortification walls and the layout of the town of Palais along the river inlet. The site of a diversionary landing during the capture of Belle Isle is shown in a quaint townscape, *Town and Harbour of Sauzon* (Plate IV.6). Serres presents these detailed views of Palais and Sauzon in a peaceful fashion, without signs of the fighting that took place during the siege. In the event, the citadel of Palais under the command of Chevalier de St. Croix succumbed to heavy bombardment by the British, and the governor surrendered the fortress on June 7, 1761. Belle Isle would remain under British control until the Peace of Paris was signed in 1763. Serres based his oil paintings on the drawings of printmaker Richard Short, who was present during the capture of Belle Isle and had the opportunity to make firsthand sketches of its coastal topography.

THOMAS WHITCOMBE

THOMAS WHITCOMBE (ca. 1752–1824) was a prolific marine artist born in London. Little is known of his training, but Whitcombe spent most of his working life in London, exhibiting a total of fifty-six marine paintings at the Royal Academy

from 1783 to 1824. He produced a vast body of work chronicling the naval engagements of the French revolutionary wars. Whitcombe's compositions exhibit excellent draftmanship in the depiction of vessels and a significant knowledge of atmospheric conditions at sea. He shows considerable ability in his handling of cloud formations and the movement of vessels in response to weather. Forty of Whitcombe's works are currently in the collection of the National Maritime Museum at Greenwich.

A magnificent panoramic canvas in the Foster Collection by Thomas Whitcombe, *The Relief of Gibraltar by Admiral Lord Howe, October 11–18, 1782* (Plate IV.7), shows the scene of a naval encounter between England, France, and Spain just preceding the Treaty of Versailles. Gibraltar was ceded to the British by the Treaty of Utrecht in 1713. It remained a British possession in spite of several attempts by the Spanish to reclaim it by force in 1720 and 1727. The British outpost continued to rankle Spanish national pride for the next fifty years. In 1779 a Franco–Spanish expedition was assembled to lay siege to the fortress and bombard it into submission from batteries constructed on the neck of the peninsula. The bombardment continued intermittently for several years, the fortress narrowly surviving only as a result of the timely arrival of supply convoys. A renewed effort in 1782 led to a blockade by Spanish "battering ships" that was initially rebuffed. Lord Howe, commander-in-chief in the Channel, learned that a large Franco–Spanish fleet was preparing to leave Cadiz for a final all-out assault on Gibraltar before the winter.

Lord Howe sailed in September 1782 with a fleet of thirty-three ships-of-the-line and a huge convoy of one hundred and fifty merchantmen. The unwieldy flotilla reached Cape St. Vincent on the 8th of October, only to find the enemy had anchored forty-six line-of-battle ships off Algeciras. In a series of brilliant maneuvers, Lord Howe managed to land troops and supplies and return to sea unmolested. On the morning of the 20th, he ordered his fleet into battle lines facing the enemy. Nearing sunset, the Spanish fleet approached the English line, but refrained from a direct engagement. Sporadic fire was then exchanged for four hours until both sides separated in the darkness, and the enemy ran for Cadiz. Howe's victory was achieved by tactical superiority without significant losses. Howe sailed for England triumphant, where he was rewarded with a viscountcy and the post of First Lord of the Admiralty. The Treaty of Versailles confirmed Gibraltar as a British possession, which it remains to this day.

NICHOLAS POCOCK

NICHOLAS POCOCK (1741–1821) was born in Bristol, England, and apprenticed in the city's shipbuilding yards at an early age. He then went to sea, and rising rapidly through the ranks, achieved command of a succession of merchant vessels sailing from Bristol to South Carolina, Cadiz, Minorca, and St. Kitts. He expressed an early interest in drawing, and produced in his ships' logbooks sketches and watercolors of his vessels from all angles and in various weather conditions. By 1778 Pocock was on hand during Rodney's West Indian campaigns as a war artist. In 1780 he submitted an early attempt in oil painting to the Royal Academy exhibition, and soon secured commissions from senior naval officers. He would continue to exhibit at the Royal Academy regularly for the next thirty years, showing a total of sixty-three oil paintings and fifty watercolors. In 1805 he became a founding member of the Old Water Colour Society, presenting twenty-eight drawings to its inaugural exhibition. Pocock lived to the age of seventy-nine and achieved a marked popularity in his lifetime. Many of his paintings are now in the collection of the National Maritime Museum, Greenwich.

Pocock produced a prolific and brilliant record of the British Navy during the period of its most spectacular achievements. He was an eye-witness recorder of the West Indian campaigns of Rodney and Hood, painted many of Nelson's victories at the turn of the century, and was likely present during Lord Howe's campaign that ended with his victory on "The Glorious First of June."[2] Pocock painted with a thorough working knowledge of the sea, with careful attention to detail, and brought to his paintings an exquisite sensitivity for color and a characteristic soft light and poetic atmosphere. Two paintings by the artist in the Foster Collection, *French and English Vessels in Battle* (Plate IV.8) and *Achilles and two Vessels after Battle* (Plate IV.9), depict Royal Navy gunships in two stages of battle. In the first, a wafting bank of cannon smoke engulfs the scene of a British vessel flanked by two furiously firing French ships-of-the-line. Although the British ship is being pounded from both sides, it has inflicted considerable damage on the French gunship to the left, whose masts are blown off and falling through the air. In the second, Pocock presents a vivid portrait of the severely battered ship *Achilles*, with two masts still standing while its companion vessels on either side float aimlessly over the water with their masts destroyed. Pocock lends a grim but balanced atmosphere to the scene, showing the surviving vessel with its stalwart crew engaged in the strenuous work of repair and recovery that will bring it back to sailing condition.

THOMAS BUTTERSWORTH

THOMAS BUTTERSWORTH (1768–1842) was born on the Isle of Wight and enlisted in the British Navy in 1795. He was probably present at the Battle of St. Vincent (1797) and the subsequent blockading of Cadiz. In 1800 he became invalided at Minorca and was sent home. Upon his return he entered into a career as a marine painter, producing watercolors and oils depicting British ships and naval engagements from the Napoleonic Wars to the War of 1812. His well-known paintings of the Battle of Trafalgar are in the National Maritime Museum at Greenwich. He exhibited at the Royal Academy and was appointed Marine Painter to the East India Company. Though no record of his formal training exists, a working knowledge of ships is evident in his paintings, with some inconsistency in detail.[3] Buttersworth used a characteristic palette of blue-grays and green-grays in a distinctively eighteenth-century style, sometimes considered "drab…with muddy green water and gray sky tones."[4] In spite of this, he often demonstrates extremely fine detail, and "superb draughtmanship."[5] As the father of James E. Buttersworth (see "American Yachting Art" chapter above), he provides an important link between the English marine school and the emerging American school of marine painting.

Two paintings in the Foster Collection by Thomas Buttersworth show British ships-of-the-line in familiar settings. *HMS* Britannia *Beating Down the Channel Past the Eddystone Lighthouse* (Plate IV.10) depicts the enormous first-rate three-decker HMS *Britannia* in fairly heavy weather passing the Eddystone Lighthouse, a landmark that would become prominent in the work of his son James E. Buttersworth. HMS *Britannia* was designed by Sir William Rule in 1812, but spent many years on the stocks after the end of the Napoleonic Wars in 1815 and was only completed in 1822. In its early years, it served as a harbor guardship in Plymouth, later had several commissions in the Mediterranean and one appointment as a flagship during the Crimean War, but was eventually recommissioned as a training ship for naval cadets. Buttersworth shows the ship pounding through heavily rolling waves, with its three rows of guns rigidly protruding. The gray-greens of the water treatment and the lowering gray blanket of the sky provide a somber backdrop for the majestic 2,616-ton warship. In *English Ships in Harbor* (Plate IV.11), Buttersworth presents a British four-decker in the midst of busy harbor traffic against a horizon of crowded masts and buildings. He includes considerable detail of crews busily engaged on the smaller craft that surround the warship. His attention to the tiny figures of sailors immersed in their tasks and the busy interaction of vessels in harbor were some characteristics of his style that his son would incorporate and develop.[6]

THE BRITISH PERIOD OF ROBERT SALMON

IN ADDITION TO WORKS OF Robert Salmon from his American period after 1828 (see the "American Marine Art" chapter above), the Foster Collection includes five paintings executed by Salmon during his early years when he traveled frequently throughout Britain painting harbor scenes in ports from Milford Haven to Greenock. Salmon spent the years 1811–22 in the town of Greenock, Scotland, on the Clyde Estuary, and recorded its colorful water traffic, commercial activity, and shore scenery in over 250 paintings.

Greenock had evolved in the early years of the nineteenth century from its origins as a small herring-fishing port into an important shipbuilding and commercial port in support of nearby Glasgow. In *Greenock Harbour, 1820* (Plate IV.12), Salmon captures the scene of ships airing their sails in the East Dock near the Greenock Custom House, which appears as the orderly, classical hub of the bustling commercial activity that surrounds it. The Custom House displays a large Royal Standard from its flagpole, indicating the occasion of a royal anniversary. During his years in Greenock, Salmon witnessed the early developments in steam navigation, and he includes in the painting a paddle steamer departing from the quay on the right. To the left, the stern of the *Clyde* of Glasgow appears in the shadows. The painting is a wonderful example of Salmon's unsurpassed style, suffused with a fine luminosity, and presenting a "harmonious blend of shipping, architectural, and human interest."[7]

In *The* Pomona *of Greenock, Riding at Anchor* (Plate IV.13), Salmon portrays the merchant ship *Pomona* anchored in the Clyde River off Greenock, preparing to set sail and ride the light breeze downriver. A revenue cutter is seen to her right, while in the foreground a yawlboat appears with the name-pennant *Caledonia*, possibly rowing toward *Pomona* to deliver the captain with his fresh sailing orders. Salmon presents the waves before *Pomona* in gentle, slightly stylized ripples, and fills the sky with a golden light.

Salmon had spent productive years in Liverpool from 1806 to 1811, and he returned to the burgeoning Mersey port for a second period from 1822 to 1825. During his stay, he participated in the revival of exhibitions held for contemporary artists, exhibiting six works in the Second Exhibition of the Academy of the Liverpool Royal Institution in 1824. In the painting *A Mail Packet in the Clyde* (Plate IV.14), executed during the second Liverpool period, Salmon turned back to the setting of the Clyde Estuary to depict a ship-rigged twenty-gun sloop that has been converted

into an English mail packet. He portrays the vessel hove-to off Cloch Point Lighthouse on the River Clyde several miles downriver from Greenock. The packet's fore truck displays a "pilot jack," indicating the need for a pilot. Her main truck carries a modified Red Ensign signaling her mission as a mail carrier. A Dutch merchant ship with a busy crew preparing to get underway appears to the left. Salmon covers the scene in a subtle and diffuse light emerging from a large bank of clouds on the upper right and glowing gently on the partially shadowed sails of the packet.

In *View of Liverpool* (Plate IV.15), Salmon turns his attention to the Liverpool waterfront from the perspective of the Wirral coastline. A ship is shown on the left working its way through a southerly wind, while the brig in the center strives toward the Liverpool Docks opposite. The dome of St. Paul's rises on the horizon between the ship and some distant sails, along with the dome of Town Hall to the left of the brig and the spire of St. Nicholas to the left of the foreground wherry's mast. Salmon shows in detail the crew of the wherry wading in the water, while directly in their line of sight the deck of the approaching ship, possibly the Liverpool vessel *Bounty Hall*, swarms with tiny figures.

The final British Salmon in the Foster Collection, *Royal Vessels off Pembroke Dock, Milford Haven* (Plate IV.16), composed after his move to America, evidences the artist hearkening back to the familiar setting of Milford Haven, Wales. A Royal Dockyard was established at Milford Haven in 1790, but was shifted farther upriver

to Pembroke in 1814. Salmon presents a glowing orange sunset spread across the horizon, blanketing the hills that fade into the distance behind the harbor town in a warm pink pallor, reflecting off the lightly rippling surface of the water with a clear, silvery intensity. Several vessels are pictured at anchor airing their sails, each in a different attitude to the sun, producing an impressive range of shadows and lending a reflective, transitional mood to the scene. The painting comes from Salmon's later period, after his successful transition to America which produced some of his "finest"[8] works, and is a splendid example of his innovative treatment of light and color.

1. From William Sandby, *Thomas and Paul Sandby* (London, 1892), p. 167, as quoted in David Cordingly, *Marine Painting in England 1700–1900* (New York: C. N. Potter, 1973), p. 83.

2. Cordingly, *Marine Painting*, p. 88.

3. See Kathryn H. Campbell, *The Thomas and James Buttersworth Collection from the Penobscot Marine Museum* (Searsport, ME: Penobscot Marine Museum, 2000), p. 10 and the Introduction by Daniel Finamore.

4. Rudolf J. Schaefer, *J. E. Buttersworth: 19th-Century Marine Painter* (Mystic, CT: Mystic Seaport Museum, 1975), p. 31.

5. Ibid., p. 29.

6. Ibid., p. 29.

7. A. S. Davidson, *Marine Art & The Clyde—100 Years of Sea, Sail & Steam* (Wirral, U.K.: Jones-Sands Publishing, 2001), p. 36.

8. John Wilmerding, *A History of American Marine Painting* (Boston: Peabody Museum of Salem, 1968), p. 132.

INTRODUCTION TO
PLATES IV.1–6

The Taking of Belle Isle 1761 by Commodore Keppel and General Hodgson
A Set of Six, Dominic Serres Snr. (1719–1793)
One signed "D. Serres" and dated "1762" (lower left), one signed "D.
Serres" and dated "1762" (lower right), one dated "1762"

WIDELY REGARDED AS THE first global conflict, the Seven Years' War (1756–63) was a titanic struggle between England and France for dominance not only in Western Europe, but also across the globe in pursuance of further colonial expansion. Several epic sea battles, most notably Lagos and Quiberon Bay, occupied both countries' fleets, but the war also witnessed several major British combined forces operations, one of which was the capture of the island fortress of Belle Isle, off the Atlantic coast of France in 1761.

The expedition, originally planned for the previous year, centered around the perennial need for the Royal Navy to blockade French ports whenever the two countries were at war. Belle Isle, which guarded the anchorages in the rivers Vilaine and Charente as well as the Loire at St-Nazaire, was a port of great strategic significance. The British transport fleet sailed from St. Helen's Roads, Isle of Wight, on March 29, 1761. In command of fifteen ships-of-the-line, eight frigates, three sloops, three bomb-vessels, and two fireships was Commodore the Honorable Augustus Keppel, who was responsible for conveying the landing force of 7,000 men commanded by Major-General Studholm Hodgson. Sighting Belle Isle on April 6, Keppel first detached six frigates to patrol the waters between the island and the mainland in order to sever any communications; he then sent a sizable squadron under Captain Buckle to cruise off Brest to prevent any interference from the French fleet there. The next morning, April 7, Keppel and Hodgson reconnoitered the coastline and that afternoon the fleet anchored in Palais Roads.

Scheduled for the following day, April 8, the initial landing at Port Andro was rebuffed with heavy losses despite the earlier success of the three ships sent in to silence the fort guarding the bay. Two weeks of bad weather then interrupted the assault, which was resumed on April 22 with a successful landing at Port d'Arsic at another point on the island. Once the expeditionary force was fully ashore, the French were driven back into the strongly fortified town of Palais where they held out, under the command of Chevalier de St. Croix, until June 7 when the governor surrendered after a particularly damaging bombardment. Belle Isle was to remain under British control until the Peace of Paris was signed in 1763.

Serres based his oil paintings on a series of prints by contemporary British artist Richard Short (active 1740–77). Short was present at the capture of Belle Isle in 1761 and made drawings on the spot. He was probably not present at each separate phase of the assault, but clearly had the opportunity to sketch the coastal topography at the time, adding the vessels and the landing craft later. Upon his return to England, probably during his spell of leave in the second half of 1762, Short began production of a set of prints of the capture of the island, turning to Serres to produce oil paintings from his drawings. The works presented in this group are the oil paintings by Serres, probably commissioned by Admiral Keppel.

Each painting is accompanied with contemporary descriptions taken from the margins of the prints.

Alistair Laird

PLATE IV.1

First Attack at Port Andro, April 8, 1761
Dominic Serres Snr. (1719–1793)
1762
Oil on canvas
14½" x 20½"

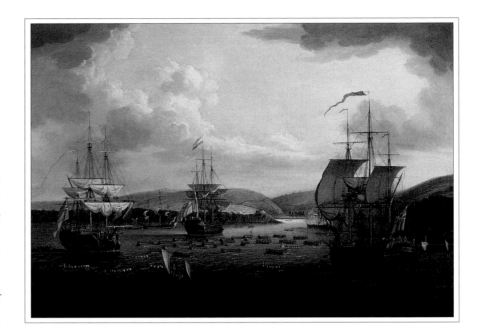

"THE GENERAL OFFICERS being determined to land at this place, the *Achilles* and *Dragon* were sent in to destroy the fort, which when silenced, the *Achilles* hoisted a Dutch flag as a signal for the boats. The broad pendant being moved to the *Prince of Orange*, the boats advanced accordingly, several of them landed, but being over-powered by great numbers of the enemy, most advantageously situated to resist them, were obliged to retire."

"To the Honble [*sic*] Augustus Keppel, Rear-Admiral of the Blue Squadron of His Majesty's Fleet, this plate having an exact representation of the First Attack made by the British Fleet under his command, 8th. April, 1761, at Port Andro on Belleisle."

PLATE IV.2

Second Attack Made at Port d'Arsic
Dominic Serres Snr. (1719–1793)
1762
Oil on canvas
14½" x 20½"

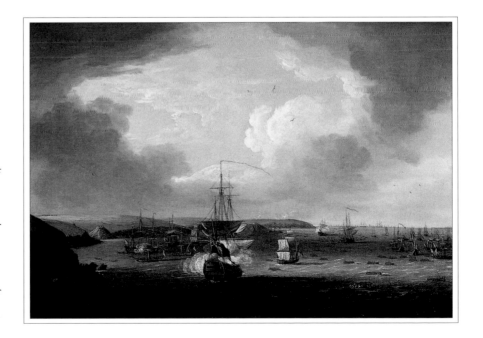

"THIS PLACE BEING INTENDED for landing the *Sandwhich* [*sic*], *Dragon*, *Prince of Orange* and two bomb ketches were ordered in to support the attack, together with two transports, armed for that purpose. The Commander of the transports, with sundry others, advanced with the troops in order to land, but in consequence of the signal for boats manned and armed, made on the other side of Locmaria Point, advance to their assistance, and to complete their landing."

"To the Honble [*sic*] Augustus Keppel, Rear-Admiral of the Blue Squadron of His Majesty's Fleet, this plate being an exact representation of the second attack made at Port d'Arsic on Belleisle, 22nd. April, 1761, which proved a feint."

PLATE IV.3

The Swiftfire, Essex, Hampton Court *and* Lynn
Dominic Serres Snr. (1719–1793)
1762
Oil on canvas
14½" x 20½"

"THIS PLATE REPRESENTS the *Swiftfire, Essex, Hampton Court* and *Lynn*, with a body of marines, two Grenadeer [*sic*] Companies and a Detachment of Royal Volunteers, commencing the attack, and the main body coming round Locmaria Point, to support them from Fort d'Arsic, where the real landing was intended to have been made."

"To Sir Thomas Stanhope Knt., Colonel in His Majesty's Marine Force, Commodore of the White Division of His Majesty's Fleet before Belleisle who commanded the attack at St. Foy near Locmaria Point, where the landing was completed on 22nd. April, 1761."

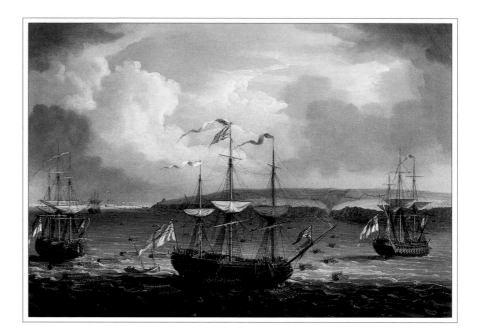

PLATE IV.4

View from the Raminet Battery
Dominic Serres Snr. (1719–1793)
1762
Oil on canvas
14½" x 20½"

"THE WATERING-PLACE, Bombs Battery, Redoubts near the Windmills – The breach in the walls of the Citadel at Palais. The land to Point Trelefar on Belleisle, and part of the road for Ships, as appeared from Raminet Battery."

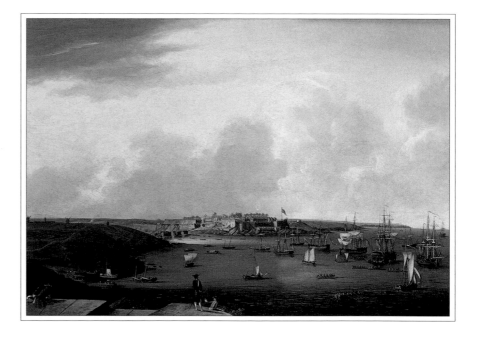

PLATE IV.5

Land View of the Citadel
Dominic Serres Snr. (1719–1793)
1762
Oil on canvas
14½" x 20½"

"THE BACK PORT OR 'LAND VIEW' of the Citadel and Town of Palais on
Belleisle, which shows the Entry to the Citadel and the Situation on the several
Walls of its Fortifications."

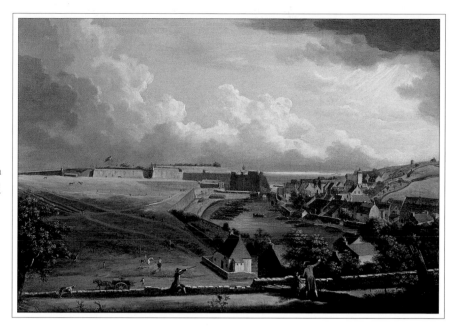

PLATE IV.6

Town and Harbour of Sauzon
Dominic Serres Snr. (1719–1793)
1762
Oil on canvas
14½" x 20½"

"THIS PLATE REPRESENTING the Town and Harbour of Sauzon, as they appear
from the sea."

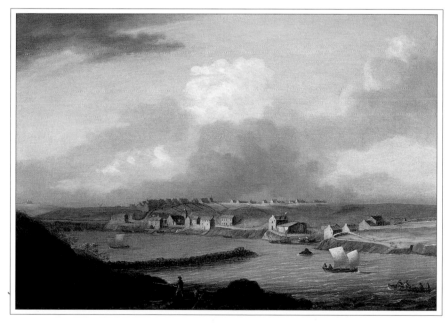

PLATE IV.7

The Relief of Gibraltar by Admiral Lord Howe, October 11–18, 1782
Thomas Whitcombe (ca. 1752–1824)
1792
Oil on panel
8⅞" x 42¾"
Signed "T. Whitcombe" and dated "1792" on the sail of the xebec (lower right)

NOBODY CONTRIBUTED MORE TO recording the naval side of the French Revolutionary Wars than Thomas Whitcombe. He exhibited fifty-six works at the Royal Academy between 1783 and 1824. The National Maritime Museum, Greenwich holds forty of his works.

The strategic fortress of Gibraltar had been captured by an Anglo-Dutch fleet under Sir George Rooke in July 1704, during the War of the Spanish Succession, and then ceded to Britain by the Treaty of Utrecht in April 1713. Despite Spanish attempts to recover it by force in 1720 and again in 1727, it remained doggedly British and an affront to Spanish national pride for another fifty years. By 1779, with France and Spain now allied against an England preoccupied by her colonists' revolt in North America, a combined Franco-Spanish expedition was assembled and hostilities commenced on June 21 with a blockade of Gibraltar on its landward side. Bombardments from the newly constructed Spanish batteries on the neck of the peninsula were soon reinforced from the sea, whereupon the British garrison gradually settled into an uneasy routine, continually disrupted by heavy shelling, which was destined to become one of the longest sieges in the history of warfare. As the weeks passed into months and then into years, the fortress managed to survive numerous assaults thanks to the timely arrival of several supply convoys, all of which managed to get through at critical moments in the three-and-a-half-year-long blockade.

One of the last and most determined attacks had been from the so-called Spanish "battering ships" in mid-September 1782. Although these were successfully rebuffed by over 8,300 rounds of shot from the garrison's batteries, word reached Admiral Lord Howe, commander-in-chief in the Channel, that a large Franco-Spanish fleet was preparing to leave Cadiz for a final assault before winter. After a speedy refit, Howe, in HMS *Victory*, sailed for Gibraltar with thirty-three ships-of-the-line but encumbered by a huge relief convoy of one hundred and fifty merchantmen. The difficulties of shepherding this unwieldy flotilla were exacerbated by the fact that his own fleet was under-manned and ill-equipped. He reached Cape St. Vincent on October 8 only to find the enemy's forty-six line-of-battle ships already anchored off Algeciras. By noon on the 11th, Howe's fleet was in the Straits and, thanks to his brilliant protective tactics on that day and those following it, the storeships and transports were able to land their troops and supplies and return to sea unmolested. On the morning of the 20th, once the relief had been secured, Lord Howe ordered his fleet into its battle lines which formed up facing the enemy. Eventually, when it was almost sunset, the Franco-Spanish fleet approached the English line but did not attempt to engage it; sporadic fire was then exchanged for about four hours until the two sides separated in the darkness and the enemy ran for Cadiz. The rivalries and jealousies in the French and Spanish fleets had conspired to breed timidity and confusion whereas Howe's tactical brilliance had inspired confidence and put the enemy to flight; it was a notable victory won without loss and barely any damage to the English fleet. With Gibraltar re-supplied and safeguarded from invasion once again, Howe returned home in triumph to be rewarded with a viscountcy and the post of First Lord of the Admiralty. The epic siege finally ended on February 6, 1783, when the preliminaries of a wider peace settlement were signed, and the subsequent Treaty of Versailles confirmed Britain's possession of Gibraltar which continues to this day.

Alistair Laird

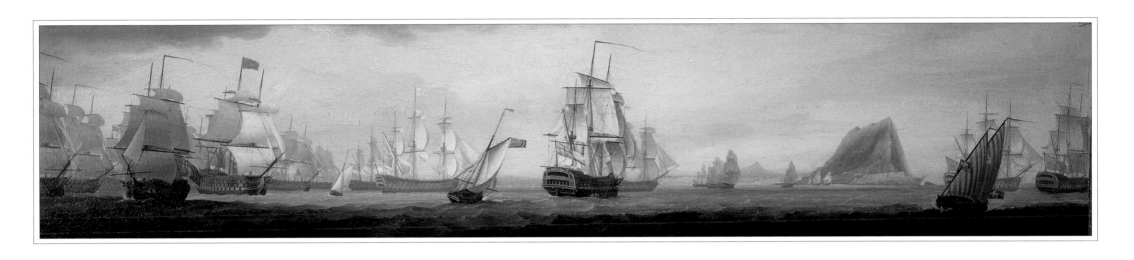

PLATE IV.8

French and English Vessels in Battle
Nicholas Pocock (1741–1821)
Ca. 1800
Oil on canvas
17¾" x 23½"

POCOCK EXCELLED AT depicting ships engaged in battle from dramatic points of view. Here he shows an English ship-of-the-line caught between two French gun-ships exchanging intense rounds of broadside fire. The billowing smoke of the cannon fire rises to surround the vessels in the haze of battle. Remarkably, the British ship appears to be wreaking considerable damage on the French vessel at left, the masts of which are shown by Pocock crashing through the air in a superb moment of arrested action. The masts and sails of the British ship at center and the French ship at right tower above the clouds of smoke and seem nearly to meet. Pocock intensifies the drama by showing the warring vessels positioned alongside each other at different angles in the midst of their heated exchange of fire.

Ben Simons

PLATE IV.9

Achilles and Two Vessels after Battle
Nicholas Pocock (1741–1821)
Ca. 1800
Oil on canvas
17¾" x 23½"

ACHILLES WAS A seventy-four-gun ship of the British Navy involved in operations against the French and Spanish fleets. Pocock portrays *Achilles* and two other gun-ships after a devastating battle with her mizzenmast blown away and her sails either destroyed or hanging in tatters. The vessel at left has only the fragment of one mast remaining, and appears to be on the verge of sinking. The battered remains of a ship at right are seen from her stern floating aimlessly like a ghost ship with all of her masts destroyed. In a note of resilience, Pocock shows *Achilles* with her flag still flying boldly in spite of the damage. Her crew is visible climbing the yards, out on the bowsprit, and scurrying about the deck actively engaged in the process of repairing the seemingly debilitated vessel. Soon a replacement mast and fresh sails will have her returning to battle like a ship resurrected.

Ben Simons

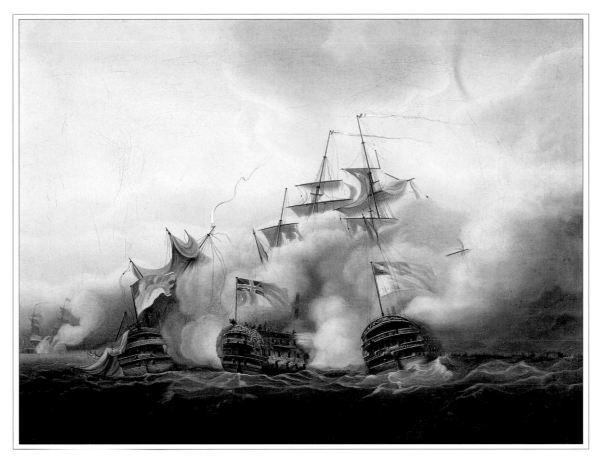

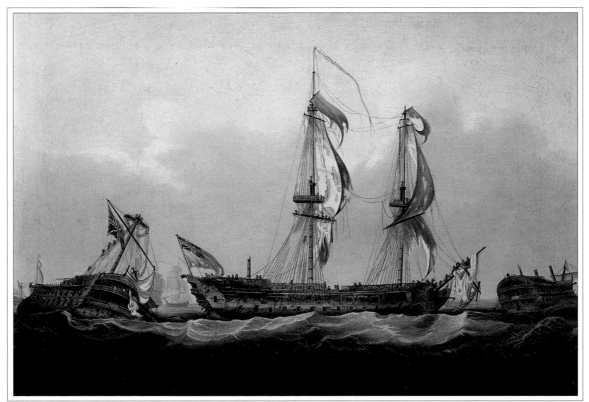

PLATE IV.10

HMS Britannia *Beating Down the Channel Past the Eddystone*
Lighthouse
Thomas Buttersworth (1768–1842)
Ca. 1820
Oil on canvas
18" x 24"
Signed "T. Buttersworth" (lower left)

HMS *BRITANNIA,* a hugely impressive first-rate ship and one of the largest of her
day, was designed by Sir William Rule in 1812 and laid down in Plymouth dock-
yard in December 1813. With the need for capital ships greatly reduced following
the end of the Napoleonic Wars in 1815, building work on her was sporadic and
she was not actually launched until October 1820 after a full seven years on the
stocks. Finally completed in late 1822, she was a majestic three-decker of 2,616
tons mounting 120 guns and carrying a crew of 594 officers and men, 66 boys,
and 160 marines. First commissioned in January 1823, she remained in Plymouth
for several years as one of the harbor's guardships and then did some short spells
of service in the Mediterranean before becoming flagship at Portsmouth in 1836.

After further commissions in the Mediterranean, she returned to Portsmouth in
1850 to become Guardship-of-the-Ordinary and remained there until 1854 when,
following the outbreak of the Crimean War, she was sent to the Black Sea as flag-
ship to Vice-Admiral Dundas. Action there included leading the combined Anglo-
French fleet in for the first great bombardment of Sebastopol on October 17, 1854.

When peace was concluded, she came home to Portsmouth where she was laid
up for several years before embarking on a new career which was to make her as fa-
mous as any ship in the fleet. On January 1, 1859 she was recommissioned as the
first training ship exclusively for the education of naval cadets and, very rapidly, her
name became synonymous with the Royal Navy's principal officer training estab-
lishment. Moored originally in Haslar Creek, Portsmouth, this berth proved un-
healthy so she was moved to Portland. When this anchorage also proved unsuitable,
she was moved again—to Dartmouth—in September 1863. By 1865 the number
of cadets had risen so sharply that the hulk of the old *Hindostan* was brought round
from Plymouth and joined to *Britannia* by means of a covered gangway. The sight
of these two ships moored end-to-end in the River Dart was to become familiar
to generations of young naval officers and, even after *Britannia* was broken up in
1869, she was replaced by another vessel and then by buildings ashore, all of which
took her name in order to perpetuate the tradition.

Alistair Laird

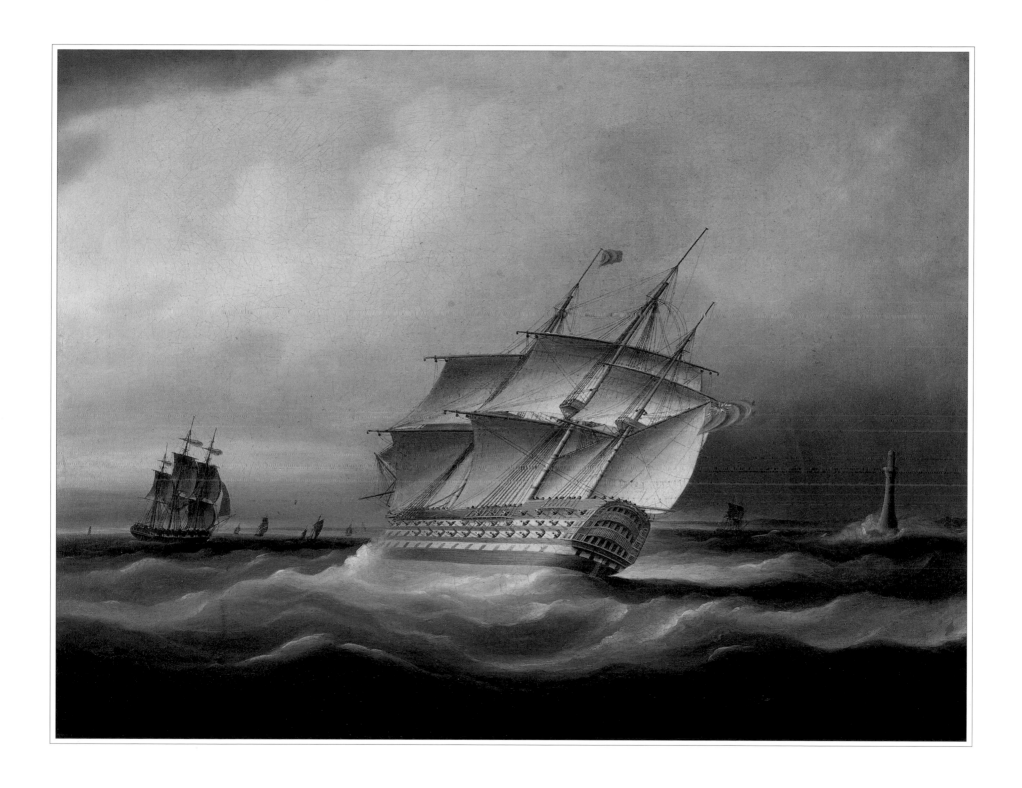

PLATE IV.11

English Ships in Harbor
Thomas Buttersworth (1768–1842)
Ca. 1820
Oil on canvas
17½" x 23½"
Signed "T. Buttersworth" (lower left)

THE CENTRAL FOCUS OF THIS PAINTING is a British first-rate ship showing her stern and starboard side. The three rows of cannons on her starboard side are visible along with the row on her stern. These were the largest vessels in the British Royal Navy. Surrounding her are a variety of small and medium craft handsomely demonstrating the range of designs of watercraft of this period. In the distance lies a harbor lined with masts of ships at anchor. The sky and water treatment are typical of Thomas Buttersworth's style, which was characterized, according to Rudolph Schaefer, by "a rather drab pallet, with muddy green waters and gray sky tones," but also "superb draughtmanship."[1]

Alan Granby

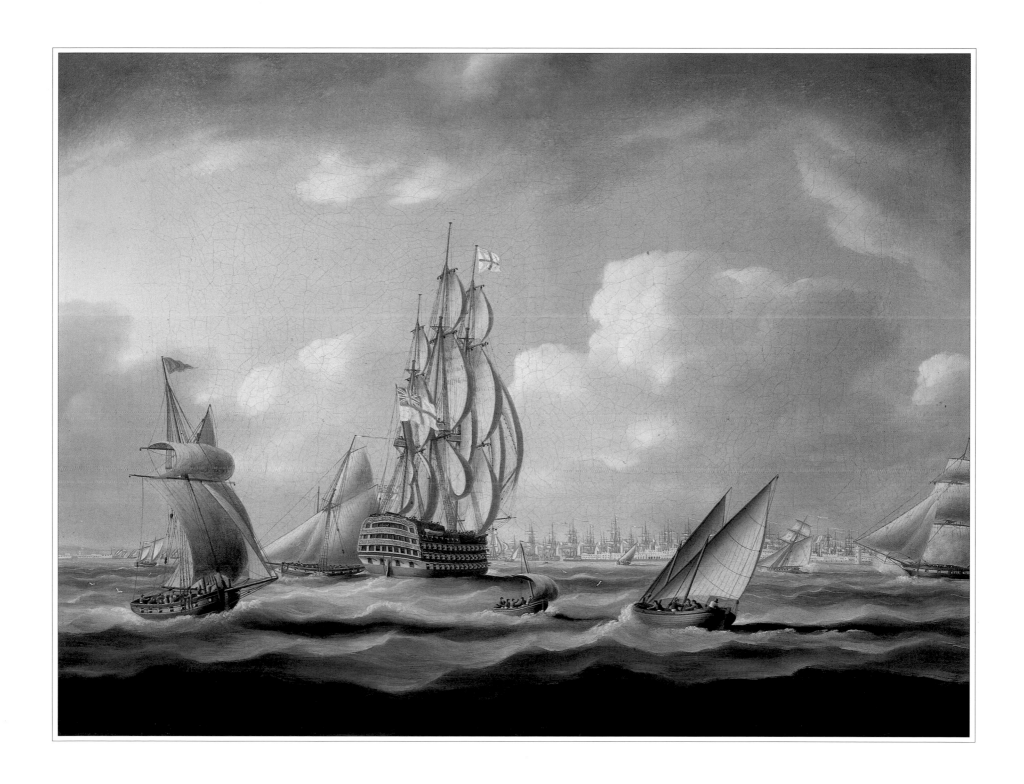

PLATE IV.12

Greenock Harbour, 1820
Robert Salmon (1775–after 1845)
1820
Oil on canvas
22½" x 36½"
Signed with initials and dated "RS 1820" (lower right)

SALMON TRAVELED WIDELY throughout Britain before emigrating to Boston, Massachusetts, in 1828, returning to Europe probably about 1842. Initially, the port of Greenock with its surrounding of great natural beauty appears to have suited him well. Here he spent eleven productive years from 1811 to 1822.

Whilst portraying the heart of the port's multifarious activities, this attractive composition achieves a harmonious blend of nautical, architectural, and human interest typical of the artist. A key ingredient in attaining depth and perspective is the oblique presentation, the front of the classically designed Custom House being bathed in early morning sunshine with its nearer side still in shadow. Such conditions are ideal for airing sails, and the ships in the East Dock beyond the Custom House are taking advantage of the opportunity. At left an anchored ship, the *Clyde* of Glasgow, its stern in shadow, forms a dark margin to the bright busy scene, the right margin featuring the masts and yards of a sailing vessel in the West Dock.

The large cutter and distant ships on the left make slow progress downstream using the ebb tide, in contrast to the early paddle-steamer which is departing the quay at top speed. Salmon's ingenious use of figures to impart perspective is well demonstrated by a comparison of those aboard the steamer with those on the quay and then with the spectators on the Custom House steps directly behind.

A. S. Davidson

211

PLATE IV.13

The Pomona *of Greenock, Riding at Anchor*
Robert Salmon (1775–after 1845)
1818
Oil on canvas
22¾" x 36¼"
Signed with initials and dated "RS 1818" (lower right)

ANCHORED IN THE RIVER CLYDE off Greenock, the merchant ship *Pomona* is preparing to get underway. She is riding to a short anchor cable so the anchor can be quickly broken out and raised. The main and mizzen topsails are set drawing, while the fore topsail is aback and the jib sheeted to weather. When the anchor breaks loose, the ship will gather sternway as the jib and fore topsail push the bow off to leeward. When the stern comes into the wind, the fore topsail will be braced around to draw like the other two topsails; the jib will be sheeted to leeward and the ship will stop, gather headway, and run down the Clyde with a following breeze and current.[1]

The flag at *Pomona's* fore truck belongs to one of a series of competing and ever-changing signal systems, this example likely being one of Marryat's early efforts. Its most likely (and certainly most appropriate) meaning for the situation is "I am making sternway." The naval cutter in the left background, which is also getting underway, is flying the same signal flag.[2]

At right, a naval cutter—a type better known as a revenue cutter—is reaching out into the river, probably to patrol the shipping channel and apprehend vessels that are carrying contraband. She flies the blue naval ensign from the gaff, and from the masthead a pennant signifying that she is a commissioned naval vessel under way. In the distance is a merchant cutter flying the red merchant ensign and a private signal, or "house flag," at the masthead.

In the foreground is a yawlboat rowing toward *Pomona* with a passenger, very likely the captain who has received his sailing orders from the ship owner or his agents, and clearance papers from the customs office. The use of boats like this for water taxis was common in ports around the world. The name pennant was one of many ways to advertise these boats' services.

Salmon kept a list of paintings he had sold and numbered his later paintings on the back. In this case no number has been discovered, but the date, 1818, indicates that this painting would have had a number between 277 and 290. In that year, Salmon still had his studio in Greenock, a thriving seaport that handled much of Glasgow's shipping business. The shipping activity there kept him busy for many years, as this painting readily attests.[3]

Erik A. R. Ronnberg, Jr.

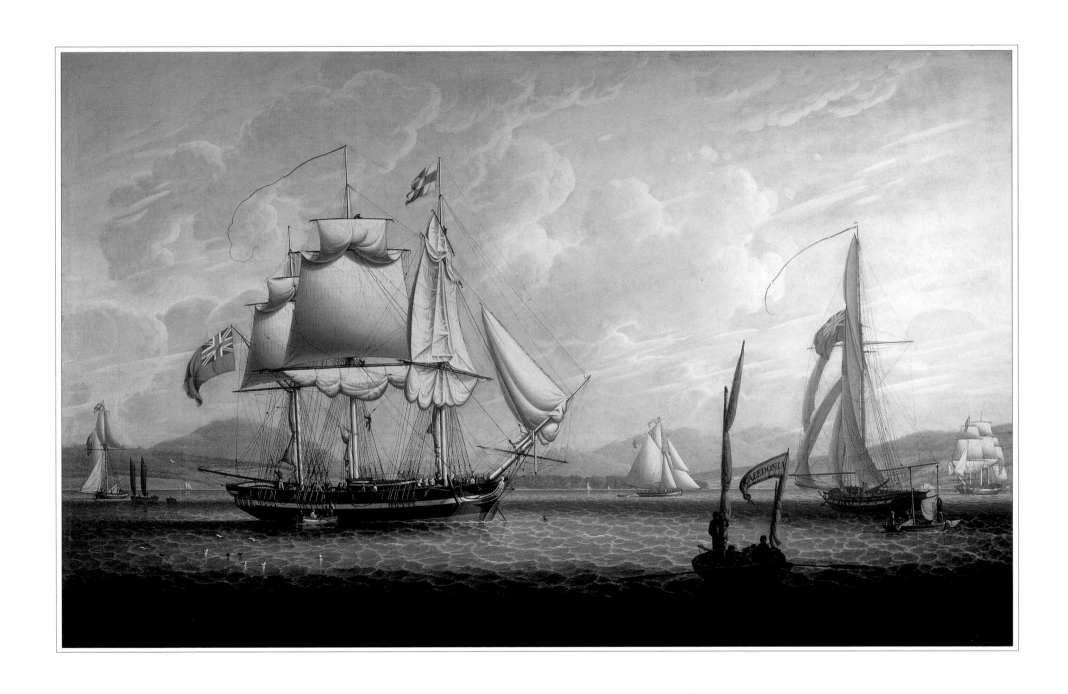

PLATE IV.14

A Mail Packet in the Clyde
Robert Salmon (1775–after 1845)
1824
Oil on canvas
22½" x 37"
Signed with initials and dated "RS 1824" (lower right), inscribed "No. 400
Painted by R Salmon 1824" (on reverse)

HOVE-TO OFF CLOCH POINT LIGHT in the Firth of Clyde, an English mail
packet is picking up a pilot before proceeding into the River Clyde in the left
background. On the far side of Cloch Point, three miles upriver, is the point of
Gourock, and beyond that the shipping port of Greenock which is this ship's
likely destination.

At her fore truck is a white-bordered Union Flag used as a "pilot jack" to sig-
nal the need for a pilot.[1] The red broad pennant at the main truck may signify the
vessel's contracted use as a mail carrier (in addition to carrying other goods for pri-
vate interests); this pennant is a modification of the Red Ensign at the spanker gaff.

The blue and red compass rose on the fore topsail is probably the emblem of a
fictitious packet line. Such designs were used by several shipping houses and they
are often seen in Salmon's portraits of packet ships. In the cases of identified ves-
sels, these emblems are accurately depicted.

Leading the English packet into the Clyde is a Dutch merchant ship, her crew
busy on deck or ascending the rigging to furl the royals, which have been lowered
and clewed up. Her pilot jack has been lowered, indicating that a pilot is on board.
She is headed directly toward the rocks around Cloch Point, so she will soon come
about and tack out into the river under topsails, topgallants, the jib, and the spanker.

The narrative contained in this composition is especially rich, reflecting Sal-
mon's knowledge, not just of ships, but of seamanship as well. This could have
come to him only through careful reading and long discussions with seafarers, ship-
wrights, and ship owners. These people were at once his mentors, his critics, and
some of his most loyal customers. This same relationship is to be detected in the
paintings of Fitz Hugh Lane. Did Lane follow this same path on the advice of
Salmon, or did he find his way independently? The question is tantalizing, but
evidence to decide the matter has not yet been found.

Erik A. R. Ronnberg, Jr.

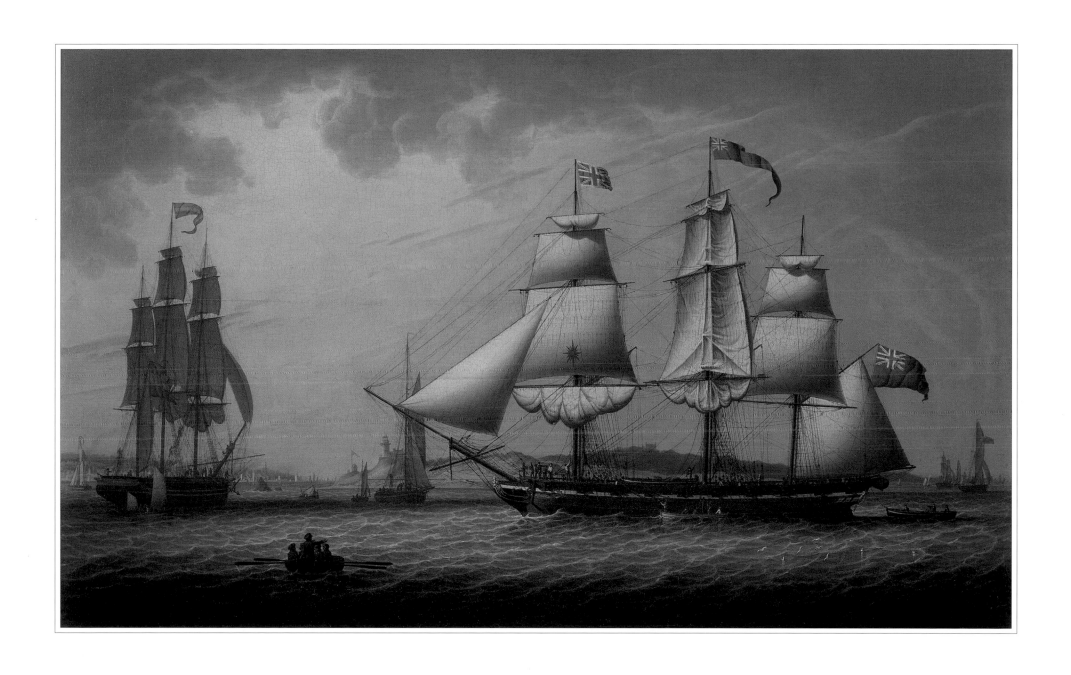

PLATE IV.15

View of Liverpool
Robert Salmon (1775–after 1845)
1825
Oil on wood panel
15¾" x 25"
Inscribed "Painted by Robert Sal...1825 No. 473" (reverse)

ROBERT SALMON SPENT two main periods in Liverpool, from 1806 to 1811, and then from 1822 to 1825. It was from the Mersey that he set sail for New York on June 16, 1828. A few small paintings excepted, the distant background of his "shipping on the Mersey" compositions is either that of the Liverpool waterfront as seen here, or that of the sparsely populated Wirral coastline opposite. The first group tends either to show a fairly close view of major Liverpool landmarks with a sailing vessel featuring largely in the foreground, or as in this case to include a view of the opposite (Wirral) foreshore as foreground, a variety of shipping in the middle distance, and a more distant view of Liverpool as background. In the second group, the entrance to the Mersey lies northwards off the painting to the left, its broad shallowing upper reaches receding into the picture on the right. This latter type of composition with its lively foreground activity enhances an otherwise somewhat empty scene, and was also employed by Salmon's Liverpool contemporary, John Jenkinson (active 1790–1821).

In his usual fashion, Salmon imparts depth and perspective, by alternating bands of light and shade, and by cleverly arranging the vessels and small craft obliquely. Human interest is also imparted by the passenger wading out to the wherry in the foreground and the two crew members straining to get it afloat. The beached coastal vessels on the right are in shade and serve as a dark "mount," as do the dark rocks in the left foreground.

Salmon was a practical sailor and his sailing vessels are attuned to the southerly wind, indicated by flags afloat and smoke ashore. Centrally, in the middle distance a brig reaches across to the Liverpool Docks. The ship seen on the left of the painting after a succession of tacks upriver, will shortly go about and follow suit. The two identical flags at her foremast probably indicate her ship number (33) in the Liverpool Code, signifying *Bounty Hall* built at Liverpool in 1816.

Some familiar Liverpool landmarks are recognizable on the skyline: the dome of St. Paul's to the left of center, the dome of the Town Hall just to the left of the brig, and the spire of St. Nicholas to the left of the foreground wherry's mast.

A. S. Davidson

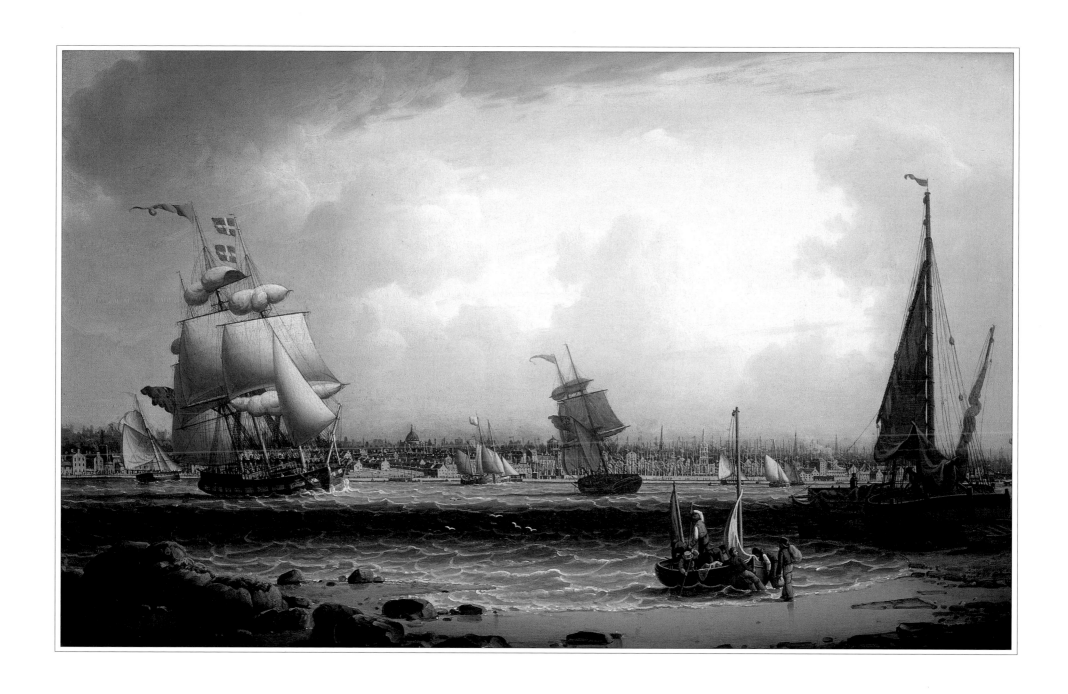

PLATE IV.16

Royal Naval Vessels off Pembroke Dock, Milford Haven
Robert Salmon (1775–after 1845)
Ca. 1839
Oil on canvas
26¼" x 40¾"

MILFORD HAVEN IS PROBABLY the United Kingdom's best natural harbor, and was especially suited to the needs of the old-time sailing navy on account of its upwind situation. It was also strategically suited for an expedition to Ireland. Not surprisingly, therefore, a Royal Dockyard was opened at Milford in 1790, but was shortly transferred upstream to Pembroke on the opposite south bank in 1814. Even with a full gale blowing at sea, this landlocked haven offers complete shelter.

The viewpoint is from the heights near Neyland looking southward over the harbor, the dramatically silhouetted rocky vantage point in the foreground containing several very typical groups of figures.

The right margin is framed by the forepart of what appears to be a topsail schooner secured alongside a small jetty. One of her "hands" is out on the jibboom making the necessary preparations for shipping the bowsprit. An interesting detail is the anchor laid out ahead, ready for hauling off the jetty on departure.

Shown in starboard bow view on the left of the picture is an anchored frigate of about thirty guns airing sails and displaying a white ensign at the after peak with the usual long pennant at the main masthead. Just to the right is what appears to be a brig-rigged corvette emerging through the gap between the frigate and an anchored two-decker of over fifty guns. The flag at her foremast suggests an Admiral of the White Squadron. On the right, viewed from the port quarter, is a sloop also wearing the white ensign and heading toward the distant dockyard marked by the many masts at the water's edge beneath the fort-like building on the skyline.

Next to the right of the flagship is a brig of about twenty guns, displaying a red ensign and at the foremast a swallow-tailed tricolor with horizontal segments of yellow, blue, and red. Very likely an Admiralty-commissioned packet, she is approaching under minimal sail and might well have mail or personnel to transfer to the flagship. In the distance astern is a third incoming vessel, ship-rigged and also wearing a red ensign. Indicated by the small number of guns and somewhat crowded decks, she may be an Admiralty-chartered transport.

These larger vessels are cleverly disposed so as to make most effective use of contrasting sunlit water and shadow, the whole relieved by a variety of ship's boats in the foreground either under oar or sail. In characteristic Salmon fashion, the canvas captures the busy atmosphere and multifarious activities of a long-departed era.

A. S. Davidson

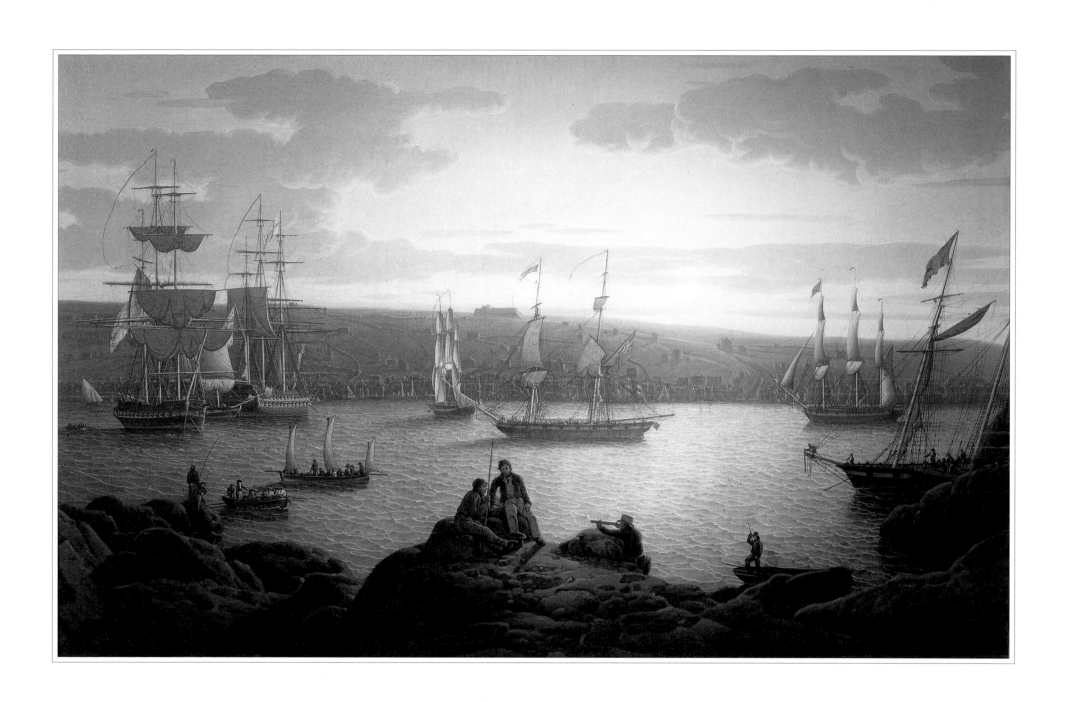

A Yachtsman's Eye

ILLUSTRATION LIST, REFERENCES, NOTES, EXHIBITIONS

Note on illustrations: Paintings are measured height by width; size is "sight" size and does not include picture frame.

AMERICAN YACHTING ART

PLATE I.1

The Sloop Maria *Racing the Schooner Yacht* America, *May 1851*
James E. Buttersworth (1817–1894)
Ca. 1851
Oil on canvas
18" x 24"
Signed "J. E. Buttersworth" (lower right)

PLATE I.2

Cutter Yacht Maria
F. F. Palmer (1812–1876), delineator
Nathaniel Currier (1813–1888), lithographer
1852
Color lithograph
19½" x 25"
Inscribed in the margins "Modelled by R. L. Stevens Esp./Owned by the Messrs. Stevens/ of New York/To John C. Stevens, Esq., Commodore/of the New York Yacht Club/Published by N. Currier,/152 Nassau Street, New York."
Note: *Maria* was actually a sloop, not a cutter as indicated by this title.

REFERENCES

Richard B. Grassby, *Ship, Sea & Sky, The Marine Art of James Edward Buttersworth* (New York: South Street Seaport Museum, 1994), pp. 96 (illustrated in color, pl. 29), 98.
John Parkinson, Jr., *The History of the New York Yacht Club* (New York: New York Yacht Club, 1975), Vol. I, pp. 10–12, 18–26, 31, 40, 42–43, 49–50, 116, 559–60.
John Rousmaniere, *America's Cup Book* (Milan, 1983), pp. 10–18.
Rudolph J. Schaefer, *J. E. Buttersworth, 19th-Century Marine Painter* (Mystic, CT: Mystic Seaport, 1975), pp. 97–99 (illustrated p. 97, pl. VI).
W. P. Stephens, *Traditions and Memories of American Yachting* (Brooklin, ME: Wooden-Boat Publications, 1981), pp. 8–9, 11, 37–39, 44, 111–12, 159, 269, 271, 297.
James Taylor, *Yachts on Canvas: Artists' Images of Yachts from the Seventeenth Century to the Present Day* (London: Conway Maritime Press, 1998), p. 84 (illustrated in color).

PLATE I.3

Schooner Yacht America *Winning the Cup at Cowes, 1851*
Attributed to William Bradford (1823–1892)
Ca. 1852
Oil on canvas
18" x 24"
Unsigned, formerly attributed to Fitz Hugh Lane

REFERENCE

Richard C. Kugler, *William Bradford: Sailing Ships & Arctic Seas* (London and Seattle: New Bedford Whaling Museum and University of Washington Press, 2003), p. 97.

NOTE

1. Erik A. R. Ronnberg, Jr., "William Bradford: Mastering Form and Developing a Style, 1852–1862," in Richard C. Kugler, *William Bradford: Sailing Ships & Arctic Seas* (London and Seattle: New Bedford Whaling Museum and University of Washington Press), p. 61.

EXHIBITION

New Bedford Whaling Museum Exhibition, *William Bradford: Sailing Ships & Arctic Seas,* May 1–November 15, 2003.

PLATE I.4

Untitled View of Match Race between Schooner Yachts America *and* Alarm, *Cowes, August 5, 1860*
James E. Buttersworth (1817–1894)
Ca. 1860
Oil on artist's board
10" x 14"
Signed "J. E. Buttersworth" (lower right)

NOTE

1. *Hunt's Yachting Magazine*, Vol. X, No. 9, pp. 377–81 (London, September 1861).

PLATE I.5

Schooner Yacht Magic *Passing Sandy Hook Lightship, America's Cup, 1870*
James E. Buttersworth (1817–1894)
Ca. 1871
Oil on canvas
18" x 24"
Signed "J. E. Buttersworth" (lower right)

REFERENCES

Phillips de Pury & Luxembourg, Catalogue, *American Art, May 21, 2002*, pp. 161–62.

Rudolph J. Schaefer, *James E. Buttersworth, 19th-Century Marine Painter* (Mystic, CT: Mystic Seaport Museum, 1975), p. 184, no. 160.

PLATE I.6

Columbia *Leading* Dauntless *Rounding Sandy Hook Lightship in the Hurricane Cup Race*
James E. Buttersworth (1817–1894)
Ca. 1875
Oil on canvas
21" x 31¼"
Signed "J. E. Buttersworth" (lower right)

REFERENCES

John Parkinson, Jr., *The History of the New York Yacht Club* (New York: New York Yacht Club, 1975), Vol. I, pp. 69, 71, 73, 77, 134, Vol. II, pp. 580–81, 588.

John Rousmaniere, *America's Cup Book* (Milan, 1983), pp. 24–27.

Rudolph J. Schaefer, *J. E. Buttersworth, 19th-Century Marine Painter* (Mystic, CT: Mystic Seaport Museum, 1975), p. 184, no. 160 (illustrated).

W. P. Stephens, *Traditions and Memories of American Yachting* (Brooklin, ME: Wooden-Boat Publications, 1981), pp. 15, 29, 31, 48.

PLATE I.7

Mischief *and* Gracie, *America's Cup Trial Race, 1881*
James E. Buttersworth (1817–1894)
Ca. 1881
Oil on panel
11½" x 18"
Signed "J. E. Buttersworth" (lower right)

REFERENCES

John Parkinson, Jr., *The History of the New York Yacht Club* (New York: New York Yacht Club, 1975), Vol. I, pp. 59, 62, 66, 69–72, 76, 78, 81–82, 90, 92, 97–99, 101–04, 106–07, 109–11, 113–14, 116, 118, 122, 128–29, 140–41, 147–48, 150, Vol. II, pp. 582–83, 589.

John Rousmaniere, *America's Cup Book* (Milan, 1983), pp. 32–35.

W. P. Stephens, *Traditions and Memories of American Yachting* (Brooklin, ME: Wooden-Boat Publications, 1981), pp. 11, 15, 29–31, 34, 45, 55, 90, 126, 208, 281, 291, 276–77, 316, 319–20, 327–28, 331, 347–48, 350–51.

PLATE I.8

The Yacht Race
James E. Buttersworth (1817–1894)
Ca. 1880

Oil on academy board
13¾" x 23¾"
Signed "J. E. Buttersworth" (lower right)

REFERENCES

Richard B. Grassby, *Ship, Sea & Sky, The Marine Art of James Edward Buttersworth* (New York: South Street Seaport Museum, 1994), p. 102 (illustrated).

John Parkinson, Jr., *The History of the New York Yacht Club* (New York: New York Yacht Club, 1975), Vol. I, pp. 10–12, 18–26, 31, 40, 42–43, 49–50, 52, 116, 559–60.

John Rousmaniere, *America's Cup Book* (Milan, 1983), pp. 44–47.

W. P. Stephens, *Traditions and Memories of American Yachting* (Brooklin, ME: Wooden-Boat Publications, 1981), pp. 91, 134, 201–02, 341.

PLATE I.9

Puritan *and* Genesta, *America's Cup, 1885*
James E. Buttersworth (1817–1894)
Ca. 1885
Oil on canvas
24" x 30"
Signed "J. E. Buttersworth" (lower right)

REFERENCES

Montague Guest and William B. Bolton, *Memorials of the Royal Yacht Squadron* (London: Murray, 1903), pp. 357–58.

Richard B. Grassby, *Ship, Sea & Sky, The Marine Art of James Edward Buttersworth* (New York: South Street Seaport Museum, 1994), p. 103, pl. 36 (illustrated in color).

John Parkinson, Jr., *The History of the New York Yacht Club* (New York: New York Yacht Club, 1975), Vol. I, pp. 94, 101, 111, 115–19, 205, 244, Vol. II, pp. 582, 589.

John Rousmaniere, *America's Cup Book* (Milan, 1983), pp. 36–39.

Rudolph J. Schaefer, *J. E. Buttersworth, 19th-Century Marine Painter* (Mystic, CT: Mystic Seaport Museum, 1975), p. 211, no. 188 (illustrated).

W. P. Stephens, *Traditions and Memories of American Yachting* (Brooklin, ME: Wooden-Boat Publications, 1981), pp. 23, 78, 87, 155, 161, 173, 327–31.

PLATE I.10

Puritan *Leading* Genesta, *America's Cup, 1885*
James E. Buttersworth (1817–1894)
1885
Oil on canvas
24" x 30"
Signed and dated "J. E. Buttersworth 1885" (lower right)

REFERENCES

Richard B. Grassby, *Ship, Sea & Sky, The Marine Art of James Edward Buttersworth* (New

York: South Street Seaport Museum, 1994), p. 102, pl. 34 (illustrated in color).

Montague Guest and William B. Boulton, *Memorials of the Royal Yacht Squadron* (London: Murray, 1903), pp. 357–58.

John Parkinson, Jr., *The History of the New York Yacht Club* (New York: New York Yacht Club, 1975), Vol. I, pp. 94, 101, 111, 115, 116–19, 205, 244, Vol. II, pp. 582, 589.

John Rousmaniere, *America's Cup Book* (Milan, 1983), pp. 36–39.

Rudolph J. Schaefer, *J. E. Buttersworth, 19th-Century Marine Painter* (Mystic, CT: Mystic Seaport Museum, 1975), p. 206, no. 183 (illustrated).

W. P. Stephens, *Traditions and Memories of American Yachting* (Brooklin, ME: WoodenBoat Publications, 1981), pp. 23, 78, 87, 155, 161, 173, 327–31.

PLATE I.11

The Seawanhaka Corinthian Yacht Club Cutter Bedouin *off Execution Rocks Lighthouse*
Elisha Taylor Baker (1827–1890)
Ca. 1885
Oil on canvas
24½" x 29"
Signed with monogrammed initials and artist's insignia (lower left)

REFERENCES

John Parkinson, Jr., *The History of the New York Yacht Club* (New York: New York Yacht Club, 1975), Vol. I, pp. 109–11, 114, 116, photograph of *Bedouin* facing: 117–18, 122, 129, 135, 139, 140, 147, 171.

N. L. Stebbins, *Stebbins' Illustrated Coast Pilot* (Boston, 1891), p. 17 (for photograph of Execution Rocks Lighthouse as seen from the same bearing as in this painting).

W. P. Stephens, *The Seawanhaka Corinthian Yacht Club: Origins and Early History 1871–1896* (New York: The Seawanhaka Corinthian Yacht Club, 1963), pp. 84, 85, 87, 106–08, 113–15, 118, 152, 169, 183, 185, illustration facing p. 46.

W. P. Stephens, *Traditions and Memories of American Yachting* (Brooklin, ME: WoodenBoat Publications, 1981), pp. 301–11, 313–14, 316, 319–20, 327–28, 347–48, 350–52.

James Taylor, *Yachts on Canvas: Artists' Images of Yachts from the Seventeenth Century to the Present Day* (London: Conway Maritime Press, 1998), p. 101 (illustrated in color).

PLATE I.12

Mayflower *Leading* Puritan, *America's Cup Trial Race, 1886*
James E. Buttersworth (1817–1894)
Ca. 1886
Oil on canvas
19½" x 30"
Signed "J. E. Buttersworth" (lower right)

REFERENCES

John Parkinson, Jr., *The History of the New York Yacht Club* (New York: New York Yacht Club, 1975), Vol. I, pp. 115, 117, 119–20, 122–25, 127, 128, 244, Vol. II, pp. 582, 589.

John Rousmaniere, *America's Cup Book* (Milan, 1983), pp. 36–44.

W. P. Stephens, *Traditions and Memories of American Yachting* (Brooklin, ME: WoodenBoat Publications, 1981), pp. 78, 91, 332–34.

PLATE I.13

Mayflower *Leading* Galatea, *America's Cup, 1886*
James E. Buttersworth (1817–1894)
Ca. 1886
Oil on canvas
24½" x 29¾"
Signed "J. E. Buttersworth" (lower right)

REFERENCES

Richard B. Grassby, *Ship, Sea & Sky, The Marine Art of James Edward Buttersworth* (New York: South Street Seaport Museum, 1994), p. 100, pl. 32 (illustrated in color).

John Parkinson, Jr., *The History of the New York Yacht Club* (New York: New York Yacht Club, 1975), Vol. I, pp. 115, 117, 119–20, 122–25, 127–28, 244, Vol. II, pp. 582, 589.

John Rousmaniere, *America's Cup Book* (Milan, 1983), pp. 40–44.

W. P. Stephens, *Traditions and Memories of American Yachting* (Brooklin, ME: WoodenBoat Publications, 1981), pp. 78, 91, 332–34.

James Taylor, *Yachts on Canvas: Artists' Images of Yachts from the Seventeenth Century to the Present Day* (London: Conway Maritime Press, 1998), p. 85 (illustrated in color).

PLATE I.14

Volunteer *versus* Thistle, *America's Cup, 1887*
James E. Buttersworth (1817–1894)
Ca. 1887
Oil on canvas
20" x 29½"
Signed "J. E. Buttersworth" (lower right)

REFERENCES

John Parkinson, Jr., *The History of the New York Yacht Club* (New York: New York Yacht Club, 1975), Vol. I, pp. 117, 126, 128–31, 244, 583, 589.

John Rousmaniere, *America's Cup Book* (Milan, 1983), pp. 44–47.

W. P. Stephens, *Traditions and Memories of American Yachting* (Brooklin, ME: WoodenBoat Publications, 1981), pp. 91, 134, 201–02, 341.

NOTE

I. John Parkinson, Jr., *The History of the New York Yacht Club* (New York: New York Yacht Club, 1975), p. 130.

EXHIBITION

New York, Wunderlich & Company, *Marine Paintings of the 19th and 20th Centuries*, 1984, p. 10, no. 9 (illustrated in color).

PLATE I.15

The Sloop Irene
James E. Buttersworth (1817–1894)
Ca. 1854
Oil on canvas
24" x 32"
Signed "Buttersworth" (lower right)

REFERENCE

Richard B. Grassby, *Ship, Sea & Sky, The Marine Art of James Edward Buttersworth* (New York: South Street Seaport Museum, 1994), pp. 113–14 (illustrated in color), 116–18.

PLATE I.16

Fetching the Mark
James E. Buttersworth (1817–1894)
Ca. 1855–60
Oil on canvas
13¾" x 20"
Signed "J. E. Buttersworth"

REFERENCE

Rudolph J. Schaefer, *J. E. Buttersworth, 19th-Century Marine Painter* (Mystic, CT: Mystic Seaport Museum, 1975), p. 116, pl. IX. (illustrated).

PLATE I.17

Yachts Rounding the Mark
James E. Buttersworth (1817–1894)
Ca. 1875
Oil on academy board
7¾" x 10"
Signed "J. E. Buttersworth" (lower right)

PLATE I.18

New York Yacht Club Regatta
Attributed to Antonio Jacobsen (1850–1921)
Ca. 1878

Oil on canvas
17½" x 29½"
Unsigned and undated

REFERENCE

Harold S. Sniffen, *Painted Ships on Painted Oceans* (Newport News: The Mariners' Museum, 1994), pp. ix, 152, 157 (very similar to the painting illustrated on p. 157).

PLATE I.19

New York from the Bay
James E. Buttersworth (1817–1894)
Ca. 1878
Oil on canvas
21 ½" x 36"
Signed "J. E. Buttersworth" (lower right)

REFERENCES

Richard B. Grassby, *Ship, Sea & Sky, The Marine Art of James Edward Buttersworth* (New York: South Street Seaport Museum, 1994), pp. 93–94, pl. 28 (illustrated in color).

John Parkinson, Jr., *The History of the New York Yacht Club* (New York: New York Yacht Club, 1975), Vol. I, pp. 87–88.

W. P. Stephens, *Traditions and Memories of American Yachting* (Brooklin, ME: Wooden-Boat Publications, 1981), pp. 29, 32, 275.

James Taylor, *Yachts on Canvas: Artists' Images of Yachts from the Seventeenth Century to the Present Day* (London: Conway Maritime Press, 1998), p. 81 (illustrated in color).

NOTE

I. John Parkinson, Jr., *The History of the New York Yacht Club* (New York: New York Yacht Club, 1975), Vol. I, p. 87.

PLATE I.20

Yacht Race on Upper Bay, New York Harbor
James E. Buttersworth (1817–1894)
Ca. 1875
Oil on artist's board
8" x 11¾"
Signed "J. E. Buttersworth" (lower right)

PLATE I.21

Chapman Dock and Old Brooklyn Navy Yard, East River, New York
James E. Buttersworth (1817–1894)
Ca. 1870

Oil on panel
7¾" x 18"
Signed "J. E. Buttersworth" (lower right)

REFERENCES
Richard B. Grassby, *Ship, Sea & Sky, The Marine Art of James Edward Buttersworth* (New York: South Street Seaport Museum, 1994), pp. 116–18, pl. 45 (illustrated in color).
Rudolph J. Schaefer, *J. E. Buttersworth, 19th-Century Marine Painter* (Mystic, CT: Mystic Seaport Museum, 1975), p. 127, no. 101 (illustrated, for another version of this painting).

PLATE I.22

The Early Racers
Frederic Schiller Cozzens (1846–1928)
1884
Color lithograph
13¾" x 21½"
Signed and dated on stone "Fred S. Cozzens 84" (lower left)

REFERENCES
J. D. Jerrold Kelley, *American Yachts: Their Clubs and Races* (New York: C. Scribner's Sons, 1884), pl. I.
John Rousmaniere, *The Low Black Schooner: Yacht* America *1851–1945* (Mystic, CT: Mystic Seaport Museum, 1986).

NOTE:
1. J. D. Jerrold Kelley, *American Yachts: Their Clubs and Races* (New York: C. Scribner's Sons, 1884), pp. 8–9.

PLATE I.23

The Finish off Staten Island—1870
Frederic Schiller Cozzens (1846–1928)
1884
Color lithograph
14" x 20"
Signed and dated on stone "Fred S. Cozzens/84"

REFERENCE
J. D. Jerrold Kelley, *American Yachts: Their Clubs and Races* (New York: C. Scribner's Sons, 1884), pl. VI.

NOTES
1. J. D. Jerrold Kelley, *American Yachts: Their Clubs and Races* (New York: C. Scribner's Sons, 1884), pp. 95–96.
2. Ibid., p. 104.

PLATE I.24

A Breezy Day Outside
Frederic Schiller Cozzens (1846–1928)
1883
Watercolor on paper
14" x 19¾"
Signed and dated "Fred S. Cozzens 83" (lower left)

REFERENCE
J. D. Jerrold Kelley, *American Yachts: Their Clubs and Races* (New York: C. Scribner's Sons, 1884), pl. XVII.

NOTE
1. The editor of *The Month at Goodspeeds*, quoted in Anita Jacobsen, *Frederic Cozzens: Marine Painter* (New York: Alpine Fine Arts Collection, 1982), p. 46.

PLATE I.25

Untitled View of Sloop Defender *Leading the British Challenger* Valkyrie III, *America's Cup, 1895*
Frederic Schiller Cozzens (1846–1928)
1896
Watercolor on paper
14" x 20¼"
Signed and dated "Fred S. Cozzens 96" (lower left)

NOTE
1. Herbert L. Stone and Alfred F. Loomis, *Millions for Defense: A Pictorial History of the Races for the America's Cup* (New York, 1934).

PLATE I.26

Crossing the Line, New York Bay
Frederic Schiller Cozzens (1846–1928)
1883
Watercolor on paper
13¾" x 20¼"
Signed and dated "Fred S. Cozzens 83" (lower left)

REFERENCE
J. D. Jerrold Kelley, *American Yachts: Their Clubs and Races* (New York: C. Scribner's Sons, 1884), pl. VIII.

NOTE
1. J. D. Jerrold Kelley, *American Yachts: Their Clubs and Races* (New York: C. Scribner's Sons, 1884), p. 307.

PLATE I.27

By Sou'west Spit
Frederic Schiller Cozzens (1846–1928)
1883
Watercolor on paper
13¾" x 20"
Signed and dated "Fred S. Cozzens 83" (lower left)

REFERENCE

J. D. Jerrold Kelley, *American Yachts: Their Clubs and Races* (New York: C. Scribner's Sons, 1884), pl. XIII.

NOTE

I. J. D. Jerrold Kelley, *American Yachts: Their Clubs and Races* (New York: C. Scribner's Sons, 1884), p. 213.

PLATE I.28

A Misty Morning Drifting
Frederic Schiller Cozzens (1846–1928)
1883
Watercolor on paper
13¾" x 20"
Signed and dated "Fred S. Cozzens 83" (lower left)

REFERENCE

J. D. Jerrold Kelley, *American Yachts: Their Clubs and Races* (New York: C. Scribner's Sons, 1884), pl. XXI.

NOTE

I. J. D. Jerrold Kelley, *American Yachts: Their Clubs and Races* (New York: C. Scribner's Sons, 1884), pp. 334–35.

PLATE I.29

Robbins Reef—Sunset
Frederic Schiller Cozzens (1846–1928)
1883
Watercolor on paper
13¾" x 20½"
Signed and dated "Fred S. Cozzens 83" (lower left)

REFERENCE

J. D. Jerrold Kelley, *American Yachts: Their Clubs and Races* (New York: C. Scribner's Sons, 1884), pl. X.

NOTE

I. J. D. Jerrold Kelley, *American Yachts: Their Clubs and Races* (New York: C. Scribner's Sons, 1884), p. 153.

PLATE I.30

In the Narrows—a Black Squall
Frederic Schiller Cozzens (1846–1928)
1883
Watercolor on paper
13¾" x 20"
Signed and dated "Fred S. Cozzens 83" (lower left)

REFERENCES

J. D. Jerrold Kelley, *American Yachts: Their Clubs and Races* (New York: C. Scribner's Sons, 1884), pl. VII.

NOTE

I. J. D. Jerrold Kelley, *American Yachts: Their Clubs and Races* (New York: C. Scribner's Sons, 1884), p. 124.

PLATE I.31

Ice Boating on the Hudson
Frederic Schiller Cozzens (1846–1928)
1884
Watercolor on paper
14" x 20"
Signed and dated "Fred S. Cozzens 84" (lower left)

REFERENCES

J. D. Jerrold Kelley, *American Yachts: Their Clubs and Races* (New York: C. Scribner's Sons, 1884), pl. XXV.

NOTE

I. J. D. Jerrold Kelley, *American Yachts: Their Clubs and Races* (New York: C. Scribner's Sons, 1884), pp. 405–06.

PLATE I.32

Moonlight on Nantucket Shoals
Frederic Schiller Cozzens (1846–1928)
1883
Watercolor on paper
14" x 20¼"
Signed and dated "Fred S. Cozzens 83" (lower left)

REFERENCE

J. D. Jerrold Kelley, *American Yachts: Their Clubs and Races* (New York: C. Scribner's Sons, 1884), pl. XIV.

NOTES:

1. J. D. Jerrold Kelley, *American Yachts: Their Clubs and Races* (New York: C. Scribner's Sons, 1884), p. 219.

2. Ibid., p. 215.

PLATE I.33

Off Brenton's Reef
Frederic Schiller Cozzens (1846–1928)
1883
Watercolor on paper
14" x 20¼"
Signed and dated "Fred S. Cozzens 83" (lower left)

REFERENCE

J. D. Jerrold Kelley, *American Yachts: Their Clubs and Races* (New York: C. Scribner's Sons, 1884), pl. IV.

NOTE

1. J. D. Jerrold Kelley, *American Yachts: Their Clubs and Races* (New York: C. Scribner's Sons, 1884), pp. 62–63.

PLATE I.34

Before the Wind—Newport
Frederic Schiller Cozzens (1846–1928)
1883
Watercolor on paper
13½" x 20"
Signed and dated "Fred S. Cozzens 83" (lower left)

REFERENCE

J. D. Jerrold Kelley, *American Yachts: Their Clubs and Races* (New York: C. Scribner's Sons, 1884), pl. XXIII.

NOTE

1. J. D. Jerrold Kelley, *American Yachts: Their Clubs and Races* (New York: C. Scribner's Sons, 1884), p. 369.

PLATE I.35

Around the Cape—Marblehead
Frederic Schiller Cozzens (1846–1928)
1884
Color lithograph
14" x 20"
Signed and dated on stone "Fred S. Cozzens 84" (lower left)

REFERENCE

J. D. Jerrold Kelley, *American Yachts: Their Clubs and Races* (New York: C. Scribner's Sons, 1884), pl. XI.

NOTES

1. J. D. Jerrold Kelley, *American Yachts: Their Clubs and Races* (New York: C. Scribner's Sons, 1884), pp. 170–71.

2. Ibid., pp. 183–84.

PLATE I.36

The Yacht Maria *216 Tons*
Charles Parsons (1821–1910), delineator
Nathaniel Currier (1813–1888), lithographer
1861
Lithograph in color
20¼" x 28¾"
Inscribed "Modelled by R. L. Stevens Esq. Built by Mr. Capes 1844 and owned by Messrs. J. C., R. L., & E. A. Stevens, of Hoboken, N.J."

PLATE I.37

Regatta of the New York Yacht Club, June 1, 1854. The Start
Charles Parsons (1821–1910), delineator
Nathaniel Currier (1813–1888), lithographer
1854
Lithograph with color added
20¼" x 28½"
Signed on stone "J. E. Buttersworth" (lower right)

NOTE

1. John Parkinson, Jr., *The History of the New York Yacht Club* (New York: New York Yacht Club, 1975), Vol. I, p. 30.

PLATE I.38

Regatta of the New York Yacht Club, June 1st, 1854. Coming in; Rounding the Stake Boat
Charles Parsons (1821–1910), delineator
Nathaniel Currier (1813–1888), lithographer
1854
Lithograph in black and white with color added
19¾" x 28¾"

PLATE I.39

Regatta of the New York Yacht Club, "Rounding S. W. Spit."
Charles Parsons (1821–1910), delineator
Nathaniel Currier (1813–1888) & James Merritt Ives (1824–1895), lithographers

Signed by "J. E. Buttersworth" on stone, lower right
1854
Lithograph in black and white with color added
14¾" x 28"

PLATE I.40

The New York Yacht Club Regatta. The Start from the Stakeboat in the Narrows, off the New Club House and Grounds, Staten Island, New York Harbor
Charles Parsons (1821–1910) and Lyman Atwater (dates), artists
Nathaniel Currier (1813–1888), lithographer
1869
Lithograph with color added
20¼" x 28¾"

NOTE

I. John Parkinson, Jr., *The History of the New York Yacht Club* (New York: New York Yacht Club, 1975), Vol. I, p. 61.

PLATE I.41

The Yacht Squadron at Newport
Nathaniel Currier (1813–1888) and James Merritt Ives (1824–1895), lithographers
1872
Lithograph in black and white with color added
18½" x 28"

NOTE

I. John Parkinson, Jr., *The History of the New York Yacht Club* (New York: New York Yacht Club, 1975), Vol. I, p. 77.

PLATE I.42

The Enterprise
John Mecray (b. 1937)
1982
Graphite on paper
11¼" x 22¼"
Signed, dated and inscribed "John Mecray © 82" (lower right)

BRITISH YACHTING ART

PLATE II.1

Mr. Ward and His Family on Board His Cutter Guerrilla
Nicholas Matthew Condy (1818–1851)
Ca. 1840
Oil on wood panel
13¾" x 18"

NOTE

I. James Taylor, *Yachts on Canvas: Artists' Images of Yachts from the Seventeenth Century to the Present Day* (London: Conway Maritime Press, 1998), p. 79 (illustrated).

PLATE II.2

Mystery *(Lord Alfred Paget) beating* Blue Bell *(A. Fountaine) on a Race in the Thames, May 23rd, 1843*
Thomas Goldsworthy Dutton (1819–1891)
1851
Watercolor on paper
6¾" x 10"
Signed and dated "T. G. Dutton 1851" (lower right)

PLATE II.3

A Racing Cutter of the Royal Thames Yacht Club Passing Astern of an Anchored Three-Decker, Perhaps the Guardship of the Nore
Attributed to William Joy (1803–1867)
Ca. 1842–48
Watercolor on paper
10½" x 16¼"

PLATE II.4

Rounding the Nore
James E. Buttersworth (1817–1894)
Ca. 1851
Oil on academy board
6¼" x 11½"
Signed "J. E. Buttersworth" (lower right)

REFERENCE

Rudolph J. Schaefer, *J. E. Buttersworth, 19th-Century Marine Painter* (Mystic, CT: Mystic Seaport Museum, 1975), p. 92, no. 67 (illustrated).

PLATE II.5

The Royal Yacht Squadron's Schooner Fair Rosamond *Running Up the Channel After Rounding the Eddystone Lighthouse in Stormy Weather*
Nicholas Matthew Condy (1818–1851)
1848
Oil on artist's board
12" x 16"
Signed and dated "N. M. Condy 1848" (lower left)

PLATE II.6

Cutter Yachts Racing at Plymouth
Nicholas Matthew Condy (1818–1851)
Ca. 1845
Oil on artist's board
7" x 12"

PLATE II.7

The Yacht Arrow *of the Royal Yacht Squadron*
Capt. James Haughton Forrest (1826–1925)
Ca. 1851
Oil on canvas
16" x 17"
Signed "H. Forrest" and inscribed "Cowes" (lower left)

REFERENCE
James Taylor, *Yachts on Canvas: Artists' Images of Yachts from the Seventeenth Century to the Present Day* (London: Conway Maritime Press, 1998), p. 86 (illustrated).

PLATE II.8

Cambria *Winning the International Race, Cowes, 1868*
Arthur Wellington Fowles (1815–1883)
1869
Oil on canvas
28" x 39"
Signed "A. W. Fowles," inscribed "Ryde I. of W." and dated "1869" (lower left)

PLATE II.9

Cambria *Winning the Town Cup, Ryde, 1868*
Arthur Wellington Fowles (1815–1883)
1869
Oil on canvas
28" x 39"
Signed "A. W. Fowles," inscribed "Ryde I. of W." and dated "1869" (lower left)

PLATE II.10

Cambria *off the Needles, Isle of Wight, 1868*
Arthur Wellington Fowles (1815–1883)
1869
Oil on canvas
28" x 38½"
Signed "A. W. Fowles," inscribed "Ryde I. of W." and dated "1869" (lower left), bears inscription on reverse

PLATE II.11

Cambria *Winning at Cowes*
Arthur Wellington Fowles (1815–1883)
1868
Oil on canvas
28" x 39"
Signed "A. W. Fowles," inscribed "Ryde I. of W." and dated "1869" (lower left)

PLATE II.12

Yachts Racing for the Mark at Cowes
Attributed to Arthur Wellington Fowles (1815–1883)
Ca. 1860
Oil on canvas
11¾" x 20"

PLATE II.13

Stars and Stripes *versus* Kookaburra III, *America's Cup, 1987*
John Steven Dews (b. 1949)
Dated 1987
Oil on canvas
23½" x 35½"
Signed "J. Steven Dews" (lower left)

AMERICAN MARINE ART

PLATE III.1

The United States
Attributed to Spoilum (active 1774–1806)
Ca. 1800
Oil on canvas
14¾" x 19½"

REFERENCES
Carl L. Crossman, *The Decorative Arts of the China Trade* (Woodbridge, Suffolk, U.K.: Antique Collectors' Club, 1991), p. 116 (illustrated), p 122.

Boleslaw and Marie-Louise D'Otrange Mastai, *The Stars and the Stripes* (New York: Alfred A. Knopf, Inc., 1973), p. 69.

PLATE III.2

Captain James Josiah
Charles Wilson Peale (1741–1827)
1787
Oil on canvas
35½" x 26"
Signed, dated and inscribed "Painted by C. W. Peale, 1787"

REFERENCES
Catalogs of the exhibitions listed below.
Catalog of the *Arthur J. Sussel American Naval Collection* (1977).
Brandon Brame Fortune and Deborah J. Warner, *Franklin and his Friends* (Washington, DC: Smithsonian National Portrait Gallery, 1999), pp. 80–82 (illustrated p. 80).

NOTE
1. Excerpted from Brandon Brame Fortune and Deborah J. Warner, *Franklin and His Friends* (Washington, DC: Smithsonian National Portrait Gallery, 1999), pp. 80–82.

EXHIBITIONS
United States Naval Academy Museum, April 8, 1978.
National Portrait Gallery, October 1982–January 1983.
Amon Carter Museum, February–April 1983.
Metropolitan Museum, June–September 1983.
National Portrait Gallery, March–September 1984.
Schwarz Gallery, Philadelphia, May 1–June 27, 1987.
National Portrait Gallery, April 16–September 6, 1999.

PLATE III.3

The Battle of Lake Erie, September 10, 1813
Ambroise Louis Garneray (1783–1857)
Ca. 1815
Oil on panel
9¼" x 18"

PLATE III.4

The Capture of HMS Macedonian *by the American Frigate* United States, *October 25, 1812*
Ambroise Louis Garneray (1783–1857)
Ca. 1813
Oil on panel
9" x 13¾"
Signed "Garneray" (lower left)

PLATE III.5

The USS Hornet *Attempting to Save HMS* Peacock *after Their Duel on February 24, 1813*
Ambroise Louis Garneray (1783–1857)
Ca. 1813
Oil on panel
9" x 14¼"

PLATE III.6

View of New York Harbor
Thomas Birch (1779–1851)
Early 1830s
Oil on canvas
19½" x 30"

REFERENCES
William H. Gerdts, *Thomas Birch: 1779–1851 Paintings and Drawings* (Philadelphia: Philadelphia Maritime Museum, 1966), p. 35, no. 33 (illustrated).
William H. Gerdts, "Thomas Birch: America's First Marine Artist," *Antiques,* April 1966, p. 532 (illustrated).

NOTES
1. John Wilmerding, *American Marine Painting* (New York: Abrams, 1987), pp. 80, 82, and Fig. 73.
2. Ibid., p. 74.
3. Peter J. Guthorn, *United States Coastal Charts, 1783–1861* (Exton, PA: Schiffer Publications, 1984), pp. 70, 72.

PLATE III.7

The Battery and Harbor, New York
Thomas Birch (1779–1851)
Early 1830s
Oil on canvas
29" x 41"

NOTES
1. Peter J. Guthorn, *United States Coastal Charts, 1783–1861* (Exton, PA: Schiffer Publications, 1984), pp. 70, 72.
2. John Wilmerding, *American Marine Painting* (New York: Alfred A. Knopf, Inc., 1987), pp. 80, 82.

PLATE III.8

The Bark Marblehead *Coming into Port*
Robert Salmon (1775–after 1845)
1832, revised 1836
Oil on panel

$15\frac{1}{2}$" x $23\frac{1}{2}$"

Inscribed "No. 771 painted by R. Salmon, 1832, and no. 851 1836 R. S." (on reverse)

REFERENCE

John Wilmerding, *Robert Salmon, Painter of Ship and Shore* (Boston: Peabody Museum and Boston Public Library, 1971), Appendix A, Salmon's Catalogue of Paintings, registered as no. 771 and no. 851, pp. 93, 95.

NOTES

1. John Wilmerding, *Robert Salmon, Painter of Ship & Shore* (Boston: Peabody Museum and Boston Public Library, 1971), p. 93.
2. Ibid., p. 95.
3. Ibid., p. 94.

EXHIBITION

New York, Hirschl & Adler Galleries, Inc., *Lines of a Different Color—American Art from 1727 to 1947*, 1982–83, Catalog, p. 20, no. 8 (illustrated in full color).

PLATE III.9

A Schooner with a View of Boston Harbor
Robert Salmon (1775–after 1845)
1832
Oil on panel
16" x $23\frac{1}{2}$"
Signed "RS 1832" (lower right) and inscribed "No. 756/Painted by R Salmon/Anno 1832" (on reverse)

REFERENCES

The American Neptune, *A Selection of Paintings by Robert Salmon: 19th-Century Marine Artist* (Salem: Peabody Museum, N.D.), Pictorial Supplement XI (illustrated).

John Wilmerding, *Robert Salmon, Painter of Ship and Shore* (Boston: Peabody Museum and Boston Public Library, 1971), Appendix A, no. 756, p. 93.

NOTES

1. John Wilmerding, *Robert Salmon, Painter of Ship and Shore* (Boston: Peabody Museum and Boston Public Library, 1971), p. 93.
2. R. B. Forbes, *Personal Reminiscences* (Boston: Little, Brown and Company, 1892), pp. 124, 125.

EXHIBITIONS

New York, Kennedy Galleries, *Aspects of America: The Land of the People, 1818–1930*, May 1985 (illustrated on catalog back cover).

New York, Kennedy Galleries, *Summits: Outstanding American Paintings: 1763–1985*, November 6–December 7, 1985, no. 4 (illustrated).

PLATE III.10

View of Boston Harbor
Robert Salmon (1775–after 1845)
1843
Oil on panel
$9\frac{1}{2}$" x $11\frac{1}{2}$"
Inscribed "Painted by R.S.A.T 1843 No. 125" (on reverse)

NOTE

1. Alex Krieger and David Cobb, with Amy Turner, *Mapping Boston* (Cambridge, MA: MIT Press, 1999), Fig. 4, p. 123; pl. 35, p. 197; pl. 36, p. 199.

PLATE III.11

American Schooner under Sail with Heavy Seas
Robert Salmon (1775–after 1845)
1834
Oil on panel
$15\frac{1}{2}$" x $23\frac{1}{2}$"
Signed and dated "R. S. 1834" (lower right), inscribed "No. 799/Painted by R. Salmon 1834" (on reverse)

NOTES

1. John Wilmerding, *Robert Salmon, Painter of Ship and Shore* (Boston: Peabody Museum and Boston Public Library, 1971), p. 94.
2. Howard I. Chapelle, *The History of the American Sailing Navy* (New York: W. W. Norton and Co., 1949), pp. 324–30 and pl. XII; 380–84.
3. Alec Purves, *Flags for Shipmodellers and Marine Artists* (London: Conway Maritime Press, 1983), pp. 57, 58.

PLATE III.12

Ship Star Light *in Boston Harbor*
Fitz Hugh Lane (1804-1865)
Ca. 1854
Oil on canvas
$23\frac{3}{4}$" x $25\frac{1}{2}$"
Unsigned

REFERENCE

Octavius T. Howe and Frederick C. Matthews, *American Clipper Ships: 1833–1858* (Salem, MA: Marine Research Society, 1927), Vol. II, p. 628 (illustrated opposite).

NOTE

1. Octavius T. Howe and Frederick C. Matthews, *American Clipper Ships, 1833–1858* (Salem, MA: Marine Research Society, 1927), pp. 628–30. See also the plate reproducing a photograph of this painting in an earlier state.

PLATE III.13

The Ship Michael Angelo *Entering Boston Harbor*
Fitz Hugh Lane (1804–1865)
1849
Oil on canvas
26" x 36"
Signed and dated "F H Lane 1849" (lower right)

REFERENCES

Dorothy and M.V. Brewington, *Marine Paintings in the Peabody Musuem* (Salem, MA: Peabody Museum, 1968), p. 153 (illustrated no. 753).

John Caldwell and Oswaldo Rodriquez Roque, *American Paintings in the Metropolitan Museum* (Princeton, NJ: Princeton University Press, 1994), vol. I, pp. 493–95.

M. and M. Karolik Collection of American Paintings 1815 to 1865 (Boston: Museum of Fine Arts, 1949), p. 411 (illustrated pl. 185).

John Wilmerding, *American Light: The Luminist Movement 1850–1875* (Washington, DC: National Gallery of Art and Harper and Row, 1980), p. 59 (illustrated pl. 8).

John Wilmerding, *Fitz Hugh Lane 1804–1865, American Marine Painter* (Salem: Essex Institute, 1964), p. 54.

John Wilmerding, *Paintings by Fitz Hugh Lane* (Washington, DC: National Gallery of Art, 1988), p. 98 (illustrated pl. 31).

EXHIBITION

Springfield Museum of Art, 1938.

PLATE III.14

Yacht America *from Three Views*
Fitz Hugh Lane (1804-1865)
Ca. 1851
Oil on canvas
18½" x 27½"
Unsigned

REFERENCES

John Wilmerding, *Fitz Hugh Lane 1804–1865, American Marine Painter* (Salem: Essex Institute, 1964), p. 57 (illustrated no. 45).

John Wilmerding, *Paintings by Fitz Hugh Lane* (Washington, DC: National Gallery of Art, 1988), p. 77 (illustrated fig. 17).

L. Francis Herreshoff, *An Introduction to Yachting* (New York: Sheridan House, 1963), p. 63 (illustrated).

NOTES

1. John Rousmaniere, *The Low Black Schooner Yacht* America *1851–1945* (Mystic, CT: Mystic Seaport Museum, 1986) pp. 17, 20.
2. The Dutton lithograph is dated October 22, 1851.

3. L. Francis Herreshoff, *An Introduction to Yachting* (New York: Sheridan House, 1963) pp. 60, 61.

PLATE III.15

Schooner Yacht Bessie *Off Newport*
William Bradford (1823–1892)
1850s
Sepia wash drawing on paper
12" x 18"
Signed and dated "Wm Bradford / 185[illegible]" (lower right)

PLATE III.16

The Mary *of Boston Returning to Port*
William Bradford (1823–1892)
1857
Oil on canvas, mounted on panel
19¾" x 29¾"
Signed and dated "Wm Bradford 1857" (lower right)

EXHIBITION

New Bedford Whaling Museum, *William Bradford: Sailing Ships and Arctic Seas*, May 22, 2003–October 26, 2003.

PLATE III.17

Ships in Boston Harbor at Twilight
William Bradford (1823–1892)
1859
Oil on prepared millboard
11¾" x 18¾"
Signed and dated "Wm Bradford/1859" (lower right)

EXHIBITION

New Bedford Whaling Museum, *William Bradford: Sailing Ships and Arctic Seas*, May 22, 2003–October 26, 2003.

PLATE III.18

The Clipper Ship N. B. Palmer *at Anchor*
James E. Buttersworth (1817–1894)
Ca. 1851
Oil on canvas
12" x 16"
Signed "J. E. Buttersworth" (lower right)

NOTES

1. Octavius T. Howe and Frederick C. Matthews, *American Clipper Ships, 1833–1858* (Salem, MA: Marine Research Society, 1927), pp. 410–15.

2. Howard I. Chapelle, *The Search for Speed under Sail* (New York: W. W. Norton and Co., 1967), pp. 333, 336.

PLATE III.19

American Ships under Sail with Vessel to Port and Starboard
James E. Buttersworth (1817–1894)
1860s
Oil on panel
12" x 18"
Signed "J. E. Buttersworth" (lower right)

REFERENCES

Richard B. Grassby, *Ship, Sea & Sky: The Marine Art of James Edward Buttersworth* (New York: South Street Seaport Museum, 1994), p. 102 (illustration).

John Parkinson, Jr., *The History of the New York Yacht Club* (New York: New York Yacht Club, 1975), Vol. I, pp. 10–12, 18–26, 31, 40, 42–43, 49–50, 52, 116, 559–60.

John Rousmaniere, *America's Cup Book* (Milan, 1983), pp. 36-39.

Rudolph J. Schaefer, *J. E. Buttersworth, 19th-Century Marine Painter* (Mystic, CT: Mystic Seaport Museum, 1975), pp. 44–47.

W. P. Stephens, *Traditions and Memories of American Yachting* (Brooklin, ME: Wooden-Boat Publications, 1981), pp. 91, 134, 201–02, 341.

NOTE

1. W. P. Stephens, *Traditions and Memories of American Yachting* (Brooklin, ME: Wooden-Boat Publications, 1981), pp. 28–32.

PLATE III.20

Columbia and Shamrock, America's Cup, 1899
Edward Hopper (1882–1967)
Watercolor on paper
9" x 10¾"
Signed and dated "E. Hopper '99"

BRITISH MARINE ART

The Taking of Belle Isle 1761 by Commodore Keppel and General Hodgson
A Set of Six (Plates IV.1–IV.6)
Dominic Serres Snr. (1719–1793)
One signed "D. Serres" and dated "1762" (lower left), one signed "D. Serres" and dated "1762" (lower right), one dated "1762"

REFERENCE

Alan Russett, *Dominic Serres R.A. War Artist to the Navy* (Woodbridge, Suffolk, U.K.: Antique Collectors' Club, 2001).

PLATE IV.1

First Attack at Port Andro, April 8, 1761
Dominic Serres Snr. (1719–1793)
1762
Oil on canvas
14½" x 20½"

PLATE IV.2

Second Attack Made at Port d'Arsic
Dominic Serres Snr. (1719–1793)
1762
Oil on canvas
14½" x 20½"

PLATE IV.3

The Swiftfire, Essex, Hampton Court *and* Lynn
Dominic Serres Snr. (1719–1793)
1762
Oil on canvas
14½" x 20½"

PLATE IV.4

View from the Raminet Battery
Dominic Serres Snr. (1719–1793)
1762
Oil on canvas
14½" x 20½"

PLATE IV.5

Land View of the Citadel
Dominic Serres Snr. (1719–1793)
1762
Oil on canvas
14½" x 20½"

PLATE IV.6

Town and Harbour of Sauzon
Dominic Serres Snr. (1719–1793)
1762
Oil on canvas
14½" x 20½"

PLATE IV.7

The Relief of Gibraltar by Admiral Lord Howe, October 11–18, 1782
Thomas Whitcombe (ca. 1752–1824)
1792
Oil on panel
8⅞" x 42¾"
Signed "T. Whitcombe" and dated "1792" on the sail of the xebec (lower right)

PLATE IV.8

French and English Vessels in Battle
Nicholas Pocock (1741–1821)
Ca. 1800
Oil on canvas
17¾" x 23½"

PLATE IV.9

Achilles *and Two Vessels after Battle*
Nicholas Pocock (1741–1821)
Ca. 1800
Oil on canvas
17¾" x 23½"

REFERENCE

Wm. Laird Clowes, *The Royal Navy: A History from the Earliest Times to the Present* (London: Sampson Low, Marston and Company, 1899), Vol. IV, p. 388.

PLATE IV.10

HMS Britannia *Beating Down the Channel Past the Eddystone Lighthouse*
Thomas Buttersworth (1768-1842)
Ca. 1820
Oil on canvas
18" x 24"
Signed "T. Buttersworth" (lower left)

PLATE IV.11

English Ships in Harbor
Thomas Buttersworth (1768–1842)
Ca. 1820
Oil on canvas
17½" x 23½"
Signed "T. Buttersworth" (lower left)

NOTE

1. Rudolph J. Schaefer, *J. E. Buttersworth, 19th-Century Marine Painter* (Mystic, CT: Mystic Seaport Museum, 1975), p. 29.

PLATE IV.12

Greenock Harbour, 1820
Robert Salmon (1775–after 1845)
1820
Oil on canvas,
22½" x 36½"
Signed with initials and dated "RS 1820" (lower right)

REFERENCE

A. S. Davidson, *Marine Art & the Clyde—100 Years of Sea, Sail and Steam* (Wirral, U.K.: Jones-Sands Publishing, 2001), p. 36 (illustrated).

PLATE IV.13

The Pomona *of Greenock, Riding at Anchor*
Robert Salmon (1775–after 1845)
1818
Oil on canvas
22¾" x 36¼"
Signed with initials and dated "RS 1818" (lower right)

NOTES

1. John Harland, *Seamanship in the Age of Sail* (Annapolis: Chrysalis Books, 1984), p. 273.
2. Alec Purves, *Flags for Shipmodellers and Marine Artists* (London: Conway Maritime Press, 1983), pp. 72–76, also Fig. 101.
3. John Wilmerding, *Robert Salmon, Painter of Ship and Shore* (Boston: Peabody Museum and Boston Public Library, 1971), p. 89.

PLATE IV.14

A Mail Packet in the Clyde
Robert Salmon (1775–after 1845)
1824
Oil on canvas
22½" x 37"
Signed with initials and dated "RS 1824" (lower right), inscribed "No. 400 Painted by R Salmon 1824" (on reverse)

NOTE

1. Alec Purves, *Flags for Shipmodellers and Marine Artists* (London: Conway Maritime Press, 1983), pp. 29, 30.

REFERENCE

A. S. Davidson, *Marine Art & the Clyde—100 Years of Sea, Sail, and Steam* (Wirral, U.K.: Jones-Sands Publishing, 2001), p. 41 (illustrated), and illustrated in color on dustjacket.

PLATE IV.15

View of Liverpool
Robert Salmon (1775–after 1845)
1825
Oil on wood panel
15¾" x 25"
Inscribed "Painted by Robert Sal…1825 No. 473" (reverse)

PLATE IV.16

Royal Naval Vessels off Pembroke Dock, Milford Haven
Robert Salmon (1775–after 1845)
Ca. 1836
Oil on canvas
26¼" x 40¾"

REFERENCE
A. S. Davidson, *Marine Art & the Clyde—100 Years of Sea, Sail, and Steam* (Wirral, U.K.:
 Jones-Sands Publishing, 2001), p. 42 (illustrated).

BIBLIOGRAPHY

American Neptune. *A Selection of Paintings by Robert Salmon: 19th-Century Marine Artist* (Salem, MA: Peabody Museum, 1969).

Anderson, Henry H. "Glen Foster Remembered," *New York Yacht Club Newsletter*, Vol. 13, No. 1, March 2000.

Archibald, E. H. H. *Dictionary of Sea Painters* (Woodbridge, Suffolk, U.K.: Antique Collectors' Club, 1980).

Arthur J. Sussel American Naval Collection, Catalog, 1977.

Blasdale, Mary Jean. *Artists of New Bedford: A Biographical Dictionary* (New Bedford, MA: Old Dartmouth Historical Society and New Bedford Whaling Museum, 1990).

Bonhams: The Marine Sale, including the Glen S. Foster Estate Collection, Wednesday, 22 January 2003.

Bray, Maynard, and Carlton Pinheiro. *Herreshoff of Bristol* (Brooklin, ME: WoodenBoat Publications, 1989).

Brewington, Dorothy E. R. *Marine Paintings and Drawings in Mystic Seaport Museum* (Mystic, CT: Mystic Seaport Museum, 1982).

Brewington, Dorothy E. R. and M. V. *Marine Paintings and Drawings in the Peabody Museum* (Salem, MA: Peabody Museum, 1968).

Brook-Hart, Denys. *British 19th-Century Marine Painting* (Woodbridge, Suffolk, U.K.: Antique Collectors' Club, 1982).

Caldwell, John, and Oswaldo Rodriguez Roque. *American Paintings in the Metropolitan Museum of Art*, Vol. I (Princeton, NJ: Princeton University Press, 1994).

Campbell, Kathryn H. *The Thomas and James Buttersworth Collection from the Penobscot Marine Museum* (Searsport, ME: Penobscot Marine Museum, 2000).

Chapelle, Howard I. *The History of the American Sailing Navy* (New York: W. W. Norton and Co., 1949).

———. *The Search for Speed under Sail* (New York: W. W. Norton and Co., 1967).

Clark, Arthur H. *The History of Yachting 1600–1815* (New York and London: G. P. Putnam's Sons, 1904).

Clowes, Wm. Laird. *The Royal Navy: A History from the Earliest Times to the Present* in Six Volumes (London: Sampson Low, Marston and Company, 1899).

Conningham, Frederic A. Conningham. *Currier & Ives Prints: An Illustrated Check List* (New York: Crown Publishers, 1970).

Cordingly, David. *Marine Painting in England 1700–1900* (New York: C. N. Potter, 1973).

Cozzens, Fred S. *Yachts and Yachting* (New York: C. Scribner's Sons, 1887).

Crossman, Carl L. *The Decorative Arts of the China Trade* (Woodbridge, Suffolk, U.K.: Antique Collectors' Club, 1991).

Cunliffe, Tom, *Pilots: The World of Pilotage under Sail and Oar*, Vol. I, *Pilot Schooners of North America and Great Britain* (Brooklin, ME: WoodenBoat Publications, 2001).

Davidson, A. S. *Marine Art and the Clyde—100 Years of Sea, Sail and Steam* (Wirral, U.K.: Jones-Sands Publishing, 2001).

———. *Marine Art & Liverpool: Painters, Places & Flag Codes 1760–1960* (Albrighton, Wolverhampton, U.K.: Waine Research Publications, 1986).

Finamore, Daniel, et al. *Across the Western Ocean: American Ships by Liverpool Artists* (Salem, MA: Peabody Museum, 1995).

Forbes, R. B. *Personal Reminiscences* (Boston: Little, Brown and Company, 1892).

Fortune, Brandon Brame, and Deborah J. Warner, *Franklin and his Friends* (Washington, DC: Smithsonian National Portrait Gallery, 1999).

Gerdts, William H. *Thomas Birch: 1779–1851 Paintings and Drawings* (Philadelphia: Philadelphia Maritime Museum, 1966).

———. "Thomas Birch: America's First Marine Artist," *Antiques*, April 1966.

Grassby, Richard B. *Ship, Sea & Sky: The Marine Art of James Edward Buttersworth* (New York: South Street Seaport Museum, 1994).

Guest, Montague, and William B. Boulton. *Memorials of the Royal Yacht Squadron* (London: Murray, 1903).

Guthorn, Peter J. *United States Coastal Charts, 1783–1861* (Exton, PA: Schiffer Publications, 1984).

Harland, John. *Seamanship in the Age of Sail* (Annapolis: Chrysalis Books, 1984).

Heckstall-Smith, B. *Yachts & Yachting in Contemporary Art* (London: Studio Limited, 1925).

Henderson, J. Welles, and Rodney P. Carlisle. *Jack Tar: A Sailor's Life 1750–1910* (Woodbridge, Suffolk, U.K.: Antique Collectors' Club, 1999)

Herreshoff, L. Francis. *An Introduction to Yachting* (New York: Sheridan House, 1963).

Howe, Octavius T., and Frederick C. Matthews. *American Clipper Ships 1833–1858* (Salem, MA: Marine Research Society, 1927).

Jacobsen, Anita. *Frederic Cozzens: Marine Painter* (New York: Alpine Fine Arts Collection, 1982).

M. and M. Karolik Collection of American Paintings 1815 to 1865 (Boston: Museum of Fine Arts, 1949).

Kelley, J. D. Jerrold. *American Yachts: Their Clubs and Races* (New York: C. Scribner's Sons, 1884).

Kirby, Bruce. "Crossing the Fleet One More Time," *Sailing World*, October 2000.

Krieger, Alex, and David Cobb, with Amy Turner. *Mapping Boston* (Cambridge, MA: MIT Press, 1999).

Kugler, Richard C. *William Bradford: Sailing Ships & Arctic Seas* (London and Seattle: New Bedford Whaling Museum and University of Washington Press, 2003).

Levitt, Michael. *America's Cup 1851–1992: The Official Record of America's Cup XXVIII & the Louis Vuitton Cup* (Portland, OR: Graphic Arts Center Publishing Co., 1992).

Mackay, Robert B. "Marine Paintings at the New York Yacht Club," *Antiques*, July 1999.

Mastai, Boleslaw, and Marie-Louise D'Otrange. *The Stars and the Stripes* (New York: Alfred A. Knopf, Inc., 1973).

Morris, Gerald E., and Llewellyn Howland III. *Yachting in America: A Bibliography Embracing the History, Practice, and Equipment of American Yachting and Pleasure Boating from Earliest Beginnings to Circa 1988* (Mystic, CT: Mystic Seaport Museum, 1991).

National Maritime Museum Staff. *Concise Catalogue of Oil Paintings in the National Maritime Museum* (Woodbridge, Suffolk, U.K.: Antique Collectors' Club, 1988).

Parkinson, John, Jr. *The History of the New York Yacht Club* (New York: The New York Yacht Club, 1975).

Phillips de Pury & Luxembourg: Catalogue of American Art, May 21, 2002.

Purves, Alec. *Flags for Shipmodellers and Marine Artists* (London: Conway Maritime Press, 1983).

Rayner, D. A., and Alan Wykes. *The Great Yacht Race* (London: Peter Davies, 1966).

Rousmaniere, John. *The Low Black Schooner: Yacht* America *1851–1945* (Mystic, CT: Mystic Seaport Museum, 1986).

_____. *America's Cup Book* (New York: W. W. Norton and Co., 1983).

Russett, Alan. *Dominic Serres R.A. War Artist to the Navy* (Woodbridge, Suffolk, U.K.: Antique Collectors' Club, 2001).

Schaefer, Rudolph J. *J. E. Buttersworth, 19th-Century Marine Painter* (Mystic, CT: Mystic Seaport Museum, 1975).

Sniffen, Harold S. *Antonio Jacobsen's Painted Ships on Painted Oceans* (Newport News, VA: The Mariners' Museum, 1994).

Stebbins, N. L. *Stebbins' Illustrated Coast Pilot* (Boston, 1891).

Stephens, W. P. *Traditions and Memories of American Yachting* (Brooklin, ME: Wooden Boat Publications, 1981).

_____. *The Seawanhaka Corinthian Yacht Club: Origins and Early History, 1871–1896* (New York: The Seawanhaka Corinthian Yacht Club, 1963).

Stone, Herbert L., and Alfred F. Loomis. *Millions for Defense: A Pictorial History of the Races for the America's Cup* (New York, 1934).

Taylor, James. *Yachts on Canvas: Artists' Images of Yachts from the Seventeenth Century to the Present Day* (London: Conway Maritime Press, 1998).

Testmonial to Charles J. Paine and Edward Burgess from the City of Boston for their Successful Defense of the America's Cup (Boston: Printed by Order of the City Council, 1887).

Thompson, Winfield M., and Thomas W. Lawson. *The Lawson History of the America's Cup* (Boston: Private Edition, 1902).

Wilmerding, John. *American Light: The Luminist Movement 1850–1875* (New York and Washington, DC: Harper and Row, National Gallery of Art, 1980).

_____. *American Marine Painting* (New York: Abrams, 1987).

_____. *Fitz Hugh Lane 1804–1865, American Marine Painter* (Salem, MA: The Essex Institute, 1964).

_____. *A History of American Marine Painting* (Boston: Peabody Museum of Salem, 1968).

_____. *Robert Salmon, Painter of Ship and Shore* (Boston: Peabody Museum and Boston Public Library, 1971).

_____. ed. *Paintings by Fitz Hugh Lane* (Washington, DC: National Gallery of Art, 1988).

Index

Glen S. Foster: sailor, connoisseur, friend.

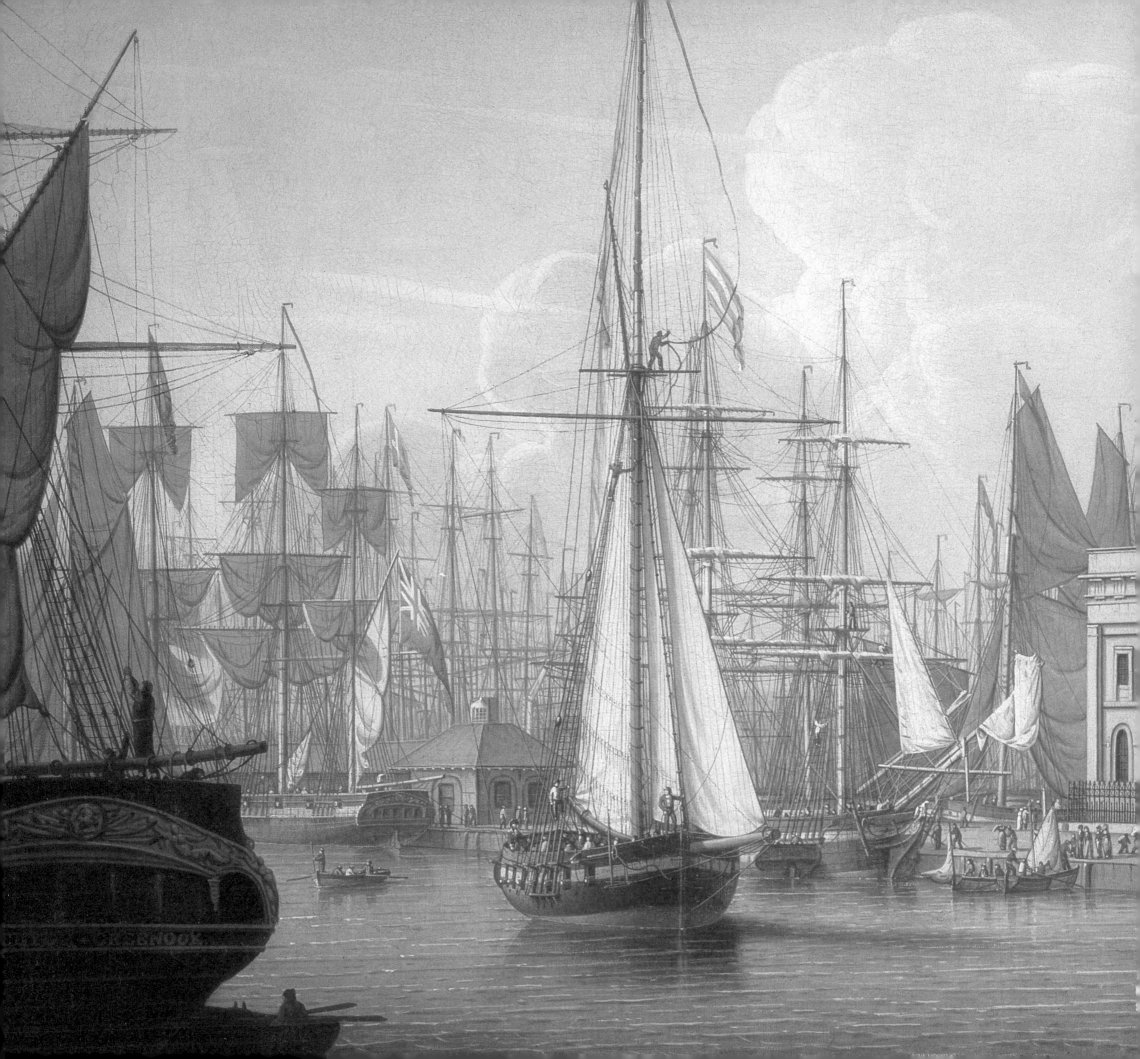